Klee and Kandinsky
in Munich and at the Bauhaus

Studies in the Fine Arts: The Avant-Garde, No. 16

Stephen C. Foster, Series Editor
Associate Professor of Art History
University of Iowa

Kenneth S. Friedman, Ph.D.
Consulting Editor

Other Titles in This Series

No. 11 Otto Dix and Die neue Sachlichkeit:
1918-1925

Brigid S. Barton

No. 12 The Life and Works of Otto Dix: German
Critical Realist

Linda F. McGreevy

No. 13 Henri Matisse and Neo-Impressionism,
1898-1908

Catherine C. Bock

No. 14 Giacomo Balla: Divisionism and Futurism,
1871-1912

Susan Barnes Robinson

No. 15 Form Follows Form: Source Imagery of
Constructivist Architecture, 1917-1925

Kestutis Paul Zygas

Klee and Kandinsky
in Munich and at the Bauhaus

by
Beeke Sell Tower

UMI RESEARCH PRESS
Ann Arbor, Michigan

Produced and distributed by
UMI Research Press
an imprint of
University Microfilms International
Ann Arbor, Michigan 48106

Library of Congress Cataloging in Publication Data

Tower, Beeke Sell.
 Klee and Kandinsky in Munich and at the
Bauhaus.

 (Studies in fine arts. The Avant-garde ; no. 16)
 Revision of thesis (Ph.D.)–Brown University, 1978.
 Bibliography: p.
 Includes index.
 1. Kandinsky, Wassily, 1866-1944. 2. Klee, Paul, 1879-
1940. 3. Group work in art–Germany. 4. Blauer Reiter.
5. Bauhaus. I. Title. II. Series: Studies in fine arts.
Avant-garde ; no. 16.

N6999.K33T68 1981 760'.092'2 81-3028
ISBN 0-8357-1179-X AACR2

To the Memory of Barbara Shupp Tower

Frontispiece. *Klee and Kandinsky*
Parodying the Poses of Goethe and Schiller
on the Weimar Memorial, 1929.

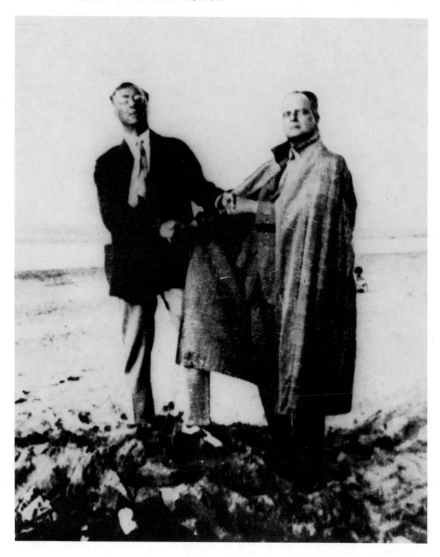

Contents

List of Figures

Frontispiece
*Klee and Kandinsky Parodying the Poses of
 Goethe and Schiller on the Weimar Memorial,* 1929.
Photograph by Felix Klee.

Foreword

The term "avant-garde" has been in use for something over a century. Originally coined to define the futuristic thrust of revolutionary political activity in the mid-nineteenth century, it has long since been applied as well to the progressive or revolutionary activities of the fine arts. The term has shown remarkable staying power and, to a surprising degree, it has maintained its original message.

For the world of the nineteenth century, the avant-garde represented an aggressive revisionism, formulated by those attempting to charter what they thought would be the new society emerging from the mid-century revolutions. Even in 1825, Henri de Saint-Simon, the French Utopian Socialist, described the new destiny of the arts as the spearhead of social progressivism, and in his essays he foresaw a ruling committee composed of philosophers, artists, statesmen, and scientists, among others. All were to participate on an equal footing in establishing a new, visionary, fair, and humane world. From its beginning, the avant-garde was composed of people representing a variety of activities, but its basic posture was political. This politicization of art has remained characteristic of the avant-garde to the present day.

Throughout the nineteenth century, the original concept and spirit of the avant-garde was kept very much alive, but increasingly the term came to mean other things as well and was applied to those branches of art that justified themselves on grounds of artistic experimentalism and formal innovation. At the same time, the political thrust of the earlier avant-garde was generalized to encompass a variety of social and critical (but not necessarily political) attitudes which were mirrored through the artists' productions. The term acquired a more general designation to "where the action is," which finally came to mean anything from politics to religion, philosophy to psychology. The avant-garde has come to be identified, then, with a variety of progressive historical circumstances.

It is clear that the avant-garde cannot be convincingly characterized in stylistic terms. It is, perhaps, better approached as a set of attitudes which are understood by the artists of any given period to represent revolutionary, even

adversarial social points of view. How, stylistically or formally, the points of view are communicated turns out to be somewhat less important in the long run than the spirit in which they are offered.

There is another crucial consideration in discussing the avant-garde: its community basis. To the degree that the avant-garde has sought to have social impact, it has generally organized itself along collective ideological lines and has employed a group strategy. To be successful, the avant-garde must persuade. Its artists must think in accord with the most advanced thinking of their time; thus, in the twentieth century, art is strongly aligned with science and technology. The avant-garde must also possess the "means" to persuade—to recruit a convinced audience. The latter accounts for the little magazines of the avant-garde, the manifestos, the polemics, and the tradition of public demonstration and provocation.

This series of volumes reveals a wide historical cross section of the avant-garde. Studies centering on activities in Italy, France, Germany, Holland, and Russia encompass all or most of the major manifestations of the twentieth-century avant-garde frame of mind before World War II. The original political motivation of the avant-garde is present in one form or another in the works examined in most of the titles offered here, but it is expressed with particular clarity in Greenberg's *Artists and Revolution: Dada and the Bauhaus, 1917-1925,* and in Christiana Taylor's *Futurism: Politics, Painting and Performance.* Although the political climates treated in these titles vary tremendously, each entails the common factor of artistic works produced under the impetus of political evolution. Greenberg traces the reactions of two, quite dissimilar groups to the establishment of the much criticized and ill-fated Weimar Republic. Taylor discusses a radically politicized and nationalistic reaction to what the futurists felt was the unutterable backwardness of Italy in cultural, economic, and political spheres. Susan Robinson's *Giacomo Balla: His Life and Work, 1871-1912* is a detailed look at one artist's historical preparation for the formulation of and sympathy toward Futurism.

Unlike the above studies, which address reactions to very specific and localized historical circumstances, the study by Kestutis Paul Zyas, *Form Follows Form: Source Imagery of Constructivist Architecture, 1917-1925,* and that by Steven Mansbach, *Visions of Totality: Laszlo Moholy-Nagy, Theo van Doesburg, and El Lissitzky* examine much broader and frankly utopian programs which, though formulated in reaction to specific situations (World War II and the Russian Revolution of 1917) aspired in their art to far more globally applicable solutions (Greenberg, in his discussion of the Bauhaus, approaches many of the same problems).

Yet politics were not the only compelling basis of avant-garde activity. Whitney Chadwick's *Myth in Surrealist Painting, 1929-1939* treats three Surrealists who in their painting became the first to systematically exploit communication through mythic symbols.

Equally important as a center of fine arts progressivism—in fact, fundamental to most of its expressions, regardless of the particular work's social content—was a concern for the autonomy of art's formal means. Catherine Bock's *Henri Matisse and Neo-Impressionism: 1898-1908* reflects the relatively unpolitical persuasion of French art throughout the first two decades of this century. The Fauves' search for a pure art found a parallel but considerably different expression in Germany among the Blaue Reiter group. *Klee and Kandinsky in Munich and at the Bauhaus* by Beeke Tower provides a detailed account of the 15-year development of this concept of art. The Russian expression of this abstraction and formalization is explored by Charlotte Douglas in *Swans of Other Worlds: Kasimir Malevich and the Origins of Abstraction in Russia,* a much needed work on an artist of great importance and influence.

The avant-garde may also be discussed in terms of the nature of the work presented and how the work is presented. Thus, in *Chance: A Perspective on Dada,* Harriett Watts discusses aleatory art as an alternative to and escape from the constraints imposed by cultural orthodoxies. In a similar vein, Haim Finkelstein's *Surrealism and the Crisis of the Object* examines altered contexts and their implications for the life of the work. Both David Zinder, in his book *The Surrealist Connection: An Approach to a Surrealist Aesthetic of Theatre,* and Annabelle Melzer, in *Latest Rage the Big Drum: Dada and Surrealist Performance,* concentrate on the theatre as a mode of presentation which, because of its simulation of life situations and its involvement of the spectator in the action, was thought to bring art closer to life. (Taylor also addresses this subject.) While ideology and aesthetics dwell at the center of any avant-garde identity, this honor sometimes falls to specific individuals. Hannah Hedrick's careful analysis of Theo van Doesburg and his role in the avant-garde underscores the importance of the organization of the avant-garde mission.

The avant-garde may crystallize around a stylistic evolution of considerable historical depth and breadth, encompassing in the work of a few the recognition and historical fulfillment of the achievement of an entire generation. Or the avant-garde may emerge as a collective insight into more locally framed circumstances given brilliant definition by a single artist, a leader, as exemplified in Brigid Barton's *Otto Dix and Die neue Sachlichkeit, 1918-1925* and Linda McGreevy's *The Life and Works of Otto Dix: German Critical Realist.*

The above are but a few of the most obvious indexes of avant-garde activity. I do not wish to suggest that these are the only, or even the most important considerations bearing on the avant-garde's historical definition, but they are important ones. Nor do I wish to suggest that the usefulness of these titles is confined to delineating the historical contours of the avant-

garde. On the contrary, each offers the richness of information of a period study. And it is important for our own time to identify the common historical and aesthetic aims of the subjects treated in these works which finally permit their being gathered into an avant-garde series.

While the avant-garde seems to lack a clear formal, intellectual, or even aesthetic common denominator, it nevertheless strikes us as a coherent and vital art phenomenon. The artists described in these volumes endeavored to obey what each understood to be the most urgent historical imperatives of their times. While most, in some way, worked in opposition to the course of past or present historical events, the avant-garde's historical consciousness has been keen. Serving both as a mirror to society's failures and as a beacon to the future, the avant-garde has become nothing less than the conscience of our time.

Stephen C. Foster
Series Editor

Preface

The translations from German and French sources are by the author. Published English translations were used for the quotations when available, but often revised to render the meaning more accurately. These passages are marked as revised.

Not all works mentioned in the text could be illustrated, due to the large number of works discussed. Appendix III, however, provides a list of bibliographical sources for the works not illustrated or annotated in the notes. When these works are mentioned in the text, a reference to the Appendix III listing (App. III-1, App. III-2, etc.) follows, whenever possible. Some recent publications have been included in Appendix III which have appeared since completion of the manuscript and which were not considered in the text itself.

Acknowledgments

The research for this study was conducted over a number of years, both in the United States and in Europe. So many individuals and institutions have helped me in my work that it would be impossible to name them all.

Professor Hannes Beckmann, Frau Professor Grote, and Frau Judith Köllhofer-Wolfskehl have shared with me their recollections of Kandinsky and Klee and of the Bauhaus, and have allowed me to study the works and material in their collections. I recall with great pleasure my hours of conversation with them which brought to life the artistic atmosphere in prewar Munich and at the Bauhaus.

It has been a special privilege to visit Felix Klee on several occasions and to be guided by him through his magnificent collection of works by his father and the Blaue Reiter artists.

I am also grateful to Herbert Bayer, T. Lux Feininger, Dr. Christian Geelhaar, Dr. Jürgen Glaesemer, Nina Kandinsky, Professor Klaus Lankheit, and Marianne Teuber for kindly providing me with information and access to research material.

The Bauhaus Archive in Berlin, the Boymans-van Beuningen Museum in Rotterdam, the Klee Foundation in Bern, the Kunstmuseum in Basel, the Kunstsammlungen Nordrhein-Westfalen in Düsseldorf, the Musée National d'Art Moderne in Paris, the Museum of Modern Art in New York, the Pasadena Museum of Art, the Solomon R. Guggenheim Museum in New York, the Städtische Galerie im Lenbachhaus in Munich, and the Stedelijk Museum in Amsterdam, all have generously given me access to the originals in their collections, as well as to their archives and other documentary material. Of the many galleries where I have been able to study works by Kandinsky and Klee I especially wish to thank the Parisian galleries Maeght and Berggruen.

My research trips were made possible by two grants. I am grateful to Brown University for the Abbott Alumnae Fellowship in Art (1975), and to the Fritz Thyssen Foundation in Cologne for a travel grant which enabled me to conduct my research in Europe.

I wish to express my profound gratitude to my doctoral thesis advisor, Professor Kermit S. Champa, whose guidance and encouragement was invaluable to me in my research, and indeed throughout my graduate studies. I also offer special thanks to Professor William Jordy and Professor Karl Weimar of Brown University. Since completion of my dissertation in 1978 the literature on both Kandinsky and Klee has grown considerably, with several studies addressing the question of their artistic relationship. For the present text, however, the recent literature could not be taken into consideration. I thank my friend Elizabeth Grossman for kindly reading parts of the study; her suggestions were very helpful in making the revisions.

Finally, I want to say "Danke schön" to my family in Germany and in the United States. My parents, Christian and Emmy Sell, and my father-in-law, Charles Tower, have encouraged and supported me in my studies throughout the years. My most deeply-felt thanks go to my husband David, who has been helpful to my research in innumerable ways and whose understanding has sustained me.

Beeke Sell Tower

Introduction

The names of Paul Klee and Wassily Kandinsky are frequently mentioned together in the context of German Expressionism, the Blaue Reiter circle, and of the Bauhaus, but the two painters are usually presented as widely divergent artistic personalities. Kandinsky is looked upon primarily as the exponent of Expressionist abstraction, as he realized it in his dramatic color visions of the prewar years, while Klee's art is associated with the whimsical figural inventions and the calmly ordered color square paintings of the 1920s.

During two important periods of time the two artists were closely associated: from late 1911 to early 1914 Klee belonged to the Blaue Reiter circle; he was an active member, although not as prominent as Kandinsky and Marc. During the 1920s and early 1930s, Klee and Kandinsky were both form teachers at the Bauhaus; in these years their personal friendship and artistic exchange intensified and became closer than it had been during the prewar years in Munich. This study examines the artistic interaction between the two artists during these two periods. Notwithstanding basic differences in their artistic approaches, there are many common aspects in their conceptual positions, as well as important mutual influences on the formal level, which have until now received fairly little consideration. In discussing their artistic relationship it will be shown that at various points each artist looked to the work of the other for solutions to crucial formal problems. During the Blaue Reiter years Klee and Kandinsky shared what can best be termed an artistic *Weltanschauung* (as it involves much more than just form theory), which continued to determine their artistic outlook during the twenties and thirties.

When the two artists met again at the Bauhaus in 1922 their works were stylistically quite far apart, but over the following years an artistic *rapprochement* took place between them. From about 1925 a lively artistic give-and-take ensued between Klee and Kandinsky which manifested itself in a number of works where they tackle the same basic formal problems and arrive at similar results. This interaction can be briefly demonstrated in a comparison of two works by Klee and Kandinsky of 1927, which defines not only the

similarities and differences in their art, but also their relationship to the contemporary avant-garde.

In these paintings, Klee and Kandinsky deal with the same basic formal theme: brightly colored overlapping triangles moving in a continuous formation across a dark ground. Klee's painting, called *Boats in the Dark*, 1927. E 3 (Fig. 1), conjures up a nocturnal sailing scene; stylistically it stands at the end of a series of three paintings with the same motif. The two earlier versions, both entitled *Departure of the Boats,* 1927, D 10 (App. III-18 and App. III-55), are similar in composition and color, but the forms are more figurative. Kandinsky's painting has a strictly descriptive title: *Points in an Arc*, 1927 (Fig. 2). Aside from the descriptive title, Klee's *Boats in the Dark* (Fig. 1) is more or less as abstract as Kandinsky's *Points*.

In Klee's *Boats,* triangular shapes, which overlap transparently, move in a swaying motion horizontally across the dark ground. Above and below the central band there is a group of larger, dark-brown 'sails' in the foreground and a small boat in the distant background. The composition is arranged in a flattened S-shape. The visual movement begins in the upper left, then proceeds from the red triangles on the left toward the larger but darker forms on the right, and back into the center of the picture via the brown triangles at the bottom. In Kandinsky's painting the compositional order is less complicated; the overlapping triangles move upward in one continuous semicircle. The horizontal red bar shape in the center divides the composition into two nearly symmetrical halves. Such horizontal accents recur throughout the composition, acting as stabilizing agents which counteract to some extent the upward surge of the arc. In Kandinsky's painting, most of the triangles are aligned with the horizontal picture axis; as a result the individual shapes appear static and balanced. In Klee's painting, on the other hand, the triangles are almost all placed slightly at an angle to the horizontal axis and their directions shift so that a complicated rhythmic motion is generated. While the composition in Kandinsky's painting is more static than in Klee's, an element of visual movement is introduced by the progression of colors from the cooler and darker colors at the bottom toward the radiant yellow at the top. The three small bar shapes at the top left point the eye into the distance, thus fulfilling a function similar to the arrows in Klee's *Departure of the Boats* (App. III-18 and App. III-55). The formation of boats in Klee's painting is broken up into individual clusters of overlapping and interlocking shapes which are read as separate configurations. In each of these configurations the black contour lines act to simultaneously distinguish the overlapping shapes from each other, and bind them together into larger units with a predominantly planar character. In Kandinsky's painting, on the other hand, the individual shapes remain more discrete and are read as separate forms. In the upper part of the arc formation, the overlaps become quite complicated and elaborate. For

example, the red triangle in the upper center cuts across as many as five other shapes and still remains discernible in its outline. The manner in which the forms overlap in Kandinsky's painting generates more spatial effects, but the space between the individual forms cannot be measured or clearly defined, as the color changes and the additional patterns and form motifs obfuscate the spatial relationships.

Klee, on his part, introduces allusions to space not only by means of the overall composition but also by the way the boats in the central band are positioned. The red 'boat' shape at the left is seen from behind, while the others are mostly shown from the side. As the boats pivot and rock on the dark ground the viewer's eye is guided not only in an up and down, but also in a back and forth motion. Such continual visual motion is characteristic of much of Klee's work of the 1920s, whereas in Kandinsky's work of the later twenties, static qualities often predominate.

It has already been stated that both *Boats* and *Points* are about equally abstract as regards the formal character of the pictorial elements. However, both artists include a small number of figurative allusions. The circle segments in Klee's painting remind the viewer of boat hulls, particularly in the two *Departure* pictures, in one of which Klee also includes a wave-like pattern. In *Points* the wavy lines in the left center also suggest water, and some of the triangles with base lines may be interpreted as boats. While Kandinsky refrains from establishing a specific figurative context, Klee provides a key for interpretation through the titles of his paintings.

The subtle differences described between the paintings by Klee and Kandinsky characterize their individual artistic approaches, yet it becomes evident how much the artists have in common when the paintings are compared to Moholy-Nagy's painting, *D IV*, 1922 (Fig. 3). *D IV* is representative of the type of Constructivist painting which may be proposed as a common stylistic source for the luminous geometric forms floating weightlessly on a dark ground in both *Boats* and *Points*. The three paintings are related in terms of colors, the type of form elements used, and the emphasis on transparent overlapping. Kandinsky's and Moholy-Nagy's paintings furthermore share the combination of planar forms with thin bar shapes which are essentially linear in character. However, there are considerable differences between Moholy-Nagy's use of these form elements and the way in which Klee and Kandinsky deal with them. In Moholy-Nagy's painting, the forms, assembled into a diagonal cross formation, exist entirely in themselves, with no gravitational focus and with no allusive dimension. In *Boats* and *Points* there is a clearly defined direction in the composition and a sense of 'top' and 'bottom' which can be associated with the natural forces of gravity. As a result, the compositions seem constructed in an organically cohesive fashion. In *D IV* the spatial distance between the overlapping shapes cannot be measured, but

where they overlap the colors change in a predictable way. Klee and Kandinsky deal with the transparent overlaps in a much less rational manner. At times the overlapping areas appear as if they were made of colored glass and the color within the overlap changes accordingly, but at other times a completely different color will be introduced where the forms intersect. This ambiguity is further increased by the surface effects. The overlapping forms appear to be transparent or semitransparent, yet the grainy paint texture and the *cloisonné*-like outlines around the forms in Klee's painting suggest solidity and opaqueness. Kandinsky achieves a similarly ambivalent quality with creamy, gradated colors. Such ambivalent and irrational effects make the forms more intangible and immaterial than Moholy's. At the same time, the textural qualities introduce organic, natural associations. Moholy's smooth black ground appears dense and impenetrable, whereas in *Boats* and *Points* it is a mysterious nocturnal space. Klee creates a sense of depth through the spatial layers of the composition; Kandinsky breaks the evenness of the surface with the blue wavy lines in the left center which evoke associations with water. (Klee uses a similar device in *Departure* (App. III-18), surrounded by an unevenly dark ground.)

The compositional focal point in both *Boats* and *Points* is the blue circle. In Moholy's painting there is a similar blue semicircular shape, but it has no associative qualities whatsoever. In Klee's three paintings the blue circle is clearly the moon, casting its mysterious light over the ships. In Kandinsky's painting the circle is not placed into a position, which reads 'above,' but it seems to be the center of gravity around which the triangles move, and its volumetric rendering invites associations with cosmic phenomena. The 'blue moon,' if we may call it so, more than anything else, introduces an associative content into the pictures. Klee's boat scenes become enchanted and mysterious, and Kandinsky's *Points* turns into a similarly enigmatic nocturnal scene. Thus, in contrast to Moholy-Nagy and the Constructivists in general, Klee and Kandinsky use the abstract geometrical forms in ways that suggest organic and even figurative qualities. Both *Boats* and *Points* have strongly associative dimensions, although Klee makes his figurative content more specific and explicit, while Kandinsky intentionally stops short of offering concrete clues for interpretation.[1]

The blue circle, or moon, is symbolic of the artistic attitudes of both Klee and Kandinsky during the late twenties. It is primarily an abstract geometric shape, but at the same time it is laden with symbolic connotations, which hearken back to the ideas of the Blaue Reiter. Comparing the two paintings with Moholy's *D IV* has shown how Klee and Kandinsky use formal means, which are clearly related to Constructivism, for entirely different ends. The comparison is representative of much of their work of the later twenties and early thirties. Both Klee and Kandinsky seek to preserve and express a

transcendental, 'cosmic' dimension in their art; they want to uphold the spiritual values of the Blaue Reiter period, while at the same time coming to terms with the formal challenges of the contemporary avant-garde. Operating from a common conceptual basis, Klee and Kandinsky often arrived at similar formal solutions. From about 1925 onward a lively artistic exchange took place between them. To understand this common basis one has to go back to the Blaue Reiter period when it developed. The formation of this common basis and the artistic interaction between Klee and Kandinsky during the Blaue Reiter period, as well as during the Bauhaus years, are the subject of this study.

During both the Blaue Reiter and the Bauhaus years the two artists took considerable interest in each other's work and ideas. For a true assessment of the importance of their artistic interaction one has to look beyond mere stylistic similarities—of which there are considerably more than generally acknowledged—and examine the basic formal and theoretical issues with which they both dealt.

The influence of Kandinsky, and of the intellectual milieu of the Blaue Reiter circle in general, played a catalytic role in Klee's achievement of a highly ambitious synthesis of an artistic philosophy based on the German Idealist-Romantic tradition and contemporary form which he had set as a goal for himself earlier in his career. Simultaneously, as Klee grapples with French modernism, and Cubism in particular, he looks to Kandinsky's work for solutions to basic problems of form and expression. On the theoretical level, Klee develops a concept of abstraction that is indebted to Kandinsky. In his self-definition as an artist, and his artistic outlook in general, Klee has much in common with the artists of the Blaue Reiter, and their ideas greatly stimulated his thinking.

In reassessing the impact of Kandinsky's art and theory on Klee's artistic maturation to be of equal significance to the influence from French artists, an image emerges of Klee as an artist who consciously strove for a personal synthesis of the dualism represented by French modernism on one side and Munich Expressionism on the other. At a time when the generic differences between French and German art were much debated in artistic circles, frequently with nationalistic overtones, for Klee the bridging of these national opposites must have seemed a logical choice, as he felt himself to be "Schweizerdeutsch," Swiss by background and upbringing, if not according to his passport, and heir to a dual culture marked by both French and German elements.

During the Blaue Reiter years, Kandinsky is essentially the donor and Klee—then still at the beginning of his career as a painter—is the receiver. When they meet again at the Bauhaus and renew their friendly association, they are both widely-acclaimed, accomplished masters. At the beginning of

this period their works are stylistically very different, but the conceptual premises for their art are still largely those that they had shared during the Blaue Reiter years. While Klee looks to Kandinsky's art in certain respects, it is primarily Kandinsky who, in his work from the mid-twenties on, moves closer to Klee. Disenchanted with the cool geometry of his style of the early twenties, Kandinsky begins to reestablish painterly qualities in his art and reintroduces biomorphic and organic allusions. In its essence, his style of the later twenties hearkens back to the semiabstract works of 1912 and 1913, while remaining within the confines of geometric forms. At this point in time Kandinsky approaches Klee's position, not only on a formal level, but also in respect to theory, as he gradually adopts Klee's belief in the relatedness of artistic and natural laws of formation. Klee had founded his personal esthetics on the concept of formative parallels between art and nature, and in his art he seeks to make visible what he considers to be the laws of nature, whereas Kandinsky for a long time had looked upon art and nature as two separate realms subject to different laws of creation. This original conceptual difference between the two artists explains a good deal of what is ultimately different in their artistic approach. Beyond the theoretical differences, the discussion of their artistic backgrounds and their interaction during the Blaue Reiter and the Bauhaus years has to take into account differences in artistic temperament and intellectual orientation between Klee and Kandinsky as well. Much of what constitutes these differences is alluded to in the nickname bestowed on the two artists at the Weimar Bauhaus, where they were referred to as 'Goethe and Schiller' for their rather Olympian aloofness from the school's daily life. Will Grohmann, the friend and biographer of the two artists has elaborated the analogy:

> The students at the Weimar Bauhaus jokingly referred to them as Schiller and Goethe, and there is more than a grain of truth in the joke, for Kandinsky was by nature a deductive thinker, while Klee's mind was inductive; Klee, like Goethe, was a realist in the deeper sense of the word, whereas Kandinsky was dominated by ideas; with Klee intuition was dominant, with Kandinsky it was speculation.[2]

That the two artists appreciated the joke is evident: in 1929 they had themselves photographed in the poses of Goethe and Schiller on the celebrated Weimar memorial by E.F.A. Rietschel (see frontispiece).

Part I

The Artistic Backgrounds of Klee and Kandinsky

1

Klee and Kandinsky: 1900-1911

There are many parallels in Klee's and Kandinsky's development prior to the Blaue Reiter period, yet in discussing these we have to differentiate between their individual attitudes. The art of both artists evolves out of their coming to terms with Symbolism and *art nouveau* on one hand, and Impressionism and Fauvism on the other. More particularly, Klee and Kandinsky take an interest in many of the same artists, such as van Gogh and Matisse, to name but two. Yet they differ not only in artistic personality, but also to some extent in their conceptual positions, and as a result they often come to terms with artistic issues in different ways. Their individual responses are also determined by what constitutes the most important difference between them: Klee is basically a draftsman and it is only during the Blaue Reiter period, after long years of groping, that he feels secure as a painter, whereas Kandinsky is essentially a painter and, by his own account, had been completely fascinated with color from an early date.

Klee's and Kandinsky's Esthetic Positions

Klee and Kandinsky began their artistic training in similar ways. Both chose Munich, rather than Paris, for studies which began at private schools and were continued for a while at the Academy. Kandinsky came to Munich in 1896, Klee in 1898; in 1900 they both attended Franz Stuck's class at the Academy without, however, becoming more closely acquainted at the time.

Around the turn of the century Munich was one of the centers of *art nouveau* and the Academy was dominated by Symbolist painters such as Stuck. Symbolism and *art nouveau* are to some extent reflected in the art of both Klee and Kandinsky, but on the *theoretical* level they were formative primarily for Kandinsky's thinking. Klee left Munich in 1901 and after spending a year in Italy, where he steeped himself in the classical tradition, he spent four years in Bern, interrupted only by short trips to Munich and one to Paris. In contrast to Kandinsky, his theoretical position was strongly shaped by the literary tradition of German Classicism and Romanticism.

Kandinsky spent the better part of the period from 1896 to 1905 in Munich, actively participating in the artistic and literary life of Schwabing. During the first decade of the twentieth century he gradually developed his theories on abstraction and expressive colors, the sources for which are to be found in the religiocultural milieu of the turn of the century.

A number of scholars have investigated Kandinsky's sources. Peg Weiss, in the most recent study of Kandinsky's background, has elucidated the intellectual milieu in which Kandinsky lived in Munich.[1] She has pointed to the manifold connections between Kandinsky and the Munich *art nouveau* artists and the Arts and Crafts movement, as well as to the Symbolist circle around the poet Stefan George. According to Weiss, Kandinsky was probably aware of the theories on abstraction in ornament (with the implication of their conceivable relevance for all art) that were put forth by Endell, van de Velde, Karl Scheffler (later the champion of Impressionism), Hoelzel, Peter Behrends, Obrist, and others. Kandinsky was personally acquainted with the latter two artists and he saw works exhibited by the others. Much of his later theories on the expressiveness of color and line is prefigured in the writings of the artists and critics which Weiss cites. She suggests that Kandinsky's own experiments in applied arts played a crucial role in marking his transition from abstract ornament to abstraction in painting, with his prints representing an intermediary stage. Weiss proposes:

> ... that Kandinsky's move towards abstraction was, more than anything else, the result of a convergence of strong *Jugendstil* tendencies towards abstract ornamentation with a symbolist striving for inner significance and "geistige" revolution.[2]

Weiss also points out the influence from the literary circle around the poet Stefan George, with whom Kandinsky had been acquainted since the early 1900s, particularly the poet and writer Karl Wolfskehl. Influenced by French Symbolism as well as by the Pre-Raphaelites and German Romanticism, the members of this exclusive circle conceived of themselves as seers and priests of beauty. Their ultimate goal was the synthesis of the arts in the *Gesamtkunstwerk*. In their poetry they put great stress on compressed, enigmatic imagery, word-sounds, and archaic, highly stylized form, and Weiss traces analogous images and stylistic features in Kandinsky's prints, pointing to their reappearance in later paintings. Furthermore she relates Kandinsky's ideas on the theatrical *Gesamtkunstwerk* to his involvement with the Munich Artists' Theatre, founded in 1908, which aimed at a total esthetic experience by returning to the mystical-religious origins of the theater as a celebration of life. (Later, in 1914, both Klee and Marc were to be briefly involved in the Artists' Theatre.) Weiss's study thus places the evolution of Kandinsky's theories into the context of the Munich intellectual milieu; she provides an excellent picture of the significant discussions taking place on the possibilities of using abstract

forms possessed of an expressiveness beyond pure ornamentation.

French Symbolism, especially in its mystical and speculative direction, theosophy, and other occult movements have been proposed as other important sources for Kandinsky's theories. The role of theosophy in Kandinsky's thinking has been much debated.[3] Kandinsky's acquaintance with theosophical and related ideas has been investigated with great thoroughness in two studies by Ringbom.[4] He demonstrates that Kandinsky was familiar with the writings of Schuré, Blavatzki, Besant and Landbeater, and Steiner, and that Kandinsky probably also knew Goethe's *Farbenlehre* which Steiner had reedited and interpreted in 1896. Ringbom proposes that, although Kandinsky never fully committed himself to theosophist doctrines, its basic tenets greatly stimulated the development of his own theories, particularly during the years from 1908 to 1910/11.

In Symbolist circles around the turn of the century there was a widespread belief in the dawning of a new, antimaterialist era. The theosophists, too, were convinced of the immanent coming of the Biblical Third Age, the new 'Great Spiritual Epoch.' Kandinsky shared this belief and thought that artists, psychic researchers, atomic scientists, and the theosophists would guide the rest of mankind toward this new age. The desire to express this spirituality in his art led Kandinsky to search for ways of 'dematerializing' painting. Theosophy confirmed Kandinsky's own notions of the new age and his ideas on color and synaesthetic perception. Ringbom suggests that theosophist color and form concepts were instrumental in Kandinsky's transition to abstraction, even though he did not adhere to their specific theories. According to theosophy, the character and emotions of a person (and of objects) generate vibrations which surround him with an 'aura' that can be perceived by very sensitive people and by 'initiates.' These auras or 'fine matter' belong to "a world of form and color independent of material objects."[5] Kandinsky's concept of the "inner sound" of all things corresponds to the theosophist notion of "fine matter," and Ringbom proposes that Kandinsky's emancipation from the representation of visible objects represents a gradual move into this invisible "spiritual" world. Just as an initiate to theosophy can interpret the aura of "fine matter" surrounding a person, Kandinsky believed that the abstract colors and forms of his paintings would communicate very subtle, nameless, inner states of emotion to the viewer. As Ringbom notes, some of Kandinsky's forms bear resemblance to the illustrations of theosophist "thought-forms." The transparency of forms and the separation of color and line into independent autonomous entities can also be related to the theosophist bias for dematerialization of form. These formal characteristics of Kandinsky's art will influence Klee in the Blaue Reiter years.

While perhaps overemphasizing the role of theosophy and other occult sources for Kandinsky's development, Ringbom makes a good case for their

importance, and he characterizes the nature of Kandinsky's mysticism very well. Very pertinent for this study is his observation that Kandinsky always dealt very independently with his sources and often transformed them considerably in the process of absorbing them into his personal system of thought.

Washton also emphasizes Kandinsky's belief in the imminent advent of a new spiritual age and in the priest-like role of the artist-seer, pointing to French symbolism and to Steiner's brand of theosophy as the main sources.[6] She proposes the ideas of Maeterlinck (whom Kandinsky admired) and Maurice Denis as sources for Kandinsky in respect to formal means which dematerialize objects and create an ambiguous and mysterious atmosphere, such as the progressive 'veiling' of imagery. Washton stresses that even though the images in Kandinsky's paintings become less and less decipherable, they continue to exist long into Kandinsky's so-called 'abstract' phase, providing iconographic keys at least for the 'initiated' viewer. Much of Kandinsky's iconography is based on the Revelation of St. John, and its messages are directed at the collapsing world on the eve of the New Age. Washton traces these apocalyptic themes back to Symbolist and Steinerian sources.

Other writers have noted Kandinsky's connections with Russian Symbolism.[7] In its main tenets the Russian movement was strongly influenced by the French Symbolists and by German Romantics, but is distinguished from the French movement by its strong position against *l'art pour l'art* estheticism, a position shared by Kandinsky. Like the Symbolists, Kandinsky thought along very anti-positivist, anti-materialist lines. This is reflected in his thinking on the role of nature in art, which he discusses in his autobiographical essay, "Reminiscences" ("Rückblicke") written in 1913.[8] The essay suggests that from early years on, Kandinsky felt encumbered by the obligation to deal with nature, be it as subject matter to be faithfully recorded or in respect to the construction principles of natural objects.[9] As he recalls in "Reminiscences," the obligation to come to terms with the *Naturgesetz* in his drawings and paintings was painful for him since it conflicted with his personal inclinations.[10] Around 1900 he dutifully subjected himself to the anatomical studies which were *de rigueur* for any serious art student. Although he was initially disgusted with the corpses, they suddenly revealed the *Naturgesetz* to him:

> Nevertheless, I soon found in those days that every head, no matter how "ugly" it seems in the beginning, is a perfected beauty. The natural law of construction which is manifested in each head so completely and indisputably gave the head its stroke of beauty.[11]

In contrast to Klee, who in 1903 had a similar revelatory insight into the *Naturgesetz* which he was to make into the guiding light for his art, Kandinsky felt thoroughly confused:

> I had a dim feeling that I sensed secrets of a realm all its own. But I could not connect this realm with the realm of art. I visited the Alte Pinakothek and noticed that not one of the

great masters had achieved the creative beauty and skill of the natural model: nature itself remained untouched. It seemed to me sometimes that it was laughing at these efforts. Much more often, though, it appeared to me in the abstract sense "divine": it wrought *its* creation, it went *its* way to *its* goals, which disappear in the mists, it lived in *its* realm, and I was strangely outside of it. How did it relate to art?[12]

Ultimately, the increasing preoccupation with the "inner sound" of color led Kandinsky to postulate that art was entirely autonomous, separate from nature. By 1913 this had become a basic tenet of his theories.

For many more years, however, I was like a monkey in a net: the organic laws of construction entangled me in my desires, and only with great pain, effort, and struggle did I break through these "walls around art." Thus did I finally enter the realm of art, which like that of nature, science, and political forms, etc., is a realm unto itself, is governed by its own laws proper to it alone, and which together with the other realms ultimately forms that great realm which we can only dimly divine.

Today is the great day of one of the revelations of this world. The interrelationships of these individual realms were illumined as by a flash of lightning; they burst unexpected, frightening, and joyous out of the darkness. *Never were they so strongly tied together and never so sharply divided.*[13] [Emphasis mine]

In the last, seemingly paradox sentence we find the essence of Kandinsky's thinking: on a general, all-encompassing level, everything in the cosmos is mysteriously related and based on the same laws—laws which, however, are still shrouded from the human mind (Kandinsky's occasional remarks on parallels in art and nature are hints at this ultimate relatedness)—but on the specific level of human perception and artistic creation, the realms of art and of nature are unrelated. They are autonomous entities and, as regards their laws of formation, are often even diametrically opposed. Whenever Kandinsky discusses nature in a direct relationship to art, be it in regard to formative laws or as subject matter, he is almost hostile toward it: in retrospect he looks upon nature as an obstacle on his path toward the realization of his inner vision. On the other hand, Kandinsky never departed from nature as radically as Mondrian, for example; the fact that he retains references to natural forms provides a common artistic basis for him and for Klee during the early Blaue Reiter years.

By 1910/11, at the latest, Kandinsky had developed the theories laid down in *Über das Geistige in der Kunst*[14] which he elaborates and develops further in the essays written during the Blaue Reiter period. Klee, on the other hand, does not articulate much of his artistic philosophy until the war years, and not until 1918 does he formulate it in an essay intended for publication. The analysis of Klee's wartime writings will show that many of his ideas relate to Kandinsky's theories and that his thinking may indeed have been stimulated by Kandinsky and by the discussions in his circle. However, in the early 1900s, at the beginning of his development, Klee had set up an artistic

program for himself which differs in certain important aspects from Kandinsky's concept of what art should express. These differences have to be outlined before we can turn to the ideas that they later share.

The most important source for tracing the evolution of Klee's artistic thinking is his diary which he kept until 1918.[15] During the early 1900s he records many of his impressions of other artists' art as well as impressions from literature. In contrast to Kandinsky, Klee seems not to have been very much aware of Symbolist esthetic writings (in 1904 he begins to read Wilde, but only in 1907 does he mention Baudelaire and Poe), although he does mention some Symbolist literature, such as Ibsen, Strindberg, and J.J. Jacobsen. On the whole Klee appears to have been more interested in the writings of antiquity and in the German classics, including more recent nineteenth century writers, Friedrich Hebbel in particular. The German literary tradition constitutes an important source for Klee's artistic philosophy, not only during his formative years but also later at the Bauhaus when he elaborated his concepts into a vast body of theory.[16]

During his year in Italy (1901-1902) where he steeped himself in the classical tradition of antiquity and the Renaissance, Klee laid the foundation for his later art theory. He now conceived of art as based on the same formative laws as nature and he saw the work of art as an organism with an internal structure analogous to the natural organism. The way Klee looked upon nature and studied architecture reflects Goethean thought. That Goethe was a guiding star for Klee during his Italian sojourn is evident from his diary. Early in his Roman stay, after having made an initial survey of the "great art of antiquity and its Renaissance,"[17] Klee felt extremely uncertain about his own direction as an artist. He wanted to create works equally classical in spirit but without becoming an artist "outside of one's own age" ("unzeitgemässer"), i.e. a reactionary artist. For the time being he resorts to satirical art. In a diary entry he lists the possible remedies for his crisis:

> Prayers for faith and strength. Goethe's Italian Journey also belongs here. But above all a lucky star . . .[18]

Goethe's vivid descriptions of Italian art and nature, of people and customs, as well as his reflections on art, were a more congenial guide for Klee in Italy than Burckhardt's *Cicerone,* about which he expressed some reservations. On his Italian journey Goethe, who had been studying the metamorphosis of plants, began to search for the *Urpflanze,* the 'construction model' for all plants. In his study of antique statues Goethe had discovered a parallel order in the human organism and, in correlating his observations he speculated on the existence of *Urgesetze* of formation. In his *Italienische Reise* the evolution of Goethe's thoughts in the direction of his later morphological art theories can be traced. It culminates in the letter written during his second Roman stay

about the antique statues that he had studied:

> These high works of art are also the highest works of nature, produced by men in accordance with true and natural laws. All arbitrariness, all self-conceit is banished; all is necessity, God.[19]

During his stay in Italy Klee was primarily interested in antiquity and in Italian Gothic and Renaissance art. Franciscono has pointed out that the art of antiquity made the strongest impression on Klee.[20] Echoes from it are to be found in much of the surviving works from his Italian and post-Italian periods.

Klee's Italian diary provides very little insight into his actual work during his stay there. A few entries, however, indicate the direction that his theoretical thinking was taking. He studies the relationships of parts within natural organisms and tries to utilize his insights for his art. On January 23, 1902 he writes:

> I drew a few queerly-shaped tree trunks in the park of the Villa Borghese. The linear principles here are similar to those of the human body, only more tightly related. What I have thus learned I at once put to use in my compositions.[21]

In the *Italienische Reise* Goethe had formulated a similar insight the other way around;

> The second consideration refers exclusively to the art of the Greeks and seeks to comprehend how these inimitable artists proceeded in evolving from the human form their system of divine types which is so perfect and complete that neither any leading type nor any intermediate shade or transition is wanting. I have a hunch that they proceeded according to the same laws that Nature works by and which I am endeavoring to discover.[22] [revised]

After attending a performance of the celebrated dancer Cleo de Mérode, Klee describes her body and her movements much in the way one would discuss the fine details of a statue. He ends:

> The proportion and mechanism of the hand reflect, in small, the beauty and wisdom of the organism as a whole.[23]

Goethe's friend Karl Philipp Moritz had postulated a similar microcosmic relationship of the part-to-whole as the central principle of formation both in nature and in art. In his essay, "On the Plastic Imitation of the Beautiful" (*Über die bildende Nachahmung des Schönen*), 1788, he proposes that the work of art should be a microcosmic reflection of nature, revealing clearly the organic order and laws of formation which rarely appear in their pure manifestation in nature. Goethe's ideas on art had been greatly stimulated by his

discussions with Moritz in Rome, and he reprinted portions of Moritz' little known essay in his *Italienische Reise,* including this key passage:

> All the relations of that great whole, but dimly divined in the active energy, must necessarily, somehow or other, be made visible, audible, or at least conceivable to the imagination; and, for the attainment of this, the active energy in which they are dormant, must fashion them after itself, out of itself. It must seize all those relations of the great whole and the highest beauty in them on the extremities of its rays, as it were, in a focus. Out of this focus a pure and yet faithful picture of the highest beauty must round itself to the measure of the eye's capacity, a picture which, in its small compass, grasps the most perfect relations of the great whole of Nature just as truly and rightly as Nature herself does.[24] [revised]

Although the diary entries that Klee made during his Italian stay indicate that his thoughts were moving along lines similar to those of Goethe and Moritz, the extent of his speculations in a classical-humanist direction becomes apparent only after his journey in retrospective entries.[25] He sets up an artistic program for himself:

> With a dim awareness of the lawful order as the point of departure, to broaden out until the horizon of thought once again becomes organized, and complexities, automatically falling into order, become simple again.[26] [revised]

By penetrating deeper into the complexities of the laws of formation, Klee hopes to reach a point where he can begin to simplify again in order to make the "lawful order" visible. Another goal which he sets for himself is self-development and growth as a human being. As he considers this to be even more important than his artistic development, one is again reminded of Goethe, who looked upon his own Italian journey as a crucial stage in his self-development and his determined efforts to join the divergent aspects of his personality into a harmonious whole. In a retrospective post-Italian diary entry from the summer of 1902, Klee critically reviews his development:

> After the productive years of academic study, my first attempts were not pictorial, perhaps rather poetic. I knew no pictorial themes.[27]

His experience of classical art and of humanism in Italy proved to be antithetical to his Munich studies. In Italy Klee found the key to a deepened understanding of form and formal relationships. To realize the new concept of form in his art becomes his paramount task for the years to come. He continues in the entry cited above:

> In Italy I understood the architectonic element in the plastic arts—at which point I was coming close to abstract art—(today I would say the constructive element).
>
> Now, my immediate, and at the same time, highest goal will be *to establish a harmony between architectonic and poetic painting.*[28] [revised] [Emphasis mine]

Despite a preoccupation with questions of form after his trip to Italy, Klee renounced "poetic" painting only temporarily. His ultimate goal was the synthesis of what he terms "architectonic" and "poetic" painting. What "architectonic" meant for Klee is further elucidated in a diary entry of December 1903 in which he refers back to his experience of architecture in Italy:

> When I learned to understand the monuments of architecture in Italy, I won an immediate illumination. . . . Its spatial organism has been the most salutary school for me; I mean this in a purely formal sense. . . Because all the interrelations between their individual form elements are obviously calculable, works of architecture provide faster training for the stupid novice than pictures or "nature." Once one has grasped the idea of measurability in the concept of organism, the study of nature progresses with greater ease and accuracy. The richness of nature, of course, is so much the greater and more rewarding by reason of its infinite complexity.
>
> Our initial perplexity before nature is explained by our seeing at first the small outer branches and not penetrating to the main branches or the trunk. But once this is realized, one will perceive a repetition of the whole law even in the outermost leaf and turn it to good use.[29] [revised]

In his art, Klee sought for ways to express his concept of the work of art as an organism analogous to natural organisms. He wants to come to terms not only with nature in its outer appearance, but also with its inner order and construction, with the *Naturgesetz,* as he calls it later. This is the fundamental difference between Klee's and Kandinsky's thinking, for the latter had arrived at the conclusion that the *Naturgesetz* was not imperative for artistic formation.

Klee, however, does not want to become a classicist solely preoccupied with questions of form: what he calls the "poetic" dimension of his art is its content and expressive qualities. At this time Klee's concept of "poetic" is essentially identical with Symbolism. In a diary entry made during his stay in Rome he circumscribes what he was later to call "poetic" with the title of the novel *Niels Lyhne* by J.J. Jacobsen, a novel quintessentially Symbolist in its content.[30] Klee describes a painting on which he is working:

> Currently I am painting with venomous pleasure a picture with a German-sentimental poet as theme. A result of opposition to Schmoll, or a reaction to the contrast between antiquity (Attica) . . . *Niels Lyhne.*[31] [revised]

The juxtaposition of "Attica" and *Niels Lyhne* indicates what the dualism of "architectonic" and "poetic" meant for Klee: the classical, self-contained, organically ordered forms of antiquity on one side, and the modern, imbalanced, and morbid world of emotions and psychological problems on the other side. Klee is not yet able to reconcile the "Attica-*Niels Lyhne*" opposites, so he retreats for the time being into satire, as in the painting of a "German-sentimental poet" and the later series of his etchings. It is this side of Klee's thinking, his concern for a "poetic" dimension in his art and for expressive

content, that provides a common basis between Klee and Kandinsky during the Blaue Reiter years despite their divergent views on the *Naturgesetz*.

On a general level Klee defined the "architectonic-poetic" dualism as the contrast between objective and subjective. After his Italian stay, Klee couched this dualism in terms of the wider context of the two great European traditions to which he is heir:

> As of now, there are three things: a Greco-Roman antiquity *(physis)*, with an objective attitude, worldly orientation, and architectonic center of gravity; and a Christianity *(psyche)* with a subjective attitude, other-worldly orientation, and musical center of gravity. The third is the state of the modest, ignorant self-taught man, a tiny ego.[32]

Klee's polarization of antiquity and Christianity, of "worldly" and "other-worldly", of objective and subjective art, places him in the tradition of Romantic thought. One could subsume Kandinsky's esthetic position under Klee's second category: Christianity, subjectivism, transcendental orientation, and musical emphasis. Klee's own artistic program is more complex: he wants to bridge the opposites in order to attain a personal synthesis of classical and romantic tendencies, of "architectonic and poetic" painting within the framework of contemporary form.

Klee's and Kandinsky's Formal Development until 1911

A central issue in the discussion of Klee's and Kandinsky's formative years is the impact of French modernism on their work. By 1911 both artists are acquainted with the entire spectrum of French art from Impressionism to Fauvism, and Kandinsky, at least, was also aware of Cubism.

Kandinsky's style of the Blaue Reiter period is rooted both in *art nouveau* and in the Impressionist-Fauvist tradition. In the early 1900s Kandinsky grapples with Impressionism and *art nouveau* at the same time, working concurrently in two distinct modes. From 1908 onward he operates with a more uniform stylistic approach which evolves into the style of the Blaue Reiter period.

Klee, on the other hand, works first in a mode indebted to *art nouveau* and Symbolism, concentrating for a long time on the graphic media. Only in 1905 does he begin to come to terms with Impressionism, when he steps up his efforts to overcome the problems that painting poses for him. While Kandinsky in his art absorbs influences from divergent sources often simultaneously, Klee, who is very deliberate in his artistic moves, as his diaries document, proceeds more slowly and systematically, dealing with one major formal issue at a time. By 1911 Kandinsky has basically developed his typical style of the prewar period, whereas Klee at this point is still groping for a definitive approach to painting, an approach which would provide him with the formal

means to give expression to his theoretical concepts. Cubism plays a subordinate role for Kandinsky's art. For Klee, however, the influence from Cubism is as significant as that from Kandinsky in helping him to attain his goal of the architectonic-poetic synthesis.

The differences in artistic temperament and outlook between Klee and Kandinsky are reflected in their individual responses to the artistic currents with which they come into contact. Kandinsky, who was acquainted with Impressionism and Post-Impressionism much earlier than Klee, recalls in "Reminiscences" the deep impression that a Monet *Haystack* painting had made on him while he was still in Moscow.[33] Although bewildered by its lack of subject matter in the traditional sense, Kandinsky was deeply moved by the colorism of Monet. In discussing Monet's painting, Kandinsky pinpoints those aspects of Impressionism which were important for his own art: the use of pure bright colors and the loose brushwork. The central issue of Impressionism, the study of outdoor light and its transposition into equivalent color *valeurs,* did not concern him very much, as he himself states in "Reminiscences":

> The "light and air" problem of the Impressionists interested me little. I always found that the clever speeches about this problem had very little to do with painting. The theory of the Neo-Impressionists later appeared to me more important, since it was ultimately concerned with the *effect of colors* and left air in peace.[34]

There are rather few paintings by Kandinsky that can be outrightly called "impressionist." From 1901 to 1907, however, he executes a large number of outdoor studies, which relate to Impressionism in regard to their loose, thickly applied brushwork and the selection of simple motifs and close-up vistas, but Kandinsky did not consider them finished works. For him these were landscape sketches in the traditional sense of outdoor studies to be elaborated into compositions.[35] The Impressionist method of Kandinsky's early landscape studies is tempered by his concurrent work in a basically anaturalistic, *art nouveau*-related mode. An early study like *The Sluice,* 1901 (App. III-20), is superficially comparable to late Monet paintings, but on closer scrutiny it becomes evident that very little attention is given to tonal gradations and to the differentiation between forms, as, for example, in the group of fir trees or the sandy road. Instead, the colors are boldly contrasted and the entire painting is organized into large, rather planar color shapes. At this point, Kandinsky works with quite large, very pastose brushstrokes, often placed far apart.[36] In the outdoor studies the colors are keyed variously to render different atmospheric effects, but on the whole Kandinsky is far removed from Impressionist light observation and *valeur* painting. The studies demonstrate that the spontaneous handling of brush and color was more important to Kandinsky than the patient study of the motif. In "Reminiscences" he recalls:

... During the period of my disillusionment with studio work and of pictures painted from memory I painted many landscapes in particular, which, however, did not give me much satisfaction, so that I later made finished paintings of very few of them. Wandering about with a paintbox, feeling in my heart like a hunter, did not seem to me as responsible as painting pictures in which I searched already at that time, half consciously, half unconsciously, for the compositional element. The word *composition* moved me spiritually, and I later made it my aim in life to paint a 'composition'. This word affected me like a prayer. It filled me with awe. In painting sketches I let myself go. I thought little of houses and trees, with my palette knife I spread colored stripes and spots on the canvas and let them sing as loud as I could. Within me resounded the hour before sunset in Moscow, before my eyes was the strong colorful scale of the Munich atmosphere, thundering in its deep shadows. Later, especially at home, always a profound disappointment. My colors seemed to me weak, flat, the whole study—an unsuccessful effort to capture the power of nature.[37]

In many of Kandinsky's outdoor studies certain forms, such as trees or houses, are simplified and schematized to the point where they become interchangeable in various paintings, prefiguring the recurring form motifs in Kandinsky's semiabstract paintings.

Whereas academic concepts of form and the detailed study of models had been a yoke for Kandinsky, Impressionist techniques provided an outlet for his colorism. He was attracted to the apparent freedom and spontaneity of Impressionist painting, its pure colors and visible *facture*. But in contrast to the Impressionists, Kandinsky projects his personal experience of colors into nature, using the actual motif more as a vehicle for expression than as a continual reference point.[38]

Concurrently with the outdoor sketches, Kandinsky paints small paintings with invented subject matter in a quite different, primarily decorative style which is indebted to *art nouveau* and Russian illustrations in particular. With tempera and gouache as preferred media, Kandinsky depicts folklore themes and fairy-tale-type subjects with undulating lines and flat, brightly colored shapes forming into vivid patterns, as for example in *Russian Village at a River,* ca. 1902 (App. III-26). Around 1903 he introduces a dot technique in works of this type.[39] Despite superficial resemblance to Neo-Impressionist methods, Kandinsky's dot technique is not divisionist; rather he uses it for interesting color effects and rich decorative patterns.[40]

These folkloristic and at times rather sentimental inventions extend over the same period as the outdoor studies. Apparently Kandinsky saw no contradiction in working in two such divergent modes. His ultimate goal was to paint "compositions."[41] He does not define his concept of a "composition" very clearly, but it is more than either the small invented scenes or the outdoor studies. The few ambitious paintings of this period combine elements of the two types. Paintings, such as *Old Town,* 1902 (App. III-54), and *The Blue Rider,* 1903 (App. III-23), are executed in a fairly straightforward Impressionist technique which has been compared to that of early Monet, such as Monet's *Duckpond* of 1873,[42] but in both paintings the actual motif is

generalized to a great extent.[43] The staffage figures, which introduce a folk-loric and fairy-tale element, are much more prominent than they would be in a typical Impressionist painting and convey a romantic mood. In *Old Town,* which is a recollection of the city of Rothenburg painted from memory, the close-up study of the crossroads in the foreground is rather awkwardly combined with a more traditionally conceived panorama of the town. The geometric forms of the buildings and the large, sharply outlined shadows recall Neo-Impressionist landscapes, with the peculiar shapes of the shadows creating an eerie effect.

These two paintings fit into the general context of contemporary natural-ist painting in Germany, whereas Kandinsky's paintings with invented figural subject matter demonstrate a conservative bent which can be associated with the esthetic concepts of the Russian "World of Art" movement.[44] The ambi-tious large-scale tempera painting, *Motley Life,* 1907 (App. III-41), can be called a pictorial encyclopedia of Russian folk life. Resembling a blown-up book illustration, it is distinguished from turn-of-the-century illustrations, such as those by Ivan Bilibin, mainly by the effectively decorative dot-and-line technique and the more audacious color choice.[45] Folklore, fairy-tale, and historical genre motifs continue to appear in Kandinsky's works far into the so-called 'abstract' period. Too little attention has been paid to the often conventional motifs that Kandinsky selects for paintings and to the drollness and melodramatic pathos—not always intentional—of some of his figural motifs, often reminiscent of Böcklin.[46]

Klee's artistic situation during the same decade is marked by dualistic tendencies similar to Kandinsky's: on one hand his art contains Symbolist subject matter and *art nouveau*-related tendencies toward stylization, and on the other hand, it reflects a strong interest in Impressionism and Post-Impressionism. Klee's artistic moves during this period are slow and deliber-ate, as if he were following a premeditated plan. Only when he feels that he has attained a degree of mastery as a draftsman does Klee begin to tackle the problems of painting, first setting himself the task of conquering tonality. After long and patient study in the black and white tonal range he finally begins to venture more frequently into the realm of color.

The main result of the years Klee spent in Bern, 1902-1906, is the well-known series of 11 satirical etchings, executed from 1903 to 1905, which Klee called *Inventions* and considered his "opus 1."[47] The etchings, an ambitious enterprise, amalgamate a wide range of stylistic and iconographic sources ranging from antiquity to Symbolism and *art nouveau.*[48] Elaborate modeling, subtle tonal gradations, and an almost mannered attention to details invest these etchings with an old-masterly air. *Two Men Meet, Each Supposing the Other to be in a Higher Position,* 1903 (App. III-32), is representative of the entire series, although less complex and enigmatic in content than most of the

other etchings. Naturalistic modeling of the bodies is combined with strong stylization and even distortion. The emphatic countours and the symmetry of the poses and the entire composition recall Hodler's figural style, a spiritual kinship which was acknowledged by Klee himself.[49] During his years in Bern, Klee took considerable interest in Hodler, in whose work stylized, reductive form—classical in its severe compositional order, yet modern in regard to expressive color and stylization—is combined with metaphysical-mystical content in a way that must have appealed to Klee as a possible model for the synthesis of "architectonic and poetic" painting which he so coveted. On a personal level as well, Klee may have seen a model for himself in Hodler, who as a Swiss-German artist was acclaimed both in France and in Germany. Evidently Klee wanted to establish his identity as a Swiss-German artist rather than as a German, for in a letter to his bride he writes about the etchings:

> ... the treatment of form (line) is new, new not only for myself, but new (so I hope to God), in general, it is not eclectic, it is Swiss-German.[50]

In comparison to the somewhat belabored *Inventions*, Klee's drawings of the Bern period could be termed 'Improvisations,' because they were characterized by formal boldness and spontaneous expression. They are private experiments, both in regard to technique and style.[51] *Youth, Leaning on a Lyre*, 1905. 33 A (App. III-17), is a representative example, if not one of Klee's most audacious drawings. The upper section of the figure is composed of thin, sparse contour lines; its elongation and frail elegance recall *art nouveau*.[52] The head, reminiscent of Greek vase painting, introduces a subtle classical note. In the lower section of the drawing the overlapping lines take on a life of their own, resulting in an almost abstract linear web. The apparent spontaneity of this drawing style prefigures Klee's interest in what he calls, in 1908, "psychic improvisation."[53] *Two Men* and *Youth* are representative of Klee's work up to 1905 as far as it is extant (Klee later destroyed a great many early works), both in regard to style and content.[54]

After a short trip to Paris in June of 1905, where he studied the Impressionists, Klee begins to grapple with some of the formal issues presented by Impressionism.[55] In contrast to Kandinsky, Klee is primarily interested in the light treatment and *valeur* painting of the Impressionists. In the technique of painting behind glass, primarily in the black and white tonal range, Klee finds the ideal medium for making the transition from his linear-graphic manner to a painterly mode of work, as glass painting allows for finely incised lines as well as loose brushwork. After years of working primarily from his imagination Klee now turns again to working directly from nature. Yet, as a painting like *Little Gardenscene*, 1905.24 (App. III-22) demonstrates, like Kandinsky, Klee by no means becomes an Impressionist *per se*. Done on glass from

nature, *Gardenscene* is one of Klee's most successful early works and one of the few executed in bright colors. The unobtrusive motif is clearly inspired by the Impressionists. However, the quiet, sun-drenched garden spot is depicted with a few, boldly contrasted colors rather than with Impressionist light and shadow effects. The white ground remains visible throughout; it makes the picture very luminous and at the same time emphasizes its planarity. Plants and grass form vivid patterns, and the rhythmic row of watering cans and the red twisted branches and chair pattern reinforce the decorative effect.

Klee succeeds in transforming the momentary natural impression—his sensation of light and color—into a decorative formal arrangement without losing the freshness and immediacy of the motif. In 1906 Klee writes in his diary with reference to this painting, "I have succeeded in maintaining my style in the immediate presence of nature."[56]

What Klee seeks to learn from Impressionism is a way of translating natural impressions into painterly values, but he wants to distill the essence from the natural motif rather than render the momentary fleeting impression. In respect to the planarity of forms, the reductive stylization and generalization of the motif, Klee's approach is shaped by *art nouveau.*

Klee's study of French modernism provides a counterbalance to the metaphor-laden, literary tendency of the Bern years. Yet immediately after the Paris trip Klee doubts that art should be preoccupied with formal questions alone. In a diary entry of July 1905 he articulates his dilemma:

> Things are not quite as simple with "pure" art as the dogma proclaims them to be. In the final analysis, a drawing simply is no longer a drawing, no matter how self-sufficient its execution may be. It is a symbol, and the more profoundly the imaginary lines of projection meet higher dimensions, the better. In this sense, I shall never be a pure artist as the dogma defines him. We higher creatures are also mechanically produced children of God, and yet intellect and soul operate within us in completely different dimensions. Oscar Wilde: "All art is at once surface and symbol."[57] [revised]

With "pure art" Klee probably refers to French art.[58] After the Paris trip, French art with its formal discipline supersedes the role of "Attica" in Klee's dualistic concept of "architectonic and poetic" painting. French art represents a challenge to which Klee wants to respond without abandoning his original goal of a synthesis of the dualistic directions, which he reaffirms with the quotation from Oscar Wilde.

In 1905 and 1906 Klee's art fluctuates between works in which the style of the etchings is somewhat simplified, as for example in the mannered glass painting *Sensitive Virgin*, 1906. 21 (App. III-22), and fairly straightforwardly Impressionist nature studies, such as *View in the Elfenau (Bern)*, 1906. o.W. (App. III-4), one of Klee's few essays in oil painting. With his interest in tonality increasing in 1907/08 he moves more decisively into an Impressionist

direction. Periodically he concentrates on outdoor painting and nature stud-
ies, restricting himself to simple motifs. From 1905 until 1913 Klee was in the
habit of categorizing his production into works done without nature (A) and
works done after nature (B). The works in the (A) category predominate until
1907, whereas from 1908 on Klee lists considerably more works done after
nature.[59] The Impressionist influence is also reflected in Klee's choice of
motifs and themes, although he continues to produce some satirical and
fantastic works. The study of Impressionist *facture* encourages him to gradu-
ally abandon his thin lines and untextured paint surfaces and to operate with
increasingly loose brushlines. Klee takes his nature studies very seriously, but
at the same time he feels very attracted to Ensor's and van Gogh's art and is
torn between the alternatives of a strictly naturalist approach and the more
'poetic' quality of their art.[60] In the fall of 1907 he notes in his diary:

> I swing like a pendulum between the sobriety of my recent tonal studies from nature, which
> I continue here by chasing through the suburbs with portfolio and easel, and the fantasti-
> cality of Ensor.[61]

In van Gogh's art Klee saw an approach to nature that went beyond the
sobriety of Impressionism, but he felt that the personal drama and pathos of
van Gogh's life made it difficult to follow in his direction. Klee's reservations
about van Gogh may have been influenced by Meier-Graefe, who considered
van Gogh as an isolated phenomenon and warned against following him.[62] In
early 1908 Klee read Meier-Graefe very attentively, seeking guidance for his
attempt to come to terms with nature.[63] In retrospect he credits Meier-Graefe
and the other major German critic, Karl Scheffler, with curing him of what he
calls his speculative tendencies:

> I owe having being cured from the speculative element in my art partly to the influence from
> the books by Meier-Graefe and Scheffler. But the ground had been prepared for it.[64]
> [revised]

The painting behind glass, *Busy Square Seen from the Balcony,* 1908. 62
(App. III-18), which Klee executed in March, is one of the most successful
examples of his 'Impressionist' phase. After having observed the motif over
the course of several days from the incidental view of his balcony, Klee felt
that he had succeeded in crystallizing its essential qualities and had trans-
formed them into his own style:

> I was able to free myself from all that was accidental in this slice of "nature," both in the
> drawing and in the tonality and rendered only the "typical" through carefully planned,
> formal genesis.[65]

Although the painting shares Impressionism's spontaneous, momentary quality, the picture is not an Impressionist study of the motif at a specific time of day, but instead is a summation of numerous observations compressed into a generalized image. Klee generates a similarly vibrating surface of light and shadow effects, but with large, carefully differentiated brushlines rather than Impressionist *facture*. The juxtaposition of the sharp spidery lines of the balcony railings to the soft brushwork behind it differs from Impressionist 'overall' surface textures. The pattern of the balcony railing as well as the very high horizon line emphasize the planarity of the surface. Yet a sense of spatial progression is generated by the tonal movement from the dark foreground toward the brightly lit place in the background, and the dark sky above it pulls the viewer's gaze back toward the foreground.[66] This exemplifies one of Klee's methods of generating visual movement in a painting; that is, tonal progression. Visual movement and the time element in painting were important to Klee, who looked upon them as analogous to the process of creation in nature.

Technically, Kandinsky's paintings, such as *Old Town*, 1902 (App. III-54), with its stippled brushwork and bright colors, relate more to Impressionism than Klee's black and white painting behind glass. Yet Klee is much more committed to the reality of the actual motif than Kandinsky, who feels free to mix actual and invented motifs in his picture. Moreover, the transposition of light into tonal values makes Klee's painting more truly Impressionist than Kandinsky's.

Klee put himself through a rigorous Impressionist schooling in order to be able to translate a natural motif into its pictorial equivalent. Yet once he feels confident of his ability to do so, he finds the naturalist method limiting and even tiresome. Ultimately, he wants his art to be more than just a faithful image of a natural motif. Furthermore, a naturalist approach to painting gives little scope to linearity *per se,* which Klee viewed as his forte. In the fall of 1908 Klee took a fresh look at van Gogh and Ensor, the two artists who make use of line as an autonomous pictorial element. In writing about this problem, Klee defines his foremost artistic goal:

> With new strength from my naturalistic *études,* I may dare to enter my prime realm of psychic improvisation again. Bound only very indirectly to an impression of nature, I may again dare to give form to what burdens the soul. To note experiences that can turn themselves into linear compositions even in the blackest night . . .[67]

The parallels between Klee's desire for intuitive expression of inner states, which he calls "psychic improvisation," and Kandinsky's artistic goals have often been noted. While Kandinsky sought to express himself via color, Klee considered line his chief means of expression. Although Klee experiments with van Goghian lines in painting, as in the satirical painting behind glass, *Gentleman and Lady in a Loge,* 1908.22 (App. III-22), in the long run he does

not adopt van Gogh's method of painting with color lines. In fact, the question of line's function in painting remains a problem for Klee for years to come. Equally unresolved is the problem of color: until 1910 Klee rarely ventures beyond a sober, rather old-masterly color range.

The main phase of Klee's naturalist studies ends in 1908. In mid-1908 he discusses various experimental methods of oil painting through which he tries to balance abstract-formal considerations with the representational demands of the motif. His experiments range from emphasizing the primacy of the natural motif to near-abstract experiments with color spots, into which he reads figural motifs, elaborating them with lines or modeling.[68] On the theoretical level, too, Klee shifts his concerns from naturalistic depiction of the motif to what he consideres to be the parallels in formation between art and nature:

> Pictures have their skeleton, muscles, and skin like human beings. One may speak of the specific anatomy of the picture. A picture representing "a naked person" must not be created in terms of human anatomy, but only in terms of compositional anatomy. First one builds an armature on which the picture is to be constructed. How far one goes beyond this armature is a matter of choice; an artistic effect can proceed from the armature, a deeper one than from the surface alone[69] [revised]

From 1908 on, Klee experiments a greal deal with his formal means and occasionally arrives at quite 'abstract' results, but on the whole nature continues to be his point of reference. Neither Klee nor Kandinsky can be considered Impressionists *per se;* both look to Impressionism primarily for specific formal solutions. However, in contrast to Kandinsky, Klee adheres more closely to the basic premises of French naturalism and takes the study of nature more seriously than Kandinsky. Although 'poetic' painting remains his ultimate goal, until 1912 Klee restricts himself largely to typically naturalist subject matter, such as figures, portraits, still life, and landscape.

From their interest in Impressionism, both Kandinsky and Klee turn to the more recent French avant-garde, especially Cézanne, Matisse, and the Fauves. Both artists look at them in respect to color, line, and composition, but Klee deals with these issues from a more consistently modernist point of view than Kandinsky.

Again, Kandinsky was much earlier aware of the contemporary French avant-garde than Klee. Through his participation in the *Salons des Indépendants* in 1905 and the following years he became acquainted with Signac and the circle of Fauvist painters around him. In June of 1906, after spending several weeks in Paris, he moved to Sèvres and lived there for a year, observing the Paris art scene from a distance.[70] He was interested in Matisse and the Fauves, but seems to have all but ignored the inception of Cubism.[71] It is only after his return to Munich from France that Kandinsky began to work in a style that relates to some extent to Fauvism. In Munich and Murnau he spent

much time with Jawlensky, whose work at the time was stylistically more advanced than Kandinsky's, reflecting an influence from Matisse. The formal qualities that had attracted Kandinsky to Impressionism were explored further by the Fauves: pure, brilliant color, very loose brushwork, and considerable freedom *vis-à-vis* the motifs. From 1908 on, Kandinsky no longer works in two distinct styles; instead, he uses the same basic formal approach for both invented scenes and landscape paintings. However, at the same time he moves further and further away from the actual motif and introduces into his paintings a strongly subjective, often rather visionary dimension. While the degree of abstraction varies considerably in the individual paintings, Kandinsky makes a decisive shift in focus from outer reality to the expressive power of color *per se*. Although he does not abandon natural motifs and figural subject matter for many years to come, he does make them more obscure and hard to decipher, so that the picture becomes enigmatic and mystifies the viewer. Even though Kandinsky uses some of the same formal means as the Fauves, he employs these means for essentially different ends. Furthermore, Kandinsky's style of the Murnau period is set off from Fauvism by its complexity resulting from his welding together essentially divergent formal approaches.

Two works from the late 1900s exemplify this development. *Blue Mountain,* 1908/09 (Fig. 4) is a transitional work where different formal sources are fused.[72] The curvilinear silhouettes of the trees and the stylized mountain shape recall *art nouveau,* while the toy-like riders as well as the dot technique hearken back to the pointillist folklore scenes. In comparison to earlier paintings, except for the small landscape sketches, Kandinsky drastically simplifies all forms and disregards scale and perspective. In terms of the color range, the undulating contour lines, the prop-like landscape elements and their symmetrical arrangement, Kandinsky's painting can be compared with Matisse's *Joy of Life,* 1905/06 (App. III-5), which, as A. Barr has suggested, may have exerted a strong influence on Kandinsky's development.[73] In *Blue Mountain,* Kandinsky still uses dark contour lines rather hesitantly; they will become an important stylistic device in his later paintings. The contour lines emphasize the flatness of shape and thus abstract from the natural image. Whereas Matisse in *Joy* leaves the contoured areas essentially flat (in other works he sometimes uses very coarse hatchings to model the shapes), Kandinsky is less consistent in his use of contour lines. In *Blue Mountain* the contoured silhouettes of the trees and the mountain are filled in with richly gradated color spots which generate a sense of volume; consequently the forms are rather hybrid in character, causing an unresolved tension between flatness and volume. There is a similar ambivalence in regard to color and composition. In contrast, Matisse succeeds in binding the colors into one plane by avoiding overlaps as much as possible and by pitching the colors to the same key. Matisse translates the light-dark contrasts into coloristic equi-

valents and treats white and black as colors *per se*. While there are composi-
tional references to depth in *Joy*, the planar coherence of the picture surface is
not broken. Kandinsky, on the other hand, operates in *Blue Mountain* with
stark contrasts of light and dark, and he juxtaposes areas of strong local color,
such as the blue mountain, with tonally gradated subdued colors, as in the sky.
These dramatic color contrasts generate space and depth in his painting,
counteracting the planarity of the large shapes. While Matisse's colors look
thinly applied and luminous, almost like watercolors, the paint surface in
Kandinsky's *Blue Mountain* appears dense and rich.[74] Compared to the
balance and serene repose of *Joy*, Kandinsky's painting is rather restless and
overbearing. In addition to the spatial tensions there are strong contrasts
between the large decorative shapes and the small clusters of colors, between
pleasing warm colors (trees) and harsh color combinations (the green face and
pink hood of the figure at the right), between the mountain as a focal point in
the background and the bewildering clutter of forms and colors in the fore-
ground. The figural scene in the foreground introduces a mystical note into
the painting, while the diagonal thrust of the riders frozen in full gallop
enhances the restless, dynamic quality of the composition.[75] The abundance of
such contrasts and visual tensions sets Kandinsky's painting off from the
deliberate sparseness and formal refinement of Matisse's art. In these basic
formal characteristics *Blue Mountain* is representative of Kandinsky's Ex-
pressionist approach.

The slightly later oil painting, *Mountain*, 1909 (App. III-20), which
prefigures Kandinsky's style of the early Blaue Reiter years, demonstrates
further how far removed his artistic conception is from French modernism. In
Mountain the mystical, visionary qualities already present in *Blue Mountain*
come to the fore. Abstraction from nature has progressed to the point where
not all forms can be identified. Perched atop the blue mountain and sur-
rounded by a red halo-like band is what seems to be a Russian church. In the
foreground two shrouded figures, roughly outlined, seem to be standing amid
gravestones. The scene is clearly painted from the imagination and its mean-
ing remains enigmatic, at least to the 'uninitiated.' The pathos of the figures
and the other figural clues do, however, invite the viewer to speculate on the
expressive content of the picture, on a meaning beyond the mere presence of
figures, forms, and colors.

The uniform brightness of the major colors and their luminosity is
comparable to Matisse, as are the simplified forms and the outlines of the
figures. However, Kandinsky makes the mountain appear voluminous by
leaving a large white highlight in its center. Just as he does not work consis-
tently with planar forms, he does not work with a consistent intensity of color
throughout the painting, and this, too, sets him off from Matisse or Fauvist
works in general. In the lower right corner of the composition, within the

white area Kandinsky contrasts the bright primary colors with light, subtly gradated tones which recall Cézanne watercolors. Such a contrast of Impressionist tonalities and juxtaposed primaries is characteristic of much of Kandinsky's later work. With his dualistic use of tonal color and primaries, of planar shapes and modeled forms, and his continued concern for depth and volume, Kandinsky differs from his French contemporaries; in all these respects his art relates more to that of nineteenth century German masters, such as Böcklin. (For a discussion of Böcklin's impact on Kandinsky's style and his theories see Appendix I.)

In the work of Matisse and of the Fauves Kandinsky saw primarily an alternative to Impressionism and its naturalist limitations. Encouraged by the example of their brilliant colors and reductive rendering of motifs, Kandinsky quickly moved on and began to employ colors and forms as expressions of his inner visionary world.

For Klee, the example of Cézanne and Matisse also suggested a development beyond what was earlier described as his Impressionist approach, primarily in regard to the reduction of and abstraction from the motif. In contrast to Kandinsky, nature continued to be Klee's point of departure.

In 1908 and 1909 Klee, feeling competent in the tonal range of black and white, begins to experiment more often with color in painting. He receives vital impulses from Cézanne for his painting, as he states in his summarized diary:

> Cézanne at the Secession; the greatest event in painting up to that time. Placed him above van Gogh—he seemed to be more wholesome and important for myself at the time. Proposition: primitivity out of capacity for reduction. What I learned from his pictures: the use of spots as factors in the chord of colors. No local color. Anticipating the Delaunay principle.[76] [revised]

Klee utilizes the insights gained from Cézanne at first in his black and white work, as in the painting behind glass, *Well-Kept Path in the Woods (Waldegg near Bern)*, 1909.16 (App. III-18). The simple motif is almost lost in the maze of tonally gradated color spots which generate a Cézannesque vibrating surface. In contrast to Kandinsky, Klee rarely uses Cézanne's *passage* technique of brushed hatchings. He paraphrases these in a personal fashion with nervous scraggly line patterns, as in drawings such as *Portrait Sketch after My Father*, 1909.19 (App. III-17), which is representative of many of his drawings over the next few years.

In the fall of 1909 Klee defined his artistic goals once more in his diary. He wrote that he hoped to express in his art a metaphysical dimension, ethical in the widest sence, but he put this off into the future. His remarks on music and its pictorial equivalents parallel the theories that Kandinsky was formulating in his book at about the same time.

I am well-acquainted with the Aeolian-harp kind of melodies that resound within. I am well-acquainted with the ethos that fits this sphere.

I am equally well-acquainted with the pathetic region of music and easily conceive pictorial analogies for it.

But both are unnecessary to me at present. On the contrary, I ought to be as simple as a little folk tune. I ought to be candid and sensuous, an open eye. Let ethos wait in the distance. There is no hurry. Let pathos be overcome. Why try to tear oneself violently away from a joyful existence here and now?

The difficulty about it is just to catch up with developments that lie already behind, but "it must be done."[77]

Perhaps Klee was encouraged to focus on a "joyful existence here and now" by Matisse's "Notes d'un Peintre" which were published in 1909 in Scheffler's widely-read periodical *Kunst and Künstler*.[78] In early 1910 Klee had occasion to see a number of paintings, drawings, and sculptures by Matisse in a show which also included works by the Fauves and other artists in Matisse's circle.[79] (For a history of Matisse exhibitions in Munich see Appendix II.) This show seems to have been momentous for Klee's coloristic development. In March of 1910 Klee writes in his diary, expressing his regrets about his inability to apply his system of dark-light gradations to the medium of oil painting:

And' now an altogether revolutionary discovery: to adapt oneself to the contents of the paintbox is more important than nature and its study. I must some day be able to improvise freely on the chromatic keyboard of the rows of watercolor cups.[80]

The radiant color harmonies of the Fauve paintings and those by Matisse must have encouraged Klee to attempt a free transposition of natural impressions into color harmonies, and to give primacy to color itself over more traditional *valeur* painting. Furthermore, Fauve contour lines suggested a possible use of line in painting. Over the following months Klee extensively discusses questions of painting in his diary. In an entry of April 1910 he no longer speaks of painting in terms of light-dark tonalities, but in terms of color areas of equal intensity, with line as an additional form-defining element, an approach which parallels that of Matisse to some extent.[81] In the following entry Klee defines the three different coloristic options that he has:

Cultivation of the means in their pure state: either the proportion of tonal values in itself; or line, as a substitute for omitted tonal values (as a boundary between tonal values); or else contrasts of color values.[82]

The color contrast method conflicts with Klee's concern for visual movement in his paintings, but a few months later he finally arrives at a way of translating the light-dark gradations (which imply motion) into color:

Transfer of the shadow image, of the chiaroscuro time-measuring process into the realm of color, in such a way that each degree (the number of degrees is to be reduced to the strict minimum), each degree of tonal value, that is, corresponds to one color; in other words, one must not lighten a color by adding white or darken it by adding black, but there must always be one color to a degree. For the next degree, the next color. Ocher, English red, caput mortuum, dark madder, etc.[83]

The method which Klee describes may be seen as a synthesis of what he had learned from Cézanne and Matisse. He has made the transition from a 'chiaroscuro' approach to tonality, which had long preoccupied his thinking, to a coloristic method where tonal gradations are expressed in color steps, but both approaches continue to coexist in his later work.[84]

One of the few oil paintings of this period, *Girl with Jugs*, 1910.120 (App. III-22) reflects the dual influence of Matisse and Cézanne. The slanting table, the changing viewpoints, and the arrangement of the still life recall Cézanne, such as *Still Life*, ca. 1900 (App. III-44). Like Cézanne, Klee uses gradated colors to indicate the volume of forms, but in keeping with his program, he operates with fewer color intervals and with more distinctly different colors, so that the forms appear flatter than Cézanne's.

The bust-length figure of the girl behind the table, gazing with large eyes past the viewer, recalls Matisse's *Self-Portrait* of 1906 (App. III-5), which had been illustrated in *Kunst und Künstler* in 1909. As with Matisse, the forms in Klee's painting are very simplified, with thin dark lines distinguishing figure from ground. Although arranged in a spatial progression, the jugs, vases, and the figure are visually compressed into nearly one plane. The planarity results from the concentration on three colors which appear in every form, with blue predominating in both figure and ground. The blue-purple color combination, too, is rather Matissean. The painting demonstrates that Klee understood the lessons of French colorism, yet he applies them with some hesitancy. There is an unresolved tension between the emphasis on planarity and the indecisively applied brushwork. While the color choice itself is bold, the painting on the whole appears subdued, without the assertive radiance of Matisse's color. The contours are marked by the same ambiguity. Altogether it is a curiously impersonal painting which could be labeled, in Klee's own terms, a "part of art history." Looking back on his development, Klee states in the spring of 1911, "I was the faithful image of a part of art history; I moved toward Impressionism and beyond it."[85]

In 1909 Klee had decided to illustrate Voltaire's *Candide*, and these illustrations preoccupied him throughout most of 1911. His explanation as to why he chose *Candide* throws light as well on what attracted him in French art: "In *Candide* there is something higher that attracts me, the exquisitely spare and exact expression of the Frenchman's style."[86]

Klee's own ambition for an "exquisitely spare and exact expression" distinguishes his work from the formal complexity and the additive method of Kandinsky. A comparison of *Mountain*, 1909 (App. III-20) and Klee's *Girl* shows how much closer Klee came to the artistic conception of the French artists by whom they had both been influenced. Kandinsky's painting points to his increasing preoccupation with the inner world of his visions and psychic sensations. *Mountain* stands at the beginning of a period during which Kandinsky produces paintings of a very complex, dynamic nature in which he seeks to communicate the depth and turmoil of man's inner life at the eve of a new, spiritual age. In his ambitious search for universal expression by means of increasingly abstract forms and colors, he assimilates influences of the most varied kind: he fuses theosophist and Symbolist concepts of color symbolism with stylistic aspects of Impressionism and Fauvism without much consideration for the conceptual implications of French modernism. Furthermore, he looks back to artists like Böcklin (see Appendix I) for principles of color composition and incorporates some aspects of traditional concepts of space and volume into his abstractions. However, the sum total of these heterogeneous sources—the body of work that Kandinsky produces during the Blaue Reiter years—is highly original and places him in the vanguard of his time. As the Expressionist counterpoint to the Paris avant-garde, Kandinsky represented a challenge that few of the artists who came into contact with him could entirely ignore.

Klee had come to terms with the formal issues of French modernism more deliberately and thoroughly than Kandinsky, and he continues to deal very seriously with French art over the next years. The formalism of French art, however, did not provide a solution for the questions of 'poetic' painting or of the *Naturgesetz* and its realization in art. In Munich Expressionism, and in Kandinsky's work in particular, Klee was to finally find a contemporary approach to expression which encouraged him to let the subjective, 'poetic' side of his artistic personality come to the fore again.[87] In coming to grips with Expressionism and Cubism at the same time, Klee eventually will be able to span the bridge between the two poles of French form and German expressive abstraction. He will achieve the synthesis of "architectonic and poetic painting" that forms the basis of his mature, highly individual style and the core of his artistic philosophy.

Part II

The Blaue Reiter Years

2

Klee and the Blaue Reiter Group

Klee's Position in the Blaue Reiter Circle

Klee and Kandinsky met for the first time in 1900 as students in Franz Stuck's class at the Munich Academy, but no closer acquaintanceship resulted from their meeting.[1] In the fall of 1911, in late October or early November, they were introduced again to each other by Louis Moilliet, who was staying with the Klees for a short time.[2] Shortly before, in September of 1911, Klee had met August Macke at Moilliet's, where the latter was living on Lake Thoun.[3] Klee recalls his meeting with Kandinsky in what appears to be a retrospective, summarizing diary entry of the winter of 1911/12:

> Kandinsky, who has often been spoken of, and who lives in the house next to us, this Kandinsky, even though Luli calls him Schlabinsky, nonetheless continues to exert a strong attraction on him. Luli often goes to visit him, sometimes takes along works of mine and brings back paintings without subject by this Russian. Very curious paintings.
> This Kandinsky wants to organize a new society of artists. Personal acquaintance has given me a somewhat deeper confidence in him. He is somebody and has an exceptionally fine, clear head. We met for the first time in a cafe in town; Amiet and his wife were also present (on their way through Munich). Then, on the trolley that was taking us home, we agreed to meet more often. Then in the course of the winter, I joined his Blaue Reiter.[4] [revised]

Obviously Klee had heard about Kandinsky before meeting him—surely Macke had mentioned his Munich friends Marc and Kandinsky at his meeting with Klee in September.[5] Klee might have also heard about Kandinsky from Kubin, who was a member of the *Neue Künstlervereinigung (NKV)*, when he visited Klee in January of 1911.[6]

Although so far there is no factual evidence that Klee was aware of the *NKV* and its exhibitions, it is most likely that he had at least heard about them. The *NKV* exhibitions at the Thannhauser gallery caused considerable stir in the local papers which probably did not escape Klee's attention, since he was attentively observing the Munich art scene in order to find exhibition possibilities for himself.[7] During the second *NKV* show, however, he was in Bern.

After meeting Macke and Kandinsky, Klee also got to know the other members of Kandinsky's circle—Münter, Jawlensky, Werefkin,[8] and Marc[9]—and he quickly took a keen interest in the group and their ideas. In early December, Kandinsky and Marc made the final break with the *NKV*. Klee probably witnessed their feverish preparations for the first Blaue Reiter exhibition which opened on December 18, 1911, as well as the editing process of the book, *Der Blaue Reiter*, which was published in late May of 1912.[10] Kandinsky's evaluation of Klee as an artist of some promise is documented by the inclusion of a Klee drawing in the *Blaue Reiter Almanac*.[11] Klee was not involved further in the preparation of the book according to Kandinsky, who wrote in 1936 to J. Th. Soby:

> I admire Klee very much and consider him one of today's greatest painters, but in the far off time when I was doing *Der Blaue Reiter*, Klee was at the beginning of his development. Nevertheless I very much liked the little drawings which he was doing then and I reproduced one of these drawings in *Der Blaue Reiter*. This was the full extent of his participation in the book.[12]

Klee was not represented in the first Blaue Reiter show, but in the second show in the spring of 1912 which was devoted to graphic media and watercolors, he exhibited 17 works, a considerable number. It appears that as a result of his involvement with the Blaue Reiter circle, Klee's opportunities for exhibiting greatly increased. His exhibition in the Cologne Gereonsklub in November of 1912 was initiated by Marc, probably with help from Macke, who was a leading figure in the Gereonsklub circle.[13] Marc, in particular, was very active on behalf of Klee. He gently coerced Herwarth Walden into taking an interest in Klee.[14] As a result, a number of Klee drawings were included in the *1. Deutscher Herbstsalon* of 1913. From then on, throughout the war years, Klee was one of the major artists of the Sturm gallery. Marc also tried to use his influence with the publisher Piper to get Klee's *Candide* illustrations published, but nothing came of it. It must also have been through the good offices of Marc (and Macke?) that Klee sold some works to their patron Bernhard Köhler in the winter of 1912/13. As late as 1914 Klee's artistic reputation in Munich was still so limited that it required Marc's help to arrange a second show at the Thannhauser gallery.[15]

Beyond his participation in the second Blaue Reiter show and the ensuing traveling exhibitions, Klee took part in other Blaue Reiter activities of the prewar years. In early 1913 Marc invited Kandinsky, Klee, Kokoschka, Kubin, and Heckel to contribute to an illustrated Bible, to be published as a Blaue Reiter edition.[16] Klee was to illustrate the Psalms. His extent drawings with Biblical themes show that the project occupied him over the course of several years, although the realization of the scheme was made impossible by the war and Marc's death in 1916.

Another project on which Klee collaborated with Marc and Kandinsky was the Munich Künstlertheater. In 1914 Hugo Ball, the *spiritus rector* of this Expressionist avant-garde theatre, proposed that Kandinsky, Klee, Marc, and Jawlensky do scene designs for the theater. A planned book, *Das Neue Theater,* slated for publication in October 1914 in Piper's edition, was to present the new ideas on which the theater was based. Kandinsky was to contribute an essay, "Gesamtkunstwerk", and Klee stage designs for *The Bacchantes,* presumably the play by Euripides.[17] The war prevented the realization of this project, too.

While Klee did not play a leading role in the Blaue Reiter group, he was highly esteemed by both Marc and Kandinsky, and his participation in their projects indicates that he was quite an active member of their circle. Certainly the exhibition possibilities and contacts with dealers like Walden and Goltz that were opened up to Klee by his Blaue Reiter friends were of great value to him, but, more importantly, he had finally found a group of truly congenial artists. He was attracted to both Marc and Kandinsky on an artistic-intellectual as well as on a personal level. How much they meant to him is apparent from the feelings Klee voices about the Munich association of artists, called *Sema* (the sign), which he had already joined in the summer of 1911, primarily in order to be able to exhibit his work. Klee was less than enthusiastic about both the artists in the group and their none-too-avantgardistic program.[18]

Considering Klee's usual reserve and reticence, his remarks about the Blaue Reiter testify to his enthusiasm for its ideas. An autobiographic sketch written by Klee or with Klee's participation, published in 1920, states:

> "Sema" attracted Klee, but Kandinsky immediately deflected him from it. "Klee rides off on the blue horse" the 'Semites' said.[19]

In a letter of January 24, 1912 to his friend Ernst Sonderegger Klee discusses his attitude *vis-à-vis Sema:*

> But I am not fully committed to it, with my heart I am more with Kandinsky if you know who that is. I am not so much referring to his specific personality as to the ideas which unite this whole group.[20]

Klee's association with the Blaue Reiter circle also led to new acquaintances in the Munich literary circles. In 1912 and the following years he met Karl Wolfskehl (in late 1912 at Münter's), Hans Carossa, and in 1915 Rilke and Theodor Däubler, to cite but a few personalities. At last, he was moving in the kind of artistic avant-garde circles that he had envisioned since his move to Munich in 1906. Kandinsky's contacts in Paris helped Klee to get acquainted with Delaunay and Kahnweiler.[21] The internationality of the Blaue Reiter circle was one of its main attractions for Klee. At this time there was a lively

exchange between French, German, and Russian artists, via Le Fauconnier[22] and the Burljuk brothers among others. The Munich artists, on their part at least, felt that they and the Paris avant-garde were all one big brotherhood, united in their struggle to open new artistic frontiers. Both *Concerning the Spiritual* and *The Blaue Reiter Almanac* are pervaded by a euphoristic mood of internationality. Klee himself points to its attraction in the summary version of his diary, where he states for year 1911:

> Through Moilliet I met Macke, Kandinsky, and Marc and moved closer to their aspirations. The wider and more international aspects appealed to me.[23] [revised]

Apropos of the second Blaue Reiter show which included Cubist works, Klee notes in his diary, "Picasso, Derain, Braque, as Schwabing cronies, a nice thought!"[24] Klee's Swiss background and dual cultural orientation toward both France and Germany have already been noted. For those alienated by the bourgeois, nationalist mood of prewar Germany, the Blaue Reiter circle in Munich offered an intellectual refuge. As an open forum for German, French, and Russian art and ideas, it was the ideal environment for Klee to pursue the synthesis of the dualistic tendencies in his art.

On a personal level, Klee was friendly with both Marc and Kandinsky, but apparently his personal ties were closer to Marc. The correspondence between the Marcs and Mackes documents the frequent visits between the Marcs and the Klee family. The fact that Klee felt very congenial to Marc as a person, although they differed an artistic issues, is documented by his diary in 1915/16—Marc is the only artist that Klee ever refers to as his friend.[25]

Being neighbors in Schwabing, Klee and Kandinsky could see a good deal of each other, and Klee's son Felix recalls frequent visiting from 'house to house.'[26] These informal visits have been memorialized by Gabriele Münter in her delightful portrait of Klee, *Man in an Armchair,* 1913 (App. III-43). Ernest Harms, a member of the coffeehouse circle presided over by Kandinsky as the uncrowned king, has given an interesting account of Klee's position in this group.[27] An irregular attendant at these meetings, Klee would quietly follow the discussion but make occasional ironic remarks. Harms suggests that Klee looked up to Kandinsky with much admiration which, however, may have been tinged with some jealousy and competitive feelings. He recalls that Kandinsky liked Klee very much and Harms suggests "that there was an intense communication between them during the periods when they were at the same place."[28] Kandinsky had very much taken to the younger, quiet, and still little-known Klee, as is demonstrated by his urgent letters of inquiry after Klee, when they were both in Switzerland after the outbreak of the war in the late summer of 1914.[29] Late in September of 1914 the Klee family was able to visit Kandinsky once more in Goldach, Switzerland, where Kandinsky was at

work on the notes for what was to become *Point and Line to Plane,* the sequel to *Concerning the Spiritual.* Kandinsky asked Klee for help in the safekeeping of the works he had left behind in Munich and, to thank him for his trouble, gave Klee an oil sketch for *Composition VII.*[30]

After Kandinsky's return to Russia, the artists' personal communication was interrupted until December 1921, when Kandinsky contacted Klee again from Berlin. During the Bauhaus years their friendship became very close, much more so than it had been during the Blaue Reiter period. But through-out the first World War Klee continued to think about Kandinsky's works and ideas and was stimulated by them in his own art. Klee himself defined his relationship to Kandinsky in an homage to his artist-friend on Kandinsky's sixtieth birthday:

> He was further along in his development than I was: I could have been his pupil and in a certain sense I was, because one or the other of his words confirmed and illuminated my searching. Of course these were not words without the resonance of deeds (Kandinsky's earlier compositions). Then happened what we thought we could do without, the all-encompassing reality of the European conflict, and as a result, after a short meeting on a neutral island, the lengthy physical separation. But work proceeded calmly, over there for him, and here for the rest of us.
>
> While the emotional ties remained unbroken, they could not be reaffirmed until in Weimar the hoped-for meeting became reality, enriched by the nuance of joint pedagogical activity.[31]

As Lankheit has pointed out, the Blaue Reiter circle was not an artists' association proper.[32] Basically it consisted of Kandinsky and Marc, who collaborated on the almanac and organized the two exhibitions, with a group of more or less congenial minds around them. After the main phase of collaboration in 1911/12 each artist focused again on his individual path. If we can call Klee a "Blaue Reiter" nonetheless, it is because he shared the group's basic ideas and spiritual orientation and because during the prewar and war years his art moves in a conceptual direction related to theirs. It is during the Blaue Reiter period that Klee finally succeeded in integrating those formal and theoretical concepts of his earlier years into a personal artistic approach that is uniquely his. In this integration Kandinsky's art and theory played a catalytic role.

Klee's Reviews of Blaue Reiter Exhibitions

Klee's commitment to the ideas of the Blaue Reiter circle is documented in the reviews which he wrote from late 1911 until 1913 for the Swiss periodical *Die Alpen.*[33] As Geelhaar has pointed out, Klee's art critical writings were partly motivated by the desire to make his own art better known and understood,[34] but Klee must have realized that by firmly backing the 'outrageous' Blaue

Reiter group he took the risk of estranging his Swiss bourgeois audience rather than convincing it. In general, the monthly *Alpen* reviews reflect the changes in Klee's artistic thinking and document his definitive move away from a naturalist point of view.

In the December 1911 issue of *Die Alpen,* Klee reviewed a large Hodler retrospective which took place at the Thannhauser gallery. The show offered Klee the possibility of taking a fresh look at Hodler whom, 10 years earlier, he had much admired. While Klee moderates his judgment in the published review, in his diary he freely expresses his disapproval of Hodler:

> . . . such things [i.e., the Hodler show] are very stimulating, even though I am not at all for Hodler. For his significance does not rest in the purely pictorial, toward which I am striving more and more. He knows well how to characterize gesturing people, this I grant him. But I am disquieted by all these figures which look as if they cannot find peace. Hodler is interested only in spiritually hyperintense beings, or more exactly, only in their image: spiritually hyperintense painting is neglected rather than put to use.[35] [revised]

In 1902 Klee had been impressed by Hodler's way of representing man, writing to his bride, ". . . that in Hodler's painting, *The Disappointed Ones,* inner man is represented in a monumental way."[36] Now he berates Hodler for lack of painterliness, which in the published review he defines in terms of Impressionist rendering in light and shadow. But a strictly naturalist conception of painting, in terms of the Impressionists' commitment to the visible world alone, is no longer satisfactory to Klee, either: his remark on "spiritually hyperintensive painting" shows that he is already thinking along the lines of Kandinsky's ideas on expressive form and on subject matter. In Klee's view the fault with Hodler's work was not its expressive dimension *per se,* but the fact that it resided in the image alone and not in formal qualities.

In the January issue of *Die Alpen* Klee reviews the first Blaue Reiter show which took place simultaneously with the third *NKV* exhibition. Without discussing specific artists or paintings—as he does in his other reviews—Klee defends the main ideas of the group, as they were to be set forth in *The Blaue Reiter Almanac.* Klee points to the "primeval origins of art" which are to be found in ethnographic art, in the uncorrupted art of children and in the art of the mentally disturbed, and he emphasizes the need to return to such 'primitive' sources if art is to be renewed. Klee does not speak of Kandinsky's concept of the 'spiritual in art,' although he refers to the book; the fact that he cites the title incorrectly may indicate that he had not yet actually seen or read the book. His review stresses those aspects of Blaue Reiter ideas which were most congenial to his own thinking. In his adamant defense of the art of the insane and that of children—at its earliest stages rather than when it becomes corrupted by the knowledge of 'real' art—Klee reveals his own strong interest in primitive art which he had already studied for a long time.[37] P. Vergo has

recently suggested a relationship between Klee's review—of which Kandinsky certainly must have been aware—and Kandinsky's own remarks on children's art, which run along very similar lines, in his essay "On the Question of Form" which appeared in May 1912 in *The Blaue Reiter Almanac*.[38] It cannot be determined with any certainty if Klee's review influenced Kandinsky's discussion of children's art. Both Kandinsky and Marc had already earlier been interested in children's art, but their taste was far more conventional than Klee's, as their selection of highly accomplished children's drawings for the *Blaue Reiter* illustrations shows.[39]

Klee does not conceal that he has some reservations about the show itself which, besides works by Kandinsky, Marc, Macke, and Delaunay, also included fairly conventional works by Epstein and Nièstlé, as well as the rather dubious and dilettantish 'visions' by Arnold Schönberg. But Klee pays tribute to Kandinsky's vision of a new era in art by saying, "I salute those who are working on the coming reformation."[40] And he proclaims his own commitment to their ideas:

> I believe in the movement and also in the real earnestness of one or the other of the Munich Expressionists . . . The boldest among them is Kandinsky who is also active as a writer.[41]

From his concluding remarks, which have a rather Kandinskyan ring, it is evident that Klee looked upon the Blaue Reiter as more than just another artistic splinter group, and shared Kandinsky's conviction that "the movement" would effect a renewal of art.

In the March 1912 issue of *Die Alpen,* Klee explicitly declines to report on what he considers the antiquated show of the Munich *Sezession* and instead again favors the Blaue Reiter. He briefly discusses the second Blaue Reiter show (in which he participated) and announces the forthcoming Blaue Reiter books, summing up their program:

> The novelty of what is felt and created today shall be revealed in its relation to earlier times and earlier stages; we are promised folk art, children's art as well as Gothic art here and in the Orient, and Africa.[42]

Although Klee had called for more attention to painterly problems of rendering light and shadow in his Hodler review of December 1911, he demonstrates an essentially anti-naturalistic point of view in his review of the Swiss painter Cuno Amiet's works in June of 1912. After discussing Amiet's early nature studies, Klee gives higher praise to Amiet's invented motifs, apparently as a matter of principle:

> Even though these works which are more imagined than perceived are unequal in quality, the least among them is of greater value to me than the above-mentioned works in which he

comes to terms with nature. The artist does not forever want to reproduce the Creator with a free interpretation, if needs be,. . . the artist wants to be the Creator himself.[43]

In the summer of 1912 Klee had met Hans Arp who invited him to participate in the second exhibition of the Swiss artists' association, *Moderner Bund Weggis,* which took place in July in the Zurich Kunsthaus.[44] His own participation presumably motivated Klee to write a lengthy review, or rather an explanatory article about the show, which included works from Paris (Matisse, Le Fauconnier, Delaunay) as well as a collection of Blaue Reiter works. Shortly before, in April of 1912, Klee had undertaken a brief trip to Paris where he had been much impressed by Cubism and Delaunay's work in particular. As had been the case with the *Salon des Indépendants* of 1911, Picasso and Braque were absent from the Zurich show. French Cubism was represented solely by Delaunay and Le Fauconnier, but Klee nonetheless used the opportunity afforded by the exhibition to present his view of Cubism in general. Beyond that, Klee's review is an attempt to come to terms with Cubism on one hand, and Kandinsky on the other, in regard to their relevance for his own art.

From the review it is apparent that Klee places himself within the context of Expressionism. As was customary in contemporary German art criticism, Klee uses "Expressionism," a term which had only recently come into use, as a blanket term for all avant-garde art, considering Cubism as one of its sub-species.[45] Like Kandinsky, Klee defines Expressionism as the opposite of Impressionism, which he speaks of somewhat condescendingly as "only a style of extended naturalist tendencies" which is lacking in "formal composition."[46] For Klee the central tenet and foremost concern of Expressionism are its return to pictorial construction as the primary consideration and, resulting from it, abstraction from nature, "Thus the scaffolding of the pictorial organism now has priority and becomes the truth, at any cost."[47] Klee uses the word "construction" as a rather general term—much in Kandinsky's sense—to denote the basic compositional principle or *Kunstgesetz* which the artist chooses; thus "construction" does not necessarily imply mathematical constructions or Cubist scaffolding. Since this formal order or construction is the primary force of expression in the picture, the rendering of the motif itself becomes secondary and ". . . a rendering which is removed from nature, once more becomes normative."[48] From his explanation of Expressionism in general, Klee turns to Cubism, of which he is very critical. He finds the Cubist approach very intellectual and rationalistic, calling it a "school of form philosophers, of men with speculative tendencies."[49] Essentially, the Cubist artist pursues the Renaissance ideal of geometrically ordered composition and measured form to its logical consequence:

The Cubists determined these proportions with all certainty down to the smallest detail, some focused more on the measurements of the plane, others, like Delaunay, also took the

measurements of light and color into account. That such a picture consequently looks like a crystallization . . . is the natural result of Cubist form thinking, which consists primarily in the reduction of all proportions and leads to primitive forms of projections, such as triangle, square and circle.[50]

Klee's definition of Cubism quite closely follows the view of Cubism in the articles of R. Allard and E. von Busse presented in *The Blaue Reiter Almanac*. Allard's article reflects the ideas of Gleizes and the *Section d'Or* circle rather than those of Picasso and Braque.[51] Like Kandinsky and others, Klee extends published statements on Cubism, such as Allard's, to the art of Picasso and Braque, who kept aloof and offered no explanations of their own.

It must be stressed that at this point, Klee is still unsympathetic to the geometrical approach of Cubism, voicing strong disapproval about the fragmentation of forms. He finds fragmentation tolerable in paintings with landscape subjects, but finds it dangerous, even ludicrous, with figural subject matter:

More severe organisms do not take well to such revaluations. Animal and man, who exist in order to live, sustain a loss of vitality with every conversion. Even more so when they have to subordinate themselves to a heterogenous pictorial organism or—as with Picasso—are cut up into individual motifs whenever the pictorial idea requires it. Destruction, for the sake of construction?[52]

Klee's view of Picasso recalls Kandinsky's remark on the Spanish artist in *Concerning the Spiritual:*

Picasso is trying to arrive at construction by way of numerical proportion. In his latest works (1911) he attains through logic an annihilation of materiality, not, however, by dissolution of it, but through a kind of fragmentation of its separate parts and a constructive dispersal of these parts over the canvas. But, strangely enough, he seems to wish to preserve the appearance of materiality.[53]

In Klee's opinion the analytical logic of this Cubist method destroys the life of forms. By contrast, he feels that both Delaunay and Kandinsky succeeded in creating pictures that are full of life and creative energy. Delaunay has found a solution for the Cubist dilemma *vis-à-vis* the object by completely eliminating objects from his paintings:

. . .by creating the prototype of an autonomous picture which has an entirely abstract formal existence without motifs from nature. An object full of plastic life, as far removed from a carpet as a fugue by Bach.[54]

Klee explains that in his discussion he has given priority to Delaunay's elimination of the object from his paintings, although Kandinsky had taken a

similar step earlier than Delaunay, ". . . because [Delaunay's approach] seemed most plausible to me."[55] Klee, in fact, may be defending Delaunay's abstractions against what Kandinsky had written in *Concerning the Spiritual:*

> If we were to begin already to sever today the bond that binds us to nature, if we were to forcefully seek liberation and if we would restrict ourselves exclusively to the combination of pure color and independent form, we would create works which would look like *geometric ornament,* and which—generally speaking—would resemble a necktie or a *carpet.*[56] [revised] [Emphasis mine]

Since writing this Kandinsky himself had moved a good deal closer to pure abstraction (and in Klee's opinion had arrived at it), but he continued to work with biomorphic rather than geometrical forms. It is clear from Klee's review that he finds abstraction, be it in Delaunay's sense or in Kandinsky's, more convincing and attractive than the fragmentation of form in Analytical Cubism. Over the following years, as Klee himself moves toward abstraction, he will conceive of it as a pictorial approach rather than as strict 'non-objectivity.'

Among the Cubists, Klee is most interested in Delaunay; he polarizes Delaunay and Kandinsky: one the representative of French modernism, the other unique and a singular phenomenon. Klee's remarks on Kandinsky express a somewhat ambivalent attitude toward Kandinsky. On the one hand he admires Kandinsky's solitary audacity as an artist, but on the other he cautiously sets himself off from Kandinsky by playing off his own complex cultural heritage as a Western European artist against the "Russian man without ballast." This is a rather curious view of Kandinsky, who during his 15 years in Western Europe, and before that, in Russia, had eagerly absorbed a great deal of Western European art and had been exposed to nearly as much academic indoctrination as Klee.[57]

> A man who never lived with great fervor in the framework of this world but who also never was burdened by the compulsion to logic and affliction of the refined Frenchman (i.e., Delaunay), Kandinsky was led by his considerable instinct and his passionate striving for freedom to what is basically the same result. We can but marvel at how such a Russian man without ballast looks around in Europe, where we walk burdened and fatigued, always in fear that we will fall down if we try to shake off some of our load. In school already we were so thoroughly infected. We had read Laocoon, we knew and appraised museums before we had even seen them. It is very questionable if we would have dared to do what he did even with an equally radical nature. The strength of his spirit makes him productive right away, his mind does not waste itself in inhibitions. Museums do not illuminate him, but he illuminates them, and even the greatest artists there do not diminish for him the value of his own spiritual world. His works are the children of his mind, they resemble each other. Free forms, suitable for creation, easily join hands in his works. The wealth is great, he does not have to be thrifty. Form is next to form, constructive ideas bind them together but do not predominate. There is nothing despotical in his works; one can breathe freely. And then again, these are also the works of a faithful child of his country, quite national in character.[58]

Klee juxtaposes Delaunay, heir to the long tradition of French painting (who developed within the perimeters of its internal logic), to Kandinsky who, free from doctrinaire fetters, could instinctively adopt from other art that which suited his needs. For Klee, having spent years of studying the colorism and formal discipline of French art, the clear geometrical abstraction of Delaunay's *Fenêtres* is more plausible and attractive than the overwhelming, 'instinctively' ordered complexity of Kandinsky's works, such as *Painting with Black Spot,* 1912, which was included in the *Moderner Bund* show. Yet in the same review Klee speaks of Delaunay's "dangerous path."[59] It is not made clear what he finds dangerous about Delaunay's approach; conceivably he finds his doctrinaire color theory limiting and restrictive. Thus, despite his admiration for Delaunay, Klee in 1912 is not prepared to move in the direction of Delaunay's color abstraction. Moreover, his reservations notwithstanding, Klee is fascinated by Kandinsky, with whom he has much in common conceptually. He is impressed by the freedom with which Kandinsky makes his artistic moves. Over the next few years Klee, in a fashion, follows Kandinsky's example by freely adopting those formal and conceptual aspects of both French art and German Expressionism that suit his own needs.

Klee's discussion of Cubism offers a key to the way he will deal with it in his own art. Like Kandinsky, he has fundamental reservations about the too 'intellectual' approach of Analytical Cubism. In contrast to Kandinsky, Cubism was to provide important formal impulses for Klee's work. However, Klee approaches it very selectively, appropriating Cubist form for his own, essentially Expressionist ends: he adopts Cubist geometrical forms and Cubist space and grid order, but he eschews a central aspect of Analytical Cubism, the fragmentation of form, with its implications of preserving the "appearance of materiality" (Kandinsky). Neither is Klee much interested in Cubism as an art of realism. He views abstraction in the sense of Delaunay or Kandinsky as more vital and viable than the Cubist approach to the object and to reality.[60]

Kandinsky's work represented an alternative, as it were, to Cubism, and even though Klee does not completely follow in Kandinsky's artistic footsteps, he will often turn to Kandinsky's example for alternative solutions to formal and theoretical problems which he finds unsatisfactorily resolved in Cubism.

3

Formal Influence of Kandinsky on Klee

During 1912 Klee embarks on a great deal of experimentation, in his media and technique, as well as his style. After years of relative artistic isolation, both in Bern and in Munich, he is able to study a great deal of avant-garde art first hand, in Munich exhibitions and on his trips to Paris and Zurich. In April he saw Cubist and Orphist works in Paris and again at the Moderner Bund in Zürich in the summer. Late in 1912 the traveling show of the Futurists came to Munich. Of course, the works of the Blaue Reiter artists were available not only through exhibitions but also through personal visits to artists. Because Kandinsky lived next door to Klee, we may assume that Klee saw not only Kandinsky's current production, but could also study his earlier works as well as his prints, especially as Kandinsky was then preparing for his large retrospective at the *Der Sturm* gallery in Berlin (October 1912) and was also producing and assembling the prints for *Klänge,* published in the fall of 1912.[1]

Klee gradually came to terms with all these new artistic impressions over the next few years. Cubist forms do not begin to appear in Klee's work until late 1912, and it is only in 1914 that Klee fully adopts Delaunay's color grid despite his admiration for Delaunay's work in 1912. The influence from Kandinsky is most apparent in 1913 works; however, in 1912 Klee makes some basic artistic decisions which conceptually relate more to Kandinsky's thinking than to French modernism. A number of works reveal a decisive shift away from nature as the point of departure; instead, Klee seeks to capture the expressive essence of objects. This reduction of forms to their barest essentials opens the way for Klee's development of semiabstract signs and figurative formulas, which are more related to Kandinsky's pictorial elements than to Cubist form fragmentation. By foregoing reality as the point of departure, Klee begins to turn toward abstraction, an important factor in the evolution of his mature style. Abstraction means for Klee, as for Kandinsky, the dematerialization of form. As with Kandinsky, transparency and the separation of color and line into independent pictorial elements become important means for making forms seem immaterial. Klee uses these means first in a style related to Kandinsky's before he begins to adapt them to Cubist forms. In

1912 and in 1913 as well Klee deals with many formal issues initially in a manner that relates to Kandinsky, and then seeks to reconcile the 'Kandinskyan' approach with the formal vocabulary of Cubism. On the whole, he adopts Cubist forms for what are essentially Expressionist esthetic concepts. Not only are the underlying ideas different, but ultimately even his very 'Cubist' works differ from French Cubism in their essential formal character and content.[2]

Changes in Klee's Drawing Style of 1912

In 1912 Klee decisively moves away from nature as the point of reference for his art, in the manner in which he represents his motifs as well as in the type of subject matter which he chooses.[3] Klee begins to develop a visually effective style of figural simplification which enables him to deal with complex conceptual subject matter. With renewed vigor he again enters his "prime realm of psychic improvisation," of which he had spoken in 1908,[4] and returns to 'invention' in his art. After the tightly controlled refinement of the 1911 *Candide* illustrations, his formal priorities in 1912 are spontaneity and expressiveness. Klee's departure from a naturalistic conception began in 1911 when he started to emphasize contour again, which for him was an essentially 'abstract' form element, as he writes in his diary in spring of 1911:

> Now I again need the contour, that it gather and capture the impressionisms which are fluttering around. Let it be the spirit ruling over nature.[5]

The contours of the thin, hyper-refined figures in the *Candide* illustrations, as for example *"Il lève le voile...",* 1911.63 (App. III-17) are constituted by myriads of little scraggly strokes, "swarming scribbles" ("Kratzfüsschen"), as Klee calls them.[6] Here his drawing style is still ultimately rooted in Impressionism; it also reflects his study of Cézanne's brushwork. If the combination of these complex, vibrating line patterns with simple figural forms and sparse scenery is ideally suited to Voltaire's ironic parable with its elegance of form and language, there is also the danger of over-refinement and mannerism. Apparently Klee was aware of this, for the later drawings for *Candide* manifest a strengthening of contour lines. Nonetheless, in most of his 1911 drawings Klee still seeks a balance between the Impressionist "Kratzfüsschen" and contour as the "spiritual element." In a few works, however, mostly pen drawings behind glass, Klee does experiment with resolute contours and primitivist forms, as for example in *Rider and Outrider, Sketch for an Illustration (originally for Candide),* 1911.99 (Fig. 5). In this drawing Klee imitates the clumsiness of children's art and outlines the figures with a coarse, dark contour line. Perhaps the few works of this type represent Klee's response to the paintings behind glass which the Blaue Reiter artists were doing in

1911. Klee, of course, had long before discovered this technique for himself, but these 1911 paintings behind glass differ from his earlier tonal studies and loosely drawn sketches behind glass. In its drastic primitivism, Klee's *Rider and Outrider* is stylistically more audacious than Kandinsky's 1911 paintings behind glass, such as *St. George II,* 1911 (Fig. 6), which adhere fairly closely to the folk art models which had inspired them. The two works are, however, related in their emphasis on contour lines and simple, fluid forms.

Rider and Outrider heralds the stylistic changes that occur in Klee's 1912 drawing style. In most of his 1912 drawings, contour and the reduction of details as means of abstracting from nature are Klee's primary concerns. Where they appear in 1912 works, the "Kratzfüsschen" are no longer "Impressionisms," but scribbles which serve entirely different purposes.

The shift in Klee's approach is demonstrated by the small drawing, *Fleeing Rams,* 1912.31 (A) (Fig. 8), which takes up the theme of the *Candide* illustration, *Candide et Cacambo montent en carosse, les six moutons volaient,* 1911.77 (Fig. 7). While in both drawings the six running sheep are drawn very sketchily, in the 1912 sketch the lines of the four sheep on the right have been simplified and are more forceful in appearance. Less attention has been paid to details such as joints and hooves. In both drawings the first pair of animals is drawn in a very abbreviated fashion, but in Fig. 8 the forms are simplified to the point where they can be identified as sheep only from the context of the entire drawing. In the 1911 drawing, despite its appearance of sketchiness, considerable attention has been given to the anatomical accurateness and completeness of the sheeps' bodies (note the legs, ears, fuzzy sheepskin, and the individual physiognomies of the sheep), whereas in Fig. 8 such details are omitted in favor of concentration on the expression of speed and motion as well as on the effect of rapid improvisation. In this version the distance from the actual appearance of the objects depicted has greatly increased.

In both of these drawings as well as in *Rider and Outrider* the animals are drawn with soft rounded outlines which make them look as if they had no bones. In *Rider and Outrider* these 'boneless' forms recall children's drawings; the fluid contours and the rhythmical sequence of animals in the other two drawings are comparable to the three running horses in Kandinsky's *Romantic Landscape* 1911/115 (App. III-20), an early work of that year.[7] Even if this similarity may be incidental, Klee was certainly interested later in this type of 'boneless' amorphous figure that occurs so often in Kandinsky's works.

In the spring of 1912 Klee saw Cubist work at the second Blaue Reiter show as well as on his trip to Paris, but he does not begin to experiment with Cubist forms himself until late in the year. After his Paris trip, Klee briefly experiments with a controlled and reductive drawing style that recalls Matisse, as in *Sketch of a Nude from Behind* (App. III-17), but he does not

explore the calculated naivety of Matisse's drawing style very far.[8] Rather, through most of the year the focus in his drawings is on qualities of spontaneity and improvisation which are both formally and conceptually more comparable to Kandinsky's linear style. The conceptual approach to drawing which he develops will also indicate the way he later uses Cubist geometrical forms. In the following discussion a group of drawings and prints have been singled out for their relationship to Kandinsky both in style and subject matter. They are representative of the new issues with which Klee dealt in his art and which he explored from various stylistic angles.

The experimental nature of many of Klee's drawings of 1912 is demonstrated by *Galloping Horses,* 1912. 85 (A) (Fig. 9), where the style of the drawing changes with each figure. Arranged in a spatial progression, three horses race across the surface, about to collapse. The largest horse, at right, is elaborately drawn with layers of pen-strokes. Its head is dramatically raised, and joints and muscles are delineated with circular line motions. The mode of drawing with layers of strokes and circular forms recalls Delacroix drawings. At first sight this horse has a quite monumental quality; yet there is a disconcerting discrepancy between the proportions of the large head and neck and the body, which seems to be split in the middle, as well as between body and the small legs. The discrepancy is even more obvious in the second horse, which appears as a parody of the first. Its head and neck are drawn with a few simple outlines, while the disproportionately small trunk and legs are sketched in with nervous pen-strokes. In the third horse, on the left, this scribbly sketchiness is even more exaggerated. Here, the forelegs are dissolved in a maze of lines, vaguely comparable to Futurist renderings of motion, but less clearly organized.

In a few small drawings Klee further pursued this almost doodle-like sketchiness. In many of his 1912 drawings horses figure as a prominent motif. Perhaps they are his tribute to the Blaue Reiter iconography, as horses were a favorite subject of both Kandinsky and Marc.[9]

In *The Hunt,* 1912.80 (A) (App. III-17), Klee focuses on the speed of the moving horses. They are rendered with quick, thick penlines which, in terms of the drawing style, can be compared to Kandinsky's sketchy horse in *Lyrical,* 1911 (App. III-41), which was included in the *Moderner Bund* show. The two configurations at the upper right of the drawing are extremely simplified, almost to the point where they become abstract line clusters.

Such improvised, seemingly haphazard qualities are even more prominent in the pen and brush drawing, *Common Goal (Two Animals in Search of Adventure),* 1912. 115 (A) (App. III-17). The brushed-in spots generate a mysterious undefinable environment similar to that suggested by the color spots around the horse and rider in Kandinsky's *Lyrical* (App. III-41). The oddly elongated head of the horse on the left has the awkward quality of a

child's drawing. That Klee was indeed inspired by children's drawings is manifest in a small drawing, *Three Galloping Horses II (Weakly Animals)*, 1912. 87 (A) (Fig. 10), where the qualities of sketchiness and improvisation are extreme. Using the back of a piece of paper on which he had made notes for the review of the *Moderner Bund* exhibition, Klee draws three vaguely horse-like animals in a semicircular frieze.[10] The horses are drawn with simple pen outlines. Details, such as the misproportions of legs and bodies, the circular hooves appended to the legs of the horses at right, or the hare-like head of the left horse, clearly refer to children's drawings. The linear scribbles which are distributed in a seemingly random fashion over the animals also recall children's drawings, and are a device that Klee also uses elsewhere.[11] The script shining through from the verso adds to the incidental, 'doodle' character of the drawing, but the fact that Klee signed, numbered and titled the drawing indicates that he considered it a full-fledged drawing and made conscious use of the means and effects described above. Although Klee achieves an effect of intuitive drawing and seeming randomness similar to Kandinsky's in his pen drawings of about the same time, such as a drawing published on the title page of the October 1912 issue of *Der Sturm* (Vol. 3, no. 120), Klee makes more direct reference to the art of children and stays within the limits of a figurative content.

The relationship of Klee's drawings to Kandinsky is most obvious in *St. George*, 1912. 117 (Fig. 11), a small lithograph. The motif is unusual in his *oeuvre* as Klee rarely dealt with specific Christian themes. Probably it was inspired by Kandinsky, for whom this rider saint was a favorite subject.[12] The lithograph is also executed in a very sketchy manner. Dark blotches at the upper and lower edge give a vague indication of scenery but cannot be read as specific objects. Horse and rider are depicted with simple soft outlines which are comparable to the horse and rider in Kandinsky's *Study for Composition II*, 1910 (App. III-47), which was included in the *Moderner Bund* show. The same rider figures appear in Kandinsky's woodcut of *Composition II* (App. III-53). While Kandinsky's horses always seem to fly effortlessly, the horses in Klee's drawings and in *St. George* look rather like old mares struggling to get on.[13] They are possessed of a Don Quixotical comic quality quite different from Kandinsky's lofty pathos. In *St. George* the princess to be freed stands with her arms pathetically raised (see the similar pose of the figure in the background of Kandinsky's woodcut of *Composition II*) (App. III-53), but half concealed by a dark spot. The dragon in the form of a human figure lies prostrate on the ground. It is not drawn with the rounded 'boneless' forms of the other figures, but with the angular, transparent forms that are typical of Klee's earliest phase of adapting Cubist forms. Pierce has pointed out that Klee uses transparency for the sake of structural clarity, as do children in their art.[14] Klee stacks the figures above each other with no concern for proportions

and spatial organization, as Kandinsky does in *Composition II*. While Klee's small print has little of the pathos and monumentality that Kandinsky strives for in paintings like *Composition II* or *Lyrical*, it operates with some of the formal means.[15]

Klee sketches his figures with increasing independence from any natural model (the drawings discussed belong in the "A" category of his *oeuvre* classification, i.e., done without nature); this and the expressive use he makes of light-dark effects *per se* mark important advances in his development.[16]

Klee not only uses brushed-in spots for expressive ends but also abstract line configurations, in a way similar to Kandinsky. The drawing, *Violent Death*, 1912. 88 (Fig. 12), depicts a thin, elongated figure cringing in its death throes.[17] Compared to the similarly elongated figures of the *Candide* illustrations, this figure has been drastically simplified, with all considerations of anatomical accuracy set aside in favor of the expressive contortion of the body. Death is symbolized by the bundle of thick brush-lines pointing downward on the figure (an early version of the artist's arrow motif). The use of nonrepresentational lines as the expression of unspecified higher forces is a device frequently found in Kandinsky's work, for example in *Improvisation 19*, 1911 (Fig. 13) or *Improvisation 10*, 1910 (App. III-23). Klee employs the same means in other drawings of 1912, such as *Fall*, 1912. 130 and *Woe is me...*, 1912. 131.[18] In *Violent Death* Klee, in a way typical for much of his work, introduces a playful and ironic note by placing his signature directly above the bundle of lines.

Violent Death is representative of Klee's 'band style,' in which the figure is created by curving bands of parallel lines. These works probably date from the middle part of the year, since one drawing of this type was included in the *Erste Gesamtausstellung*, October 1912, at the Munich Goltz gallery.[19] Whereas in their stylistic ancestors, the *Candide* figures, emotions had been expressed by the subtlest nuances of gesture, the 'band' figure drawings are exercises in the dramatic, succinct expression of feelings. In *Loneliness*, 1912. 128 (App. III-17), *Fall*, *Woe is me...*, and numerous other works, the same type of completely a-naturalist figure is distorted in various ways. Each drawing expresses a specific emotion or "state of mind" to borrow a Futurist phrase.[20] Their expressive quality is no longer based on subtle gestures but on the direct visual impact of the lines. Based on the expressive properties of linear configurations which are almost abstract, these drawings seem to explore Kandinsky's concepts of the 'inner sound' of lines and forms.

In four woodcuts of 1912—the only ones he ever executed[21]—Klee also experimented with various modes of linear expression. Klee takes the medium into account by focusing on strong dark-light contrasts and simple forms, as in *Contrition*, 1912. 120 (App. III-32), and *Under the Sun*, 1912. 135 (App. III-32).[22] The lines in these woodcuts are not jagged and pointed (as in most of

Marc's woodcuts), but soft and rounded, as in many of Kandinsky's woodcuts for *Concerning the Spiritual.* The figural shapes in Klee's woodcuts are simplified to the point where they are nearly abstract. In *Contrition,* where the 'band style' is transposed into the woodcut medium, Klee operates solely with the expressive qualities inherent in the curved lines and their clashing with the horizontal lines. The figure, poised in an uneasy balance, is literally 'crushed,' for the curved lines are uncomfortably compressed. Both the undulating lines and the rather melodramatic title recall *art nouveau* prints. In February 1912 Klee had seen an exhibition of Munch works which he reviewed favorably for *Die Alpen.*[23] Perhaps this woodcut reflects impressions derived from Munch's prints, but Klee could also find a similar method in Kandinsky's early woodcuts, such as *Singer,* 1903 (App. III-53) or *Baba Jaga,* 1907 (App. III-53). In his early work Kandinsky had also dealth with emotional themes similar to Klee's of 1912, as in his 1907 print *Panic.*[24]

Under the Sun (App. III-32) is more enigmatic in theme. Only the sun is clearly identifiable. A worshipping figure with raised arms seems to stand underneath it. With the sparest means possible, Klee creates a mysterious confrontation between human figures and cosmic forces, comparable to Kandinsky in his *Improvisation 19,* 1911 (Fig. 13). If it seems somewhat preposterous to compare Klee's tiny sketches and prints to Kandinsky's large, ambitious paintings, we have Klee's own testimony that he learned from Kandinsky's early compositions. Many of Kandinsky's paintings he could also study, translated into black and white and small scale, in the prints for *Klänge.* Moreover, as we have seen, earlier when he was interested in Hodler and the Impressionists, Klee had also adapted stylistic aspects of paintings to his own, primarily graphic media.

In the later part of the year Klee began to use Cubist-geometrical forms, as in *Carried Away to Dance,* 1912. 126 (A) (App. III-17). However, continuing his interest in expressive, a-naturalist themes, he adapts the style for his own purpose. In constructing figures with geometrical forms, Klee emphasizes their anatomical construction which he had disregarded in the 'band style' figures. He does not, however, fragment these figures or present them from multiple viewpoints in the Cubist sense of analysis of objects. Moreover, by avoiding Cubist *passage* effects which would generate a volumetric quality, Klee divests his figures of any physical reality. These puppet-like creatures are as transparent and immaterial as the amorphous figures in Kandinsky's paintings. Thus Klee eschews the basic tenet of the Cubist esthetic: the tension between abstraction on one hand and the reaffirmation of reality and materiality on the other. This approach characterizes Klee's response to Cubism in general: he frequently employs Cubist formal means in order to dematerialize form in an essentially Kandinskyan sense.[25]

On a formal level Klee's drawing style of 1912 is characterized by reduc-

tion of forms and a degree of abstraction, as well as by an emphasis on unrefined contours and a sketchy, improvised mode of drawing. Klee consciously adopts features from children's art—ranging from awkward distortions to scribbles and transparent overlaps—and uses these means so directly that the viewer becomes very aware of these primitivisms.[26] I suggest that by making such direct reference to children's art in his own work Klee wants to acknowledge and affirm his belief in intuitive work methods and in art as spontaneous expressions of "inner necessity" in Kandinsky's sense. While no other artist of the Blaue Reiter circle was as directly inspired by children's art as Klee, they all considered it one of the purest manifestations of artistic creativity.

In his *Alpen* reviews of the Blaue Reiter shows, Klee heartily subscribes to the call back to the "primeval stages of art." Klee had already thought along similar lines, but it was only after actually joining the group of congenial and supportive artists that he eased up on the formal discipline of his previous work and experimented with new modes of linear expression. In his essay, "On the Question of Form" Kandinsky describes what he calls the "great realism" in terms that would equally well characterize certain Klee drawings, such as *Galloping Horses II* (Fig. 10):

> The emergent great realism is an effort to banish external artistic elements from painting and to embody the content of the work in a simple ("inartistic") representation of the simple solid object. Thus interpreted and fixed in the painting, the outer shell of the object and the simultaneous cancelling of conventional and obtrusive beauty best reveal the inner sound of the thing. . . . *The "artistic" reduced to a minimum must be considered as the most intensely effective abstraction.*[27]

Kandinsky's defense of "distortion" ("verzeichnen")[28] for reasons of inner necessity, and of the freedom to choose and combine all formal means, media, and materials, confirmed Klee's own ideas and further encouraged him to attempt their realization in the wide range of formal and technical experiments in this and the following years.

Beyond the formal changes in this year, Klee significantly shifted in his relationship to nature. Although during his 'Impressionist' phase Klee had produced works of the "A" category (i.e., done without a direct model), most of these provide clear references to the outer appearance of the objects represented. While this also holds true for much of his 1912/13 work, Klee in a number of works, such as the animal sketches and the 'band' figure drawings, manifests a concern with the direct expression of what his Blaue Reiter friends call the 'inner' quality of an object, that which represents a higher truth, as it were, than the imitation—in its widest sense—of outward appearance. An essay by Marc which appeared in *Pan* in early March of 1912 summarizes the attitude shared by the Blaue Reiter artists:

Cézanne already was brooding over new means through which he could penetrate more deeply into the organic structure of objects and which would ultimately enable him to reveal their inner spiritual meaning. . . . Today we [i.e., the young artists] search beneath the veil of appearances for hidden aspects of nature which seem more important to us than the discoveries of the Impressionists. . . . It is not fancy or the desire for something new that makes us seek and paint this inner spiritual side of nature, but it is because we see this side, just as formerly one "saw" all of a sudden the violet shadows and the ether enveloping all things.[29]

Klee's Paintings 1912-1914: The Question of Color and Line as Autonomous Pictorial Elements

During 1911 Klee had concentrated his energies on drawing. Only nine "colored sheets" are listed in Felix Klee's statistical survey of his father's *oeuvre*.[30] In 1912 Klee renewed his offensive against the "fortress of painting";[31] one oil painting and 31 colored works in different media are listed for this year. In 1913 the number increases to six paintings and 54 "colored sheets." From 1914 on, after Klee's much cited 'breakthrough to color,' paintings and watercolors outnumber drawings. From then on, stylistic innovations are first manifest in painting rather than the graphic media. Until 1914 Klee experimented in various directions in his colored works of 1912 and 1913. Then he adopted the Cubist grid order and the resulting shallow space as the compositional basis for his work.

Kandinsky's influence on Klee's paintings is manifest in two respects— his color range and, more importantly, his use of the linear element in painting.

Encouraged by the example of both the Blaue Reiter artists and Delaunay, Klee in 1913 introduced more intensive colors into his paintings and watercolors and occasionally he operated with juxtaposed primaries.

In his 1913 landscape watercolors, Klee adopts the coloristic approach typical for both Jawlensky and Kandinsky during the *NKV* period. Like them, he intensifies and exaggerates the natural colors and adds some unnaturalistic, strong color accents. For example in *In the Quarry*, 1913. 135 (B) (App. III-18), of the summer of 1913, a bold, rather Matissean purple-orange foreground is contrasted with the subdued natural green shades of the tree zone. Motif, composition, and color choices are quite similar to a painting like Kandinsky's *Landscape with Tower,* 1909 (App. III-23), but in comparison, Klee's colors are rather pale and less radiant, even if the difference between oil and watercolor medium is taken into account. *In the Quarry* is representative of the color range in Klee's nature studies.

However, in a few oil paintings Klee works with somewhat bolder colors. *Composition with Blossoms and Leaves,* 1913. o.W. (App. III-18) represents an early attempt to work along lines comparable to Delaunay in his *Fenêtres*

series; for example, *The Windows, First Part, Second Motif,* April 1912 (App. III-2), which Klee could have seen on his visit to Delaunay's studio. The color choice and the geometricized, spatially inflected shapes, which are abstracted from biomorphic forms, recall Delaunay's method.[32] But Klee's opaque colors do not attain the luminosity of Delaunay's paintings; the dark contour lines encircling the forms—related to Blaue Reiter landscape painting—prevent the facet shapes from interacting in a Cubist sense.

Another painting of the same type, *Flowerbed,* 1913. 193 (App. III-49), relates more immediately to Blaue Reiter paintings in its color choice. The predominant red-blue color 'sound' and the strong contrasts of dark and light colors recall paintings like Kandinsky's *Landscape with Tower,* 1909 (App. III-23) or Jawlensky's *Princess with a White Flower,* 1913 (App. III-61). In these paintings Klee tries to combine impressions from Delaunay and from the Blaue Reiter artists.

In general, Klee's coloristic decisions in his 1913 painting and watercolors document his hesitancy *vis-à-vis* color. He wavers between bright, 'abstract' colors and more or less naturalistic tonalities. The Tunis experience in the spring of 1914 finally seems to have set free his abilities as a colorist. From then on he operates with color in an essentially a-naturalist way and within a very wide range of color combinations. His 1913 paintings already document how catholic and varied Klee's coloristic approach is. In this respect he follows Kandinsky's example of freely choosing his means, rather than basing himself on any color theoretical dogma. In contrast to Delaunay, Klee does not give any special emphasis to the three primaries and their simultaneous contrasts, athough he does employ them to some extent beginning in 1914. Like Kandinsky, he continues to employ bright, unmixed colors as well as tonally gradated hues, colors of equal intensity as well as light-dark contrasts and chiaroscuro effects.

At least during the Bauhaus years Klee was well familiar with a wide range of color theories, yet he refused to submit his work to the dictates of any principles of color theory. Instead, his color choices were determined by the needs of each individual composition and by his own intuition. Thus, one lasting aspect of Kandinsky's influence on Klee was that Kandinsky set a general coloristic example, which encouraged Klee to continue to employ a very diversified range of colors.

Kandinsky's influence was of more crucial significance in regard to the role of line as an autonomous formal element in painting. In adopting Kandinsky's method of using color and line as independent, rather than interdependent, elements in his paintings, Klee arrived at an artistic approach which enabled him to introduce references to objects at any stage during the work process. He thus could develop a work from abstract beginnings toward a figurative content, rather than working with a specific motif as the point of

departure. By this means Klee was also able to present objects in a transparent, immaterial way; that is, divested of any relation to material reality.

Ever since Klee's Symbolist beginnings, the linear element had been of central importance to his work. His attempts to approach painting from a more or less Impressionist angle had put him in an artistic predicament which he formulated very succinctly in 1908:

> The chief drawback of the naturalistic kind of painting—to which I continually return for thorough orientation and training—is that it leaves no room for my capacity for linear treatment. Actually no lines as such exist in it; lines are merely generated as frontiers between areas of different tonalities or colors. By using patches of color and tone it is possible to capture every natural impression in the simplest way, freshly and immediately.

After discussing van Gogh and Ensor as possible models Klee continues:

> With new strength from my naturalistic *études,* I may dare to enter my prime realm of psychic improvisation again. Bound only very indirectly to an impression of nature, I may again dare to give form to what burdens the soul. To note experiences that can turn themselves into linear compositions even in the blackest night. Here a new creative possibility has long since been awaiting me, which only my frustration resulting from isolation interfered with in the past. Working in this way, my real personality will express itself, will be able to emancipate itself into the greatest freedom.[33]

Klee's definition of line in terms of "psychic improvisation" relates to the ideas Kandinsky expressed in *Concerning the Spiritual.* The formal means—for Klee primarily line, for Kandinsky both color and line—are vehicles of direct, spontaneous expression of inner processes, a kind of seismographic recording of the soul where references to outward reality are of secondary importance.

The linear element in painting was a problem that Klee grappled with over many years. Although Klee had admired van Gogh's synthetic approach to line and color, he did not adopt it for his own work. He also had experimented with Matissean contour lines. In paintings like *Girl with Jugs,* 1910. 120 (App. III-22) form-defining lines subdivide and organize the colored ground; color and line thus belong to the same pictorial plane and are interrelated. This approach to color and line continues to appear in Klee's later work.

Given the import of linear elements in "Analytical" Cubism where lines serve as structuring agents for the grid composition as well as marks for edges of the form segments, it is interesting that although Klee uses the Cubist segment and *passage* method in a number of 1913 drawings and prints,[34] he does not use it in the sense of Cubist 'analysis' and form fragmentation. As was pointed out earlier, Klee was essentially unsympathetic to the Cubist dissection of form. In general, where Klee operates with a Cubist line and hatching or *passage* method (1913 and later) he usually modifies it in a way that divests

the forms of any volumetric qualities and does not allow for the typical, almost tactile relief effect of French Cubism. Whereas with Matisse and Cubism color and line are highly interdependent, Klee on the whole emphasizes the autonomy of color and line as pictorial elements, and keeps them on separate visual planes. In this respect he was influenced by Kandinsky.[35]

In 1911 Kandinsky had gone beyond Matissean contour lines and had begun to completely disengage color and line in order to dematerialize the forms in his paintings. *Improvisation 19,* 1911 (Fig. 13) was cited as an example where the superimposition of lines over the ground caused the figures to become transparent and have no semblance of physical reality. From then on, line served two functions in Kandinsky's paintings: first the linear forms represent residual figural shapes which are increasingly simplified and abstracted to a degree where their figural character and meaning is evident only if considered within the context of his earlier paintings;[36] and secondly, the linear forms exist as expressive form elements and abstract signs in an essentially nonrepresentational sense. In both functions the lines are very often superimposed on the color ground and do not serve as outlines of a color area. Kandinsky in 1911-1913 was the most radical of contemporary artists in treating color and line as completely autonomous entities. Furthermore, he often used line in his paintings in an explicitly 'graphic' sense. Looking back on his own development in 1932, Kandinsky wrote about this question to his biographer Grohmann:

> A few years ago I mixed up the "world of drawing" and the "world of painting," that is, I obliterated what seemed to be a permanently fixed frontier—as I often did later, too. I brought line from its narrow designation as part of the "graphic arts" into "painting." For quite some time I was scolded for this.
>
> Discussing paintings, "where line as such appears autonomously and with the same rights as 'painterly elements,' " Kandinsky cites *Improvisation 8,* 1910 and *Winter 2,* 1911: "In these examples line is not yet autonomous but it is used as the *most abbreviated allusion to the object.* Later it became more and more emancipated—already in 1913 it has no more objective connotation, as for example in *Composition VII.* . . . Another question is related to this: in my eyes black and white are not just characteristic of 'graphic arts,' they can just as well produce a painting, like any combination of 'motley' colors."[37] [Emphasis mine]

Kandinsky's unorthodox views on the role of 'graphic' lines in painting and on black and white as colors are views which he also expressed, if less succinctly, in *Concerning the Spiritual.* His outlook must have been encouraging to Klee, all the more since the latter had always considered line the "spiritual," i.e., an inherently abstract form element in his art.

Klee begins to disintegrate color and line in some paintings of 1912. In an early work of the year, *View onto a Square,* 1912. 10 (App. III-42), a combination of gouache and pastel, color and line are still interdependent as in his earlier paintings.[38] The ground is a diffuse mixture of light blue and

yellow areas, and the houses are outlined by thin contours of the same blue as the ground. These contours are very subtle and barely emerge from the hazy ground. Thus, color and line are interrelated and belong to the same visual plane.

In other works by Klee the linear element becomes more prominent and is distinguished from the ground. In the watercolor, *Bathing Establishment,* 1912. 167 (App. III-42) brushed-in outlines are superimposed over color areas. Additional forms are freely brushed in with thin colored lines, as in the fence and the bush, a method which is similar to the trees in Kandinsky's *Winter 2,* 1911 (App. III-23). In his drawings of 1912, such as *Ice Skaters,* 1912. 159 (App. III-4) and the lithograph *St. George,* 1912 (Fig. 11), Klee operates more forcefully in superimposing transparent contour lines on a hazy ground, making his figures appear as transparent and immaterial as those in Kandinsky's *Improvisation 19,* 1911 (Fig. 13).[39] A similar effect is achieved by Klee in a full-fledged oil painting, *Cacti and Tomatoes,* 1912. 169 (App. III-42).[40] Klee defines the forms of fruit and plants primarily with white and colored lines. The pots and plants appear transparent and, as a result, they seem immaterial, like the figures in Kandinsky's *Improvisation 19.*

While Klee's paintings relate to Kandinsky's in regard to the emphasis on line and the transparency of forms, it should be noted that they differ from Kandinsky's contemporary work in regard to composition. Most of Kandinsky's 1911/12 paintings are neither composed into coherent vistas nor based on any consistent system of scale, whereas Klee's works remain organized in these ways. Compositionally, many of Klee's paintings relate to the 1908-1910 Murnau paintings by Kandinsky, Jawlensky, and Münter, which are characterized by high horizons, simplified forms, and large areas of color.[41]

The year 1913 is a crucial one in Klee's coming to terms with Cubism. It is also the year during which Klee is most open to influence from his Blaue Reiter friends, both for formal issues and for Expressionist subject matter. During this year Klee approaches the question of line in painting in various ways.

The Battlefield, 1913 .2 (Fig. 14), watercolor and pen, dates from early in the year.[42] It is a somber color vision of dark browns with some cool red and an area of intense ultramarine blue in the foreground. Laid over this ground, dark lines barely indicate a few houses and a group of figures which appear to be soldiers on horses. The forms are reduced to the barest essentials, the indistinctness of figures and scenery generates a sense of mystery. Space or time of day is not indicated. There is an ambiguous, visionary quality about the painting. These characteristics, along with the expressive use of dark colors contrasted with a few bright ones, make the little watercolor comparable to Kandinsky paintings such as a *Lake (Boatride),* 1910 (App. III-59).[43] Both the use of color and line as separate elements, and the blotchy color connect the

painting to some of Kandinsky's paintings behind glass, for example *Resurrection*, 1911 or *Rowing*, ca. 1912.[44]

During 1913 Klee developed two basic approaches to painting in which color and line remain separate entities. Both methods continue to appear in 1914 and are used again in his later work. In one group Klee superimposes brushlines over a diffusely colored ground; in the other group he places a web of thin, 'graphic' dark lines over the colored ground. Of the first group, the watercolor *Sun in the Courtyard*, 1913 .9 (Fig. 15) is the most important work for our purposes as it is particularly close to Kandinsky's work of 1911. Covered with radiant colors (blue, orange, yellow, purple) which flow into one another, the ground is divided into three triangular areas, the largest of which, the yellow-orange triangle, moves from left to right between the two blue zones. The colors seem to swirl around the white center, yet at the same time the eye is drawn to the radiant yellow mass at the left. The dark, densely painted blue area in the upper right weighs heavily on the airy yellow in the lower left. There is a great deal of visual tension and drama in the interaction of the colors of the ground. Laid over this ground with sketchy brushstrokes are the barely discernible outlines of houses and two vertical, but slanting, rows of windows and balconies. (They recall the swaying Eiffel Tower of Delaunay's paintings.) As all forms appear to be weightlessly floating in an undefined space, there is continual back and forth movement into depth. The composition with emphasis on diagonal divisions and slanting verticals, the brilliant colors, the undefined space, the floating forms and their odd concentration on the left side, all relate to Kandinsky's style, as represented by *Impression III (Concert)*, 1911 (Fig. 16). Like Kandinsky, Klee uses simplified, almost abstract, sketchily-drawn figural forms which stand *pars pro toto* for the entire complex of houses. In both paintings the forms appear weightless and immaterial as a result of the soft contours, the slanting axes, and the transparency of all forms.[45] What should be static, solid houses appear to float in space, just as the heavy black expanse of the grand piano in Kandinsky's *Concert* hovers beneath the upper edge of the picture.

In *Concert* Kandinsky recaptures his experience of a concert, with the audience enraptured in a room pervaded by music and warm light. Music, light, and festive atmosphere are all contained in the color 'sound' of the picture. Similarly, Klee recreates from memory the sudden burst of sun into a dark courtyard where the objects appear like apparitions to the bewildered eye. Both artists translate actual experience directly into color.[46] The brushed-in linear forms found in both works are the "most abbreviated allusion to the object" with a function different from and set in contrast to that of the colors. They provide the information needed for a figural reading of what are otherwise pure color visions. *Sun in the Courtyard* is unusual in Klee's *oeuvre* because the space is as deep and undefined as it is in most of Kandinsky's paintings.

In *Concerning the Spiritual,* Kandinsky defines the paintings which he calls "Impressions" as ". . . direct impression of 'outward nature' which finds its expression in a *graphic-painterly* form."[47] [Emphasis mine] Klee, who had not yet completely emancipated himself from naturalistic concepts, must have been particularly interested in Kandinsky's "Impressions" and other works of his transitional stage between nature and abstraction.

Klee continues to work with superimposed, transparent lines as form-defining elements, even when he begins to introduce Cubist elements into his art.[48]

The watercolors in which the Cubist influence begins to manifest itself differ from Kandinsky's work in that the brushwork is ordered into a coherent net of lines placed over the tinted ground. Whereas in Kandinsky's paintings there are numerous spatial levels receding into indefinite depth, Klee reduces the space to essentially two visual planes. In *Suburb Milbertshofen,* 1913. 44 (App. III-4), the ground consists of merging areas of different colors which roughly indicate the three spatial zones: foreground, houses, sky. The transparent linear structure of brushlines placed over this ground reminds one of Cubist grid organization, but color and line are not interdependent in a Cubist way.[49] Spatial relationships are indicated, but there is no sense of volume. Other examples of this method are *Health Resort,* 1913. 7; *Cemetery Building,* 1913, (both included in the March 1913 show); *Houses by the Gravel Pit,* 1913. 43 (B), a study after nature, closely related to *Suburb; Wicker Chair in the Garden,* 1913. 205; and *Villas for Sale,* 1914. 22.[50] In the last work the resemblance to the Cubist grid is close and it is underscored by the oval 'Cubist' format. Yet in all of these works the delineated forms are transparent and, as a result, they seem as immaterial as the figures in Kandinsky's *Improvisation 19,* 1911 (Fig. 13).

The basic formal approach of these works, the use of the colored ground as the general setting and of brushed-in linear forms as abbreviated indications of objects (in the sense of Kandinsky's "most abbreviated allusion to the object") as well as semiabstract or abstract signs, continues to play a role in Klee's work. Such brushed-in forms appear in some of the Tunis watercolors, as for example the *Tunisian Sketch,* 1914. 212 (App. III-1). In the 1914 painting, *Carpet of Memory,* 1914. 193 (App. III-18)[51] Klee places colored lines and colored shapes on the ground as autonomous elements (though implicitly part of a grid structure) in a way that relates to Kandinsky's method, as in such watercolors as *In the Circle,* ca. 1911-1913 (App. III-41).[52] Superimposed brushlines play an important role in a number of works of 1917, of which *Dynamic of a Lech River Landscape,* 1917 (App. III-22) is an example. In its expression of the 'inner sound' of the landscape in essentially abstract forms, this watercolor is particularly close to Kandinsky. The predominantly geometrical line rhythms, possibly inspired by Futurist 'force lines,' of this

work by Klee are even more abstract than the more biomorphic linear configurations in comparable landscape paintings by Kandinsky, such as *Untitled (Improvisation 28)* 1912/160b (App. III-47), where lines serve both as expression of dynamic forces and as figurative allusions. In numerous works of 1918, Klee again uses brushed-in lines for the "most abbreviated allusion to the object." *Landscape of the Past,* 1918 (App. III-42), recalls his *Sun in the Courtyard,* 1913 (Fig. 15) as well as Kandinsky's 'Impressions' and landscapes of 1910/11, such as *Winter II,* 1911 (App. III-23). *Landscape* is particularly comparable to Kandinsky's work because of the hazy depth of the pictorial space and the pastose, cloudy colors. In other works of this type the space is more defined and shallow; in some appear residual elements of the Cubist grid, but even in these works the linear element is employed in a manner which is conceptually related to Kandinsky's method.

In another group of 1913 watercolor paintings, Klee uses lines of an explicitly graphic character, executed with a pen or with very thin brushlines. *Cross-Roads,* 1913. 27 (Fig. 17), (exhibited in March, 1913), which was acquired in 1921 by Gabriele Münter, has a spotty ground of warm earth and foliage colors.[53] A structure of thin, nervous pen lines, concentrated along the upper edge of the painting, is laid over the ground. The web of triangles, which, rather abstractly, represent houses, is somewhat reminiscent of Cubist etchings; for example, Picasso's *Still-Life with Bottle,* 1911-1912 (App. III-19),[54] but there is considerably less spatial tension and volumetric effect in Klee's watercolor. Tiny cyclists and pedestrians provide the key for the interpretation of the picture as a street scene; without them the drawing would be highly abstract. Compositionally, the watercolor with its extremely high horizon and vast foreground relates to the Murnau landscapes painted by Blaue Reiter artists, such as Münter's *Autumn Landscape,* ca. 1912 (App. III-33).

In *Cross-Roads* Klee pointedly juxtaposes the soft, spotty color ground with superimposed thin black lines. This method frequently appears in his 1920s work, as in the oil transfer drawings and the 'Constructivist' works (late 20s), where the colored ground serves as a kind of stage for the figural theme that is presented in the drawing. In 1908 Klee had speculated about "situation" and "action" in his art:

> I shall paint human figures from nature in a deeper sense, dividing them into two time periods and treating each separately.
> 1. Situation (imperfect): the space, the environment; this stage must be allowed to dry too.
> 2. Action begins (perfect, *passé défini,* aorist): the figure itself. For: in nature too the environment was already complete when motion joined in, occurred.[55] [revised]

In 1908 Klee had sought to present these different stages in terms of separate layers of color. By ascribing the function of "situation" ("Zustand") and

atmospheric space to color, and of "action" to line, Klee's distinction between the two stages of creation becomes more self-evident: line not only denotes figural action, it also implies *visual* action as the eye has to move along the lines to read the entire image. By placing drawn lines prominently over the ground Klee underscores this temporal dimension which he considered so important, as it symbolizes the dynamic forces in nature and in the cosmos in general.

Kandinsky frequently uses thin black lines as autonomous elements in his watercolors, as, for example, in the designs for the cover of *The Blaue Reiter Almanac* and in his large watercolors, such as *In the Circle* (App. III-41). In his etchings of 1913-1914 he experiments with various types of hatchings and scraggly line bundles.[56] Kandinsky uses the method of Klee's small watercolor in two large oil paintings, which according to their *oeuvre* numbers were executed late in 1913: *Light Picture*, 1913/188 (App. III-47) and *Black Lines*, 1913/189 (Fig. 18). *Light Picture* has the character of a watercolor. The light ground is accented by a few spots of orange and blue with blurred edges. The thicker lines are colored, while the thin black lines appear as if they were drawn with an old-fashioned pen which scratches and spatters over the ground. In *Black Lines* the ground consists of brightly colored circular forms arranged in a concentric cluster. Black lines are 'drawn' over this ground in a variety of 'doodle-like' patterns—parallel line bundles, hatchings of all types, and circular line motions. In both paintings Kandinsky stresses the graphic quality of the lines.

The linear structure in Klee's *Cross-Roads* relates more to Cubist geometric forms and to the grid than to the way Kandinsky distributes the linear configurations over his canvas in *Black Lines*. Furthermore, both pictures differ considerably in medium, scale, and the degree of abstraction, but both artists explore and comparably resolve the same basic formal issue; that is, the use of color and (graphic) line in painting as separate entities and with different functions. By using color and line as separate entities the forms appear transparent, which results in an effect of immateriality. Since Kandinsky's two paintings date from the end of the year, it is not likely that Klee's watercolor was inspired by them. But the use of lines of an explicitly graphic character in watercolors and paintings preoccupied Kandinsky during much of 1913, and it is conceivable that this formal issue was also discussed in general in their circle.

Klee uses the same approach in a number of other watercolors in 1913, in which he sometimes organizes the motif in terms of Cubist segment shapes but without fragmenting the forms. Examples are *Villa for Sale*, 1913. 73 (App. III-46) and *Friendship of Two Girls*, 1913. 81 (App. III-7),[57] (exhibited in the *Herbstsalon* 1913).

That Klee understood the Cubist line and *passage* method and its volu-

metric implications is apparent from a watercolor of 1913 which represents a third type of color-line approach which he occasionally employed. *Emmenthal Landscape*, 1913. 95 (App. III-42), was probably executed during or shortly after his summer stay in Switzerland. The wide vista with a high horizon and the simple, near-symmetrical composition again recall Murnau landscapes, such as Jawlensky's *Summer Evening in Murnau*, 1908-1909 (App. III-20). Klee reinforces the color shapes with thin penlines so that they resemble Cubist semicircular segments, but he does not dissect the natural forms. With subtle use of color *passage* he generates an effect of volume. Due to this volumetric quality, the landscape appears more naturalistic than *Cross-Roads;* otherwise the two works are similar in terms of composition and color. The use of line-as-outline of a color shape and line in conjunction with *passage* continues to appear in Klee's later work; for example, *Arctic Thaw*, 1920,[58] although usually in a more abstract context than in this landscape of 1913.

Two abstract watercolors of 1914 by Klee, *1. Moses 1. 14*, 1914 (App. III-42), and *Composition (Untitled)*, 1914. 18 (Fig. 19) may be seen as responses to the two Kandinsky paintings of 1913.[59] In both works the Cubist influence is reflected in the organization of the ground into a color grid, as well as in the predominantly geometrical character of the linear construction. In *Composition* the linear forms, including the minute volute shapes, distinctly recall Cubist paintings, such as Braque's *Man with a Violin*, 1911 (App. III-19),[52] but as in Kandinsky's *Black Lines* (Fig. 18), the lines are placed over the colored ground, and color and line do not interact the way they do in Cubist works. In Braque's painting, the linear forms interact with the colors by means of *passage*, and they generate the characteristic Cubist relief effect which implies volume, although the object forms as a whole are broken up. Notwithstanding the considerable degree of abstraction, a sense of the physical reality of the model is still communicated by the plasticity of the individual form segments. This type of modeling is absent in Klee's painting. There is space in the Klee, but it recedes *behind* the picture plane. Absent in the Klee is also the almost tangible relief that in Cubist paintings seems to project from the picture surface. In Klee's *Composition* the color plane and the linear configuration are independent of each other and both appear immaterial. Another difference between Klee and the Cubist work is the approach to abstraction. Despite its initial abstract appearance, there are enough figurative 'clues' in Braque's *Man* to enable the viewer to assemble a general image of the model and his instrument, his position within the picture, his size, and even the lighting which appears to come from outside of the picture, whereas with Klee it comes from within. The formal evidence suggests that Braque abstracted from the object he was depicting. Klee reverses the process beginning with the colored ground and he initially proceeds without specific representational intentions. The form elements can have associational qualities, but these are often introduced

at a late stage in the work process. In *1. Moses* and *Composition* Klee is on the same level of abstraction as Kandinsky in his two paintings. *Composition* cannot be interpreted in any specific way—there are no clues for the scale and dimension of the shapes, only the circular form with a light halo in the upper left can be interpreted as a natural light source.[60] The circles, crosses, and volute forms scattered throughout the linear construction invite speculation as to their meaning, but they are like hieroglyphic fragments that can no longer be deciphered. In Kandinsky's *Black Lines* the biomorphic quality of his color spots and of some of the linear forms (for example the three mountain-like triangles in the upper left) invites similar speculation. In these ways, Klee adapts formal aspects of Cubism to a pictorial conception that is indebted to Kandinsky. For Kandinsky a picture is a microcosmic world in itself. It is related in mysterious ways to the entire cosmos. Sharing this view, Klee in *1. Moses* makes this microcosmic dimension quite explicit and literal by way of the title he chooses, which refers to the creation of sun and moon, day and night. Although it is carefully composed, the emphasis on motion and improvisation in Kandinsky's *Black Lines* evokes primeval chaos, whereas Klee uses the Cubist grid system to generate a sense of equilibrium between the dynamic forces of creation. This formal clarity and balance expresses *his* view of the cosmic order.

Kandinsky's approach to linear expression had encouraged Klee to focus again on "psychic improvisation" in his drawings. In Klee's experiments with painting, Kandinsky's use of line as an autonomous pictorial element was of interest to him in several respects: figural forms could be presented in an a-naturalist, abstracted way by reducing them to simple outlines placed transparently over the color ground. Forms appear immaterial, figural motifs are reduced to "the most abbreviated allusion to the object" as they have crystallized in his memory. The reduction of forms prepared the way for Klee's development of a personal sign language which he uses in conjunction with purely nonrepresentational shapes and lines. In this way Klee could express the 'inner sound' of objects in Kandinsky's sense; it provided him with a viable alternative to the Cubist 'dematerialization' of form by way of fragmentation. By adopting Kandinsky's concept of dematerialization and abstraction (see also Chapter 4, on theory), Klee significantly shifted further away from the esthetic of French art and its affirmative attitude *vis-à-vis* reality. By 1914 Klee often begins a work without a specific subject in mind. Representational associations are introduced during the work process or only suggested after completion of the work by the addition of an evocative title. In numerous works of 1914/15 only the poetic titles enable the viewer to read 'content' into the essentially abstract works. The fact that Klee no longer feels the need to reaffirm a relationship to outward, visible reality in his art is reflected in his imaginative titles which often touch on metaphysical dimensions or are purely conceptual, exemplified by *1. Moses*.

In Klee's intuitive work process, linear forms could be introduced at any stage, as part of the surface structure or superimposed on the ground, as nonrepresentational expressive elements, as semiabstract signs, or as figural contours with a specific meaning.[61]

In contrast to the Cubists, Kandinsky uses lines in his paintings in many different ways—as broad brushlines or as thin 'graphic' lines, in bundles of parallel lines or in circular clusters, in many types of hatchings and infinite combinations of curved and straight, broken and continual, parallel and overlapping lines. Many of these means can also be found in Klee's works, in addition to geometric Cubist linear forms. In the 1920s Kandinsky and Klee will resume this experimentation with linear configurations in painting, mutually inspiring each other and often arriving at similar results.

Expressive Form Motifs and Abstraction in Klee's Drawings and Prints, 1913-1915

A number of Klee's form motifs as well as his essays in abstract expression can be related to Kandinsky's work.

In his drawings and prints of 1913-1915 Klee uses two main types of figures. *The Fleeing Policemen*, 1913. 55 (App. III-17), exemplifies one type, in which Klee uses transparent geometrical forms derived from Cubism for his figures, emphasizing the construction of the body. In later drawings, of 1914 and 1915, Klee further reduces these geometric forms to the point where the puppet-like but still individualistic figures of 1913 are transformed into schematic beings. Drawings like *Inhibited Striving*, 1914. 122 (App. III-17), or *Collapse*, 1915. 67 (App. III-17), are simple visual formulas for human actions and emotional experiences. Basic geometrical shapes, functioning on two levels of meaning, symbolize both the physical and the metaphysical forces to which the figures are subjected. Again, Klee uses the Cubist shapes in an essentially un-Cubist way. He divests his figures of any physical reality and individuality by making them transparent, weightless and puppet-like. Reduced to the barest essentials, these figures take on a symbolic function and become paradigms for human situations.

In another group of works of 1913 and 1914, Klee uses a soft-contour, 'boneless' type of figure that is very similar to the amorphous figure type in Kandinsky's works of 1910/11, as for example in *Study for Composition II*, 1910 (App. III-47). Klee employs this type of figure primarily in works with expressive themes. The most prominent example of this group is the etching, *Garden of Passion*, 1913. 155 (App. III-32). Jordan has already pointed to its relationship to Kandinsky, especially to the two woodcuts of *Composition II* motifs which Klee could study in *Klänge* (App. III-53). Jordan notes

that the influence from *Composition II* is reflected in the composition in horizontal layers, in the undefined space and the unspecific character of the landscape and of the figures, apparently cosmic beings, as well as in the Cézannesque use of *passage* which relates more to the *NKV* artists than to Cubism. The figures—Jordan interprets those on the right as angels—merge with the landscape in the kind of "cosmic animism" which is typical of Kandinsky's paintings with religious subject matter. Although the title provides no clue for any specific theme, Jordan convincingly suggests that this etching relates to the religious themes of the Bible illustration project. He suggests that the etching represents a "redemptive cycle," from the fall in the Garden of Eden to Christ in the Garden of Gethsemane which culminates in the resurrection of a shrouded Kandinskyesque figure in the lower center (p. 263). Regarding the form character of the etching Jordan concludes:

> In these works, Blue Rider biomorphism, present in the abstractly equivalent plant, animal, and inanimate shapes, somewhat dominates the Cubist facet.[62]

He places *Garden* and the works around it in the earlier part of 1913. They belong in his second group, a transitional phase in Klee's coming to terms with Cubism.[63]

Within the context of this study it is necessary to discuss *Garden* further in regard to Klee's approach to his themes. Earlier it was pointed out that in his 1912 drawings and prints Klee had sought concise formal expression for emotions, as in *Contrition* (App. III-32) and *Loneliness* (App. III-17). In 1913 Klee moved on to more complex and ambitious themes and he also began to deal with these in terms of semiabstract forms. He seemed to follow the path that Kandinsky had mapped out for the individual artist and for art in general. Kandinsky had postulated that the basic principle for the new, "spiritual" art is "the constructive element". "Construction" in his sense is the creation of a pictorial organism according to its own inherent laws based on the criterion of "inner necessity."[64] Although the term itself may be derived from Cubist theory, it has little to do with Cubist geometrical constructions. For Kandinsky it means the predominance within a work of art, of linear and painterly forms *per se* over natural references, with the ultimate goal of pure, abstract pictorial forms. In an essay, "Painting as Pure Art" ("Malerei als reine Kunst"), published in the September 1913 issue of *Der Sturm*, Kandinsky proclaims:

> Nowadays there is a conscious or maybe still unconscious tendency which manifests itself strongly and is ever increasing, to replace the objective by the constructive; this is the first step of the emerging pure art. . .[65]

"Construction" necessitates the departure from concepts of naturalist painting, but representational forms can exist if they are compressed into sign-like images that express the "inner sound" of the object. In *Concerning the Spiritual* Kandinsky extensively discusses these abstracted natural (he calls them "organic") forms and their role in art.

> The coming treatment and change of the organic form aims at uncovering the *inner* sound. The organic form here no longer serves as direct object but is only an element of the divine language which needs human expression because it is directed from man to man.[66] [revised]

He suggests two basic possibilities for dealing with organic forms, "stripping bare" and "hiding" or "veiling." The first concept means the reduction of form and its simplification in the sense of the "most abbreviated allusion to the object;" the other involves making forms indistinct, concealing them in unusual places in the picture, etc. Each of these approaches to form can be combined with the other as well as with purely abstract forms.[67] Klee's 1912 drawings are essays in "stripping bare," concentrating on the "inner sound." The same is true for many works of 1913 and the following years, but he also experiments with the more complicated combinations of forms, in Kandinsky's sense, and ultimately with abstract forms. In *Garden* the rounded and pointed shapes are ambivalent in their meaning—they can represent stones, plants or plant segments, hills or clouds. Consequently it is impossible to get a clear idea of the landscape, its dimensions and scale. Although the forms are biomorphic in shape, most of them are nonetheless abstract, and only a few, such as the twisted leaf in the lower left or the sun (or moon) in the upper left, and the tower in the upper center, provide clues for a landscape reading of the scene. The method is very similar to Kandinsky's in works like *Sketch for Composition II*, (App. III-47), where figures are embedded in the maze of biomorphic shapes and are drawn in the same fashion. With Kandinsky and Klee, figures and natural forms are not set off from each other; the result is the "animistic" unity that Jordan noted. In *Garden* a number of figural motifs emerge only after close scrutiny of the print, as in the case of two figures flanking the figure with raised arms at the upper edge of the print. They are "hidden images," to borrow the term that Washton has coined for Kandinsky's increasingly abstracted motifs.[68] The figures are generalized to the point where they can be interpreted as either human or cosmic beings; their specific meaning remains tantalizingly enigmatic. The title is allusive, but does not provide the key to any specific interpretation, even if it is possible to make conjectures from the context of the entire group of works, as Jordan has attempted.[69] Some of the shapes in this print recall Cubist facets, but they are not fragments of forms. Rather, each shape represents a "most abbreviated allusion to the object" in Kandinsky's sense, and some are abstract. In Cubist paintings, for instance

Picasso's *Poet,* 1912 (App. III-63) which was included in the February 1913 show at Thannhauser's, the references to reality offer clues not only for the specific subject matter but also for the scale and proportions of all the form elements in the picture. In Klee's print, on the other hand, the recognizable forms only increase the ambivalence and uncertainty. For example, what at first sight appears in the center of the print to be a leaf shape must be interpreted as a tree or large bush if seen in relation to the scale of the figures on either side of it. Kandinsky operates with the same ambivalence of scale in his paintings as in the figure and towers in the background of *Study for Composition II* (App. III-47). Klee's print and Kandinsky's semiabstract paintings (other comparable examples are *Improvisation 19a,* 1911 and *Improvisation 21a,* 1911[70]) are related in general by a sense of mystification which they evoke in the (uninitiated) viewer due to the ambivalence of scale and setting, the enigmatic quality of the figures, the pathos of the figures' gestures, and the elusive, yet allusive titles.

Garden is particularly close to Kandinsky's artistic conception, since this print is devoid of the ironic, playful dimension which in most other works distinguishes Klee's approach from the visionary pathos of Kandinsky.

Irony, however, does seem to be present in another work which, as Jordan has suggested, might chronologically be placed at the beginning of this group. In the drawing *The Spirit on the Heights,* 1913. 151 (App. III-17), jagged, triangular shapes are juxtaposed with the circular form at the lower right. The "spirit" stands above, his wing-like arms spread wide in a Zarathustrian gesture of grand pathos. Yet there is also something peculiar about this "spirit," in its visage and the birdlike wings. In German the word "Geist" means "spirit" or "intellect" as well as "ghost" and I, for one, am not certain which one of the word's meanings Klee is alluding to. The drawings might belong into the group of Psalms illustrations, perhaps representing the Lord reigning over the cosmos (cf. the German version of Psalm 139: "Gott ist Geist" or the Psalms 89 and 135), but, at least from today's vantage point, it might just as well be a subtle persiflage of Kandinsky's (and Klee's own) cosmic beings.

In later works of this stylistic group Klee moves in a more abstract direction. Perhaps he realized that the pathos of these figures was somewhat problematic. The drawing, *Song of Lamentation,* 1913. 163 (Fig. 20), stands stylistically between the dense forms of *Garden* and the loosely structured *Sketch for the 137th Psalm,* 1913. 156 (App. III-42).[71] In this drawing Klee operates with abstract forms in much the same way as Kandinsky does in works of around 1912. The *passage* effects and some of the forms recall Cubism, but Klee uses these forms as expressive elements *per se* in a way that conceptually relates to Kandinsky; for example, to the woodcuts from *Klänge* (App. III-53, no. 105; III-53, no. 124). *Song of Lamentation* is distinguished

from the more straightforward Cubist uniformity of shapes in *Spirit* and *Sketch* by its wealth of different shapes and types of hatching. Some of the rounded shapes have a biomorphic quality and can be associated with landscape elements like mountains or plants. The row of *M* shapes reminds one of the tombstones in Kandinsky's *Improvisation 18 (with Tombstones),* 1911 (App. III-20). Possibly the volute shape in the center alludes to the shofar, the ancient ceremonial instrument made from a ram's horn. But in comparison with *Garden* the individual forms are less biomorphic and interpretable, and the composition as a whole can be read neither as a coherent scene nor as a landscape. In *Song* the spatial relationships are completely ambivalent: some forms seem to recede into depth while others, like the volute form, seem to come forward. Certain forms, such as the row of *M* shapes, are set against the white ground, whereas elsewhere, as in the volute form or the large rounded shapes to the right, the white ground becomes part of the form which is set off from the dark surroundings. Kandinsky uses the white ground for similarly ambivalent effects of figure-ground reversal in semiabstract paintings like *Untitled (Improvisation 28),* 1912/160b (App. III-47). While in Klee's drawing the forms are more densely interwoven than in Kandinsky's painting (in this respect *Song* reflects Cubist influence), the way in which forms are combined or juxtaposed is comparable to Kandinsky's method. As in the work by Kandinsky, there are many individual form clusters but no central compositional focus (or the Cubist empty edge), directions change abruptly, and small and large forms are placed side by side. In the chapter entitled "The Language of Forms and Color" of *Concerning the Spiritual* Kandinsky describes the use of linear forms in a way that is characteristic of Klee's drawing as well:

> The flexibility of each form, its internal, organic variation, its direction (motion) in the picture, the relative weight of plastic or abstract forms and their combinations, which create the large shapes of the groups of forms, the combination of the individual forms with the form groups which create the overall formal appearance of the picture; further, the principles of concord or discord of the various elements of a pictorial structure, that is the clashing of the individual forms, the restraining of one form by the other as well as the projection, the pulling along as well as the pulling apart of each form, the equal handling of the groups of forms, the combination of the hidden and the stripped bare, of the rhythmical or unrhythmical on the same plane, of abstract forms as purely geometrical or simple or complicated nongeometrical forms, their (stronger or weaker) contiguity or separation, etc.—all these things are the elements of structure in drawing and they constitute and lead towards the "counterpoint" in drawing.[72] [revised]

In Klee's drawing the overall composition is organized into three diagonally divided areas of about equal extension. The left section is the most densely packed with forms, and contains the darkest hatchings. In the middle section the forms are larger and less angular. The rhythmic row of *M* shapes

and the three line bundles converging in the center as well as the volute shape provide visual accents. As in Kandinsky's painting, the composition appears to continue beyond the edges of the drawing.[73] The tripartite composition of the drawing—perhaps an evocation of the versicles of a Psalm—becomes apparent only after close study. Because of its complex structure, spatial ambivalence, and the multitude of competing forms, the drawing gives a general impression of agitation and turmoil which is also characteristic of Kandinsky's semiabstract and abstract work. It is possible that Klee settled on the title of the drawing only after its completion; the title is not prerequisite for the appreciation of its expressive quality but supplements it.

In *Sketch* (App. III-42) Klee abandons the densely packed, contorted forms in favor of a looser arrangement. The sorrow of the captive Jews is evoked with rounded, heavily drooping forms. The shapes generated by outlines and *passage*-type hatchings are derived from Cubism, but they are less plastic and less uniformly drawn than Cubist segmented shapes. By using widely spaced and mostly straight parallel lines for the hatchings, Klee counteracts the quality of volume associated with Cubist hatchings. In comparing *Sketch* to Braque's 1911-1912 drypoint *Fox* (App. III-19) one finds similarity in terms of the shallow space but not in respect to plastic qualities. Klee subtly varies his shapes so that they take on a vaguely biomorphic quality. Most importantly, Klee uses the Cubist facet forms as abstractly expressive elements.[74] The plight of the Jews is expressed by the concentration of forms which loom large around the small figure in the upper left who pleads to the Lord with raised arms (a kind of "hidden" figural form). The comparison with *Spirit on the Heights* demonstrates the breadth of expression that Klee attains with variations of the same form motif, the more or less Cubist facet. Such variations on a basic form motif with entirely different expressive results recur throughout Klee's *oeuvre*.

During 1913 the question of abstraction must have been much debated in the Blaue Reiter circle. In *Concerning the Spiritual* Kandinsky had raised the possibility that some day the artist could express himself without referring to specific objects. In *"Reminiscences,"* which Kandinsky wrote in the spring of 1913, he implies that he has himself attained this goal at last. Although figurative associations are not yet completely ruled out by Kandinsky (see, for example, his 1913 paintings, *Sea Battle* and *Small Pleasures*) some works, like *Composition VII*, 1913, are essentially abstract, even if some of the amorphous color forms and lines can be interpreted as utmost abstractions from figural motifs. Late in 1913 Marc, too, ventured into abstract expression in his paintings, culminating in his series of *Forms* paintings of 1914.[75] Like Klee, Marc tries to reconcile the influence from Kandinsky with formal aspects of Cubism and Futurism. Thus in this group of drawings and prints Klee responds to the issues that Kandinsky and Marc were dealing with

in their works, issues which may have also been discussed on a theoretical level in their circle. From *Garden* which relates to Kandinsky's stage of development in 1910/11, Klee moves to the type of abstract expression represented by *Song of Lamentation* that corresponds to the level of abstraction attained by Kandinsky in 1912/13. Klee's oil paintings of 1913 were already mentioned. Here, too, Klee experiments with abstraction, but on a less Expressionist level.

The Expressionist quality of *Song of Lamentation* becomes fully apparent in comparison to the drawing *Shifting toward the Right*, 1913. 158 (App. III-17), probably of late 1913.[76] In this drawing Klee adopts the Cubist grid structure and uses hatchings as form elements in the Cubist sense. Here the hatchings produce a subtle spatial and voluminous effect that is similar to Cubist works, such as Braque's drypoint *Fox*, 1911-1912, (App. III-19) but this effect is counteracted by the wide spacing of the individual shapes. Compared to the compact form clusters in Braque's print, the linear structure in Klee's drawing appears as immaterial as a spider's web inflated by the wind. Whereas in the works discussed earlier Klee had manipulated the Cubist facet shapes to evoke biomorphic associations, in this drawing they are simply geometric shapes. However, Klee uses the Cubist forms in an abstract manner that relates to Kandinsky; this abstractly expressive dimension is implied in the alternative title by which the drawing is also known: *Flight to the Right (abstract).*[77]

In another group of drawings, which probably also date from late 1913, Klee uses the Cubist grid as compositional structure and as expressive means. In *Torments*, 1913. 187 (App. III-17) Klee uses the type of line bundles that were first discussed in *Violent Death*, 1912 (Fig. 12). With these lines he constructs a tree-like structure with human figures and faces squeezed into spaces between the line bundles. The jagged lines and harsh light-dark contrasts produce an effect of anguish and torment, similar to Kandinsky's *Klänge* woodcuts (App. III-53 no. 105; III-53 no. 124). Other works of this group are *Three Vignettes*, 1913. 184, and *Fabulous Island*, 1913. 189 (App. III-17). Here, Klee appropriates Cubist compositional structures for expressive ends. *Island*, with its combination of enigmatic figural motifs, semiabstract forms, and nonrepresentational black expressive shapes and lines, recalls works from Kandinsky's semiabstract phase, such as *Untitled (Improvisation 28)*, 1912/160b (App. III-47).

In 1914 Klee concentrates his energy on paintings, and his drawings are no longer the testing ground for his formal advances. In many drawings of that year he combines abstract and figural elements, often intertwining the two in a complex linear structure that is organized around slanting vertical or horizontal axes as in Cubist grid paintings. (See, for example, *Pastorale*, 1914. 79 (App. III-17). Rounded organic forms and geometrical shapes appear in

these drawings and often they are combined. The amorphous figure type of the 1913 *Garden* group appears in various forms, especially in drawings which relate to the war.

The outbreak of the war put an end to the activities of the Blaue Reiter circle and most of its members had to leave Munich. Klee felt isolated and somewhat estranged from his friends. When he met Kandinsky in Rorschach in September of 1914 Klee was struck by the anti-German attitude of Kandinsky, as he reports in a letter to Marc.[78] Although his friendship with Marc grew closer during the war years, Klee was very uncomfortable with Marc's acceptance of the war and of his role as a soldier.[79] Klee shared neither the general patriotic enthusiasm at the beginning of the war nor Marc's mystical belief that the war would be a spiritual cleansing for Europe.

Although Klee inwardly felt unaffected by the war (cf. his diary statement: "I have long had this war inside me. This is why inwardly it does not concern me."[80] [revised]) its outer manifestations disquieted him nonetheless:

> What the war meant to me was at first something largely physical: that blood flowed nearby. That one's own body could be in danger without which there is no soul! The reservists in Munich, singing foolishly. The wreathed victims. The first sleeve turned up at the elbow, the safety pin on it. The one long leg, clad in Bavarian blue, taking huge strides between two crutches. (1915)[81]

Because Klee's sense of national identity was as much Swiss as it was German, the prospect of being drafted weighed heavily on him. His pessimism and disgust is reflected in a few small drawings with war-related themes. In contrast to other works with war themes in which he uses Cubist forms, these drawings which express his private feelings show him again taking recourse in the biomorphic shapes and expressive line bundles of the 1913 works discussed earlier. The amorphous, soft-contour figures from *Garden of Passion*, which appear also as boisterous ghosts in *Moved Spirits*, 1914. 158,[82] turn into crippled, barely humanoid beings in *Death on the Battlefield*, 1914. 172 (App. III-42). Black triangles symbolize the deadly forces. The black line bundles and circular forms allude perhaps to cannons and cannon balls or are meant as general expressions of destruction. The bristly hatchings make the figures seem repulsive and aggressive. In *War in the Heights*, 1914. 173 (App. III-17), these forms have become even more amorphous; abstract, unspecifiable forces are battling each other. In *Premonitions of Grim Fates*, 1914. 178 (App. III-17), the vaguely figure-like shapes and the residues of landscape elements (in the upper drawing) recall Kandinsky's forms. On a very small scale Klee attains with a few lines a monumental pathos equal to that of Kandinsky's large painting *Improvisation 19*, 1911 (Fig. 13).

Another small drawing of 1914, *War, Which Destroys the Land*, 1914. 166 (Fig. 21), relies solely on linear scribbles and thick black lines (suggestive of

cannons) to express doom and destruction. The thin spiral at the left, a kind of organic ornament, appears to be a fragile residue of the land's vegetation before the war began its destructive reign. In these drawings, which have a pronounced 'doodle' quality, Klee once more responds to the type of expressive lines and biomorphic forms typical of Kandinsky's 1910-1912 work. These drawings are "psychic improvisations" or, as Klee puts it in early 1914: "Graphic work as the expressive movement of the hand holding the recording pencil—which is essentially how I practice it. . ."[83]

In other works with war-related themes Klee stresses formal order, generated by geometric forms and the Cubist grid organization. Such works lack the elemental force of expression that is evident in the drawings discussed above. An example is the watercolor, *abstract-kriegerisch,* 1914. 219 (App. III-9), which belongs in the group of works around *Carpet of Memory.* The vivid linear pattern collapses in the center around the circular shape. This 'destruction' of the formal order may have inspired Klee to introduce an allusion to war in his title, but the expressive quality is comparatively restrained.

In the fall of 1914 Klee was invited to provide a drawing (pen lithograph) to accompany a "fairly abstract" (Klee) poem by Theodor Däubler in the periodical *Zeitecho.* At first consideration Klee's drawing *Battlefield,* 1914 looks like an abstract arrangement of Cubist facet forms.[84] However, the relationship to Cubist works, such as Picasso's and Braque's 1911/12 etchings (App. III-19), is superficial. In Klee's lithograph the planar hatchings frequently cut over the edges of the linear forms so that no effect of volume or of spatial relationships between the shapes is produced. Rather, lines and hatchings create spatial effects independently of one another at a few points in the drawing. As a result of this separation of lines and hatchings the individual forms are more immaterial and ambivalent than in the Cubist etchings. On closer scrutiny "hidden images" emerge: star shapes, a sun or moon at the upper edge, landscape elements, and at the right there seem to be large leaf shapes (or flames). But no clues as to scale or dimension of the scenery are provided. Assisted by the title, the viewer may interpret these evocative forms, together with the flickering pattern of the hatchings and lines as either a battlefield or, more generally, a cosmic *Weltenlandschaft* of sorts. *Battlefield* relates to the 1913 etching, *Garden of Passion* (App. III-32) in respect to the ambivalence of forms and its metaphysical dimension, but *Battlefield* is devoid of the overt pathos of *Garden.* In *Battlefield* the expressive dimension is elegantly concealed in the airy, transparent, yet very nervously drawn web of lines. Klee himself joked about the French character of form in the drawing when he described its rejection by the publishers to Marc:

After 5000 copies had already been printed the publishers became afraid, probably they feared that the harmless thing would be considered highly treacherous French art which the subscribers would have to object to.[85]

The drawing, *Jerusalem My Highest Joy,* 1914. 161 (App. III-18), is representative of Klee's post-Tunis style in which he attains a personal synthesis of Cubist and Expressionist influences. Because it again takes up the theme of the Psalm illustrations, it is particularly well suited to demonstrate the changes in Klee's drawing style and in his approach to expression. Lankheit has suggested that the drawing also refers to the 137th Psalm.[86] While the 1913 *Sketch for the 137th Psalm* (App. III-42) had expressed the plaint of the captive Jews, *Jerusalem* offers the image of their lost city. A precariously balanced structure of cubes and stairs conjures up the vision of an ancient, narrowly built-up and crowded oriental city. Volumes are implied, but, again, they do not appear material, as all forms are transparent. The distribution of the cubes on the left and right recreates the balancing of building blocks in visual terms, at the same time the cubes represent whole architectural complexes. The pattern on the dome stands, *pars pro toto,* for the rich decoration of oriental buildings. The star and cross shapes on the right side of the drawing can be read as decorative ornaments or as window and balcony railings, but they may also point to sacral meanings, especially the cross placed so conspicuously in the upper center.[87] Such stars and crosses can be found in many of Klee's works as, for example, in the stylistically related *Carpet of Memory,* 1914.193 (App. III-18), and their possible meaning varies with the pictorial context. Such forms are neither specific fragments of reality (as in Cubism) nor symbols having a fixed meaning, but rather they are semiabstract signs which can either have a purely formal function or allude to a variety of possible meanings. Klee's use of such hieroglyphic motifs can be compared to the recurrent motifs in Kandinsky's semiabstract period, where abstracted figural motifs (as, for example, the horse and rider or the arc form) and abstract shapes and lines symbolic of unspecified cosmic forces recur in different paintings. Whereas Kandinsky's motifs become increasingly more obscure and harder to decipher, Klee gradually develops very poignant signs and metaphors for the expression of emotions, physical actions, as well as transcendental forces, such as the eye, the arrow and other geometrical forms, or the star and moon signs, as symbols for cosmic forces.

Klee defines his approach in 1916, when, in differentiating between himself and Marc, he writes:

I place myself at a more remote starting point of creation, where I assume, *a priori formulas* for men, beasts, plants, stones and the elements, and for all the whirling forces.[88] [revised, emphasis mine]

This passage points to a basic difference between Kandinsky and Klee. For Kandinsky, the semiabstract signs and abbreviated figural motifs are needed during the transitional stage of art, until the artist can do without them and transmit his message with purely abstract color and form 'sounds.' Kandinsky wanted to get away from references to nature and reality. Klee, on the other hand wants to retain specific signs, for they enable him to present his concept of nature and reality in terms of 'formulas'; that is, in more highly abstracted and generalized forms than either naturalistic depiction or symbolic motifs would allow for. It must be emphasized that the years from 1913 to 1915 contain a good many works by Klee which remain essentially abstract in Kandinsky's sense [as, for example, *Song of Lamentation*, 1913. (Fig. 20)], but on the whole Klee seeks to make his abstractions interpretable by including some figurative clues or by adding an allusive title.

In 1915 Klee's drawings fluctuate between formalist restraint and an Expressionist forcefulness, exemplified by some drawings which deal with war or doom and destruction in general.

In drawings, such as *Naval Station*, 1915.10,[89] and *Crystallinic Memory of Destruction by the Navy*, 1915. 11 (App. III-42), the martial themes are subdued by the playful irony and the formal elegance of the geometric forms. In *Mist Covering the Perishing World*, 1915. 15 (App. III-17), the same kind of geometric forms are partially obscured by the dark patches of 'mist.' Reinforced by the elegiac title, these dark-light contrasts again introduce a more expressive quality. In *Dispatches from the Ship*, 1915. 209 (App. III-27) Klee uses broad bundles of black lines over a sketchily drawn ship. The effect of these lines is threatening and aggressive. Once more, Klee here returns to the quality of spontaneous abstract expression that had prevailed in the 1913 drawings, such as *War, Which Destroys the Land* (Fig. 21).

In the small lithograph, *Death for the Idea*, 1915.1 (App. II-32), Klee combines the two approaches to form and expression that were discussed. Most of the sheet is occupied by a rectangular architectural structure composed of variations on the Cubist facet motif, but without *passage* hatchings. It looks like an imposing city with an abundance of towers and domes, windows and stairs, but its spatial organization and extension is not clarified. Because all forms are transparent, the structure seems to be simultaneously spatial and planar, confusingly complex and yet clearly presented; it is 'crystallinic,' to use a term so popular in Klee's day. It is Cubist in respect to the quality of formal order and the type of linear shapes employed, but not as regards the space or the image of the city as a whole.

A corpse lies in front of the city gate and the surrounding forest. In visual terms, however, the figure seems to be buried *underneath* the city. In drawing this figure, murdered or killed for a cause, Klee resorts to the sketchy, soft-contour style of his 1912 drawings. Death is symbolized by scribbles canceling

out most of the figure. The scene recalls the 1912 lithograph *St. George*. In visual terms the Expressionist death scene is contrasted to the pristine order of the architectural structure which may symbolize the 'idea' and its overbearing impact.[90] In this visual confrontation of Cubistic and Expressionist form, Klee once more articulates the dualism between "architectonic and poetic" painting.[91]

In sum, in those works by Klee which relate stylistically to Kandinsky's formal approach the spontaneous, intuitive work process and the expressive qualities are self-evident in their formal appearance. Klee uses the same creative method for the works which are based on a more Cubist vocabulary of form, but by the very nature of the geometric forms and the grid order these works project a sense of order and emotional detachment that sets them off from the first group. After experimenting with the pathos and drama of Kandinsky's Expressionist form vocabulary, Klee turns to Cubist composition and geometric forms, means which enable him to introduce an ironic distance and playfulness into his work. In his mature style Klee synthesizes formal and esthetic aspects of both Cubism and Expressionism. From Cubism Klee derives the architectural, classical quality of order and balance that counterbalances his complex, poetic Expressionist content and artistic *Weltanschauung*.

Klee's Themes and Subject Matter, 1912-1916

Whereas in the preceding section the abstract qualities of Klee's formal elements were emphasized, we shall now turn to an analysis of the figurative content of Klee's work during the Blaue Reiter years. It is as the result of his reduction of figural forms to 'formula'-like signs and of his use of abstract and semiabstract forms that Klee can return to 'poetic' content and can deal with complex subject matter—taken from reality as well as reaching into transcendental and speculative dimensions—on a anti-realist level. Now operating with different formal means, Klee takes up again the kind of social, psychological, and metaphysical themes that he had dealt with in his early works (especially in the etchings) in what had been an essentially realistic, if stylized and distorted, mode of representation.

Klee's subject matter and iconography are the most complex among the Blaue Reiter artists and an extensive discussion would require a study in itself.[92] To outline the scope of his subject matter I have singled out major thematic groups which represent new departures in Klee's work after the years of naturalist studies but at the same time hearken back to his Symbolist beginnings, or relate to the Expressionist themes of the other Blaue Reiter artists.

The Blaue Reiter circle provided a congenial and stimulating environ-

ment for Klee's renewed attempt to tackle "poetic" painting. Among the artists of this circle the views on subject matter were quite heterogeneous, but for all of them art had a quasi-religious, metaphysical dimension. Marc and Kandinsky in particular bestowed a priest-like function on the artist; therefore the message conveyed by the pictorial themes was not without importance.

Macke, who was the most French-oriented artist of the circle, considered simple objects and everyday scenes as visible manifestations of the invisible, divine spirit. He formulated his ideas in his very poetic essay, "Masks," in *The Blaue Reiter Almanac*:

> Form is a mystery to us for it is the expression of mysterious powers. Only through it do we sense the secret powers, the "invisible" God. The senses are our bridge between the incomprehensible and the comprehensible.[93]

While Macke sees the divine revealed in all of nature's outer, sensuous manifestations, Marc wants to cull from nature symbolic, ideational images to express his mystical, pantheistic experience of the world. In his essay, "The 'Savages' of Germany" in *The Blaue Reiter Almanac* Marc postulates the return to a new mysticism: "Mysticism was awakened in their souls and with it primeval elements of art."[94] He distinguishes between the goals of the Cubists and of the German Expressionists:

> Their thinking [i.e., that of the German artists] has a different aim: to create *symbols* for their own time out of their work, symbols that belong on the altars of a future spiritual religion, symbols behind which the technical producer cannot be seen.[95] [revised]

In his introductory essay, "Spiritual Treasures," Marc demands of the artist that he reveal higher truths and unveil the underlying relationships of the world system. Speaking of Greco and Cézanne he says: "In their views of life both felt the *mystical inner construction* which is the great problem of our generation."[96]

Kandinsky's position on subject matter is somewhat ambivalent, as expressed in his writings up to 1912. In his works of 1912 the figural motifs are increasingly abstracted and become harder to decipher, yet he does not yet consider the time ripe for completely abolishing figural references. The whole problem was discussed at length in *Concerning the Spiritual:*

> Today the artist cannot yet do with purely abstract forms. These forms are too imprecise for him. To restrict oneself exclusively to imprecise forms would be to lose possibilities, to exclude the human dimension and therefore to weaken one's means of expression.[97] [revised]

Until the artist can proceed to pure abstraction, the themes for the transitional period are to be found in the "human dimension," the expression of emotion.

Kandinsky himself feels that he has already progressed to the point where he no longer needs to deal with specific emotions and their expression via natural forms. In an earlier passage of his book he discusses such themes with reservations, even some disdain:

> Cruder emotions, like fear, joy, and grief, which belong to this [still materialist] period of experimentation, will not attract the artist very much. He will attempt to arouse more refined emotions, as yet unnamed. . . .
> The observer of today . . . either seeks an imitation of nature with a practical function (portrait, for example. . .) or a representation of nature which involves a certain interpretation, "impressionist painting" or an *inner feeling expressed by nature's forms* (as we say, a "picture of mood"). When they are true works of art, such forms fulfill their purposes and nourish the spirit, particularly in the third case, in which the spectator hears an answering chord in himself. . . . The spirit at least is preserved from coarseness.[98]

Although he is basically opposed to the representation of specific, 'coarse' emotions, Kandinsky acknowledges their legitimacy for subject matter, provided they are dealt with in truly artistic fashion. 'Artistic' for Kandinsky means anaturalistic. He states that it is impossible for the artist to really copy nature; interpretation and stylization are always part of the creative process and they provide the means by which the artist proceeds towards truly artistic creation:

> The impossibility and (in art) the purposelessness of copying an object, the desire to cull expressive elements from the object itself, are the beginning of leading the artist away from "literary" color to purely artistic, i.e., pictorial aims.[99] [revised]

In his essay, "On the Question of Form" in *The Blaue Reiter Almanac,* Kandinsky discusses the artist's choice between abstract and representational means:

> The artist's inner intuition does and will always control the combination of the abstract and the objective, . . . the choices among the infinite number of abstract forms or of objective matter, i.e., the choice of the particular means in both fields.[100]

Kandinsky's remarks on the artist's progress from a 'literary' presentation of his subject matter to a purely artistic approach, from "cruder" themes, such as basic emotions, toward the expression of finer, more complex and nameless feelings, as well as his ideas on the free combination of representational and abstract forms map out in many respects the development in Klee's approach to 'poetic' subject matter.

Klee's position regarding subject matter, as it evolved during the Blaue Reiter years, relates to some extent to the ideas of all three of his colleagues. With Macke he shares the belief that divine forces are manifest even in the

smallest natural forms, but in contrast to Macke he looks beyond nature's outer sensuous appearance into its inner construction. Like Marc, Klee wants to reveal the "mystical inner construction" of the world, but he does not conceive of pictorial symbols in Marc's sense. Klee's pictorial language of signs, formulas (in 1916 he speaks of the ". . . a priori formulas for men, beasts, plants, stones and the elements, and for all the whirling forces."[101]), and abstract elements is less self-evident in its symbolic dimension than Marc's archetypal symbolism. His language is more abstract, more differentiating and complex in meaning, richer in variations and, as a result, more enigmatic. Conceptually Klee's approach to pictorial motifs comes closest to that of Kandinsky in 1911/12; his signs often are the "most abbreviated allusion to the object" in Kandinsky's sense and, as with Kandinsky's colors and forms, the expressive "sound" varies within the different contexts of his works. In contrast to Kandinsky, however, Klee in most works provides a key for interpretation by including figural motifs or he guides the viewer's imagination by the titles which are important, integral parts of Klee's works.

In a number of 1912 works Klee deals with exactly those "cruder emotions, like fear, joy and grief . . .," which Kandinsky was not interested in for himself but permitted as suitable subject matter for an artist's transitional period from naturalist, i.e. "materialist," to spiritual art. After years of self-imposed restraint regarding 'poetic' painting the choice of such themes constitutes a major new departure for Klee.

Both Kandinsky and Klee make use of the inherent expressive qualities of more or less abstract forms per se. Yet they use them to different ends. Kandinsky wants his forms to exist in themselves, to be expressive in a truly abstract sense, as music is expressive. His forms are to evoke emotions and psychic sensations that cannot be defined with words, even though they will conjure up certain general feelings in the viewer. At times Klee experiments with this same kind of abstract expression, but more often he makes the expressive content specific by introducing allusive elements or by the addition of a title. While the emotional expressiveness in Kandinsky's work can be compared to the abstractly expressive character of music, in Klee's work the expressive dimension tends to be more literal, comparable perhaps to poetry, which—no matter how enigmatic or 'abstract'—will invite interpretation because of the meaning that the individual words or images have in themselves. Klee, indeed, very often relies on the suggestive power of words and their preconceived meaning to direct the viewer toward a specific interpretation of his works. Later he often puts words into the works themselves. Conversely, Kandinsky makes very little use of associative titles, precisely in order to avoid such direct interpretation. The difference between them becomes apparent in comparing Kandinsky's *Improvisation 19,* 1911 (Fig. 13) with Klee's *Violent Death,* 1912. 88 (Fig. 12). In both works an abstract form

looms large and threatening as it points down at a figure or figures. The figures in both works seem to be in distress or in some kind of predicament, to judge from their gestures. Kandinsky, however, does not provide any further clue as to the meaning. The viewer experiences the juxtaposed forms as a primeval confrontation which evokes a variety of possible associations, but no definitive interpretation can be arrived at. (For an interpretation based on Kandinsky's writings see Appendix I.) Klee, on the other hand, adds a title, which puts the work within the context of specific human experiences, such as murder or war.[102] The roots for these different approaches are to be found for both artists in their Symbolist beginnings: already in his etchings Klee had sought to pinpoint emotions and lay bare man's soul and inner conflict, much in the spirit of the Symbolist authors he preferred, like Jacobsen, Ibsen, and Strindberg, all of whom were primarily interested in man's psyche and social conflicts. Conversely, Kandinsky is rooted in the more mystical and abstract-occult direction of Symbolism (theosophy, Maeterlinck, the George circle, for example), which sought to transcend human reality rather than reveal and denounce it, and which saw art as a means to transport man into an other-worldly realm of mystery and visions. In contrast to Kandinsky, Klee, for all his transcendental orientation, also maintains a connection with the reality of life in his art. An astute observer of the life around him, Klee transposes his observations and psychological insights into concise, expressive images. His continuing interests in actual life and nature—including human nature—reflect not only his long years of naturalist study and observation, but also his belief that art should capture the essence of life, but life as seen and observed from such a detached distance that all living objects and things can be reduced to "formulas," as Klee puts it in 1916.

'Modernist' themes, such as landscapes and other natural motifs or scenes from everyday life, continue in Klee's work throughout the Blaue Reiter period, but need not be considered here. There are several types of subject matter of an 'Expressionist' nature, of which the following four groups shall be discussed: (1) 'psychological themes' dealing with emotions and human relationships; (2) 'metaphysical themes' alluding to invisible higher forces and cosmic relationships; (3) 'musical themes' which operate with sound associations; and (4) abstract and semiabstract expression.

1. Psychological Themes

In his works with 'psychological' themes Klee deals with basic emotions as well as with complex human relationships. In a number of drawings and lithographic essays, mostly executed in the "band" style that is typified by *Violent Death* (Fig. 12), Klee deals with basic emotions and 'states of mind,' such as *Loneliness,* 1912. 128; *Fall* 1912. 130 (which seems to refer to physical as well

as emotional collapse); *Fear,* 1912.155; *Self-Glorification,* 1912. 157.[103] The woodcut, *Contrition* (App. III-32) has previously been discussed. In contorting the same basic type of figure into a variety of poses Klee concentrates on the formal expression of one specific emotion in each work. These drawings are 'finger exercises' in expression, as it were; all naturalistic detail or narrative, 'literary' elaboration is avoided.

In works with two or more figures, Klee explores the relationships between people, often adding poetic titles which introduce an allegorical dimension. Examples are *The Higher Spirit in Mourning over the Lower,* 1912. 138; *The Future as Burden,* 1912. 144; *Promises,* 1912. 94; and *Praise of Fertility,* 1912. 96.[104] In a number of works from these years there is an explicitly sexual dimension, an aspect of Klee's art which is often overlooked. Frequently they deal with sexual frustration and noncommunication between couples, as in *The Poisonous Animal,* 1913. 34; *Mating in the Air,* 1912. 129; *Don Juan or the Last Stage of Amorousness,* 1913. 48; *Temptation of a Policeman,* 1913. 58.[105] Some of these drawings, like *Crouching Couple,* 1913. 38,[106] or *Don Juan* have a Munchian quality about them, reflecting perhaps impressions Klee had received at the 1912 Munch exhibition which he had reviewed.

Expressionist themes also prevail when Klee begins to work with geometric, Cubist forms, as for example in *Temptation of a Policeman,* 1913. 58 (App. III-17). Klee deals with similar subjects in drawings of 1914 and 1915 where he uses simplified geometrical shapes, as in *Inhibited Striving,* 1914. 122 (App. III-17) and *Collapse,* 1915.67 (App. III-17). Such "state of mind" themes recur throughout Klee's *oeuvre;* occasionally he draws on earlier pictorial solutions.[107]

Many of Klee's expressive figural motifs, expecially those of the 'band' style type, can stylistically be compared to Kandinsky's soft-contour figures in works of 1910-1911, as for example *Study for Composition II,* 1910 (App. III-47), *Improvisation 19,* 1911 (Fig. 13) and *All Saints Picture II,* 1911,[108] and the paintings behind glass. But Kandinsky's figures are more or less variations on the same formula for pathos, with little expressive differentiation. Klee, in contrast, creates visual equivalents for very specific emotions, although he, too, operates with the same basic figural type. Furthermore, Kandinsky's and Klee's different world views are reflected in their figural subject matter. In Kandinsky's works the amorphous beings—often one cannot determine if they are human or cosmic beings—are chosen ones, possessed of visionary *élan,* heralds of the anticipated spiritual renewal. Klee remains closer to actual life, and his view of man is rather more related to Munch's pessimism than to Kandinsky's messianic zeal. Klee deals with lonesomeness, anxiety, fears, and isolation; his figures are dominated by their passions and they are subjected to higher forces from which they cannot escape. Kandinsky reduces his figures to fluid contours and makes them seem transparent in order to emphasize their

immaterial spirituality. Klee uses the same means and additional primitivizing formal means to make his figures appear as puppet-like creatures who are unable to control their own fates. Tempered now by humor and irony, the cynical pessimism about man and his life which had marked his early etchings resurfaces in these drawings.

2. 'Metaphysical' Themes

In the drawings just mentioned the 'higher' forces are usually symbolized by abstract bundles of lines; their relation to Kandinsky's black lines has already been noted. In other works Klee deals more explicitly with the forces that govern man's fate, even with the cosmos in its entirety. Analogous to the recurrent motifs in Kandinsky's works, such as the sun motif or the angel with a tuba as herald of the Apocalypse, Klee develops recurrent form motifs which stand for metaphysical and cosmic forces.

Astronomical motifs begin to appear in 1912, often as symbols of cosmic forces. In the woodcut, *Under the Sun,* 1912. 135 (App. III-32) the sun which is worshipped by the figure represents more than just the source of daylight. In *Rise to the Stars,* 1912. 35 (App. III-32), Klee, for once, allows his figures to take their place among the stars. More often, they are subjected to the dictates of the cosmic forces, which in *Human Weakness,* 1913.35,[109] are represented by the sun. A web of lines emanates from the sun in which men are held as captive puppets, some resigning themselves to their fate, others protesting and struggling against it. The same is true of *Grim Message from the Stars,* 1913.32 (App. III-8), which contains the whole arsenal of Klee's cosmic signs. Klee's pessimism is particularly evident in comparing *Grim Message* to Kandinsky's painting behind glass, *All Saints Picture I,* 1911 ((App. III-20), where the saints and all of nature (like Klee, Kandinsky includes sun *and* moon as symbolic references to the totality of the cosmos) rise ecstatically to the trumpet call of the angel.

Suns, moons, and stars are central motifs in Klee's iconography throughout his *oeuvre* and they appear in a great variety of configurations. Their meaning can vary a great deal within the context of each work. Klee uses such signs also as ordinary landscape elements, but more often than not they have a transcendental dimension and symbolize the forces that dominate man's fate. As such, the signs are particularly prominent in Klee's works of the years 1917-1919, which Grohmann has subsumed under the heading "Cosmic Picture-book."[110] While Klee disdained theosophic theories of 'fine matter,' etc., his cosmic symbolism, also represented by such simple geometric signs as the arrow and triangle, demonstrates that Klee certainly believed in invisible natural forces and their impact on man. An eminent example is the 1917 watercolor, *Dynamic of a Lech River Landscape* (App. III-22), where he

presents a 'supra-natural' image of a landscape, as it were, by visualizing its inherent, invisible forces much in the way a theosophist purports to perceive the aura of 'fine matter' around a person.

Besides dealing with man and the invisible forces governing him, Klee also depicts man as part of the entire cosmos of animate and inanimate beings of which man is but one and on an equal footing with all other elements. *Garden of Passion* has been analyzed by Jordan in respect to its "animistic unity" and its thematic relationship to Kandinsky and Marc. The etching *Little Cosmos*, 1914. 120 (App. III-32) is another example. At first sight it reminds one of the pattern incised on a weathered stone. At closer scrutiny one discovers that this 'abstract' pattern is actually teeming with life. Plants, rocks, fossil formations, stars, and figures emerge as 'hidden images' in the manner of Kandinsky's pictures, such as *All Saints Picture I*, ca. 1911 (the oil version) (App. III-20). As so often happens in Kandinsky's paintings, the figures in Klee's print are ambiguous beings, neither clearly human nor supernatural. They look aggressive and brutal, yet at the same time they are puppet-like and visually they are locked into the planar, roughly grid-like compositional structure. Franciscono rightly suggests that in this way Klee expresses their impotence *vis-à-vis* their fate.[111]

'Metaphysical' themes are so frequent in Klee's *oeuvre* and are dealt with from so many different angles and under so many thematic guises that it would be impossible to explore their scope within the context of this study. Suffice it to note that from 1912 onward Klee more and more makes his art the vehicle for the expression of his philosophical beliefs and his view of the cosmos, and conceives of his pictures as microcosmic reflections of the macrocosmos. In this respect he is in accordance with his fellow Blaue Reiter artists, Kandinsky and Marc, even though the view of the world projected in Klee's work differs from their evangelical belief in the forthcoming spiritual renewal.

3. *'Musical' Themes*

Within the context of the Blaue Reiter a small group of works in which Klee tries to evoke the sounds of musical instruments is of particular interest. The titles he gives to these works make it clear that he is not just alluding to the external appearance of instruments but wants the viewer to *hear* their sounds. He wants to obtain a synaesthetic effect.

Synaesthetic phenomena play an important role in Kandinsky's theory. In his writings Kandinsky makes very specific analogies between sounds and colors, but he by no means intends his paintings to be visual transpositions of music.[112] Rather, he borrows the term 'sound' from musical terminology to denote the abstract, nonrepresentational character inherent in every form and

color. For Kandinsky music and art were related primarily in regard to their abstract basic means, color and sound. Although he frequently calls for a *Generalbass* in art as it already exists in music, he does not suggest that the compositional principles of music could be applicable to art.[113]

While Kandinsky is interested primarily in music's synaesthetic evocations (in terms of sensory perception) and abstract qualities, Klee looks to music from a more intellectual point of view, taking a strong interest in its compositional order. As R. Verdi and A. Kagan have shown, Klee utilizes concepts of music primarily for their compositional principles and rhythmical structures.[114] The Cubist grid and its individual units provides a formal basis for Klee's experiments with musical structure, which preoccupy him primarily in the 1920s and 30s.

Although their basic thinking on art-music relationships differs considerably, Klee occasionally operated with synaesthetic evocations in a way that relates to Kandinsky's work. Until 1913 Kandinsky frequently introduced figural references to sound into his work by including instruments or figures playing instruments, often angels blowing the trumpet. Examples are *Landscape with Rider Blowing a Trumpet*, 1908/09; *'Sound of the Trombones' (Large Resurrection)*, 1910/11; (App. III-26); *All Saints Picture I* (glass), 1911 (App. III-20). These figurative forms are progressively abstracted until in *Sketch II for Composition VII*, 1913 (App. III-23), only the outlines of a trumpet remain discernible.

In Klee's *Song of Lamentation*, 1913. 163 (Fig. 20), the reference to sound is introduced by the title and reinforced by the horn shape which may be an allusion to the shofar. But in a stylistically related drawing, *Sound of the Fanfares (for the Psalm)*, 1913. 168,[115] Klee evokes the musical praise of the Lord in essentially abstract form. There are no figural allusions to instruments; instead Klee apparently sought to conjure up the fanfare sound only by means of the expressive qualities of the graphic forms. The 1914 watercolor and pen drawing, *Sounds of the Organ*, 1914. 93,[116] is also entirely abstract. Over a ground of green and yellow color squares a delicate, complex line pattern is laid. The relationship to organ sounds is not self-evident but must have suggested itself to Klee after the completion of the work. These works indicate that Klee associated their abstract expressive forms with certain sound qualities, in the sense of Kandinsky's color and sound associations. In contrast to Kandinsky, Klee makes these synaesthetic evocations quite specific by adding interpretive titles. Such basically abstract evocations of sounds continue to appear in Klee's later *oeuvre*, especially in his color grid paintings of the 1920s, such as *Ancient Sound*, 1925 (App. III-57).

In other works with musical themes Klee includes more direct figurative associations. In *Pastorale*, 1914. 79 (App. III-17), he generates sound evocations both through the image and through its abstract form character, juggling

complex levels of meaning. Such a translation of music into an image and into expressive forms may have been attempted earlier by Marc in a small water-color entitled, *Sonatina for Violin and Piano,* 1913 (App. III-34). The water-color was painted on a postcard and sent to Klee, apparently in May of 1913, to thank him for an evening of music at the Klees'.[117] It depicts a small landscape with sun and moon and horses amid blue and red mountains. But beyond the representational forms Marc may also allude to music and instruments: the abstract pointed triangular and bow shapes interspersed with the landscape might allude to the spirited musical cadence of the violin.

In Klee's *Pastorale* the figure playing the flute in the center is a shepherd in a landscape setting, surrounded by birds and trees. On this level the drawing represents a pastoral shepherd scene. The scroll of a violin and the flute, which resembles the bow of a violin, allude to the musical meaning of the term *Pastorale.* Furthermore, the light, mostly rounded forms abstractly allude to the serene, melodious character of a musical *Pastorale* movement, just as Marc in *Sonatina* may evoke the serene character of the music with bright colors and an idyllic landscape.[118] Klee uses a combination of abstract and figural forms for synaesthetic sound evocations as well as for intentionally ambivalent meaning and lighthearted visual punning. The same is true of the well-known drawing *Instrument for the New Music,* 1914. 10[119] which alludes to musical instruments, notation, and the presumed sound of the new music (of which Klee reportedly was not too fond).

Such elaborate, multileveled 'representations' of specific types of music were essentially alien to Kandinsky's thinking. Klee comes closer to Kandinsky's concept of sound evocation in the drawing, *Psalm Blown (23rd Psalm),* 1915. 23 (Fig. 23).[120] By their very nature as songs the Psalms are ideally suited to such references to sounds, and Klee makes it clear by the title that he wants the drawing to be 'heard'. On the right side of the drawing a trumpet form alludes to the instrument. The shapes in the upper third of the drawing seem to emanate from the trumpet, like visual equivalents of the trumpet sounds. In composition and in respect to the geometric forms the drawing is Cubist-influenced, but it can be compared to Kandinsky's painting behind glass, *Resurrection (Large Version),* 1911 (Fig. 23) in regard to its combination of abstract forms and figural motifs as well as to its symbolic signs (such as the rose in Kandinsky's painting and the star in Klee's drawing). Both artists include trumpet forms to evoke synaesthetic associations, but Klee seems to elaborate further on such associations. In contrasting the simple, large, and clear forms at the bottom with the small vivacious shapes in the upper section, Klee conceivably tried to transpose the different sound qualities of horn instruments into their visual equivalents, contrasting the deep sound of a tuba with the higher and more complex sounds of a trumpet or fanfare.

Figurative or semiabstract allusions to music and instruments continue

to appear in Klee's later works, for example in the 1930 painting *Drum Organ*.

Klee's diary shows that he had already thought about pictorial analogies to music in 1909,[121] but it was only during the Blaue Reiter period that he, stimulated by the talk of his artist friends about art-music relationships,[122] ventured to realize such concepts in his art. Because he could now deal with such association in abstract and semiabstract terms, he was able to avoid any literary illustration.

4. Abstract Expression

Klee's use of essentially abstract forms, both biomorphic and Cubist-geo-metrical, for expressive ends has been pointed to throughout the preceding discussion. His approach to abstract expression is exemplified in the war drawings and those works relating to the Psalm illustration project. A brief discussion of Klee's most ambitious and poignant comment on the war, the lithograph, *Destruction and Hope*, 1916. 55 (App. III-32), shall serve to elucidate and summarize Klee's use of abstract forms for expressive ends.

In its formal character the print is essentially Cubist, with its grid com-position, geometrical shapes, and hatchings. Linear configurations and cir-cular forms are joined in a coherent transparent structure. Some of the forms recall architectural features, such as brick walls, iron constructions, bridges, and arches. In the upper half of the print one discerns two martial, armored figures, their forms reminding one of Léger. Franciscono has pointed out the formal relationship of this print to Gleizes' painting, *La ville et le fleuve,* 1913, and, more specifically, the drawing for the painting.[123] He also noted the difference in conception between the two works. Gleizes, in his drawing, works in a more truly Cubist fashion, starting from a specific model which he divides into segments and then reassembles in a kaleidoscopic fashion. In contrast, Klee does not work from a specific motif to be 'analyzed,' but instead begins his work with abstract forms—possibly even without a specific subject in mind—and introduces associative elements as he proceeds. Klee, in this print, takes the Cubist concept of dissection literally in order to create an abstract image of destruction, but his formal method is not that of Cubist dissection of an object.[124] Despite architectural and figural associations he does not specify what it is that is being destroyed; it could be a house, a city, or the entire world. Rather, Klee creates a visual expression of destruction *per se*. That such an encompassing symbolic dimension was intended by Klee is indicated by the change in title: one version is entitled *Ruins and Hope*.[125] By changing this to *Destruction and Hope* the representation becomes more abstract and the symbolism more universal in scope.

Both the Gleizes drawing and Klee's print are composed in typically Cubist fashion, with the forms clustering in the center of the ground. A subtle

nuance, however, sets Klee's composition off from Gleizes'. In most Cubist works, even if the picture space around the edges is nearly empty, the forms and lines extend into this area. In Gleizes' drawing, in particular, the forms in the center are anchored to the edges by long lines extending to the edges or ending shortly before. The city structure seems to continue beyond the limits of the ground. On the other hand, Klee's composition is totally self-contained, placed in the center of the sheet with no lines extending outward. A fairly wide space is left void all around it. Thus visually isolated, the linear configuration becomes a world in itself, a pictorial microcosm comparable to that in Kandinsky's painting, *Black Lines,* 1913 (Fig. 18). The absence of clear references to scale and dimension makes it impossible to place this pictorial microcosm in relation to the world of outer appearances. Despite the differences in form character, Klee's approach to forms as expressive means *per se* is similar to Kandinsky's. The integration of a few ambiguous but associative elements into the predominating abstract forms is also comparable to Kandinsky's method in 1912/13, represented by *Improvisation Deluge,* 1913 (App. III-20), which, incidentally, shares with Klee's lithograph the cataclysmic theme.

Kandinsky's goal was the direct communication between artist and viewer by means of abstract forms, the transmittal of a 'content' so 'fine' that it could not be expressed in words or images. To this end he gradually eliminates the "most abbreviated allusions to the object" as well as descriptive titles. Klee, on the other hand, did not want to give up references to specific objects, emotions, ideas, and thoughts. For him art was the means to communicate not only inner states in Kandinsky's sense, but also a view of the world in its outer manifestations, insights into nature, and empirical experiences and observations. Nonetheless he considered his pictorial means abstract, even if the completed work is rich in figurative associations. (Klee's theoretical concept of abstraction will be further discussed below.) In 1914/15 Klee produces quite a few abstract works. Sometimes they remain entirely abstract, in Kandinsky's sense; at other times Klee himself interprets the expressive quality of the forms by adding a specific title. A case in point are two drawings of 1914. They are executed in the same style and both contain no figurative elements. One, 1914. 153, remained untitled while the other drawing, with its languid, flowing forms received the evocative title, *Sleep.*[126]

While both artists operate with an essentially abstract language of form, they employ it in differing ways and for different ends. Kandinsky's approach to abstraction is reductive. He progressively eliminates references to objects in order to get to the abstract essence of colors and forms, by which he hopes to establish an inner communication between artist and viewer. His entire artistic development had been a move away from nature and the world of outward appearances toward the realization of his inner vision of abstract 'sounds.' For

Klee, in contrast, abstraction represents a *new* way of dealing with nature and reality on a more complex level which allows him to refer to inner construction as well as to outer manifestations. Taking abstract forms as his point of departure, he elaborates them with signs and figurative allusions. He introduces complex levels of meaning into his works, which can range from simple references to observed nature to making clear the analogies that he sees in the formative laws of art and nature (see the discussion of *The Niesen* below, for an example).

The linear configuration of *Destruction and Hope* is conceived of in abstract terms that are comparable to Kandinsky's *Black Lines* (Fig. 18), but Klee goes further than Kandinsky by introducing cosmic signs as symbols of the higher forces which have the power to end the destruction and bring about renewal and hope. Brushed in with delicate watercolors, these signs are set off in medium as well as in their formal character from the earthly realm of destruction. The visual character of the linear configuration by itself gives a clue to the theme of collapse and destruction, but Klee clarifies further by adding the watercolor signs and the title. In this way he reestablishes, as it were, the references to nature and reality which Kandinsky on his part sought to eliminate.

Working within an essentially abstract form language allows Klee to return to 'poetic' content. Combining abstraction with Cubist geometry, he arrives at a modernist approach which enables him to deal with what is often quite traditional subject matter, or rather, he can dare to select traditional, even commonplace titles for his more or less abstract works. Titles such as *Death for the Idea* or *Destruction and Hope* would have been acceptable to any nineteenth century *Salon* jury. As regards his themes, Klee in these 'abstract allegories' recalls his Symbolist beginnings. In respect to the more explicit symbolism of some of his abstract forms (in contrast to Kandinsky's), there are some parallels between Marc and Klee.[127]

In July 1917 Klee looked back on his development in a diary entry. At this time he often reflected on his art and he seems to have frequently thought of his Blaue Reiter friends. It is not made clear to whom Klee is referring in this entry, but I think that he is acknowledging his indebtedness to Kandinsky and Marc, who by their examples and ideas had encouraged him to return to "poetic" painting, and to approach art as the expression of the artist's inner self and his experience of the world.

We investigate the formal for the sake of expression and of the insights into our soul which are thereby provided. Philosophy, so they say, has a taste for art; at the beginning I was amazed at how much they saw. For I had only been thinking about form, the rest of it had followed by itself. An awakened awareness of the "rest of it" has helped me greatly since then and provided me with greater variability in creation. I was even able to become an illustrator of ideas again, now that I no longer saw abstract art. Only abstraction from the transitory remained. The world was my subject, even though it was not the visible world.[128]

4

The Synthesis of "Art—Nature—Self"

The Trip to Tunis

In April of 1914 Klee undertook his celebrated trip to Tunis, in the company of August Macke and Louis Moilliet, an experience which is usually associated with Klee's 'breakthrough to color.' The watercolors that Klee produced during and after the trip are of momentous importance not only because of their coloristic mastery, but also because in them Klee arrives at a formal approach which accommodates and reconciles the dualistic tendencies that had been manifest throughout his development. By coming to terms with the Cubist color grid Klee arrives at a compositional basis for abstraction which enables him to translate into pictorial form his concepts of the structural parallels in artistic and natural formation.

North Africa had long been a preferred travel goal for French artists: Delacroix had experienced color in a new way on his journey to Morocco; Monet and Renoir had gone to Algeria. More recently, Matisse had twice stayed in Tangiers and had made important stylistic advances in his Moroccan paintings. Having spent the two years since his trip to Paris in early 1912 primarily in the Expressionist milieu of Munich, Klee on the Tunisian trip was once more confronted with French colorism, if only indirectly via Macke's example. Macke's style, as well as his artistic outlook in general, were oriented toward France; confronting the metaphysically charged art of Kandinsky and Marc, he insisted on the primacy of *peinture* in the French sense. Macke and Klee grew quite friendly during the journey; that the generic differences between French and German art were a point of discussion between them is indirectly evident from a letter of June 12, 1914, written by Marc to Macke:

> . . . neither do I believe that we both are proceeding on the same path. I think more or less like Klee, whose opinion you will have become acquainted with. I am a German and I can dig only in my own field; what does the *peinture* of the Orphists concern me? We Germans will never be as good at it as the French, or let's say, the Romance nations are. We Germans are born graphic artists and will remain so, illustrators, even as painters.[1]

Klee may have identified less than Marc with the national character of German art, but at least until the Tunis trip, he certainly considered himself a "graphic" artist in Marc's sense.

The primary impulses for Macke's art came from Fauvism; in particular from Matisse, as well as from the 'Orphist' Cubism of Delaunay, whose principles of simultaneous contrasts Macke adopted in his paintings. While the importance of Delaunay for both Macke and Klee has been frequently pointed out, most notably by Jordan and Laxner, less consideration has been given to the Matissean qualities of Macke's Tunis works which, I suggest, may have been of interest to Klee.[2] These Matissean qualities are significant primarily in respect to Klee's formal concept of abstraction. (His *theoretical* concept of abstraction will be elucidated further in the next chapter).

Macke had been able to study Matisse's Tangiers paintings when they were exhibited in Berlin in May of 1913 *en route* to Moscow.[3] Reflections from Matisse's works can be found in Macke's Tunis watercolors, both in respect to formal solutions as well as in regard to the representation of the motif. The influence culminates in Macke's post-Tunis paintings, such as the *Turkish Cafe, II,* 1914 (App. III-20). Conceivably Macke and Klee discussed Matisse on their trip, and Macke may have described Matisse's Tangiers paintings to Klee. From Klee's fairly extensive account of the journey it does not appear that the three artists spent much time in theoretical discussion, yet Marc's letter to Macke implies that they did at least discuss their respective attitudes to French art.

Laxner has traced the process of gradual abstraction in Macke's Tunis watercolors; it proceeds to a point where the grid becomes the basic compositional device without, however, obliterating the appearance and coherence of the natural motif. *In the Bazaar* (App. III-39), which Laxner places early in Macke's Tunis work[4] does not yet have a grid order, but the pronounced emphasis on horizontal and vertical accents points toward it. The complicated motif, a figural group in front of an architectural complex, is compressed into a tightly organized pictorial construction. The various spatial layers of the motif are pulled together visually by the distribution of recurrent colors as well as ornamental patterns throughout the picture. Operating with the full range of primaries and their complementaries, Macke places the most intense colors so that the eye, in moving across the surface, perceives the individual spots of one color as virtually belonging to the same plane. In addition, Macke uses two other means of reaffirming the flatness of the color surface: he juxtaposes two colors of equal intensity, such as the blue and green in the upper left, so that neither color appears to recede behind the other, and he uses the same basic color for two different, but adjacent spatial planes, differentiating between them either with a slight change of hue or with a darker dividing line, as in the two yellow-pink houses in the upper right quarter. Both methods

are typical of Matisse's approach, as for example in *Entrance to the Kasbah,* 1912 (App. III-5). The way in which diagonal lines cut across the surface rather than recede into depth is also Matissean, as is the emphasis on framing devices. [Compare, for example, the striped awning in Macke's watercolor with the upper left corner in Matisse's *Zorah,* 1912 (App. III-5).] The little use Macke makes of *passage* effects underscores the planarity and discreteness of the individual color shapes. However, due to the complexity of the motif and its subdivision into numerous smaller units, *In the Bazaar* on the whole recalls early Cubism as much as Matisse.[5]

In adopting the color grid as pictorial order Macke either lets it predominate and subjects the motif to it, as, for example, in *Merchant with Jugs* (App. III-39), which results in a strongly decorative effect, or he sets up the grid in one section of the picture only so that it implicitly appears to be the compositional order but does not interfere with the actual spatial arrangement of the motif. Since for Macke the natural motif usually remains the point of reference, the partial introduction of a grid into the essentially intact motif represents his most successful compositional solution, as in the watercolors of Kairouan or in *Bright House* (App. III-39). As Laxner has noted, Delaunay, in his *Windows* series, *L'Equipe de Cardiff* etc., does not fragment his motifs either, but with Macke the motif is considerably more prominent and less subordinated to the abstract color structure. The grid itself is, of course, derived from Delaunay, but where it appears, it consists usually of separate, planar units which occasionally overlap. Square units predominate, in contrast to Delaunay, who uses a great deal of triangular forms. On the whole, Macke's Tunis watercolors occupy a stylistic position somewhere between Delaunay, whose influence is reflected in the grid as well as the simultaneous color contrasts, and Matisse, to whom they are indebted in respect to the representation of the motif and the emphasis on planar values.

In her discussion of Klee's Tunis watercolors, Laxner traces the development in terms of the increasing abstraction from nature to the point where the color grid itself becomes dominant. Associational elements are brought in at any stage, even toward the very end of the creative process. Thus, in contrast to Macke who abstracts from the motif but never works without a motif as his point of departure, Klee, in his later Tunisian works, begins with an essentially abstract composition.[6] Yet, despite the high degree of abstraction, Klee's watercolors capture the essence of his visual impressions of North Africa.

From the beginning of the trip Klee had felt that North Africa provided the right environment for him to attempt the synthesis of the divergent elements with which he had been trying to come to terms. Concerning his first impression of Tunis at night he writes: "Reality and dream simultaneously, and myself makes a third in the party, completely at home here. This will be fine,"[7] and on the following day he sums up his experience: "Art—Nature—

Self."[8] Right at the beginning of his stay Klee sets his goal: "Began the synthesis of urban architecture and pictorial architecture."[9] The cubic architecture of North Africa lent itself naturally to an interpretation in terms of the Cubist grid. In what is stylistically an early watercolor, *In Front of a Mosque in Tunis*, 1914. 204 (App. III-1), the grid is used rather hesitantly and for the architectural part of the motif only, whereas the foreground is organized into large individual planes. But the grid quickly becomes more predominant and Klee uses it for landscape motifs as well, as in *Garden in St. Germain in Tunis* 1914. 213 (App. III-22). Unlike Macke, who grapples with the problem of reconciling the grid order with a concept of spatial layering that is still rooted in traditional perspective, Klee simplifies his motif and abstracts from it to the point where he can translate the spatial layers into color planes stacked above one another. Although the abstract grid order predominates, the actual motif in this work is still clearly discernible as the point of departure. The process of abstraction proceeds further in *Hammamet with the Mosque*, 1914. 199 (Fig. 24), where the actual motif is almost completely transposed into abstractly equivalent color shapes. In *Motif from Hammamet*, 1914. 48 (App. III-42), possibly painted after the trip, only an ephemeral reference is made to the original motif (the sky and house relate it to a portion of *Hammamet with the Mosque*).

In respect to the grid, the colors, and the high degree of abstraction, Klee's *Hammamet* watercolors relate closely to Delaunay's *Windows* series which Klee had seen.[10] But there is a momentous difference in Klee's use of the individual color shapes, a difference which relates more to Macke and—indirectly—Matisse than to Delaunay's Cubism. In Delaunay's *The Windows*, 1912 (App. III-2), the basic grid order is almost obfuscated by the triangular forms placed over it. The triangles, strongly colored and painted with *passage* gradations, appear as if they were hinged to the ground and could move freely within a radius of 180 degrees. The result is a complex interaction of forms within the diffuse, atmospheric picture space. Klee, on the other hand, keeps each color segment discrete and planar, making only very sparing use of tonal gradations for *passage* effects. He also works predominantly with square units rather than triangular ones, which further underscores the planarity of the grid composition. Whatever spatial qualities there are in Klee's watercolors result from color juxtapositions, but Klee does not create the kind of Cubist relief space that is still present in Delaunay's *Windows*.

Klee's different interpretation of the grid and facet forms is very apparent in *Hammamet with the Mosque* (Fig. 24). The foreground is divided diagonally into a large, primarily red area on the right and a light pink area on the left. Klee subdivides the red area into segments of different reds but visually it remains intact, appearing as one red surface with green inserts which extends

all the way up to the pointed red triangle in the right center. In a similar way the pink expanse at left appears as one surface, although there is some spatial inflection as a result of the slightly darker color blocks laid over it. Diagonal compositional lines appear also in Delaunay's *Windows* (App. III-2), but there they serve as a scaffolding for the facets rather than as continuous outlines of a larger picture area. Klee's use of these diagonals for essentially planar effects, as well as his breaking up of a color area into different hues of the same color, relates to Macke's method in his Tunis watercolors, in *Bright House* (App. III-39) or *Kairouan I* (App. III-24);[11] reflecting perhaps an indirect influence from Matisse. Klee's interpretation of the Cubist grid in terms of predominantly planar and discrete units serves a dual purpose. First, by renouncing the vestiges of three-dimensionality still present in Delaunay's facet shapes, Klee makes his forms more intangible and immaterial. This dematerialization of forms underscores the abstract character of his watercolors. In contrast to Macke, who often operates with bright, opaque colors, Klee exploits the immaterial qualities inherent in the watercolor medium by applying his washes very thinly and with an emphasis on their transparency. As has been pointed out, for Klee abstraction meant—and in this he follows Kandinsky—the dematerialization of form, the avoidance of all naturalistic residues, as it were, of the "appearance of materiality," as Kandinsky had put it in his criticism of Picasso's form fragmentation.[12]

Second, by using the color shapes as separate units rather than as interacting facets, Klee makes them distinct pictorial building blocks. In *Motif from Hammamet* (App. III-42), for example, the shapes and colors are stacked and balanced as if Klee were building a wall. Klee works with the grid in what is a very "architectonic" way, employing it for natural and architectural motifs alike. Earlier it was pointed out that Klee equated architectonic principles of formation with basic laws of construction in nature. The grid order, as it is employed in the Tunis watercolors, represents his first successful formal solution for painting in which Klee can fully express his artistic philosophy. While the new approach is basically abstract, it can at the same time be related to nature, both in a purely conceptual sense, as regards the structural parallels between art and nature, as well as in terms of the transposition of an actual motif into essentially abstract forms. Until 1914, Klee had considered line his primary formal means for abstraction; during his Tunisian stay he freed color from its naturalistic connotations, and from then on he succeeded in capturing the essence of natural impressions in abstract pictorial equivalents. A good many works of 1914/15 remain on an entirely abstract level; that is, Klee does not add an interpretative title, as for example, *Watercolor (like 1914.85)*, 1914. 94 (App. III-18). Other works, like *Red and White Cupolas*, 1914. 45 (App. III-15), start out as abstract compositions with associative elements introduced at some point during the work process, often

being linear forms as "most abbreviated allusions to the object." In a few works Klee succeeds in making the analogies he sees between art and nature very transparent, and he juggles complex levels of meaning. One such work is *The Niesen* of 1915 (Fig. 25), which will be analyzed in detail below.

The grid order represents the "architectonic" aspect of Klee's Tunisian works, whereas the colors introduce a subjective, "poetic" dimension. Although Klee operates with complementary colors to some extent, he is much less systematic in this respect than Macke, whose preference for the full range of spectral colors occasionally overburdens his watercolors. Klee makes his color choices more intuitively, and he makes use of color gradations and hues adjacent to the primaries with great subtlety. In the atmosphere and colors of North Africa, Klee found reflected his innermost emotions; he so submerged himself in this experience that he identified himself with the North African landscape. Speaking of Kairouan he writes:

> At first an overwhelming frenzy, culminating that night with the *Mariage arabe*. No single thing, but the total effect. And what a totality it was! The essence of *A Thousand and One Nights,* with a ninety-nine percent reality content. What an aroma, how penetrating, how intoxicating, and at the same time clarifying. Nourishment, the most real and substantial nourishment and delicious drink. *Structure (Aufbau) and ecstasy.* Scented wood is burning. Home?[13] [revised, emphasis mine]

"Structure and ecstasy," reminiscent of Nietzsche's antithesis of 'appollinic' and 'dionysian,' sums up the total experience of the Tunis trip: the synthesis is achieved between ordered, "architectonic" formal construction and subjective "poetic" color, expressive of the sensuous experience. Furthermore, in his Tunis works Klee reconciles on the formal level a compositional order that is derived from French Cubism with a striving for abstraction and immateriality in the sense of Munich Expressionism. Klee himself articulated the meaning that the Tunis trip had for his art in the celebrated diary passage:

> I now abandon work. It penetrates so deeply and so gently into me, I feel it and it gives me confidence in myself without effort. Color possesses me. . . . That is the meaning of this happy hour: Color and I are one. I am a painter.[14]

"Architectonic and Poetic Painting:" an Analysis of "The Niesen," 1915

> To ". . . seize all those relations of the great whole . . . on the extremities of its rays, as it were, in a focus."
>
> (Karl Philipp Moritz)

The 1915 watercolor, *The Niesen* (Fig. 25), is particularly well suited for an analysis of Klee's mature, post-Tunis style. A microcosmic image iconographically as well as formally, it is an exemplary work in which the central

formal and theoretical issues with which Klee had been dealing over the past years are gathered as if in a focal point. In *The Niesen* Klee comes to terms with these issues in a way that is representative for his artistic approach in general throughout his career.

Although small in size, *The Niesen* is a highly ambitious work which Klee himself designated "Sonderclasse," a category reserved for what he considered his most outstanding works. Its formal and thematic antecedents include Caspar David Friedrich's visionary mountain scenes, Cézanne's *Mont St. Victoire* paintings, Hodler's Swiss Alp landscapes, and Kandinsky's mountain motifs, beginning with his *Blue Mountain* of 1908/09. *The Niesen* bridges the gap between the poles signified by Cézanne's infinite devotion to nature and Kandinsky's visionary imagery, between the translation of objective reality into pictorial values which is at the core of French modernism, and the metaphysical subjectivism and color mysticism of German Expressionism.

Situated on Lake Thoun in the Berner Oberland, the Niesen mountain is particularly striking because of its near-pyramidal shape. Klee had been familiar with its silhouette since childhood, as he and his family made frequent trips to the Lake Thoun area.[15] From his diary it appears that in this magnificent region Klee always felt particularly happy and at one with nature.[16] Thus, on a personal level the Niesen mountain may have symbolized for Klee the state of equilibrium and pantheistic well-being which he experienced on his trips there.

Glaesemer has suggested that Klee selected the title for the watercolor *post factum* because of an incidental resemblance of the pyramidal mountain with the Niesen; however, in this instance Klee may well have had the Niesen in mind from the start, possibly as a response to and challenge of Hodler's 1910 oil painting *The Niesen* (Fig. 26).[17]

Klee's critical stance *vis-à-vis* Hodler has been noted earlier. He felt that the interest of Hodler's paintings was generated by their subject matter and was not the result of "spiritually hyperintense painting." Whereas in his early years Klee had admired Hodler's landscapes, in 1911 he included them in his negative judgment: ". . . whereas only those landscapes are completely successful which are monumental in their motifs."[18] Hodler's great mountainscapes of the Alps surely must have been considered "monumental in their motifs" by Klee, and Hodler's *Niesen* could have been one of the paintings that Klee found successful, at least within the limitations of Hodler's art. Given Hodler's position before the war as the foremost Swiss painter, it must have been a challenge to Klee to create his own version of the Niesen motif.

Hodler's *Niesen* is monumental in its simple composition and its emphasis on symmetry. The viewer looks through the framing cloud pattern at the pyramidal mountain, which is surrounded by clear blue sky, as if through a frosted windowpane. The composition is divided into equal vertical and

horizontal halves, with the peak of the mountain just above the center of the picture. This calm formal organization is enlivened by the stylized cloud pattern and the detailed rendering of the mountain with its ridges and crevices. The massive, squatting mountain, framed by the ring of clouds, is an image of isolated majesty. The viewer gazes at it from a distant but almost equally high viewpoint. As a result, it appears that Hodler felt on a par with the lone grandeur of the mountain and identified with it. Stylistically the painting occupies a position somewhere between *plein-air* painting and Symbolist stylization.

In 1911 Klee had criticized Hodler for lack of painterliness (in an Impressionist sense) and of colorism:

> Hodler does not depict the objects with the light falling on them, rather he paints the objects in themselves, sharply contoured and in full plasticity.[19]

In contrast to Hodler, Klee, in his *Niesen,* works exclusively with planar, translucent color shapes and seeks to transcend the material reality of the motif, as it were, in order to achieve "spiritually hyperintense painting."

Klee's *Niesen,* too, has both objective and subjective dimensions, if on a different level than Hodler's. On one hand it is a transposition of a natural motif into abstract color shape: on the other it is imbued with a strongly metaphysical quality. This dual character is reflected in the formal organization of *The Niesen.* Composed of mostly square and rectangular color shapes, the picture is divided into three horizontal zones of unequal width. In the middle zone, which rises from the center in two triangular blocks upward to either side, rectangular color shapes form an irregular grid reminiscent of Klee's Tunis watercolors. Implicitly, the grid seems to be the compositional basis for the entire picture, but the grid is not uniform, as the units vary in size and format. Primary colors and intermediary hues, light and dark colors, are set side by side with some overlapping and tonal gradations, resulting in a slightly spatial quality. Jordan has compared this spatial inflection to the "ambiguous, shifting, translucent space of Analytical Cubism;"[20] however, since the plastic qualities of Cubist segments and *passage* are almost totally absent, the spatial quality of Klee's grid pattern is more closely related to the vibrating surfaces of late Cézanne than to Cubist relief space. Impulses from Cézanne and Delaunay are combined in Klee's own approach to the color grid.[21]

The lively middle zone of the picture represents zones of vegetation in the valley and on the mountain slopes—at bottom the predominantly green and red patches stand for fields and meadows; above is the mixed woodland of the lower mountain region; and finally, the large shapes of somber greens at the top stand for the fir tree and shrubbery zone found furthest up on

any mountain. Such a translation of organic phenomena into geometric forms is the fruit of Klee's experiences in Tunis: in synthesizing the cubic architectural structures of North Africa with the grid order, Klee had found the key to represent nature and its internal order as well. For him the structural laws of nature were reflected in the principles of architectural formation and artistic creation in general.

In *The Niesen* the changing colors of the middle zone not only represent the vegetation zones of the mountain, but may also allude to all growth in general. The two triangular shapes slowly rise from the center upward and outward, proceeding from the many small and delicate squares at bottom, with colors suggestive of young plants and blossoms, or of spring, toward the larger, less bright, 'mature' forms in the center with their autumnal colors, and further on to the large, dark patches of aged trees at the top. The two triangular zones unfold like the growth stages of a plant or like the cycle of seasons in general. Klee creates a simultaneous image of the natural cycle of growth and decay.

Set off from the bright and lively middle zone is the vast expanse of the blue mountain. It is a pure pyramidal shape, with a thin blue line marking the ridge of intersection between its two sides. Without disturbing the planar expanse of the blue triangle, the ridge hints at the volume of the mountain rather than defining it. It recalls the linear subdivisions in Matisse's Tangiers paintings, as, for example, the *Entrance to the Kasbah,* 1912 (App. III-5). Klee may have indirectly been aware of Matisse's approach in these paintings via Macke's example. Also reminiscent of Matisse is the combination of ultramarine blue in the mountain with the lighter, slightly reddish blue of the sky. The areas are juxtaposed, yet bound to the same visual plane, in the manner of Matisse's Munich *Geraniums,* 1910 (App. III-5) which Klee could have studied at the Pinakothek.[22]

The peak of the Niesen mountain is located almost in the center of the upper edge of the picture, but the mountain ridge subdivides the composition vertically into two unequal halves. By balancing the coloristic 'weights' on either side, Klee counteracts this unequal division so that the overall composition seems to be almost symmetrical. The three horizontal layers of the composition are stacked above each other. They do not recede into depth. There are subtle spatial effects, but the composition on the whole is rather planar, much more so than a Cubist painting with its manifold overlaps and volumetric effects.

Considered so far, the watercolor is an image of a mountain, transposed from a natural impression into abstract coloristic equivalents. The degree of abstraction is evident in comparison to Cézanne's *Mont St. Victoire* (App. III-44) or Hodler's *Niesen.* As regards composition, Klee's *Niesen* has much in common with Hodler's representation, both in respect to the symmetrical

division of the surface and in the framing forms surrounding the mountain. In Hodler's painting the cloud frame separates the viewer from the mountain, reinforcing the qualities of isolation and distance that the painting projects. In Klee's painting, on the other hand, mountain and color grid are enclosed by the framing forms on the same visual plane, producing the effect of a self-contained world.

Just as the colors of the grid zone can be related to all seasons, the very unspecific blue of the sky might refer to dusk or dawn, rain or sun. Indeed, that Klee wants his colors to hint at all times of day and all seasons is evident from the cosmic signs in the sky, where suns, stars, and the moon are included side by side to symbolize the complete day and night cycle, and in a wider sense the cosmos in its totality.[23] Thus composition, colors, and signs each imply totality and contribute to the character of the work as a microcosmos in itself.

In other respects, too, Klee goes beyond the natural motif. While Cézanne and Hodler monumentalize the mountains they depict by underscoring their massive solidity and weight, Klee's *Niesen* is an immaterial apparition: the mountain occupies the upper half of the picture, its base is not visible, and since Klee explicitly breaks off the contour lines of the mountain, it does not seem to be anchored in the ground. In the foreground the mountain rises from a misty orange area to which access is blocked by the small color rectangles in front. Just as its volumetric quality is ambiguous, the mountain's color surface is neither opaque nor transparent. It hovers immaterially above the color grid zone, as if it were slowly rising upward toward the opening in the band of blue rectangles across the top. This visionary quality relates Klee's painting to Kandinsky's mountain motifs, as well as to Romantic landscapes such as Caspar David Friedrich's *Mountain Landscape, with Rainbow,* ca. 1809 (App. III-25). In Friedrich's painting, which in composition shows a balance and symmetry similar to that of Klee, the mountain in the center rises like an apparition from the indistinct ground. The moon is half concealed behind clouds, but the bright rainbow and the light in the foreground presuppose the presence of sunlight as well,[24] and thus a similarly cosmic dimension is present as in *The Niesen.* The only truly alive object in Friedrich's painting is the small, brightly illuminated figure in the foreground, absorbed in contemplating the inaccessible mountain. In Klee's painting the small fir tree in the foreground, the only natural form amid all the geometric shapes, fulfills a similar *staffage* function. Its left-hand branches are curiously raised as if in an exclamatory gesture and it thus serves as a focal point for the viewer's emotions, similar to the figure in Friedrich's painting. Friedrich's mountain, like Klee's *Niesen,* is based on a specific natural motif, but Friedrich's representation of it emphasizes its intangible, immaterial, 'abstract' character so that it takes on symbolic value. The same is true of Klee's *Niesen:* its symbolic dimension becomes particularly apparent in comparison with

Cézanne's *Mont St. Victoire,* which is clearly a specific mountain squarely planted in its surroundings, or in comparison with Hodler's *Niesen* where the realistic qualities of the mountain image prevail over stylization and symbolic connotations.

Kandinsky's *Blue Mountain* of 1908/09 (Fig. 4)[25] with its curved, organic forms and rich color modulations is superficially closer to nature than Klee's geometric forms. But in proportion and scale of landscape and figures Kandinsky distorts nature, whereas Klee in *The Niesen* creates an analogy to natural relationships which is more 'real' in respect to the *Naturgesetz.* Abstraction and generalization notwithstanding, Klee's *Niesen* is based on acute observation of nature—its proportions and order. Kandinsky's painting is instead a fantasy landscape, the backdrop for the rider scene in the foreground. This mysterious scene has a visionary quality which is further underscored by the deep 'magic' blue of the mountain and the eerie mood in the sky. In Klee's *Niesen* the visionary aspect rests in the apparition of the mountain alone and is not relayed by a figural scene. Although near-symmetrical in composition, Kandinsky's painting is much more restless and tension-laden in its formal character than Klee's. The mountain was a major motif in Kandinsky's work, both in landscapes and in apocalyptic scenes. In the 1913 painting, *Small Pleasures,* (App. III-47) the mountain is the center of gravity surrounded by weightless, whirling forms. Interpretations of *Small Pleasures* vary a great deal. The painting can be considered a personal recollection of simple pleasures but also as a microcosmic reflection of the cosmos in its totality.[26] In both paintings by Kandinsky, agitated, dynamic qualities of form prevail, and there is an unbridled pathos of expression. One could subsume the formal difference between these paintings and Klee's *Niesen* under the terms 'romantic' (Kandinsky) and 'classical' (Klee). 'Classical' however, does not fully do justice to Klee. The qualities of balance and order in his composition as well as the emphasis on the *Naturgesetz* represent the classical aspect of his art, while the transcendental dimension and the color introduce a romantic quality. The introduction of this rather worn pair of art historical blanket terms is justified by the importance that Klee attaches to them in his own thinking. Ever since he had made it his goal to reconcile "architectonic and poetic" painting, the search for a synthesis of the classical-romantic dualism had been at the core of his art-theoretical thinking, and it continued to preoccupy him during the Bauhaus years. In early 1915 Klee felt that he had achieved this synthesis:

> One deserts the realm of the here and now to transfer one's activity into a realm of the yonder where total affirmation is possible.
> Abstraction.
> The cool Romanticism of this style without pathos is unheard of.[27]

In his Bauhaus teaching Klee was later to define "Romanticism" as the dynamic, cosmic forces, unbounded by laws of gravity and earthly fetters. The 'romantic' dimension is imaginable to the human mind, which is bound by gravity, but it is never attainable, except on the symbolic level of the work of art. Klee also associated "Romanticism" with untempered pathos. 'Classical' on the other hand, means earthbound, static, firm, the here and now. Glaesemer has convincingly interpreted Klee's term "cool Romanticism without pathos," as the synthesis of the two dualistic qualities:

> Klee's concept of abstraction, his idea of being "ouside of this world" and his style of a "cool Romanticism" therefore are the expression of his striving to put statics and dynamics into equilibrium, as two antithetical parts of an organic whole.[28]

In *The Niesen* Klee fully realizes the synthesis of romantic and classical aspects, in terms of form as well as content. Static and dynamic forces, such as the horizontal and diagonal compositional lines, are in equilibrium, a balance which is particularly apparent in comparison to Kandinsky's *Blue Mountain* where dynamic, 'romantic' forms prevail. Looking ahead, it may be noted that in 1925 Kandinsky defines his concept of "Romanticism" in terms very similar to Klee's "cool Romanticism" at precisely that period in Kandinsky's development when those formal aspects which Klee circumscribed as 'classical' begin to play a more important role in Kandinsky's art.

The most romantic aspect of *The Niesen,* namely, the color, especially that of the deep blue mountain, has not yet been considered. Klee later remarked to his students that he was rather reserved about blue as a color, perhaps an aversion fostered by the predominant blue-white-green harmonies so familiar from Hodler.[29] The light-blue sky of Hodler's *Niesen* seems bland and placative compared to the mysterious off-colored blue of the sky in Klee's watercolor. The blue of Klee's mountain, like that in Kandinsky's *Blue Mountain,* is deep and of a magic radiance, inviting associations with the blue color of the Romantics and its symbolic connotations. Blue is the noblest color in the color theories of Goethe, Kandinsky, and Marc. Although Klee never developed a theoretical system of color symbolism, he must certainly have been aware of the ideas of Kandinsky and Marc on this subject. Later, in his Bauhaus teaching, he acknowledged his indebtedness to Goethe's and Kandinsky's theories. For Klee, colors represent the dynamic element in art; he shares Kandinsky's ideas on the 'temperature' of colors and on their cosmic character. While the colors in Klee's works often have associative qualities, one can rarely pinpoint their specific symbolic significance, as one can, for example, with Marc. But in *The Niesen* Klee uses color for once very much in the spirit of his Blaue Reiter friends.

Like Goethe, Kandinsky considered yellow and blue the main pair of

colors, the *Urkontrast,* as it were. He defines blue as the heavenly, the most spiritual color:

> Blue tends so much toward depth that especially in its deeper tones it becomes more intensive and characteristic in its inward-turning effect. The deeper its tone, the more do we feel its call to the infinite; it arouses in man the desire for purity and transcendence. It is the color of heaven, just as we imagine it at the sound of the word heaven.[30] [revised]

Marc saw blue in similarly exalted terms as Kandinsky. In a letter to Macke of December 1910 he defined his ideas on the expressive properties of color, saying about blue: "Blue is the masculine principle, restrained and spiritual."[31] Like Kandinsky, Marc considered red and green as the earthly, material colors which have to be counteracted and silenced by the celestial, immaterial blue and yellow:

> With green you can never quiet the eternally material, brutal red, as with the color sounds discussed earlier . . . Green always needs the help of blue (sky) and yellow (sun) *in order to silence matter.*[32]

As Böcklin before them, both Kandinsky and Marc consider blue the quintessentially spiritual, transcendental color. The blue mountain in Klee's *Niesen* has exactly the spiritual, immaterial quality that Kandinsky and Marc associate with blue. It is set in contrast to the 'active' clutter of predominantly red and green color sounds in the fore- and middle ground, which may stand for terrestrial, material life in general.

Operating with complementary colors in the manner of Delaunay's *contrasts simultanées,* Klee introduces in *The Niesen* the totality of the six-partite color circle, much in the spirit of Goethe, who postulated that true harmony is achieved in the work of art by the inclusion of all main colors. In addition to this color harmony, the equilibrium established between 'passive' blues and 'active' reds and yellows, to use Goethe's terms, further underscores the quality of self-contained totality in *The Niesen.*

The Niesen is mountain and pyramid at the same time, just as the mountain in Kandinsky's *Blue Mountain* can be seen as a soft-contour pyramid. The pyramidal form in general is associated with monumentality and with sacral usages. Beyond these general connotations two contemporary *geistesgeschichtliche* sources may cast light on the symbolic dimension of Klee's blue pyramid. Wilhelm Worringer, in his book *Abstraction and Empathy,* with which Klee at this time was certainly familiar, defines the pyramid as the quintessential form of abstraction.[33] Speaking of the Egyptian pyramid he says:

> Our reasons for terming the pyramid the perfect example of all abstract tendencies are evident. It gives the purest expression to them. Insofar as the cubic can be transmuted into

abstraction it has been done here. Lucid rendering of material individuality, severely geometric regularity, transposition of the cubic into surface impressions: all the dictates of an extreme urge to abstraction are here fulfilled.[34]

Klee's pyramid is at once an abstraction from the actual Niesen mountain and a purely abstract form in Worringer's sense. Rising above the lively color zone, which may be interpreted as alpine vegetation but also as the natural cycle of growth and of the seasons (and in the widest sense, as material life in general), the blue pyramid represents the transcendental, spiritual dimension of life. It conjures up Kandinsky's image, in *Concerning the Spiritual,* of the slowly ascending triangle as the symbol of spiritual life. Documenting the spiritual kinship between Kandinsky and Klee, Klee's blue pyramid can be interpreted as the visual embodiment of Kandinsky's poetic vision:

> Everyone who immerses himself in the hidden *internal* treasures of his art is an enviable coworker on the *spiritual pyramid which will reach to heaven.*[35] [Second emphasis mine]

Seen in this context *The Niesen* is Klee's response to Blaue Reiter ideas, on a par with Kandinsky's cover for the *Blauer Reiter Almanac* and Marc's celebrated *Tower of Blue Horses* of 1913. Painted in 1915 when the group had been dispersed, *The Niesen* is Klee's homage to the Blaue Reiter and at the same time its epitaph.

The Niesen accomplishes the synthesis of "architectonic and poetic painting" for which Klee had been searching. It is an image of nature and at the same time an abstract color vision; its formal and conceptual sources lie both in French and in German art. Looking back to the challenge of Hodler's *Niesen,* this intermediary position between French and German art appears to be the common denominator of Hodler's and Klee's paintings and may indeed represent the 'Swissness' of their art.

Excursus: The Esthetic Theories of Friedrich Hebbel as a Source for Klee

The preceding interpretation of *The Niesen* as a pictorial microcosm which represents simultaneously a specific mountain scene, the quintessence of a mountainscape in all its seasons, the cycle of growth and decay, and, ultimately, life in its totality, with the mountain image as a visionary symbol of spiritual life, is founded in Klee's theoretical statements. These statements were not made at the time when he actually painted the watercolor, but rather in his early diary as well as shortly after 1915. In his 1918 essay "On Graphic Art"—discussed below in more detail—Klee makes clear that the work of art can encompass such multiple levels of meaning, and he further expands on this thought in his Bauhaus teaching.[36] However, the concept of the work of art as an organism which is based on and reflects the structural laws of growth

and formation in nature dates back to the early years of Klee's development. In Italy Klee had begun to study the parallels between art and nature along the lines of Goethe and Moritz, thoughts which he developed further during the years in Bern. But it is only when Klee had mastered his abstract language of form that he was able to express his ideas in a work of art in such a way that the viewer could deduce them from the work of art itself.

Before turning to the analysis of Klee's theories in comparison to Kandinsky's, Klee's concept of the work of art as an organism must be further elucidated, as it represents an important difference between his thinking and Kandinsky's thinking. Both artists conceived of the art work as a living entity, a pictorial microcosm in itself. But for Kandinsky the inner order of the microcosm was based on entirely art-inherent laws without relationship to natural laws, whereas Klee saw close analogies between the internal structure of the work of art and the natural organism. Klee defined his concept in an entry for 1903 in his summarized version of the diary:

> Reading Hebbel, Theoretical Writings. . . . Praise of architecture as a school for the plastic arts. The concept of organism. "Nature" as school; it is a delicately meshed organism. Organisms fitted into organisms, so that the part constantly becomes the mother of new parts. Such an insight on the smallest scale is already an example.[37] [revised]

The corresponding entry in the actual diary, in which Klee expands on his observations, explaining how classical architecture had facilitated his understanding of organic relationships in nature, has been discussed earlier (cf. Chapter 1). Klee's theoretical concept of the organism, for which the foundations had been laid in Italy, was further developed through the ideas of the German writer Friedrich Hebbel, to whom Klee felt indebted.[38] In his Bern years Klee avidly read the dramas of Hebbel (1813-1863), as well as his diaries and theoretical writings, and throughout his life he returned to Hebbel's diaries.[39] Hebbel was heir as much to the German Classical-Romantic tradition as he was a precursor of modern nihilism, and this dual orientation may have constituted his fascination for Klee, who had returned from Italy steeped in Classicism, yet wanting to go beyond it, and whose personal outlook on life seems to have been much indebted to Nietzsche.[40]

In his *Theoretische Schriften,* which Klee read in September of 1903, Hebbel defined the work of art as an organism analogous to the natural organism. In his most important essay, "My Word on Drama" ("Mein Wort über das Drama") (1843) Hebbel defines drama, which for him is representative for the art work in general, as a cosmos in itself, which on a symbolic level contains the totality of life, and is composed of elements of varying importance related both to each other and to the whole:

> Even though the basic idea, on which is dependent the dignity and value of a drama and which we take for granted here, provides the encompassing circle within which everything

moves in a planetary fashion, the poet has to provide, without damaging the true unity, a certain measure of complexity, or rather, he has to make us aware of the totality of life and of the world . . . The most perfect image of life results when the relationship between the protagonist and the lesser characters as well as the antagonists is the same as between him and the fate with which he is struggling, and when everything, in this way, down to the smallest subdivisions, develops through and with each other, and is mutually dependent and mutually reflective.[41]

Like the Classicists Hebbel postulates that drama should distill the essential order from life, but he goes beyond them in emphasizing the essentially symbolic nature of the art work and all its elements:

> . . . that drama is symbolic not only in its totality, which is self-evident, but also in each of its elements, and that each element has to be considered as symbolic.[42]

External *Naturwahrheit* is de-emphasized by Hebbel in favor of the internal *Naturgesetz* and its symbolic expression, anticipating to some extent Klee's 1916 concept of "formulas . . . for men, beasts, plants, stones, and the elements and for all the whirling forces."[43] In the analysis of *The Niesen* as a symbolic image of life in its totality, it was pointed out that the watercolor is not only an image of outer life (the mountainscape) but also an expression of the essence of life in general through juxtaposition of material and spiritual life. In this regard it conforms to Hebbel's basic esthetic postulate, with which he begins his essay on drama:

> Art is dealing with life, with inner as well as outer life, and one can say that it represents both forms of life at the same time, the purest form of life as well as its innermost essence.[44]

Art has to represent life in its dual aspects of becoming and being, and in this respect, too, Hebbel anticipates Klee's theories:

> The main elements of art and its laws result directly from the diversity of elements which art in each instance has to take from life and give form to.
>
> Life, however, appears in dual form, life as being and life as becoming, and art solves its task most perfectly if it maintains a measured equilibrium between the two. Only in this way can art insure its present as well as future, which both are of equal importance, only in this way does art become what it should be, that is life within life; for that which is accomplished and completed (*das Zuständlich-Geschlossene*) suppresses the creative breath in the work of art without which it is ineffectual, while that which embryonically convulses (*das Embryonisch-Aufzuckende*) is devoid of form.[45]

The work of art as a living microcosm which reflects the growth process itself and holds a delicate balance between formation and realized form ("Geform-theit"), between static and dynamic elements, is a central concept in Klee's thinking. He formulates it in his diary in 1914: "Genesis as formal movement is

the essential thing in a work,"[46] and he adds in the following entry: "From the genuinely living thing to the objective thing (*zum Zuständlichen*)."[47] Whereas for Klee the act of formation itself is the more essential aspect of the work of art, like Hebbel he acknowledges the necessity of striking a balance between formation (the more or less intuitive creative act itself) and lasting form which Klee calls the "Zuständliches," using a term very similar to Hebbel's "Zuständlich-Geschlossenes." Hebbel sums up his concept of the art work as a mirror of life *per se* in his statement: "Drama represents the process of life *per se*."[48] Similarly, but with greater emphasis on the act of creation itself, Klee in 1916 postulates: "Art imitates creation."[49]

In Hebbel's view the creative process itself is intuitive. It cannot be explained by a knowledge of the laws of formation. In his review of L. Tieck's *Kritische Schriften*, Hebbel states:

> The knowledge alone of the telluric laws suffices as little to explain the process from which results the organism and its greatest miracle, individual life, as does the knowledge of the general categories of the mind for comprehending the process of formation which corresponds in all stages to the process of the creation of life and only repeats it.[50]

And in another essay "Dismissal of an Esthetic Tub-Thumper" ("Abfertigung eines aesthetischen Kannegiessers"), Hebbel speaks of the artist who creates intuitively: ". . . because creation happens in him unconsciously and intuitively, and the artist is only the instrument for transformation."[51] Hebbel thus sees the artist as the instrument and medium of the all-encompassing creative spirit. The artist intuitively comprehends the creative process and can reveal its secrets to the thinkers and philosophers who by way of reason alone can never penetrate to the core of creation. Hebbel's exalted view of the artist is related to Romantic thought. Similarly Klee saw himself as the medium of the spirit; for example, in 1918 he writes in his diary: "My hand has become the obedient instrument of a remote will."[52] Klee's self-definition as an artist will be discussed in greater detail in the next chapter.

Since Klee's relationship to Hebbel cannot be fully explored in this context, suffice it to say that beyond the points discussed Hebbel's esthetic concepts, in which both Classical and Romantic ideas are synthesized, prefigure to a sometimes astonishing degree the views Klee formulated during the Blaue Reiter years and in his Bauhaus teaching. Klee himself refers to Hebbel as the source for his concept of the artistic organism, but beyond that Hebbel seems to have influenced Klee's thinking in general, even if one takes into account that Klee articulated his ideas on the genesis of the art work and on the artist only later, during the war years, and therefore many years after his initial interest in Hebbel's writings. Many of Hebbel's theoretical statements are also expressed in his diaries; since we know that Klee read them often, it is likely that Hebbel continued to exert an influence on Klee's thinking.[53] During

the years in Bern, when Klee was searching for ways of synthesizing Classical and Romantic ideas to give them expression in a new and contemporary form, Hebbel was the author most congenial to his thinking. His ideas prepared the way for Klee's own theories which, although their inception may date back many years, are articulated in his writings only during the war years, in response and reaction to the ideas of his Blaue Reiter friends.[54]

5

Klee's Artistic "Weltanschauung"

While Klee's diary is rather silent concerning artistic matters during 1912 and most of 1913, from 1914 on it is again rich in reflections on art, perhaps as the result of the artistic isolation imposed on Klee during the war.

Klee's metaphysical speculations on the origin and content of art and on the role of the artist relate to the thinking of his Blaue Reiter friends. This relationship is further underscored by the Expressionist language of Klee's wartime diary which is often rather mystical and difficult to interpret. The writings of Kandinsky and Marc and the discussions in their circle must have inspired Klee to formulate his own artistic concepts.[1] The poetic style of his wartime writings demonstrates that Klee was not without literary ambitions.[2]

In the following some major aspects of Klee's artistic philosophy will be considered in relation to Kandinsky's theories.[3] Within the context of this study the question of other possible sources, such as German Romanticism, cannot be explored. The relationship of Blaue Reiter ideas to German Romanticism has been frequently noted.[4] While it appears that Kandinsky was familiar with Romantic ideas only indirectly via their revival and reformulation in Symbolist thought, Klee's writings indicate some degree of familiarity with the original Romantic sources. I suggest that in coming to terms with Kandinsky's theories Klee may have also gone back to Romantic writers, perhaps at the suggestion of Marc, whose thinking most strongly reflects influence from Romantic literature, especially Novalis.[5] However, Kandinsky's writings had the most immediate impact as they were of the greatest actuality and current interest. German Romanticism as well as Hebbel's theoretical writings, which, as was suggested earlier, may have influenced Klee's thoughts, could only offer theoretical concepts, whereas in Kandinsky's work theory and art were congruent. Klee admired this very much in Kandinsky. At this point Kandinsky's provocative ideas and their realization in his art, with which Klee was almost constantly confronted, must have provided more stimulation for his thinking than Romantic thought, especially since Klee was trying to make a place for himself among the German avant-garde. It seems to me that German literary sources from the Classical and Romantic

period were to be of greater importance for Klee later, during the Bauhaus period when Klee expanded and consolidated his artistic theories.

The three main points of Klee's art philosophy to be discussed in relation to Kandinsky are: (1) abstraction, (2) the genesis of the art work and its cosmic character, and (3) the role of the artist. For the sake of clarity they will be discussed separately even though they are interrelated and are articulated by Klee at about the same time. The main sources are Klee's diary of 1913-1917, his correspondence with Marc in 1915, and, finally, Klee's 1918 essay "On Graphic Art," where for the first time he formulates his esthetic concepts for publication. As this essay dates from a period much later than his association with the Blaue Reiter, it shall be discussed separately, as a summary of Klee's thinking at the end of his Munich years.

Abstraction

During the war years Klee frequently uses the term abstraction in his meditations on his own art. In the preceding chapter, where the role of abstraction in Klee's art was discussed it was emphasized that abstraction relates to his formal means but does not necessarily entail the absence of representational references. Although Klee is not an 'abstract' artist in the widespread understanding of the term ('nonrepresentational' or 'nonobjective'), Klee himself defines his art as essentially abstract. His work differs from that of Kandinsky in regard to the visual character of abstraction, but the two artists agree in their general philosophical definition of abstraction. Both view abstraction as the dematerialization and spiritualization of art and as such, the antithesis of naturalism. Klee considers the process of abstraction as a gradual emancipation from nature with the goal of rendering the essential or inner nature of things. (In 1917 he speaks of "abstraction from the transitory.")[6] Kandinsky basically defines abstraction in the same way in his essay "On the Question of Form," where he equates "total abstraction" with "total realism," because both deal with the "inner sound" of things.[7] For Kandinsky the main artistic criterion is the dematerialization of the object in the work of art, which could be attained through various formal approaches, including Cubist geometrical forms.

Klee had long considered line an inherently abstract form element. Its abstract qualities become increasingly important to him. In his diary of late 1913 he discussed the subject matter that currently interested him:

"A flash of lightning in the night: the day screams sharply in its sleep. Mr. Canine Faster, who is invited at Frau Gfeller's for a full plate." Such things I am now able to express with a certain precision, and this by line alone, *line as absolute spirituality, without analytical accessories,* simply taken for granted.[8] [revised, emphasis mine]

The themes Klee describes remind one of Expressionist poetry; as subject matter for drawings they are highly conceptual, even nonsensical. Yet Klee feels that he is able to deal with such fantastic themes in what he considers purely spiritual terms. He wants to directly convey the 'inner sound' of such themes, without having to take recourse in "analytical accessories," i.e., the cubistically dissected representation of material reality. While Cubism 'dematerializes' reality by fragmenting it (according to Kandinsky's explanation), Klee wants to operate directly from his imagination; that is, without depending on reality as the point of departure.

In an entry made shortly after the one cited above, Klee describes his current production:

> Sometimes, a long time passes without struggle. Then I turn out "innocence upon innocence." A naïve style. The will is under anesthesia.[9]

Klee defines his art as the result of inner, more or less unconscious processes, an intuitive method. His view of the artist as the medium for his subconscious is comparable to Kandinsky's concept of the "inner necessity" as the determining factor for the work of art. In *Concerning the Spiritual* Kandinsky states:

> What is artistically right can only be attained by feeling, especially in the beginning of one's development.[10] [revised]

Klee continues his diary entry:

> 1913/162 is a real declaration of love toward art. Abstraction from this world more than a game, less than a failure of the earthly. Somewhere in between. The man in love no longer drinks and eats.[11] [revised]

The pen drawing, 1913. 162 is entitled (*Linear Construction abstract*).[12] I have not been able to find an illustration of it. As it is listed among the drawings of the type of *Song of Lamentation,* 1913. 163 (Fig. 20), it may be stylistically related to this group, but the title also suggests the possibility that it is similar to *Shifting Toward the Right,* 1913. 158 (App. III-17). If we consider the entry in its entirety, Klee states that in following his intuition he achieves works which are successfully "abstracted from this world." Klee associates both the intuitive work process and abstraction with another realm, beyond and above the material world—a spiritual realm where the lover-artist no longer needs physical nourishment. Klee thus equates abstraction with transcending the material world, with spiritualization in the sense of the German word *Vergeistigung.*[13]

After realizing his concept of abstraction in his drawings of 1913, Klee, in

1914, as a result of the Tunis trip, is finally able to also free color of its naturalistic connotations and transpose natural impressions into abstract color equivalents. Glaesemer has described the gradual process of abstraction in Klee's Tunis watercolors as abstraction in terms of purification from all incidental and temporal qualities and as the reduction to the essence of things.[14] Earlier *The Niesen,* 1915 (Fig. 25), was discussed as an example of Klee's mature approach to the transformation of nature into essentially abstract color forms.

The experience of the war furthered the transcendental bent of Klee's thinking. Whereas Marc had embraced the war with mystical fervor as a terrible, but necessary cleansing for Europe, Klee assumed a position of distance from the world. Outwardly showing little concern for the events, he felt himself to be increasingly removed from the real world, transcending its terror. In the first diary entry of 1915 he writes:

> 1915. The heart that beat for this world seems mortally wounded in me. As if the only memories still tied me to "these" things. . . . Am I turning into the crystalline type?[15]

And he continues in the next entry:

> One deserts the realm of the here and now to transfer one's activity into a realm of the yonder where total affirmation is possible.
> Abstraction.
> The cool Romanticism of this style without pathos is unheard of. The more horrible this world (as today, for instance), the more abstract our art, whereas a happy world brings forth an art of the here and now.
> Today is a transition from yesterday. In the great pit of forms lie broken fragments to some of which we still cling. They provide material for abstraction. A junkyard of unauthentic elements for the creation of impure crystals. That is how it is today.
> But then: the whole crystal cluster once bled. I thought I was dying, war and death. But how can I die, I who am crystal? I, crystal.[16] [revised]

Klee here defines abstraction again as transcending this world. Like Kandinsky he views his own time as a transitional period in which the process of abstraction, i.e. purification, has only begun. Klee's views on abstraction relate him to the ideas that Wilhelm Worringer put forth in his 1907 dissertation, *Abstraction and Empathy.*[17] Republished in 1908, the book is a major document for Expressionist esthetics, widely read and discussed by German artists at the time.[18] Worringer was loosely associated with the Blaue Reiter artists, who thought highly of his books. As Worringer's ideas are helpful in elucidating Klee's concept of abstraction, they shall be briefly outlined here.

Taking Lipps's theory of empathy and Riegl's concept of the 'artistic volition' as his points of departure, Worringer postulates that the psychological state of a people and its perception of the world is reflected in its art. To

Lipps's 'urge to empathy' (*Einfühlungsdrang*), which finds its satisfaction in organic beauty, Worringer juxtaposes the 'urge to abstraction' (*Abstraktionsdrang*) which finds beauty . . .

> . . . in the life-denying inorganic, in the crystalline, or, in general terms, in all abstract law and necessity.[19]

The state of empathy, a happy, pantheistic feeling of union with nature and of vitality, generates a naturalistic, sensuous art, an art which is the self-expression of a rational, unspeculative culture like that of classical Greece. The urge to abstraction, on the other hand, is the primary instinct of primitive man, an urge to overcome his *Angst* and uncertainty *vis-à-vis* nature by imposing an anorganic, geometrical order on his art and artifacts, thus bestowing upon them the qualities of rest, order, and permanence which are absent in nature. Abstraction, in Worringer's view, is therefore typical of cultures with a dualistic, transcendental orientation. Oriental art, especially the art of Egypt, is based on the 'urge to abstraction,' not because it is a primitive culture dominated by fear, but rather because of the Oriental insight into the relativity of all things. It stands *above* things and through art it transcends reality by divesting objects of their physical reality. With reference to the German Romanticists, Worringer suggests that modern man, after thousands of years of rationalistic search, has finally come around to the ancient Oriental insight that he cannot comprehend the mysteries of the world. While Southern cultures, like that of Antiquity and the Renaissance, are based on empathy, and those of the Orient on "crystallinic" abstraction, the Northern primitive cultures and the culture of the Gothic period are characterized by a dual urge toward both empathy and abstraction.[20] The uneasy balance of naturalistic and abstract elements imbues the art of the North with a strongly expressive quality that reflects Northern man's anxiety and alienation amid a harsh, even hostile nature:

> The lucid consciousness of the impossibility of knowledge, absolute passive recognition, had led Oriental artistic volition to that expressionless tranquillity and necessity of the abstract; here in the North, however, there is anything but tranquillity; here an inner need for expression desires, in spite of all inner disharmony—or rather all the more so because of it—to speak itself out.[21]

German Expressionism in general has the qualities that Worringer associates with the Northern type of 'urge to abstraction.' Klee's remarks on the art of a "world full of terror" refer to abstraction in this sense, as does his description of the transitional phase of "impure crystals." Klee himself, however, has transcended this stage; he associates himself with the "crystallinic" type of oriental abstraction which stands above things and is no longer affected by the

turmoil of the world. In Tunis, Klee had experienced the Orient and he had asked himself if that was not his true spiritual home.

In the discussion of *The Niesen* the Egyptian pyramid as the embodiment of crystallinic abstraction was cited and it was pointed out that the form qualities which Worringer associates with the pyramid were also present in Klee's painting. Here only the question of space shall be considered. Worringer defines "dread of space" (*Raumangst*)[22] as one of the main motivations for the 'urge to abstraction.' Voluminous form as well as the complex relationships of form in space are too closely related to physical reality, therefore the 'urge to abstraction' in art seeks to counteract such effects as much as possible by flattening out forms and ordering them in terms of clear, if anorganic relationships. Egypt solved this problem best with the relief style, and Worringer cites Hildebrand as a modern artist who resorts to the relief style in order to reduce the ". . . agonizing quality of the cubic" in his sculpture.[23] Throughout the preceding chapters it was noted that while adopting Cubist shallow space Klee avoids the use of Cubist facets and *passage* as definitions of volume, thus avoiding exactly those formal means by which Cubism reaffirms its relationship to the reality of the objects depicted. Possibly taking his cue from Worringer's book or intuitively guided by his own 'urge to abstraction,' Klee eschews precisely what may be called the "empathetic" qualities of Cubism. Instead, he adopts the Cubist grid and the geometric forms which enable him to create a "crystallinic" art marked by transparent clarity and repose and based on an essentially anorganic formal order.

Klee concludes the diary entry which was cited above:

> And to work my way out of my ruins, I had to fly. And I flew. I remain in this ruined world only in memory, as one occasionally does in retrospect. Thus, I am "abstract with memories."[24]

The last sentence very succinctly defines Klee's concept of abstraction. As an artist he feels no longer bound to the material world, but neither does he turn completely inward and away from it—which Kandinsky wanted to do; instead he places himself at a point beyond, transcending the world, as he quite literally implies with the metaphor of flying. Objects continue to exist in his art only as "memories," experiences filtered through his mind and soul, abstracted and immaterialized in the process. As such "memories" they rise from his subconscious and take on a life of their own; in 1917 Klee speaks of his art as a "a long deep gaze inward,"[25] [revised] and in 1918 he says about works he has just completed: "My hand has become the obedient instrument of a remote will."[26] Because of his inner distance from reality he no longer perceives objects as individual beings or even as species but feels that he penetrates to the very core of their existence. Klee defines his transcendental position in the well-known

diary entry of 1916 in which he differentiates between himself and Marc, who is more earthbound, more loving and empathetic:

> I place myself at a more remote starting point of creation, where I assume *a priori* formulas for men, beasts, plants, stones, and the elements, and for all the whirling forces.[27]

Like Kandinsky, Klee looks on abstraction as an act of purification and dematerialization; abstraction for him is a means of revealing a higher truth, the spiritual, inner qualities and the cosmic origins of things, or that which Kandinsky defines as the "sound" of things. Whereas Kandinsky sees the purest manifestation of the inner sound in abstract forms with no, or relatively little, representational connotations, Klee emphasizes the associational dimensions of his conceptually abstract forms. While Kandinsky increasingly focuses on his inward vision, Klee synthesizes his perception of the outer world with his inner vision of the world as a cosmos and as a universal order. In speaking of his 1917 watercolors painted in the Lechauen, the meadows along the border of the Lech River, Klee himself defines this synthesis of outer and inner vision:

> The last one, painted in the evening, completely captured the sound of the miracles around me; at the same time it is thoroughly abstract and thoroughly this Lechau region.[28]

Genesis of the Art Work and Its Cosmic Character

After the Tunis trip in 1914 many of Klee's diary entries take on the form of Expressionist poetry. At times his highly poetic language, with its combination of pathos and humorous, even banal imagery, recalls the style of Kandinsky's poems in *Klänge*.[29] In a number of these diary entries Klee contemplates the creative process. Already in Italy and later in Bern Klee had become acquainted with Goethe's concept of the work of art as a microcosmic organism, and with Hebbel's ideas on the genesis of the work of art. In his diary of 1914 Klee takes up these themes again, but the manner in which he formulates his concepts indicates that his thinking is now also stimulated by Kandinsky's theories.

Whereas Hebbel, in discussing the genesis of an art work, had emphasized the balance between being and becoming, Klee puts more stress on the becoming of the art work, on the dynamic aspect of creation.

> In my productive activity, every time a type grows beyond the stage of its genesis, and I have about reached the goal, the intensity gets lost very quickly, and I have to look for new ways. It is precisely the way which is productive—this is the essential thing; becoming is more important than being.[30]

Klee's emphasis on the creative process itself, on its continual growth and change as well as on the living nature of the art work connects his thinking with that of Kandinsky, who continually warns against forms "hardening," becoming lifeless. Kandinsky sees both the individual work of art as well as art in general in a continual process of evolution. He describes this general evolutionary process in his essay "On the Question of Form":

> All evolution, which is internal development and external culture, is thus a shifting of obstacles. . . .
> Obstacles are constantly created from new values that have pushed aside old obstacles.
> We see that basically the most important thing is not the new value, but rather the spirit that has revealed itself in the new value. And the freedom necessary for the revelations.[31]

In one of the last entries before the outbreak of the war Klee again discusses the genesis of the art work:

> The creation lives as genesis beneath the visible surface of the work. All intelligent people see this after the fact, but only the creative see it before the fact (in the future).[32]

His last sentence corresponds closely to Kandinsky's vision of the spiritual life which he circumscribes with the image of an ascending triangle: only the artist can look ahead and guide the rest of mankind; the people in the triangle section below the artist, even though they are spiritually-oriented people, can only comprehend what is already accomplished.[33]

In the first sentence of his diary entry Klee suggests that creation in general is reflected in the 'genesis' of the art work and continues to be present in the work; so that the work of art is a living entity in itself, a mirror of creation and as such, a part of the cosmos. Kandinsky defines the work of art in similar terms. In his 1914 notes for the Cologne lecture he states: "The genesis of the work thus is of cosmic character."[34] Furthermore, in *Concerning the Spiritual* he defines the work of art as a being of its own:

> The true work of art is born "of the artist" in mysterious, enigmatic, mystical ways. Detached from the artist, it acquires an autonomous life, becomes a personality in its own right, turns into an individual, spiritually vibrant subject, which also leads a materially concrete life, it is a *being* in itself. . . . It exists and is productive and it plays an active role in creating the spiritual atmosphere that was spoken of earlier.[35] [revised]

In another diary entry, written after the outbreak of the war, Klee makes his comparison of artistic creation with the genesis of life more specific:

> Genesis as formal motion is the essential thing in a work. In the beginning the motif, activation of energy, sperm. Works as shaping of form in the material sense: the primitive female component. Works as form-determining sperm: the primitive male component. My drawings belong to the male realm.[36] [revised]

By likening the artistic process to the process of procreation, Klee divides it into two aspects: the original creative impulse (i.e. the conception), and the production of form itself, the materialization of the art work. The latter aspect plays a secondary role in Klee's thinking; he even implies that, to a degree, the materialization of the art work detracts from the purity of the initial creative impulse:

> The shaping of form is weak in energy in comparison with the determining of form. The final consequence of both ways of forming is form. From the ways to the end. From activity to the accomp. ʒhed. From the genuinely living thing to the objective thing *(Zuständliches)*.
> In the beginning the male speciality, the energetic stimulus. Then the fleshly growth of the egg. Or: first the bright flash of lightning, then the raining cloud.
> When is the spirit at its purest? In the beginning. Here, work that becomes (dual). There, work that is.[37]

In his essay, "On the Question of Form" Kandinsky had discussed the creative process along similar lines. Like Klee he saw the creative spirit as the central force, existing in itself, which takes on material form in the work of art. For Kandinsky, too, the material form is often an impediment for the perception of the true spirit:

> . . . the creative spirit (which could be called the abstract spirit) makes contact with the soul. . . Consciously or unconsciously man tries, from this moment on, to find a material form for the spiritual form, for the new value that lives within him.
> This is the search by the spiritual value for materialization. Matter is a kind of larder from which the spirit chooses what is necessary for itself, much as cook would.
> This is the positive, the creative. This is goodness. The white fertilizing ray.[38]

Kandinsky's term "the white fertilizing ray" is comparable to Klee's "form-determining sperm." Ringbom has suggested that Kandinsky's expression may have been inspired by Blavatsky's comparison of theosophy to a white ray of light.[39] My contention that Klee's formulation of his theories is indebted to Kandinsky's writings would confirm Ringbom's general suggestion that Klee was indirectly—and unwittingly—influenced by theosophy via Kandinsky. The division of the work of art into the two aspects of the pre-existing spirit and its material form relates to theosophist ideas as well as to Romanticist philosophy. This notion is more pronounced in Kandinsky's thinking than it is in Klee's. For both, however, the preeminence of the spirit as the life-giving force in the art work is crucial. Kandinsky continues in his essay:

> This white ray leads to evolution, to elevation. Behind matter, within matter, the creative spirit *(Geist)* is hidden.
> The veiling of the spirit in matter is often so thick that, generally, only a few people can see through it to the spirit.[40]

In the material form of the art work the creative spirit is most strongly manifest in abstraction. For Kandinsky it is abstract form in general, which represents the spiritual, abstract element, while for Klee it is line. Line for Klee is intuitive expression and therefore the purest manifestation of the creative spirit.

It is instructive to compare the language of Kandinsky's and Klee's statements. Kandinsky conceives of the *Geist* as if it were something like the Holy Ghost, a force existing in itself which takes hold of certain select souls. Klee, too, considers the artist as a select being, closer to God than others, but for him the creative spirit is directly inherent in the artist himself. Kandinsky describes the conjunction of spirit and matter in the art work with a curious mixture of lofty pathos ("the white fertilizing ray") and simplistic, but very graphic images (the cook). Such a combination of unrelated images is characteristic of his language. He conjures up an indistinct vision of his ideas rather than presenting them in a logical train of thought. Klee, conversely, expresses an equally complex and mystical concept of artistic creation in terms of a very poignant analogy with procreation. He provides not only an easily understood definition of artistic creation as he sees it, but by equating artistic creation with procreation in nature he also puts forth his view of the art work as a living microcosmic entity analogous to the natural organism. His secondary definition, a comparison with lightning and the rain following it, is also taken from nature. Although Klee's speculations on the creative process are rather mystical, his choice of metaphors makes them seem quite self-evident and almost logical. These observations on the writing styles of the artists can by extended to describe a basic difference between their artistic approaches: while Kandinsky's works and writings are often enigmatic and even nebulous, Klee uses expressions and graphic images which *seem* to be immediately accessible and clear in their meaning. Upon closer scrutiny, however, it becomes evident that Klee's underlying ideas are often as complex and esoteric as are Kandinsky's.

In "Reminiscences" Kandinsky defines his concept of the art work as a microcosmic image of the cosmos:

> Painting is a thunderous collision of different worlds, intended to create a new world in, and from, the struggle with one another, a new world which is the work of art. Each work originates just as does the cosmos—through catastrophes which out of the chaotic din of instruments ultimately create a symphony, the music of the spheres. The creation of works of art is the creation of the world.[41]

In a 1916 diary passage in which he compares himself with Marc, Klee states: "Art imitates creation."[42] Marc and Macke as well as Kandinsky, expressed similar ideas. Marc wrote in a 1915 letter to his wife: "Art . . . is simply the symbolic act of creation."[43] And Macke wrote in a 1913 letter to the collector Bernhard Köhler:

> The work of art is an analogy of nature, not a likeness (if it were a likeness, we would have to be God ourselves and create trees and people with flesh).[44]

Although Klee's poignant formulation was to become the most celebrated and widely cited, he only articulated an idea that all the Blaue Reiter artists shared. What set Klee apart from the others is that he came to base artistic creation very specifically on what he considered the formative laws of nature. However, in regard to rhythmic relationships Macke also made such an analogy in the conclusion of his letter:

> The work of art represents our experiences, our wonderment about the proportions of things, the rhythm in a work of art is an analogy for the rhythm in nature itself.[45]

Kandinsky's and Klee's views differ to some extent in respect to the nature of cosmic creation. Kandinsky describes creation as the clashing of chaotic forces, whereas Klee conceives of it in terms of an ordered progression and balancing of forces. In general, however, Klee shares Kandinsky's concept of antitheses ("Gegensätze"), of dualistic forces, as the basic principle of creation for the cosmos as well as its microcosmic reflection, the work of art. Both consider the dualism of forms in the work of art as representative of the basic dualistic forces in the cosmos: order—chaos, life—death, good—evil, etc. In *Concerning the Spiritual* Kandinsky defines the colors white and black as birth and death, and in his diagram of the color circle he equates the circle with the entire cycle of life: "The antitheses as a circle between two poles, i.e., the life of the basic colors between birth and death."[46] [revised] Antitheses and contradictions of form were the central tenet of Kandinsky's compositional esthetic. The principle of antithetical composition also plays an important role for Klee. In late 1913 Klee discusses his own compositions:

> The small-scale contrasts together compositionally, but also large-scale contrasts; for instance: confront chaos with order, so that both groups, which are separately coherent, become related when they are placed next to or above each other; they enter into the relation of contrast, whereby the characters of both sides are mutually heightened.[47]

Although Klee in this entry speaks of formal problems of composition, his later remarks indicate that such compositional principles attain a metaphysical dimension. In a diary passage preceding the one concerning the genesis of art, Klee imagines himself to be God. Being God, he would help those praying to him, the just and good ones, but he would also let the evil forces coexist:

> ... for I know full well that the good must be maintained in the first place, but that it cannot live without the evil. In each particular case therefore, I would order the proportionate weights of the two components, so as to make things to a certain degree bearable.[48]

Couched in ethical terms, the passage defines Klee's basic compositional principle—the precarious balancing of dualistic, contrasting elements.

Kandinsky felt that in his time, catastrophic as it was, the antitheses and contradictions in his compositions should not be resolved and harmonized:

> The strife of sounds, the balance we have lost, tumbling "principles," unexpected drumbeats, great questions, apparently aimless striving, seemingly torn impulses and longing, broken chains and bonds which unite several into one, antitheses and contradictions—these make up our harmony.[49][revised]

Klee, whose esthetic principles are marked by his 'classical' orientation, wants to balance and synthesize the dualistic aspects. In 1917 he once more defines his concepts of composition in terms of ethical categories which represent the antithetical elements. Speaking of paintings he is working on he says:

> New work is preparing itself; the demoniacal shall be melted into simultaneity with the celestial, the dualism shall not be treated as such, but in its complementary oneness. The conviction is already present. The demoniacal is already peeking through here and there and cannot be suppressed. For truth asks that all elements will be present at once.[50][revised]

The Role of the Artist

"I, crystal;" with these words Klee ended his 1915 entry on abstraction. Just as abstraction means for him the dematerialization and spiritualization of art, he feels that as an artist he shares this 'abstractness'; i.e. that he has transcended material reality and shaken off all earthly fetters. Klee likens his nature to that of the crystal (the stone of the seers), which displays utmost purity and clarity, and he defines himself as the "crystallinic type" in Worringer's sense. That "crystallinic" can be equated with Kandinsky's term 'spiritual' becomes evident from Klee's comparisons of himself with other artists.

In 1915 Klee criticizes his friend, the sculptor Hermann Haller, for having excessively pursued the excitement of physical, worldly pleasures and for having neglected his "active spiritual development."[51] In contrast, Klee himself had turned inward and had become a kind of monk ever more concentrating on the essentials: "Here too I struggled away from memories, down toward the essence, and to a considerable depth, at that."[52] Klee looks upon his own development as a spiritual growth toward the essential, deeper truths, and toward transcendental dimensions. Klee remarks that Kubin, in contrast to Haller, had attempted to follow the same path as he himself and had tried to liberate himself from reality by fleeing this world, without, however, entirely succeeding:

> He [Kubin] remained stuck halfway, yearned for the crystalline, but could not tear himself out of the sticky mud of the world of appearances.[53]

In the subsequent entry Klee discusses Rilke, whose acquaintance he had been very pleased to make. But after reading some of Rilke's works he becomes somewhat critical of the poet. To his mind Rilke is still overly bound to the appearances of the material world:

> His sensibility is very close to mine, except that I now press on more toward the center, whereas his preparation tends to be skin-deep. He is still an Impressionist, while I have only memories left in this area.[54]

Klee's self-definition as an artist is further elucidated by a three-way debate between him and Franz and Maria Marc which took place in conversations and in letters in the spring of 1915. The controversy also casts light on Klee's attitude *vis-à-vis* Kandinsky.

While Marc was in the field, Maria Marc had been involved in long discussions about art with the composer Kaminski. Apparently at Kaminski's suggestion she had read Tolstoy's *What Is Art* and she had been deeply shaken by views expressed in the book.[55] Marc had read it earlier, but in order to respond to Maria's arguments he reread it and commented on it at length in his letters.[56] Tolstoy, who took a strongly anti-symbolist stance, postulated that art was not to be concerned with beauty, but that the artist should communicate basic emotions to *all* people, not just a select class of aesthetes.

> To evoke in oneself a feeling one has once experienced, and having evoked it in oneself, then, by means of movements, lines, colors, sounds, or forms expressed in words, so to transmit that feeling that others may experience the same feeling—this is the activity of art.[57]

Taken out of context, Tolstoy's words seem to prefigure Kandinsky's ideas. However, Tolstoy was thinking rather in terms of folkloristic, realist art dealing with simple Christian feelings, an art which could be easily understood by uneducated people. He postulates:

> Art of the future, that is to say, such part of art as will be chosen from among all the art diffused among mankind, will consist not in transmitting feelings accessible only to members of the rich classes, as is the case today, but in transmitting such feelings as embody the highest religious perception of our times. Only those productions will be considered art which transmit feelings drawing men together in brotherly union, or such universal feelings as can unite all men.[58]

Moved by Tolstoy's quest for truly social relevance, Maria Marc apparently attacked Kandinsky (and with him the whole circle) for his elitism and for focusing too much on personal feelings. She seems to have felt that in its self-centered Romantic exclusiveness the circle was unable to reach others and failed to be generally relevant and comprehensible.

Although Marc discounted Tolstoy's demand for a kind of Christian folk art as shallow and simplistic, he was affected by Maria's questioning of his own direction. In his art he wanted to express his pantheistic religious feelings and communicate them to others. It appears that Maria doubted the validity of abstraction for the communication of such feelings, for in his replies Marc defends both Kandinsky and the concept of abstraction. As with Kandinsky and Klee, form for Marc is a function of emotion in its widest sense: "Form is the natural result of an emotion."[59] Marc, like Kandinsky and Klee, believes that abstraction transcends nature and reveals a deeper, mystical truth which represents "something which is universally valid and unifying."[60] It had been Kandinsky who had pointed the way, and Marc defends him against Maria's reproach of self-centeredness and egotism:

> There is no doubt that Kandinsky has come close to this goal of truth—that is why I love him so much. You may be right that as a person he is not pure and strong enough, and therefore his emotions may not be generally valid, but may only be relevant for sentimental, sensually nervous, romantic people. But his striving is wonderful and it is full of lone grandeur.[61]

Like Kandinsky, Marc, too, feels that seekers in art, among whom he counts van Gogh, Hokusai, Klee and others, are at first understood only by the very few. However, he does agree with Maria that the egos of modern artists take too preeminent a place in their art. His agreement with Maria on this point and his approval of Tolstoy in other regards led to certain misunderstandings with Klee.

Klee had been rather aghast about Maria Marc's ideas.[62] He had entered into debates with her primarily in order to help her regain her balance and to keep her from turning against her husband in this matter. From what Maria told him about Marc's responses to the Tolstoy question, Klee gained the impression that Marc was turning against the ideas they shared before the war and that Marc was becoming critical of Kandinsky. In order to clarify matters, Klee overcame his dislike of writing and wrote a lengthy letter to Marc, on April 14, 1915:

> Your wife is urgently searching for a critical position from which the questions of art can be solved. But I cannot go along with her in this regard. Whatever practical results there were, such as the disavowal of the entire Romanticism, I found outrageous. To think of Kandinsky as purely sensual painting!!

And he ends:

> For a warrior on the battlefield it may well be incomprehensible that somebody else can be watercoloring and playing the violin at this point in time. And yet I find both things very important! In general the self! And Romanticism![63]

Unlike Marc, Klee felt not in the least affected by Maria's Tolstoyan quest for social relevance in art. Klee was concerned with the production of his art, not with its reception. The public had to learn to understand him, not vice versa.

In his reply to Klee's letter, Marc disavows Maria's Tolstoyism and reaffirms his admiration for Kandinsky, but he does share some of Maria's concerns, especially in regard to the artist's ego:

> But in the final analysis the true matter of conscience is the quest for the essence, for the heart of the matter, not your "the self and Romanticism:"! . . .
>
> If the Self is considered more important than the *cause* itself, it will result in bad, impure art. The artist is the medium and he creates unselfishly. . . This selfishness, this basic root of our European impurity and impiety, how can it be eradicated?[64] [revised]

In his answer to Marc's letter Klee clarified his concept of the self and he thanked Marc for his belief in Kandinsky:

> Therefore I am very grateful to you for expressing your conservative attitude towards Kandinsky. For it is the "application" which is most important to me: the works.[65]

Klee's remarks testify to his admiration for Kandinsky and to his commitment to Kandinsky's ideas and their realization in his art. To clear up Marc's misunderstanding of "the Self and Romanticism" Klee adds:

> Of course I am referring to the divine self as the center. For me this is the only reliable criterion and my trust in others rests in the common domain of two selfs. . .[66]

In his diary Klee paraphrased this letter in an instructive way:

> Then I defended the self, distinguishing between a selfish ego and a divine self. This self, I explained, was the only reliable element in the entire matter of creative art.[67][revised]

In Klee's thinking is reflected the Romantic concept of the divine spirit which is present in the artist, enabling him to reveal a higher truth in his art.[68] Its embodiment in his art is the basis for the communication between artist and viewer. Equally Romantic as Klee's "divine self" in its ultimate origins is Kandinsky's concept of the "spiritual" which preexists before it is embodied in the art work through the medium of the artist. In the notes for the Cologne lecture Kandinsky states:

> The origins of the work of art are of cosmic nature. Therefore the spirit is the author of the work. So the work exists abstractly before its embodiment which makes it accessible to the human senses.[69]

Kandinsky sees the artist as the medium of transmission for the spirit. Similarly Klee, in defining himself as a crystal which gathers and reflects the (divine)

light, considers himself as the vessel or medium of the spirit. In *Concerning the Spiritual* Kandinsky speaks of that which Klee calls the divine in the artist. There are three "mystical necessities" which determine the work of the artist, of which the third one is the most elevated:

> 3. Every artist, as a servant of art, must express that which is generally valid in art (this being the element of the purely and eternally artistic, which is constant in all ages and among all nationalities, found in each work of art and at all times. As the main element in art it knows neither time nor space).[70]

All three artists realized they were understood only by a few people, but they also felt that this happens to all visionaries. Each of the three believed that art had a religious, revelatory function: Marc proclaimed that the new art should be placed on the altars of a new religion and mysticism. Kandinsky speaks of the artist as the "priest of beauty" and the only one who can understand the message which the "invisible Moses" brings down from the mountain,[71] and Klee describes himself as a monk. The difference between priest, whose function is 'extroverted,' i.e. directed toward the people, and monk, who leads an introverted life in cloistered isolation, is quite characteristic of the divergent attitudes of Kandinsky and Klee toward their public. Convinced of his messianic role and the evangelical function of his art, Kandinsky comforted himself in face of the hostility which his art provoked by recalling Beethoven who had been equally misunderstood. Marc, on the other hand, desparately wanted to open people's eyes to the new art and he was torn by self-doubts as to the rightness of his chosen path.[72] Of the three, Klee, although eager for recognition and a (buying) public, was the most self-contained and aloof. He felt little messianic zeal and he accepted his remoteness from other people. In the 1916 diary entry about Marc and himself he writes:

> I only try to find a place for myself near God, and if I am related to God, I don't fancy that my brothers are not also related to me; but that is their business.[73] [revised]

Klee's 1918 Essay, "On Graphic Art" ("Über Graphik")

In the fall of 1918 Klee for the first time formulated his thoughts on art in an essay intended for publication.[74] The published version of the essay is usually cited under the title "Creative Credo" ("Schöpferische Konfession"); the following discussion, however, is based on the draft version of the essay as it is closer to Kandinsky's thoughts in language and in some ideas. Possibly Klee worked on the draft version under the immediate impact of reading or re-reading Kandinsky's 1913 essay, "Painting as Pure Art" ("Malerei als reine Kunst"), which had been reprinted in H. Walden's 1918 publication *Die*

Kunstwende. Klee mentions receiving the book in the same diary entry (Sept. 19, 1918) in which he states: "The first draft of my essay for Edschmidt is already finished."[75] Only in the next entry, dated September 24, does Klee directly mention the Kandinsky essay, praising it very highly:

> In the *Kunstwende* yearbook, the excellent essay by Kandinsky surpasses everything else, it is so simple and at the same time so spiritual. Perfectly designed to persuade, sheerest clarity. And people are screaming for clarification! A phrase like "the work of art becomes the subject" says it all. And the whole course of the argument is so gentle and calm.[76] [revised]

Klee's remarks document again the extent of his admiration for Kandinsky and his agreement with the latter's ideas.

In a letter to his son Felix of November 3, 1918 Klee writes: "The essay about graphic art, which I am writing for a book, is likewise almost finished now."[77] It is not clear whether Klee is referring to the draft version, which was written in several stages, or to the final version. The relatively few corrections and the clear organization of the extant draft version make it seem possible that it had been preceded by still earlier notes or drafts. From the chronological evidence given in the diary it appears that Klee read or re-read the Kandinsky essay *after* having written the first draft of his own essay. Because much of Klee's wartime diary is copied from letters to his family, his praise of Kandinsky's essay might well be based on a letter and could postdate his actual reading of it by some time.

With the available chronological information it cannot be definitively established at what point during this work on the essay Klee read Kandinsky's essay and if it had an immediate influence on his own formulations. More significant is that when Klee read the essay he felt that it confirmed his own thinking and answered his own questions. The preceding discussion already showed how much Klee was in accord with Kandinsky on questions of art philosophy. After the death of his friend Marc, to whom Klee had felt close on a personal level but with whom he differed on artistic questions, Klee's thoughts appear to have often turned to Kandinsky whom he was hoping to meet again.[78]

Klee begins his essay by defining *Graphik*—i.e. graphic techniques and drawing—as the medium which tends most toward abstraction and for this reason is highly esteemed by the time. Like Kandinsky, Klee feels that in his time there is a general move toward abstraction and the reaffirmation of spiritual values. Already earlier, at the beginning of the war, Klee had claimed that during fearful periods the urge toward abstraction preodominates.

Graphic art in its pure form is anti-realistic:

> Graphic art in principle is suited for rendering the objective more unreal, fairy-tale-like and more nonrepresentational, and all this with much greater precision.[79]

For Klee the graphic means are ideally suited for what he considers the transitional stage in abstraction, where the object is veiled or presented in near-hieroglyphic, enigmatic fashion in order to counteract illusionistic, i.e. materialistic effects. Kandinsky, in *Concering the Spiritual*, had proposed a similar approach to the representation of the object in the transitional stage.[80]

Klee demands that graphic elements maintain their pure form character; that they should not be combined into seemingly realistic depictions:

> Pure art results when the expression of the form element and the expression of the formal organism are obviously identical with the spirit.[81]

In his "Painting" essay Kandinsky formulates this basic tenet of his theory in a similar way:

> Therefore the work of art is an indivisible fusion of the inner and outer elements, of content and form. The content is the decisive element. Form is the material expression of the abstract content.[82]

Both Kandinsky and Klee define the work of art as an organism in itself. Kandinsky, in the "Painting" essay, states:

> Therefore a beautiful work of art is a lawful combination of the inner and the outer element. This union gives the work its homogeneity. The work of art becomes the subject. As a painting it is a spiritual organism which, just like each material organism, consists of many individual parts. These individual parts, taken separately, would be lifeless like a cut-off finger. The life of the finger and its useful effect depends on the lawful connection of the finger with the remaining parts of the body. *This lawful combination is the construction.* The work of art is subject to the same law as the work of nature: it is subject to construction. The individual parts come to life only in their totality.[83]

Taken by itself, out of the context of Kandinsky's theories, this statement is surprisingly similar to Klee's concept of the analogous construction of pictorial and natural organisms. However, as was pointed out earlier, Kandinsky sees a relationship between artistic and natural creation only in a very general sense, and not in respect to specific formation. For him the 'construction' of art work is based on art-inherent laws; 'construction,' in fact, is understood by Kandinsky as the "purely artistic" of the art work, its abstract dimension which is not related to nature except in the widest, i.e. cosmic, sense. In this regard Klee's definition of the pictorial organism differs from that of Kandinsky:

> With an organism the relationship of the parts to the whole is based on self-evident proportions. These are based on small numbers.[84]

Whereas Kandinsky does not specify what the basis for the "lawful combination"of the elements of the pictorial organism is, Klee speaks of the "relationship of the parts to the whole based on self-evident proportions"—for him the relationship of the parts to the whole is visible and measurable. Within the pictorial organism the elements are microcosmically related to the whole. The word "self-evident" implies this important difference in Klee's ideas and it is further underscored by the sentence: "These are based on small numbers." Speculations on numerical relationships in art were frequent at the time, with the Symbolists as well as with theosophists and some of the Cubists. In *Concerning the Spiritual* Kandinsky, in speaking of the "laws of harmony (Harmonielehre) in painting," proclaims: "The final abstract expression of every art is number."[85] The specific nature of such numerical order, however, remains mysterious and vague. Klee, on the other hand, points to clear numerical relationships ("small numbers") which the viewer might be able to discern in the work. That Klee indeed considered such numerical relationships an essential aid in his work is corroborated by his later remark to his students that he often found himself counting more or less unconsciously during his work.[86]

In the second section of his essay Klee discusses the graphic elements: "The form elements of graphic art are points, linear, planar, and spatial energies."[87] Klee's analysis of these elements prefigures many of the ideas proposed later in the *Pedagogical Sketch book*. Klee defines line as a point set in motion, as Kandinsky had done in "Reminiscences" where he stated: "Thus every still and every moving point (= line) became equally alive and revealed its soul to me."[88] During the Bauhaus years both artists were to elaborate on their ideas about the character of the form elements, but perhaps Klee and Kandinsky had already discussed these questions earlier, since Kandinsky had long been planning to deal with them in a sequel to *Concerning the Spiritual*. At Goldach on Lake Konstanz, where Klee visited him in September of 1914, Kandinsky was working on his notes for what was to become *Point and Line to Plane*.[89]

Klee demonstrates his idea of the graphic elements by drawing an imaginary picture for the reader, wherein the adventures of a journey are described in terms of lines and patterns that can be associated with the protagonists and their actions (for example, wavy lines evoke the association with a river). The resultant drawing would be essentially abstract, but the form elements have an associational dimension which inspires the viewer to read meaning into them. Klee operates basically on the *Klang* principle of Kandinsky's color theory (that is, each color or form has its specific 'sound' which adapts to different contexts), but in contrast to Kandinsky, Klee encourages the viewer to associate the forms with objects and figures, whereas Kandinsky wants to lead the viewer away from a figurative reading of his colors and forms.

A major difference in Klee's and Kandinsky's concepts of the pictorial organism is to be found in their views concerning the time element in art. Klee puts great stress on temporal sequence in the production and perception of the art work: "Motion is the basis for the becoming of all things."[90] The viewer is to trace the 'genesis' of the picture in slow, extensive contemplation. Earlier, Klee had compared his concept of the time element in painting to music to which the dimension of time is inherent.[91] He believed that modern painting had an advantage over music because it could include the past and the future and thus produce a complex 'polyphony.' Kandinsky had arrived at the opposite conclusion:

> Music, for example, has at its disposal duration of time; painting, in not having this distinction, can present to the spectator the whole content of its message at one moment, of which music in turn is not capable.[92][revised]

However, in a footnote Kandinsky already qualified this statement, and he was later to change his mind on the question.

Klee's emphasis on temporal progression in the art work is important not only in formal, but also in a philosophical respect: on the formal level it implies that the artist must make visible the temporal sequence of the 'growth' of an organism, be it in nature or in art, and that he is able to introduce various stages of growth and time simultaneously (Klee uses the example of the seed, blossom, and fruit of an appletree which can be all depicted simultaneously). On the theoretical level the temporal movement in in the work of art symbolically represents the motion and dynamic nature of the entire cosmos:

> In the cosmos, too, motion is the primary condition. Rest on earth is an incidental inhibition of matter. It is a fallacy to take this tenacity for a primary phenomenon.
> The genesis of writing is a very good example for motion. The work of art, too, is above all genesis, it is never experienced as a product.[93]

Klee's emphasis on the dynamic character of the art work and its symbolic function connects him with the ideas of German Romanticism.[94]

While they disagree on the modus of perception and on the temporal dimension of the work of art, Kandinsky and Klee discuss the creative impulse and its communication to others along similar lines. In the "Painting" essay Kandinsky states:

> The work of art consists of two elements: of the *inner* and of the *outer*. The inner element, taken by itself, is the emotion in the artist's soul. This emotion is able to call forth what is basically a corresponding emotion in the soul of the viewer. As long as the soul is bound to the body, it generally can receive vibrations only via feelings. Feeling thus is a bridge from the immaterial to the material (artist), and from the material to the immaterial (viewer) Emotion—feeling—work—feeling—emotion.[95]

"Feeling" to Kandinsky denotes sensory perception, while "emotion" refers to the very fine, immaterial vibrations of the soul which have to be communicated, with the senses and matter as the necessary transmittor. If in less theosophical terms, Klee similarly defines art as a communication from soul to soul:

> A certain spark, the impetus to become, ignites, is transmitted through the hand, rushes onto the board and on the board, then the spark jumps into the third dimension and into the eye, and, closing the circle, it returns to where it came from.[96]

Thus the artist is the medium who intuitively gives expression to the forces in his soul.

In the fifth section of his essay Klee discusses the content of art. He agrees with Kandinsky that the art of their time no longer depicts the visible, incidental reality, but reveals something more essential:

> The relativity of all things visible becomes now apparent, and the belief is expressed that in relation to the world as a whole the visible is but an isolated example and that it is outnumbered by other truths. Things appear in a broader and more complex sense which may seem to contradict the rational experiences of yesterday. The goal is to distill the essential from the incidental.[97]

In the "Painting" essay Kandinsky defines the goal of art as:

> . . . the attainment of the higher stage of *pure art* (in which the remainders of practical purposes have been completely cast aside). Pure art speaks from spirit to spirit in artistic language and it is a realm of painterly-spiritual beings.[98]

For Klee the new art allows for the possibility of dealing with a theme in its totality (as, for example, with the stages of growth of an appletree)—representing it as a microcosmos in itself while at the same time making transparent its relationship to the cosmos as a whole—whereas Kandinsky eschews natural forms and wants to deal instead with the "fine matter" of the cosmos, with its nameless 'sounds.' That this entirely abstract dimension, however, is also part of what Klee considers to be the 'content' of art, is evident from his essay:

> Each energy calls for its complement in order to attain that self-contained stage which is beyond style, where *abstract forms* become analogies for objects or, remaining pure symbols, such as numbers or letters, unite to become symbols of the cosmos, that is religious expression.[99] [emphasis mine]

While in general Klee's view of the symbol hearkens back to Romantic thought, it relates to Kandinsky's theories in respect to the demand for a priori

abstract forms which are either "most abbreviated allusions to the object" (Kandinsky), enigmatic symbols, or simply abstract 'sounds.' In either function these abstract forms have a religious dimension, for they reveal the divine, the cosmic forces.

Klee looks at nature very much in a Goethean way. He does not emphasize with it or enter into a mystical union with all living beings as Marc did (at least in Klee's opinion); rather, he studies nature in all its manifestations from a distant and detatched point of view, classifying and ordering the phenomena, looking upon them as individual systems which in turn belong into a greater, all-encompassing system. For Klee all things have paradigmatic character; he studies and analyzes them in terms of their general structure and internal order and their place in the larger order. For him, negative, evil things are an integral part of the whole system. While Kandinsky sees the cosmos in terms of chaos and unresolved antitheses, in Klee's view order and balance ultimately prevail. His ethical value system is expressed in his art:

> The inclusion of the concepts of good and evil creates an ethical sphere. . . A simultaneity of primitive masculinity *(urmännlich)* (mean, arousing, passionate) and primitive femininity *(urweiblich)* (good, calm, growing) as a state of ethical stability.[100]

Since his Italian journey, Klee had frequently turned in his readings to Goethe, especially the older Goethe. During the Bauhaus years he would be greatly interested in Goethe's morphological writings. In the summer of 1918 he had been reading Goethe's *Wilhelm Meisters Wanderjahre* with great enjoyment.[101] In this novel Goethe presented his vision of a world guided by higher wisdom, a world in which ordered and balanced relationships develop despite error and confusion, and where good and evil forces each have their preordained place and purpose.

In the final analysis, however, Klee's thoughts go beyond the ideals of Goethean Classicism. For him the work of art is more than a formally balanced, harmonious organism, more than a microcosmic image of order— in its highest dimension it attains a mystery which the intellect cannot grasp: "Art in the uppermost circle, where the mystery begins and where intellect expires pitifully."[102] On this level, art transcends all vestiges of earthy reality and allows man a glimpse of the cosmic forces: "Where the spirit is comforted by symbols, because it understands that it is not chained to the one possibility of earthly life."[103] Here Klee's thinking again meets with Kandinsky's definition of pure art ("which . . . speaks from spirit to spirit in artistic language"). Klee continues:

> Art transcends the object, the real object as well as the imaginary object. . . just like a child imitates us, so we in our play imitate the forces which created and create the world.[104]

In art man can experience that part of himself which is divine (cf. "the divine self") and can feed his hungry soul and spirit. Art . . .

> may help man to take off his cover and for a few moments imagine himself to be God; and, knowing that such a transformation may be repeated, to look forward to his leisure time when the soul goes to table *(an dem die Seele sich zu Tische setzt)* to feed its hungry nerves and to refresh its sagging vessels with new juice.[105]

In the passage of *Concerning the Spiritual* which describes the pyramid of the spiritual life, Kandinsky writes:

> It is clear that every segment hungers, consciously or (more often) not, for adequate spiritual nourishment *(geistiges Brot)*. This nourishment is offered by the artists, and already tomorrow the segment below will stretch out eager hands for this nourishment.[106] [revised]

On the next page Kandinsky speaks of the "spiritual bread" as "transfigured bread," thus appropriating a term for the work of art which is usually reserved for the sacramental Host. Klee's phrase "an dem die Seele sich zu Tische setzt" in this context recalls a common paraphrase for Holy Communion, "zum Tische des Herrn kommen" (to come to the Lord's Table). Such small details of language point to the exalted view of art and of the artist which Klee and Kandinsky share. For them art has essentially taken on the function of religion: It provides spiritual nourishment for man and enables him to perceive God and the divine in himself. The artist fulfills a priest-like function. He is the medium for the spirit which finds its material manifestation in the work of art. This role elevates the artist above the rest of mankind.

In nuce Klee's essay anticipates the central tenets of his mature art philosophy and of his Bauhaus teaching. At the Bauhaus Klee further elaborates his theories on the formal organization of the work of art and its relationship to nature. During the last years at the Bauhaus, Kandinsky's thinking on these questions begins to change and he more closely approaches Klee's position.

Finally, a brief note on the published version of Klee's essay. Essentially the same basic thoughts are presented, but more concisely and also somewhat modified in their metaphysical dimension. The very Kandinsky-like sentence on "Pure art . . . " is omitted, and more emphasis is put on the concept of the genesis of art. The concluding section is contracted and it is a little less hymnic in language. Typical for the changes is the replacement of the word "zu Tische" with "zur Tafel" ("Dich stets wieder auf Feierabende Freuen, an denen die Seele zur Tafel geht").[107] While the earlier version of this phrase could evoke associations with the altar, the final version conjures up a festive banquet. The final version takes on more of the playful-ironic tone that is characteristic of Klee's writings as well as of his works of the 1920s.

In analyzing the essay, emphasis has been placed on those ideas which the two artists shared, ideas which were to provide a common basis for their fruitful exchange during the Bauhaus years.

In respect to the metaphysical origins and purpose of art, Klee is in agreement with Kandinsky, although they differ to some extent on the nature of the artistic organism and its formal organization. In the final version of his essay Klee puts the weight on elaborating on the central tenet of his artistic philosophy: "Art imitates creation."[108]

Part III

The Bauhaus Years, 1921-1932

Introduction to Part III

A few years after the war, Kandinsky and Klee met again and renewed their friendship when both joined the Bauhaus as "Formmeister." Klee was invited to the Bauhaus by Gropius and the faculty in November 1920. He arrived in Weimar to begin his teaching in January 1921. Kandinsky joined the school in the summer of 1922. Apparently Klee helped in providing him with the appointment.[1]

At the Bauhaus their main responsibility was instruction in form theory; both artists taught obligatory form courses which followed after the *Vorkurs*. Klee taught the second semester; Kandinsky the third. In addition, during the Weimar years they also had some responsibilities as form masters for the workshops. Klee was in charge of the bookbinding and the glass painting workshops, and, more importantly, also advised the weaving workshop for a while. Kandinsky was form master for the wall painting workshop in Weimar, which, among other things, developed the color scheme for the experimental house in the 1923 Bauhaus exhibition. From accounts by Bauhaus members, it appears that in the first years after his arrival Kandinsky was also quite involved in the Bauhaus administration and other general activities, at least until the arrival of Moholy-Nagy, who quickly rose to great prominence in the school.[2] Klee, on the other hand, intent on preserving time for his artistic work stayed rather aloof from Bauhaus affairs. Ultimately both masters developed a reputation as "Korridormeister," seen more in the hallways than in the workshops.

At times both artists also supervised the classes for drawing from the nude. When the Bauhaus moved to Dessau, both Klee and Kandinsky began to teach courses in free painting (which until then had not been considered desirable at the Bauhaus). The best students were allowed to attend the classes of both artists. While they continued to teach the form courses (in the late twenties Klee apparently spent much time on the preparation of his courses, in which he dealt with complicated geometrical problems), they withdrew more and more from the activities of the Bauhaus, because they were not very much in accord with the Bauhaus's increasingly technological orientation. Their lack of solidarity with the school in its perennially endangered existence is documented by the fact that among the faculty only Kandinsky and Klee refused to accept a ten

percent salary cut which in 1926 was proposed for the school's rescue.[3] Their opposition grew during the tenure of Hannes Meyer, and at least Kandinsky was apparently involved in Meyer's ousting.[4] Nonetheless Kandinsky remained at the Bauhaus until its dissolution in 1933. Klee, who felt increasingly burdened by his teaching obligations, left the Bauhaus in the spring of 1931 to accept a less demanding position at the Düsseldorf Academy. Until the spring of 1933, however, he kept his house in Dessau and commuted regularly between the two towns.

During the years at the Bauhaus, the two artists resumed the friendly association which had begun during the Blaue Reiter years and it intensified. Klee and Kandinsky, with their families, together attended social events at the Bauhaus, went to concerts and operatic performances, celebrated holidays and undertook walks and outings into the environs of Weimar and Dessau.[5] While the Dessau houses were under construction, Klee commuted between Weimar and Dessau, subletting a room from the Kandinskys in their Dessau apartment. In Dessau they shared a double house in the Bauhaus colony. In a letter of December 16, 1936, Kandinsky wistfully recalls the happy days when they were neighbors:

> It would be so nice to have tea together once again, as we did so often and so enjoyably in Dessau. We often recall the time when we were neighbors, how we watered the plants at the same time, and our games of bowls and—sad memory—the joint complaints about the Bauhaus meetings. How far back all this is now![6]

In 1929, both families spent their summer vacations in nearby villages in France, and on one of their joint excursions Klee and Kandinsky posed for a photograph as 'Goethe and Schiller,' in reference to the nicknames bestowed on them by the students at the Weimar Bauhaus (see frontispiece). Every year Klee and Kandinsky exchanged small works of their own as birthday gifts. Furthermore, Klee edited the catalogue for the show in honor of Kandinsky's sixtieth birthday, at the Arnold gallery in Dresden, while Kandinsky, in turn, edited the farewell issue of the Bauhaus magazine when Klee left the Bauhaus in 1931.

A description of their friendship would be incomplete without mention of their joint 'art politicking.' As the salary cut episode shows, they joined forces in preserving their financial self-interests *vis-à-vis* the Bauhaus, although they were financially better off than most of their colleagues. In their letters and diaries Feininger and Schlemmer, both with large families, registered with some bitterness the complaints Klee and Kandinsky would make about their financial situation. In 1924 the two artists together with Feininger and Jawlensky established the "Blue Four" association, at the instigation of Galka Scheyer, who took it upon herself to promote their art in the United States. With its name reminiscent of the Blaue Reiter, the association was primarily formed for exhibition purposes. Kandinsky's extensive correspondence with

Galka Scheyer demonstrates his business acumen.[7] Both he and Klee usually drove hard bargains with their dealers and buyers. One dealer, Otto Ralfs, in 1925 formed a Klee Society as well as a Kandinsky Society which insured some annual sales for both artists; this venture, too, was looked upon with some reservations by their Bauhaus colleagues. On the other hand, both Klee and Kandinsky sought to help the ailing and impoverished Jawlensky; Kandinsky, in particular, became very active in his behalf.

Klee and Kandinsky also stood out from the other faculty at the Bauhaus by the numerous publications that appeared about them in the 1920s. Kandinsky seems to have been disappointed at times that his work did not meet with the kind of reception that he was hoping for, but, according to Grohmann, their joint friend and biographer, he was never envious of Klee, whose success in Germany and abroad was greater in respect to exhibitions and publications.[8]

The personal friendship between Klee and Kandinsky has been sketched here because it provides the framework for their artistic interaction during the twenties. They had much opportunity to exchange ideas and study each other's work, especially in Dessau where they worked in adjacent studios.[9] The artistic exchange between them during the Bauhaus years shall be outlined in the following chapters. At the beginning of the twenties their works are stylistically far apart, but by the early thirties they have developed to a point where their colleague Oskar Schlemmer could mistake works by Kandinsky at first sight for works by Klee.[10] This formal *rapprochement* is based on the spiritual kinship which had developed between them during the Blaue Reiter years and which, after the years of separation, intensified during the Bauhaus period. Klee himself pointed to the roots their friendship had in the Blaue Reiter years when he wrote to his wife in a letter of 1932:

It is a friendship in which a number of negative things do not count, because the positive side holds its own, and above all because there is a connection with my productive youth. What one acquires later always has less weight.[11]

6

Klee's and Kandinsky's Work, 1921 to 1926

Some Aspects of Klee's Development, 1921 to 1926

Klee's works of the 1920s, a prodigally productive decade in his *oeuvre,* demonstrate an astounding versatility and breadth in style and subject matter. This period has been extensively discussed in the literature on Klee; therefore, only a few summarizing remarks are necessary here.[1]

During this decade Klee moved from the poetic, figural inventions typical for much of his work in the early twenties toward greater emphasis on the abstract, geometrical qualities of the pictorial elements. With his basic artistic outlook remaining essentially unchanged, Klee gradually reduced the explicitly figurative and narrative dimensions of his art in favor of greater abstraction. Toward the later twenties it is very often only the title of a work which introduces representational associations. The formal changes throughout this period reflect Klee's gradual coming to terms with impulses from De Stijl, Constructivism, and from Kandinsky.

Throughout the twenties Klee worked in a cyclical fashion, as it were, exploring a formal problem in a number of works, then moving on to another mode, but periodically returning to certain formal approaches. An example of this *modus operandi* are the color square compositions which, having originated in 1914, appear again and again from 1923 on into the late thirties.

Klee likewise moves back and forth between an emphasis on linear elements in his paintings and a concentration on coloristic problems.[2] The linear element is of considerable importance in many paintings, either as a structuring device for the composition or as the figurative (in the widest sense) 'action' on a colored ground. An example of the latter approach is the well-known *Twittering Machine,* 1922 (App. III-22), where the blue and reddish ground is subtly gradated in a chiaroscuro fashion to set up a shallow stage for the linear configuration. Executed in Klee's special oil transfer technique the *Twittering Machine* also demonstrates that Klee made no formal distinctions between the media of drawing and painting, as this process allowed him to reuse drawings by transferring them into watercolor or mixed media paint-

ings. In many paintings, color and line are treated as distinctly separate elements and are set off from each other.

The linear element becomes predominant in a number of paintings from about 1924 onward, paintings in which Klee covers the surface with a kind of abstract calligraphy, as in *Collection of Signs,* 1924 (App. III-22), or with rhythmic line structures as in the 1926 painting, *Young Forestboard* (App. III-31). In many of these predominantly linear works Klee explores the form problems of rhythmic order, dividual and individual structure, hatchings and patterns, spatial progressions, and the static and dynamic properties of linear configurations, problems which he also deals with at length in his Bauhaus teaching. In the later twenties he begins to draw with a ruler and other mechanical aids, so that his linear work takes on a Constructivist look of precision, as in *Air-Station,* 1926.26 (App. III-18), an early example of this method.

While in the works cited the 'graphic' character of line predominates, in other works Klee uses line in a more 'painterly' fashion. In *Cosmic Flora,* 1923.176 (App. III-18), Klee uses finely brushed colored lines for the hatchings. In later works these colored lines become more painterly, a development culminating in *Gate in the Garden,* 1926.81 (App. III-18), where the wide, parallel brushlines recall Klee's early interest in van Gogh.

In other groups of works throughout the twenties color does not just provide the ground and setting for the linear forms, but color and line interact as equivalent, yet distinct form elements. An early example is *Garden City,* 1922.183 (Fig. 27), where line serves both as outline for shapes and as a structuring agent for the diffuse ground. In works of the later twenties linear and color forms often coexist as independent form elements, as for example in *Plant On Window Still Life,* 1927 (Fig. 47).

Already in the early twenties the works in which Klee focuses on color alone are more abstract than the predominantly linear works. Klee explores quite systematically the visual tensions between individual colors as well as the optical effect of movement generated by light-dark gradations and the tensions between cold and warm colors and 'false' and real complementaries. He also investigates the visual 'weight' of individual colors which he balances as if they were building blocks in his color square paintings, reminding one of his early interest in architectural construction. Klee operates both with contrasting colors and with gradated color steps, as in the series of so-called *Fugue Paintings*[3] and the color-band paintings, such as *Separation in the Evening,* 1922 (App. III-48). In a number of the color square paintings he combines tonal gradations with color contrasts, as for example in *Ancient Sound,* 1925.x6 (App. III-57). In *Ancient Sound* the dark tonal color steps generate what is an almost Rembrandt-like chiaroscuro effect. Throughout the twenties Klee is interested in such dark tonal colors and chiaroscuro effects;

considered within the context of European avant-garde art of the twenties, other than the new realism, his penchant for distinctly old-masterly effects in works like *Ancient Sound* is unusual. In other works, like *Ad marginem,* 1930,[4] this aspect is further underscored by a minute execution. That Klee, indeed, intended and welcomed such old-masterly qualities is apparent from his delight in creating paint surfaces which appear aged and worn and possess a kind of false patina that might best—if disrespectfully—be described with the term "antiqued" as used by the furniture trade.

The title of *Ancient Sound* explicitly introduces associations with music. References to sounds and harmonies in the musical sense are frequent in Klee's *oeuvre* of the twenties, particularly in the color square paintings, a fact that has often been interpreted as influence from Kandinsky. However, with Kandinsky the analogies between music and art do not extend much beyond 'correspondences' between abstract color and musical sound along essentially Symbolist lines. He is not very interested in utilizing actual compositional principles of music for his art, something Klee was fascinated with. Klee believed there were parallels between art and music in terms of the role temporal sequence has in each art, whereas for Kandinsky the temporal element in music was its distinctive feature setting it off from art.[5] Going beyond the sound associations in some of his color paintings, Klee made use of principles of musical composition, such as polyphony, for the compositional structure of his own works.[6] Kandinsky's frequent references in his writings to the parallels between music and art may well have encouraged Klee to experiment along such lines, but Klee takes these analogies much more literally than Kandinsky.

The color square paintings are also exemplary for Klee's use of basic compositional systems, such as the grid or the subdivision into color bands, as well as of recurrent patterns and linear configurations.[7]

In his dissertation Jordan outlines Klee's gradual response to Constructivism and De Stijl. He proposes three phases in Klee's stylistic transition from the Cubist shallow space toward the indefinite and immaterial Constructivist space in which forms appear to float weightlessly. Jordan considers Klee's progress from 1922 onward in terms of a move away from Cubist compositional principles and *passage* space toward pictorial constructions which can be read simultaneously as two-dimensional and three-dimensional because of the complete transparency of forms and a space which is both planar and infinitely deep. The use of a dark ground is particularly suited for this spatial concept, as forms seem immaterial and appear to float. Other than this new type of space, Jordan points to the transparency of both linear constructions and of overlapping planes, the increasing independence of color and line, as well as Klee's interest in exploring compositional 'systems' as formal aspects of Klee's art of the later twenties in which is reflected the influence of the

Constructivists (El Lissitzky, Naum Gabo, Moholy-Nagy, Rodchenko, et al.) and of Kandinsky. He sees in Klee's development a trend . . . "toward disembodiment and absolutism."[8] *Air-Station,* 1926 (App. III-18), which exemplifies the final stage of Klee's adoption of Constructivist means, is compared by Jordan to Kandinsky's *Zigzag Upward,* 1928 (App. III-40), and to *Line Construction* by Rodchenko of 1920:

> Both works present disembodied, transparent linear constructs, surmounted by astronomical signs, in a cloudy undefined space. In detail the Kandinsky is perhaps a little more regular and mechanical—this is particularly evident in his quantity of precise arcs and parallels—and a little less related to Cubist notions of composition. . . . Klee shares in *Air Station* in the disembodied Constructivist sense of design which Kandinsky had employed since his return from the milieu of Revolutionary Russia. . . . On the other hand, comparison with Rodchenko's *Line Construction* establishes the measure of both Klee's and Kandinsky's lingering "romanticism" . . . Rodchenko's evenly weighted mechanical line makes not the least reference to observed nature in its abstract exploration of space. Klee and Kandinsky, though they use the same drafting instruments and the same means of construction as the younger artist, yet create with them not objective forms in space, but personal symbols and romantic signs. After the many intervening years, both Klee and Kandinsky had yet kept many fundamental aesthetic roots back in the Blaue Reiter Expressionist period.[9]

Although Jordan notes the fundamental differences between a 'true' Constructivist, like Rodchenko, and Kandinsky and Klee, he explores these no further. How Kandinsky and Klee transform the Constructivist formal means, which they appropriate for their art, will be elucidated in the final chapter of this study.

Some observations on Klee's composition may be added to Jordan's basic analysis of Klee's style of the twenties. In Klee's works of the early twenties the individual form elements are usually similar in type and commensurable in proportion and visual weight; they are also subordinated to a cohesive compositional structure, as for example the linear configuration in *Twittering Machine,* 1922 (App. III-22), or the grid system of interdependent color areas and linear elements in *Garden City,* 1922.183 (Fig. 27). In the color square and color band paintings the compositional system is based on units of more or less equal size and visual 'weight.' The 1922 painting, *Senecio* (App. III-55), is composed of essentially geometric forms, but the geometric quality of the parts is softened by coloristic transitions which join them into a composite image. Beginning in 1923, Klee often breaks up this compositional cohesiveness, emphasizing instead the autonomous existence of the pictorial elements as separate forms. By keeping the form elements more discrete and apart, Klee enhances their geometric character and abstract nature. *Child on the Stairs,* 1923.65 (Fig. 28) is an early example of this method. The colored forms emerge from the indefinite dark ground as separate entities of a pre-

dominantly abstract-geometrical nature. With the clues provided by the title and the few figurative elements in the picture the viewer gradually is able to read the forms in the upper half of the painting as segments of a partially invisible architectual structure. In *Child* the form elements seem to be quite firmly fixed in their positions, whereas in another painting of the same type, *Assyrian Game,* 1923.79 (App. III-29), the individual forms, loosely aligned in three horizontal rows, appear to be floating and rotating in an indefinite space. Some of the individual forms can be related quite directly to Constructivist prototypes. In the upper left corner the triangle in pursuit of a square recalls El Lissitzky's picture book, *Von zwei quadraten,* 1920.[10] The foreshortened grid motif occurs frequently in Kandinsky's paintings as well as in his prints; for example, in the 1922 *Kleine Welten* series.[11]

In another group of works, of which *Cosmic Flora,* 1923.176 (App. III-18) is an example, Klee uses the hatchings, which technically derive from Cubist *passage,* not so much for Cubist interlocking of form elements than in order to set the individual forms off from one another. This becomes even more apparent in works of 1924, such as the drawing, *Growth Under the Half Moon,* 1924.59 (App. III-22), where the hatchings isolate the forms rather than interconnect them.[12] The drawing further demonstrates a new manner in which Klee deals with the ground. Because the dense hatchings imply shadow effects, one would assume that the delineated forms stand out from the ground in relief. This spatial reading, however, is obliterated by the fact that the hatchings extend all the way around the form, thus precluding an illusionistic shadow effect. With other forms, such as the overlapping bar shapes, Klee omits the hatchings at both ends so that the white part in the center can be read either as a figure raised in relief or as white ground. Because of this visual ambiguity the form elements take on an irrational, immaterial quality.[13] Klee makes use of the same devices in a number of paintings, replacing hatchings by colored shadings. In *Landscape for Lovers,* 1924.76 (Fig. 29) Klee uses these shadings to distinguish figure from ground and at the same time to create an ambivalent, atmospheric spatial quality. The individual forms are so far apart that they are visually isolated, but at the same time they appear to magnetically attract each other. In the lower half of the picture the shapes offer fragmentary clues for a landscape reading, while in the upper half abstract forms, some with erotic connotations, are loosely scattered. Such a decentralized scattering of forms over the ground is characteristic of Kandinsky's mode of composition, as in *Composition VIII,* 1923 (App. III-47), where geometric forms of varying size float around the central cluster of linear shapes. Although Kandinsky's forms intersect and overlap, they remain discrete and autonomous. In *Composition VIII* some of the diagonal lines suggest movement into depth, without, however, clearly establishing spatial relationships (see, for example, the pair of diagonals, slightly at an angle to

each other, in the lower left side). Similarly Klee in *Landscape* introduces the path as a form element which leads the eye into undefined depth. The colored shadings around the circular and square forms in Klee's painting recall the colored auras or haloes with which Kandinsky frequently surrounds his geometric forms, and which increase the spatial ambiguity, as, for example, in *Composition VIII*.[14] The similarity to Kandinsky is even greater in comparison with Kandinsky's painting *Deep Brown*, 1924/271 (Fig. 30) (the *oeuvre* catalogue number would place it around the middle of the year). In the lower right corner of Kandinsky's painting there is a 'still-life' of geometrical forms which are shaded all around in the same manner as in Klee's painting. Conceivably Klee's transformation of his painted hatchings (as in *Cosmic Flora*) into colored shadings and 'haloes' around forms owes something to Kandinsky's example. Klee uses this device in a number of works in 1924 as well as later.

In his book *Point and Line to Plane*, 1926, Kandinsky states that in nature all lines are 'concentric'; that is, they are part of a cohesive structure.[15] Line by itself does not exist in nature, whereas in art 'eccentric' lines and compositions with free, unbounded lines are possible. In *Landscape* Klee seems to use the bar-like forms as linear elements in Kandinsky's sense and experiments with an 'eccentric' composition along the lines of Kandinsky's *Composition VIII*. Such isolated or 'eccentrically' used linear elements appear also in Klee's later works, if with much less frequency than in Kandinsky's *oeuvre*. Another example is *Reconstruction*, 1926. To (App. III-13), where isolated forms and lines are set off from the ground by colored shadings. The title Klee selected for the painting very wittily underscores the unconnected, fragmentary character of the composition, while at the same time implying that the scattered forms formerly were connected as parts of a larger structure. In *Reconstruction* Klee increases spatial ambiguity by placing a foreshortened cube form in front of what appears to be a wall with stairs (in the lower right corner). Such 'irrational' spatial effects and ambiguous overlaps are frequently found with Kandinsky; for example, in *Little Worlds* (App. III-53). Transparent overlaps, 'irrational' foreshortening, figure-ground reversals, and many other modes of creating ambivalent spatial relationships are used by both Kandinsky and Klee throughout the twenties, often in similar ways, in order to achieve an effect of dematerialization of form.

A major characteristic of much of Kandinsky's work of the twenties is his preference for starkly contrasting form elements. In *Composition VIII* (App. III-47), for example, the large black and purple disk at the upper left looms disproportionately large over the delicate, light blue triangle and the linear configuration in the center. Klee, in general, operates with form elements which are more commensurable in their proportions (in accordance with his desire to create works in analogy to natural organisms), but in the second half

of the twenties he becomes more interested in the almost inordinate juxtaposition of formal elements in which Kandinsky delights. An example is the drawing, *Sign of Terror*, 1925.16 (in the Paul Klee *Stiftung* in Bern), where a large rhomboid form weighs heavily on the delicately outlined figures below, similar to *Composition VIII*.[16] In 1926/27 Klee experiments a great deal with oppositions of very light linear constructions having an explicitly 'graphic' character and large solid color areas, as they were noted in Kandinsky's *Composition VIII*. In *Flag-Bedecked Town*, 1927 (App. III-55), for instance, a frail transparent linear web has to hold its own against the visual weight of the comparatively large opaque color shapes in the upper half of the composition.

The new departures in Klee's stylistic development during the first half of the twenties are reflected in a small, not very ambitious work, which Klee gave Kandinsky for his birthday. Here it is discussed as an example for the spray technique which both Klee and Kandinsky used often in the late twenties and early thirties.[17] The spray technique allows for a further refinement of the hatching and halo-type shading method: the sprayed edges around the shapes appear like shadings which raise the shapes from the ground, yet at the same time all forms remain completely immaterial and float like apparitions on the misty ground. In *Letter Picture (To Mr. Kandinsky in [Moskau, München, Weimar] Dessau.)*, 1926.23 (Fig. 31), Klee darkens the ground in the four corners, so that a diffuse cross-shaped area emerges in the center. Overlapping rectangular shapes float diagonally across this ground, moving from the lower right toward the upper left. Where they overlap the lightness increases, but each form remains distinct. There is no tangible spatial relationship between the intersecting forms. The immaterial transparency of the overlapping form is comparable to the colored disks in Kandinsky's 1923 painting *Circle within the Circle* (Fig. 35). Only the small red circle in the upper right provides a definite planar accent and a point of orientation in the fathomless space, comparable to the effect of the black disk in Kandinsky's *Composition VIII* (App. III-47). The changes in Klee's spatial concept, which were noted by Jordan, are reflected in *Letter Picture*, if compared, for example, to the 1922 *Twittering Machine* (App. III-22). Furthermore, in the latter the composition is centered and predominantly static, whereas in *Letter Picture* the emphasis is placed on diagonal movement across the surface with some countermovement in the opposite direction. In *Twittering Machine* the lines and shapes form a composite, fantastic image, replete with representational associations. In *Letter Picture* the geometric forms remain discrete and basically nonfigurative. Only the writing—thin, graphic lines pointedly juxtaposed to the diffuse atmospheric ground—provides the clue for the interpretation of the rectangular shapes as letters. As letters they are not so much symbolic of the artists' correspondence, which was very limited and sporadic,

but of their exchange of thoughts and, in a wider sense, of the friendship and communication existing between them wherever Kandinsky might be.

This small work holds a delicate balance between geometric precision and diffuse, atmospheric effects, between abstract form and narrative content. As such, it points forward to Klee's work of the later twenties. Furthermore, it is also representative of the relationship, both on a stylistic and a conceptual level, between Klee's and Kandinsky's art during the Bauhaus years at Dessau.

Stylistic Changes in Kandinsky's Art, 1923-1926

Kandinsky's work of the 1920s has been the subject of comparatively few scholarly studies.[18] His development in the 1920s cannot be surveyed comprehensively here; instead the discussion will focus on those aspects of his art which relate to Klee's work of the twenties.

Without changes in his basic artistic concepts, Kandinsky in the early 1920s adopted much of the formal vocabulary of Constructivism, but by the mid-twenties he was dissatisfied with what he calls his 'cool' style and he began to reintroduce more 'painterly' qualities into his art. His compositions become more classically balanced, quieter and simpler in their overall character, as well as more personal and intimate. As a result, Kandinsky's style approaches that of Klee; in the later twenties a considerable stylistic proximity can be noted in many of their works. From about 1927 on, both artists in adapting formal impulses from De Stijl and Constructivism for essentially Expressionist esthetic concerns frequently proceed along similar lines.

From 1914 to 1921, during the years in Russia, Kandinsky apparently painted fairly little. After the war he became very active in the new cultural administration and the Inkhuk Schools; however, he was gradually eclipsed by the more radical Constructivist factions, and ultimately he realized that he would not be able to succeed in Russia with his artistic and educational concepts. His work of this period is still relatively little known, but it is evident that around 1920 the fluid, amorphous forms of his prewar and wartime work begin to harden, as it were, and become more discrete. But it is only after his return to Germany in 1921 that Kandinsky begins to employ geometric forms more resolutely. His graphic cycle, *Little Worlds,* 1922, executed at the Bauhaus, is representative of this transitional stage. The 12 prints are extremely varied in style, ranging from the retrospective color lithograph, *Little Worlds III* (App. III-53) with its jagged lines, amorphous shapes, and landscape-like forms reminiscent of the paintings of 1914, to the color lithograph *Little Worlds IV* (App. III-53) where all forms are clearly defined and distinct and most are geometric, except for a few still biomorphic shapes. As in Malevich's Suprematist paintings the white ground itself becomes the space in which the forms float freely. The foreshortened band of colors and the checkerboard

grid pull the eye into depth, but in different directions. Such diagonal thrusts into depth had already been typical of Kandinsky's prewar compositions; now, in the twenties, he frequently uses explicitly illusionistic devices to create ambivalent spatial qualities. Reminiscent of Kandinsky's prewar work, too, is the rotating, centripetal motion in the composition which draws almost all forms into its circular center. This type of centripetal composition can be found in many works of the twenties, its frequency diminishing in the later part of the decade. The compositions of this type are quite literally 'little worlds' in themselves, as they appear to have a center of gravity of their own which acts like a magnet on the forms floating around the picture. In later compositions more often than not the pictorial elements seem to either obey extrapictorial, terrestrial laws of gravity, or they try to overcome them, seeming to float weightlessly away from the center of gravity. In general terms, the 'top' and 'bottom' of the physical world frequently serves as the point of reference in Kandinsky's compositions of the later twenties, thus providing an important stabilizing factor.

Both the dynamism and the combinations of small and large geometric forms, as well as of linear elements and color shapes in *Little Worlds IV* recall Malevich's Suprematist paintings of ca. 1915/16; however, Kandinsky's form elements—and his style in general—are much more heterogeneous in nature than Malevich's. Malevich's Suprematist philosophy and Kandinsky's ideas are quite comparable in terms of their metaphysical concepts, but the *Suprematisms* are far more elemental and abstract metaphors of motion and flight than Kandinsky's dynamic forms in *Little Worlds,* which by its very title already alludes to the natural world.

In 1923 Kandinsky adopts the Constructivist form vocabulary more consistently than before, but from the way he makes use of this vocabulary it is evident that his artistic concerns differ from those of Constructivism. *In the Black Square,* 1923/259 (Fig. 32), which precedes *Composition VIII* in the *oeuvre* catalogue, is typical of Kandinsky's style of that year. A foreshortened white square is placed on a solid black background which, however, appears to the eye as a frame through which one looks into the white area. While the positioning of the square reminds one of Malevich's *White Square on White,* 1918,[19] Kandinsky places numerous other forms on the lightly tinted white square so that it becomes a picture within the picture; a small world in itself. Many of the formal aspects of the painting relate to Constructivism: the precise, geometric forms and lines, the transparent overlaps, the indefinite space and the weightlessness of forms. Some parts of the painting are directly comparable to Constructivist works; for instance, the intersecting bundles of converging lines in the lower right corner, which are quite similar to Rodchenko's *Line Construction,* 1919 (Fig. 33). However, Kandinsky's linear configuration does not share the kind of spatial tension which Rodchenko

generates. Kandinsky's lines recede into depth, but there is very little spatial interaction between the individual line bundles. In Rodchenko's picture the line construction is the central (and only) theme of the picture and it occupies the entire pictorial space (the main diagonals start at the lower edge, thus providing the eye with a starting point from which to explore the spatial relationships). Kandinsky, on his part, uses this type of linear construction as a form motif of secondary import, a 'picturesque' detail within a larger and very complicated composition. The same difference exists between another motif of Kandinsky's painting, namely the rainbow-like semicircle in the upper left quarter transversed by three brown bar-like shapes, and a similar motif in El Lissitzky's lithograph *Proun 5a*, 1921 (Fig. 34). In Lissitzky's *Proun* the bar shapes at the bottom clearly overlap the ovoid form and the viewer can at least fathom the spatial relationships in the picture, even though they may not correspond to our empirical experience of forms in space. In Kandinsky's painting the bar shapes appear to merge with the semicircular bands. The spatial order becomes even more incomprehensible because of the triangular form in front of the semicircular motif. The triangle appears to be transparent, but its tip suddenly turns into an opaque green. While in Lissitzky's *Prouns* the spatial relationships are very complicated and not necessarily logical (in the upper half of *Proun 5a*), the space is considerably more 'imaginable' than it is in Kandinsky's painting. Kandinsky uses the Constructivist form motifs in a highly irrational way, delighting in ambivalent effects such as the triangle which is partly transparent and partly opaque. Kandinsky's compositional method is basically additive: although the numerous pictorial elements intersect and overlap, they remain separate and are not joined together in the manner of Constructivist *constructions*. Kandinsky's paintings make no reference to three-dimensional empirical space. Rather, the artist creates a very personal, alogical space where forms can at will overlap, interpenetrate, metamorphose from transparency into opaqueness, and can be read simultaneously as figure and ground. As a result both the space and the individual elements appear intangible, immaterial. Kandinsky's style is further set off from Suprematism and Constructivism by the wealth of different form motifs and pictorial elements which exist in a single work. Although *In the Black Square* is a relatively sparse work, it incorporates numerous contrasts of shapes, colors, and textures in addition to the spatial ambiguity and the many directional changes in the composition. Although the form elements have changed in character, Kandinsky's compositional principles are still founded on the "antitheses and contradictions" of his prewar work.

In discussing Kandinsky's and Klee's work of the Blaue Reiter period the transparency of linear configurations superimposed on the colored ground was pointed out as an important means of dematerializing form. During the twenties Kandinsky continues to superimpose linear forms in this manner,

and he also begins to use transparently overlapping color planes to the same end. Kandinsky uses such transparent overlaps in two ways: either he treats the overlapping planes as if they were pieces of differently colored glass laid over one another, with the color changing accordingly in the overlapping areas, or Kandinsky introduces a completely different color where two color shapes overlap. The latter method again results in an effect of irrational ambiguity. *Circles within a Circle,* 1923/261 (Fig. 35) (listed fairly late in the chronological sequence of that year), is an example of the first method. It is a work which relates more directly to Constructivism and to the researches at the Bauhaus than most other other works of the early twenties.

In *Circles within a Circle* two diagonal bands of color, beige and light blue, intersect like two rays of colored light over an even, white ground. Placed over these crossing diagonals is a cluster of overlapping transparent disks which are enclosed within a black circle. The colored disks remind one of very thin pieces of colored glass, yet they appear more immaterial than glass because no spatial relationship is established between them. Although this work is an oil painting, the effect is similar to that achieved by the overlapping transparent glazes which Klee used in his watercolors. Perhaps Kandinsky's painting was inspired by Hirschfeld-Mack's experiments with colored light in which the Bauhaus members apparently were much interested.[20] Moholy-Nagy, who was very preoccupied with the problem of transparency in painting, had experimented since 1921 with colored transparent forms in oil paintings, in which he sought to realize his vision of light and space. His painting, *Z III,* 1922 (Fig. 36), is in some respects very similar to Kandinsky's 1923 *Circles,* where, too, thin black lines are interspersed with the color disks. With Moholy-Nagy, however, the circular forms seem to be precariously held up by the tangential lines so that a structural relationship is established between lines and circles which increases the visual tension. In Kandinsky's painting the circle forms and the lines belong to two different compositional systems which do not interact. The viewer focuses either on the color disks or on the web of lines which functions as a contrapuntal accompaniment rather than as a supportive scaffolding for the cluster of circles.

Circles within a Circle is exceptional in Kandinsky's work of this period because of its concentration on one basic form. In this respect it can be compared to the paintings by Klee, which use a single form motif such as the color square and color band paintings. The interaction of warm and cool colors in Kandinsky's painting is also reminiscent of Klee's watercolors, such as *Separation in the Evening,* 1922.79 (App. III-48), although Kandinsky does not operate with the gradual progression from cool to warm colors that Klee explores.[21]

Another work of 1923, which can be related to Klee in some aspects is *Red in Blue,* 1923/100 (App. III-48). The cloudy ground in this watercolor

with its red center and bluish surrounding edge recalls the color space in Klee's oil transfer drawings, such as the 1922 *Twittering Machine* (App. III-22). The geometric precision of the black line drawing placed over this ground suggests Constructivism, but here, as in the other works considered, there is no spatial cohesiveness between forms, and the profusion of different, isolated form motifs further sets the watercolor off from Constructivist art. Its combination of precise geometric drawing and a diffuse 'painterly' ground prefigures much of the work of both Kandinsky and Klee in the later twenties.

Kandinsky in 1924

In a letter of January 31, 1924 to Will Grohmann, which concerned a book and an article Grohmann was writing about him, Kandinsky wrote: "I think for this purpose only new works are necessary—perhaps from 1921 on when my so-called "cool period" began from which I am now sometimes emerging."[22] In a later letter to Grohmann of December 18, 1928, he characterized this period in retrospect as: "cool, sometimes downright cold, almost hardened, much white."[23] 1924 is a year of retrospection and transition in Kandinsky's work. In Grohmann he had found the first congenial interpreter of his work and he spent a great deal of time explaining his art and his artistic goals to him.[24] That Kandinsky was also thinking back to his prewar work, most of which was still in Russia or with Gabriele Münter, is documented by the painting *Backward Glance*, 1924/268a, which hearkens back to *Small Pleasures*, 1913.

Grohmann's publications disappointed Kandinsky in one respect: he felt that he was being presented as a "special case" and that his ideas were given too little exposure.[25] He did not want to be characterized as an isolated phenomenon; he aspired to be understood as the leader of a movement; indeed, of *the* artistic and spiritual renewal in general. Grohmann's presentation of him must have been all the more disappointing as Kandinsky was beginning to feel that it was impossible to realize his dream of a synthesis of the arts at the Bauhaus. In his first years at the Bauhaus, Kandinsky had been actively involved in the school's affairs and had occupied a position of leadership.[26] When Moholy-Nagy joined the school, however, he was eclipsed by this young and enthusiastic champion of Constructivism, and he felt increasingly alienated from the Bauhaus' new, more technological orientation.[27] On November 23, 1923 Kandinsky wrote to Grohmann:

> In the Bauhaus, which in many respects I esteem very much, I am quite superfluous; I can go only to certain limits in my teaching here, since all that goes further does not fit within the limitations of the Bauhaus.[28]

He was resigning himself to the fact that even at the Bauhaus he could not attempt the synthesis of the arts that he had long envisioned. In October of 1924 Kandinsky wrote again about this to Grohmann:

> Synthetic work in space, thus in conjunction with architecture, is my old dream . . . , which I had hoped to realize when I joined the Bauhaus (but, alas, in vain until now). But: *besides* synthetic collaboration I expect of each art a further powerful and hitherto never realized *inner* development, an absorption, completely free of external purposes, into the human spirit which is only beginning to touch on the world spirit.[29]

Kandinsky's ideas ran entirely counter to Moholy's views. While Kandinsky conceived of the synthesis essentially in terms of the collaborative *Gesamtkunstwerk,* where each art makes its individual contribution, Moholy saw no distinction between the individual arts and between art and design. He sought to realize his artistic vision in all media and materials including painting, film, photography, book design, light fixtures, and all other aspects of design. His interest in the practical application of his esthetic vision as well as his considerable influence at the Bauhaus must have represented a threat to Kandinsky's ideal of art as "absorption . . . into the human spirit."

In retreating more and more from Bauhaus activities to his personal domain of painting and theoretical work, Kandinsky apparently also felt a need to differentiate more firmly between the Constructivists and himself. In a letter to Grohmann of November 21, 1925 he implies that he feels misunderstood by the public which looks at his art within the context of Constructivism:

> I really wish that one finally sees what is *behind* my painting . . . and that one does not content oneself with stating that I use triangles or circles . . . It must finally be understood that form for me is but a means to an end and that I also occupy myself so much and so thoroughly with form on the theoretical level, because I want to penetrate into the *inner* dimension of form and want to elucidate it also for other people in a way that is clear, very clear.
>
> You once dropped the word "Romanticism" and I was pleased . . . The meaning, the content of art, is romanticism and it is our fault if we mistake a period for the entire concept . . . And the coming romanticism will indeed be deeply beautiful . . . full of content, making us happy; it is a lump of ice with a flame burning inside.[30]

Kandinsky's concept of "Romanticism" recalls Klee's "cool Romanticism" of 1915. Indeed, during the second half of the twenties we can note a balancing of 'classical' and 'romantic' aspects in Kandinsky's art which is similar to what Klee strove for in his "cool Romanticism without pathos."[31]

In reaffirming the "spiritual" dimension of his art Kandinsky moved away from the cool, precise, and to a degree Constructivist appearance of most of his 1923 work. He returned to what may be termed more painterly

values. His forms remained geometric, but he sought to imbue them with more organic qualities and consequently references to nature—in the widest sense—increase.

Deep Brown, 1924/271 (Fig. 30), is representative of Kandinsky's new direction. The smooth white or black ground of the 1923 works is superseded by a deep, earthy brown which, toward the lower right corner, metamorphoses into a cloudy blue-grey. A band of gradated blues spans the upper edge of the picture. Such bands were frequently used by Klee; for example, in *Eros*, 1923.115 (App. III-15). The oval shape beneath, from which rays seem to be emanating, in conjunction with this sky blue band takes on the character of a cosmic body. Similarly the yellow triangle with its tail of haloed lines recalls representations of comets. The blue triangles in the lower right evoke associations with mountains. As a result, the painting has some of the character of a landscape, in contrast to, for example, *In the Black Square* (Fig. 32). Of course the painting does not depict a landscape proper and Kandinsky may not even have intended such associations, but the fact that such associations with natural forms can be made documents a shift in his art.[32] The warm natural colors reinforce this impression. The light haloes around many of the forms not only soften the geometric shapes but also increase their expressive significance. The small forms and linear shapes in the lower right are transformed into mysterious signs illuminated by some supranatural light source.

The term "landscape" has been introduced here only to denote associations with the organic world invited by *Deep Brown*. A watercolor of 1924 (Fig. 37) however, was entitled *Landscape* by Kandinsky himself. In *Landscape* the white ground provides an indefinite space. While most forms move in a diagonal direction, a sense of equilibrium is established by the division of the picture into two horizontal halves. The upper section is filled with large, partly transparent shapes in subdued brown and black colors, while the lower half contains small forms in brilliant colors. A bridge spans the area between what appear to be two houses, and the cluster of bright shapes in the lower center can be read as three boats on the red water.[33] The shapes in the upper half suggest clouds and a black sun. The forms are irregularly shaped, neither geometric nor truly biomorphic. Some, like the curved black line at the left and the boat recall motifs from *Small Pleasures*, 1913 (App. III-47).

Although the form elements and color 'sounds' in the watercolor are numerous, the composition as a whole is quieter and less tumultuous than *In the Black Square* (Fig. 32), for example. In *Landscape* a visual equilibrium is created by the balanced distribution of colors which recur throughout the picture (for example the three brown areas) and by restricting the visual movement of forms to a few basic directions. Such a more rhythmic approach to composition as well as the limitation of colors to a main pair of contrasting colors and their variations can be observed in numerous works of this year.

More figurative than abstract, *Landschaft* stylistically belongs to the retro-spective moment in 1924 when Kandinsky painted *Backward Glance*.[34] How-ever, the same basic tendencies can also be observed in more geometric-abstract works. In the watercolor, *Dawn,* 1924 (Fig. 38), a large black triangle poised precariously on its tip looms before an indefinite opalescent back-ground. The point of the triangle is capped by a pinkish transparent circular shape. In this upper part of the picture the ground is gradated from light grey to a deep black at the top, thus reversing the color sequence of the lower half. While the triangle appears to rise, the circular form seems to descend. The interpenetration of these two forms in this cosmic atmosphere may symbolize the transition from night to day, as in Klee's *Separation in the Evening,* (App. III-48) which represents dusk. Whereas Klee translates the movement of light into a regular sequence of color steps and introduces the arrows as symbols of movement, Kandinsky generates visual movement with the diagonal direc-tions predominating in the composition. He dramatizes the action by sharply juxtaposing contrasting forms and colors. Both artists capture the natural "Ur"-event of the separation of dark and light in entirely abstract forms. Only the colors and the titles introduce some specific references to nature.

In general, Kandinsky considered titles a necessary evil, preferring simple, descriptive titles, but from 1924 on, allusive titles became more frequent. Although they refer primarily to the form character of the paintings, titles like *Cheerful,* 1924; *Silent,* 1924; *Quiet Harmony,* 1924; *Capricious Line,* 1924; *Contact,* 1924; and *Conclusion,* 1926, also have emotional connotations which invite interpretations. In other titles Kandinsky invites musical associations, as in *Green Sound,* 1924; *Contrasting Sounds,* 1924; *Melodic,* 1924, etc., comparable to some of Klee's titles, such as *Ancient Sound* or *Polyphony.*

In most of Kandinsky's works of the early twenties diagonals predomi-nated as the main compositional axes. As a result the compositions are very dynamic and often rather restless in character. In 1924 Kandinsky begins to make more use of horizontal and vertical axes, which results in crucial changes in the overall character of his compositions. The oil painting *Still,* 1924/278 (App. III-37) for instance, is composed in terms of vertical and horizontal elements held in equilibrium. The light brown foreground and the darker brown background set up stage-like space, with prop-like elements at either side. The triangles and squares in the lower half of the picture do not appear to float in space; instead, they are fixed in their positions by the black baselines. The only dynamic element is the ascending green cloud-like shape. The diagonal line bundles painted over it recall Constructivist configurations, whereas the small colorful grid motif in the center relates to De Stijl. The De Stijl grid, as opposed to the more Constructivist foreshortened grid pattern of the early twenties, turns up frequently in Kandinsky's work from 1924 on-ward. Usually it appears only as a form motif, but in a few works it serves as

the dominant compositional order. Both Klee and Kandinsky took a keen interest in De Stijl. Although neither of them liked van Doesburg, they thought highly of Mondrian, whose work was beginning to be better known in Germany by the mid-twenties. Although Kandinsky was intrigued by Mondrian's insistence on the exclusive use of verticals and horizontals, he found such a restriction too limiting for his own art. However, vertical-horizontal compositional orders became more and more prominent in his work.

Another form motif that appears in *Still* are the layers of color stripes at the left and in the green area, reminiscent of Klee's color stripe paintings. In contrast to Klee, Kandinsky does not work with gradated color steps; instead he uses related colors which create the effect of color progression. Color bands of this type appear frequently from 1924 onward, both as small form motifs, as in *Still,* and on a larger scale in some paintings, where they extend over part of the ground or subdivide the entire composition into horizontal bands.

While Kandinsky is never as deeply interested as Klee in using systems such as the grid or the color bands as a basis for his compositions, he does occasionally experiment with such a systemic approach. An early example is *Watercolor,* 1924 (App. III-59). Here the combination of horizontal subdivisions with the grid order at both ends creates the effect of a shelf on which numerous smaller motifs are aligned. The basic order recalls some of Klee's compositions, such as *Cosmic Flora,* 1923 (App. III-18). As in *Flora* the forms in Kandinsky's watercolor are partly abstract and partly figurative-allusive, although no general figurative context as exists in *Flora* can be established.

In a number of works of 1924 Kandinsky restricts himself to a basic form motif and its variations, as with the composite geometric shape in *Moist Green,* 1924/172 (App. III-58). This watercolor relates to Klee not only in respect to the 'systemic' approach (the shapes are aligned in horizontal rows), but also in regard to the subdued natural colors and the textural effects.

Many of the titles of Kandinsky's 1924 works refer to silence, quiet, harmony and the like. These references connote the basic characteristics of the works which follow his 'cool' period, as he himself defined them in his letter to Grohmann of December 18, 1928:

> 3. [period]: great calm with strong inner tension, often very colorful (here and there predominance of 'graphic' elements, or predominance of color, which, however, is quiet, etc.). But in each case the purely painterly means were the point of departure and the purpose (content) striven for was also painterly.[35]

Kandinsky's Work in 1925 and 1926

Manifesting itself in a reduction of the number of form elements and in greater stability of the composition as the result of their placement in a predominantly

horizontal and vertical orientation, the trend toward "calm" persists and increases in Kandinsky's work of 1925 and 1926. That he concentrates on a few basic form elements and on variations of one form in a number of his paintings may be an outcome of his work on the book *Point and Line to Plane,* written during 1925, in which he discussed in great detail the inherent perceptual and expressive properties of the basic elements of form.

Kandinsky's second painting of 1925, *Blue Circle Nr. 2,* 1925/289 (Fig. 39),[36] is of the utmost simplicity. The picture has a diffuse spotty ground. A horizontal black bar in the bottom section of the picture is contrasted to a ring-like blue circle which hovers in the upper half of the picture, slightly off center. In itself this juxtaposition of line and circle is a very elemental contrast, used frequently by Moholy-Nagy, for example in his *Z III,* 1922 (Fig. 36). But Kandinsky introduces a symbolic dimension by surrounding the ring with a large colored aura. With this 'halo' the circle is transformed into a cosmic apparition. The cosmic connotations which the circle had for Kandinsky are further underscored here by the blue color with its own spiritual, transcendental dimensions.[37] In *Point and Line* Kandinsky defines the horizontal line as an element of absolute repose and passivity. It corresponds to the color black which is the silence of death.[38] Interpreted in terms of Kandinsky's own theories, the painting may thus embody the basic dualism of cosmic, spiritual life and material death, an archetypal juxtaposition, or *Urkontrast,* as Goethe would say, similar to those that Klee deals with in his color paintings, such as *Separation in the Evening,* 1922 (App. III-48) and *Eros,* 1923 (App. III-15).

It is rare that Kandinsky uses his form elements so directly in accordance with his theories, but in *Blue Circle* they enable the viewer to decipher the painting's symbolism. Despite Kandinsky's assertion that he uses the circle primarily in a formal sense, both the positioning of the circle within his compositions and the way it is presented more often than not make it appear as a cosmic symbol of sorts.[39] Similarly, large circle forms frequently serve as cosmic signs of Klee's work of the later twenties.

In his third painting of 1925 Kandinsky adopts Klee's color band division for the entire ground. In *Sign,* 1925/290 (App. III-3) the colors progress in irregular intervals from yellow at the bottom toward orange at the top. Kandinsky uses color gradations less systematically than Klee. Furthermore he counteracts the planarity of the ground by introducing the spatially ambivalent black and white color ladder at the right. In Klee's color band watercolors, such as *Separation in the Evening,* 1922 (App. III-48) the arrows are integrated into the ground, whereas in Kandinsky's painting the black sign hovers in front of the ground. Kandinsky employs similar signs, reminiscent of Chinese calligraphy, also in other works. Klee, too, makes use of such calligraphic signs, particularly in works of 1924, as for example *Collection of Signs,* 1924 (App. III-22). For both artists the signs are more than just

decorative linear configurations. While they cannot be deciphered, their obvious sign character nonetheless hints at some hidden meaning, thus raising the 'content' of the work beyond a purely formal exploration of line combinations.

In 1925 and 1926 Kandinsky often makes use of gradated color bands for his compositions, but in contrast to Klee, he mostly uses them only in part of the ground to set up a kind of stage for the pictorial action. In the 1925 watercolor, *Descent*, no. 195 (Fig. 40), however, Kandinsky uses color bands very much in the same manner as Klee; namely, as a means of representing movement. *Descent* is a very regularized work. It is painted with the same kind of transparent overlapping glazes that Klee used in *Eros* (App. III-15). Descending from the solid black stripe across the top, the brown and grey tonalities lighten toward the white center. A terracotta-red band extends across the bottom of the composition. The complete symmetry is broken only by the small black triangle and the red bar placed off-center at the tip of the triangle. As a result the triangle looks like an arrow tip with a bent point. In contrast to Klee, who in *Separation in the Evening* and *Eros* adheres to strict regularity in respect to the color steps and the symmetry of the composition and also emphasizes the complementary nature of his colors, Kandinsky introduces irregularities to enliven the composition. He operates with much more strongly contrasting colors (they are not complementary) and dramatizes the clashing of black, white, and red in the center of the painting. In comparison, the culminating juxtaposition of the red triangle and the black arrow in *Eros* is quite hidden. In Klee's *Separation in the Evening,* the complementary blue-orange contrast of itself suggests an analogy to nature and the colors of sunset. In Kandinsky's *Descent,* which is similar in its descending motion, the more abstract color scheme precludes such an interpretation. In these works both artists operate with the same method and with similar, abstract forms, but while Klee selects his means so that he can introduce references to natural phenomena, Kandinsky intentionally stops short of such obvious analogies. Although Kandinsky increasingly accommodates for associative and biomorphic qualities, he rarely uses them to provide clues for literal interpretation.

While in *Descent* Kandinsky mitigated the regularity of the composition, in the gouache *Colored Hexagons,* 1925/199 (App. III-35), he uses a systemic approach throughout the picture. In this respect the work is comparable to Klee's color square paintings, as for example *Ancient Sound,* 1925 (App. III-57). Like Klee, Kandinsky makes the individual units irregular in size so that they seem organically grown, like the pattern of a honeycomb, rather than rigidly geometric. By choosing the hexagon rather than the square as his basic unit, Kandinsky works with a more complex and dynamic form which makes the composition more complicated and livelier than the very balanced and

'architectonic' square paintings by Klee.

Earlier it was noted that the circle form in Kandinsky's paintings almost always has symbolic overtones, even if its specific meaning can rarely be pinned down. The same is often true of other geometric shapes. *Red in Black,* 1925/298 (App. III-23) contains the three basic geometric forms, (circle, square, triangle) but they are presented in such a way (the 'eye' in the circle, the double-cross in the square, the textural effect) that they take on an enigmatic significance, comparable to the more figurative but equally mysterious objects in Klee's *Mystic Ceramic,* 1925 (App. III-22). Such geometric or biomorphic forms charged with unspecifiable meaning can be frequently found in the work of both artists throughout the later twenties.

One visual sign that Kandinsky does use with more specific meanings is the arrow. As a symbol of motion the arrow is a central motif in Klee's work of the early twenties.[40] As Kandinsky increasingly abandons the diagonal, dynamic compositional scheme of the early twenties in favor of a more static, horizontal-vertical orientation, he makes use of arrow-like forms more frequently in order to introduce an element of motion. An example is the painting *Above and Left,* 1925/294 (Fig. 41), where two directional systems interact. The diagonal lines and foreshortened grid pattern introduce an element of action and instability to the static cluster of overlapping color planes and black and white bars. The arrow forms at left and at the top, however, provide the main directional emphasis and stabilize the composition in terms of vertical and horizontal axes. While for Klee the arrow often has a transcendental dimension as a symbol of higher forces, Kandinsky tends to use the arrow primarily as a directional sign.

Above and Left can also be seen as Kandinsky's personal synthesis of the De Stijl grid and Constructivist dynamics, but the warm colors and the earth brown, textural ground differ from both. Kandinsky's interest in Mondrian and De Stijl is reflected in a number of works of 1925 and 1926, although he never adopts their restrictive approach completely. Like Klee he often operates with a basic framework of horizontal and vertical axes, but he usually introduces subtle deviations or additional diagonal elements which provide dynamic accents. Furthermore, he uses primary colors as well as intermediary hues and a wide range of painterly and textural effects. *Untitled (Oval No. 2),* 1925/312 (App. III-57), one of a series of three oval paintings, relates quite obviously to De Stijl. However, Kandinsky counteracts the cool colors and linear precision of the painting by placing brown, grainy 'haloes' around the lines which result not only in a textural effect but also give a somewhat faded and old-masterly look to the painting, much in the way that Klee would 'antique' his paint surfaces.[41] In the later twenties such surface effects are frequently used by Kandinsky to soften the precision of his geometric forms.

The new aspects of Kandinsky's 1925 work can best be summed up in an

analysis of the watercolor, *Upward*, 1925/208 (Fig. 42). The *oeuvre* catalogue number indicates that it was the last watercolor of that year.[42] The format is vertical, but two black lines across the bottom and a white band between them establish a horizontal counterweight and act as a base for the colored triangles. The upper right corner is tinted a dark brown, providing a flat area behind which the yellow-pinkish ground seems to be indefinite and immaterial.[43] At the bottom, overlapping red, green, and blue transparent triangles create the effect of an immaterial mountainscape; coloristically they are reminiscent of Klee's color band watercolors, such as *Eros*, 1923 (App. III-15). The upper left corner of the watercolor is occupied by a small circle, neatly divided into white and blue halves. It is surrounded by a large halo which changes from deep blue in the center to reddish tones in the outer part. As described so far the watercolor might suggest a mountainscape in the sunset, reminiscent of *Blue Mountain*, 1908/9 (Fig. 4), but the placid landscape mood is disturbed by a jagged diagonal shape which ascends from the lower right toward the circle in the upper left. Precisely drawn parallel line bundles are placed over this blue-yellow shape, making it look like some futuristic technical construction. This configuration which introduces a dynamic, even disquieting element into the picture is a geometric version of the enigmatic black lines that cut across Kandinsky's prewar paintings, such as *Untitled (Improvisation 28)*, 1912/160b (App. III-47). Parallels between this painting and *Upward* can also be drawn in respect to its colors, painterliness, and overall landscape character. Following the geometric abstraction of the early twenties, as represented by *In the Black Square*, 1923 (Fig. 32), the reintroduction of painterly values and of allusive forms makes the works of the mid-twenties resemble in their general approach the productions of Kandinsky's semiabstract period of 1913/14.

While the warm colors and translucent glazes of *Upward* reflect the influence of Klee, Klee in turn seems to have been attracted to Kandinsky's combination of geometric precision and soft, atmospheric color, as well as to his combination of abstract linear constructions and what seem to be cosmic phenomena. He uses a very similar approach in his 1927 painting *The Limits of Intellect*, (App. III-15).

The predominant form motif in Kandinsky's work of 1926 is the circle, either by itself or in conjunction with other geometric shapes. *Several Circles*, 1926/323 (App. III-47), the first painting of the year, takes up the theme of overlapping circles that Kandinsky had explored in *Circles within a Circle*, 1923 (Fig. 35), but the painting has an entirely different character. Small, brightly colored circles are scattered throughout the painting like stars in the sky, most of them gravitating to the large blue circle in the lower left as if attracted by a magnetic force. While in *Circles within a Circle* the circle forms were all transparent, here they are both semiopaque and translucent. The

large blue circle with the black disk and the white halo around it almost seems to be an eye gazing at the viewer. In contrast to the bright clutter of circles around it, the blue circle appears remote and mysterious. It is a cosmic symbol, charged with Romantic overtones in Kandinsky's sense.

Just as the white halo seems to originate from some distant source of light, the circles are illuminated by an undefined light source or they are luminous in themselves. Moholy-Nagy, too, often uses such luminous forms on a dark ground, as for example in his *Composition Q XX,* 1923 (App. III-56). Moholy's black ground is even and impersonal, whereas Kandinsky creates an effect of texture on his dark ground. All around the picture edge the ground is painted in gradated brownish-greyish tones, arranged in a flowing pattern similar to the traces of receding waves on sand. Around the blue circle the ground is black so that the circle seems to come forward from some infinite outer space. Both this chiaroscuro effect and the color range of Kandinsky's painting can be compared to Klee's *Ancient Sound,* 1925 (App. III-57). Both artists operate with a single geometric form—the square for Klee, the circle for Kandinsky—but by means of chiaroscuro, variation of size, textural effects, and warm, blended colors, they imbue their paintings with an organic life, as it were, which transforms the geometric abstraction into evocative configurations: "Romantic" indeed.[44]

Throughout the twenties Kandinsky and Klee both make frequent use of dark grounds—Kandinsky especially in 1926, Klee in 1927 more than any other year. In most cases they do not use the even black ground typical of Constructivist works, as for example Moholy-Nagy's *Composition Q XX* but instead they create a mysterious nocturnal space by modulating the color or by texturing the ground. In 1926 Kandinsky paints a number of works which contain a few basic geometric shapes on a dark ground. *Small Values,* 1926/336 (App. III-3), if seen only in a black and white illustration, is quite similar to Constructivist works such as Moholy-Nagy's linoleum cut for *Der Sturm* of June 1924 (App. III-56). But the ground of *Small Values* is brownish-black and textured with small color splotches, while the translucent shapes glow in rainbow colors. The large semicircle is colored blue at right but transforms into green-yellow-pink, while the small shape at left is a mixture of greens and purples. Again Kandinsky modifies the geometric forms so as to invest them with an organic quality. This is even more apparent in other works of the group, like *Sickle,* 1926/339,[45] which alludes to the crescent of the moon, or *Dark Impulse,* 1926/345,[46] where the rainbow-colored, translucent circles, evoking images of slowly rising air bubbles, are abstract metaphors of slow motion and growth in general. Such floating, semitranslucent color forms also appeared in Klee's 1925 fish paintings, such as *Fish Magic,* 1925 (App. III-22).

In a few paintings of 1926 Kandinsky comes very close indeed to the form

character of Klee's enigmatic fish paintings of 1925/6. *Pointed Accents,* 1926/342 (App. III-50), could be called an abstract synopsis of *Fish Magic* and *Around the Fish,* 1926. C4 (App. III-22).[47] Luminous, partly transparent shapes float in a circular motion on the dark nocturnal ground. The restless diagonal movement in Kandinsky's earlier compositions is here replaced by the quiet gradual motion of forms in a continuous circular direction from the lower right upward, across the top and downward on the left, similar to the visual movement in Klee's *Around the Fish.* In *Pointed Accents* the large red shape at the upper center provides a focal point without, however, interrupting the visual motion. All forms seem to float weightlessly in an undefined space, much like Klee's underwater dream world of *Fish Magic.* With Kandinsky the individual elements are less figurative than with Klee, but the spotty colors, crescent shapes, fish scale pattern and air-bubble-like circles at the top evoke associations with organic matter. Although Klee's *Fish Magic* contains many clearly identifiable representational elements, the combination of fish with a clock, flowers, and a double-faced figure is nearly as enigmatic as Kandinsky's abstract yet allusive forms. Although less similar in form character, *Calm,* 1926/357 (App. III-47), comes even closer to Klee's *Fish Magic* in conception. In *Calm* abstract and biomorphic forms, reminiscent of plants as well as of amoebas or primeval forms of life are mysteriously assembled in an eerie, nocturnal space.[48]

Toward the end of 1926 Kandinsky paints three pictures which apparently form a cycle of sorts, perhaps a tripartite 'story' of the circle.[49] *Beginning,* 1926/358,[50] recalls the cosmic landscapes of the Blaue Reiter years. Its composition is conceived in terms of horizontal axes which emphasize the quiet 'landscape' character of the picture. In the next painting, *Development,* 1926/359,[51] there is a clashing of forces where diagonals and dynamic motion prevail. Finally, in the last painting, *Conclusion,* 1926/360 (Fig. 43), there is perfect equilibrium. Again Kandinsky works with the gradated bands of color that he had adopted from Klee's watercolors. The colors change from dark purple to dark blues and bluish greens in small color intervals but without the systematic progression from one color to its complementary that Klee most often uses. The horizontal line at the bottom is black and the colors of the triangle are composed of dark and lighter greens and browns and a brilliant corn yellow. The circle at the top is a deep purplish red with pink and green around it. The combination of warm and cool colors with dark colors, accentuated by a few brilliant tones, creates an unusual, somewhat jarring color effect considerably different from the harmonious color pairs which Klee uses for his color gradations. Kandinsky selects a very narrow tall format which generates a strong effect of top (the circle) and bottom (the triangle and the line), but the horizontal division provides a counterweight. Black line, triangle, and circle are all aligned on the vertical middle axis of the picture, so

that complete symmetry and balance prevail in the composition. The narrow vertical format, however, generates an active movement upward, thus preventing the composition from becoming lifeless and ornamental. With its strict regularity the painting, more so than the 1925 watercolor *Descent* (Fig. 40), recalls Klee's *Eros*, 1923 (App. III-15) or *Parting at Night*, 1922 (App. III-48), but here, too, the basic conceptual difference between their approaches to content, which was noted earlier, applies as well: in *Parting at Night*, for example, Klee deals with the *Urkontrast* of cold and warm color which is analogous to the *Urkontrast* of night and day. In *Conclusion* Kandinsky also represents an *Urkontrast*, that of triangle and circle, which he defines as "the primary contrasting pair of planes."[52] Although in his theories he associates these forms with basic emotions and stages of growth and life, he does not project such analogies directly in his painting.[53] On a less specific level than Klee, however, Kandinsky has become very interested in dealing with motion in terms of organic growth and movement. In the early twenties Kandinsky had conceived of pictorial movement in terms of clashing forces and dramatic action. In 1925 and 1926 the pictorial drama calms down and many works are characterized by gradual movement and slow progression, visually expressed by color gradation, weightlessly rotating, hovering or ascending forms, or by the stages of development indicated in the cycle of these three paintings. Kandinsky also makes frequent references to such organic processes in some of his titles, as for example *Becoming*, 1925; *Cool Energy*, 1926; *Pressure*, 1926; and *Dark Impulse*, 1926.

On the whole, Kandinsky's style as it had evolved by 1926 is marked by a striving for balance and harmony of the pictorial elements, which are placed within a horizontal-vertical compositional scaffolding within which the forms can move freely. There is now a definite sense of top and bottom in the paintings, yet the forms are not always bound by laws of gravity. If we use Klee's definition of Romanticism, Kandinsky's works of the early twenties, with their predominance of dynamic elements and formal *Sturm and Drang*, can be characterized by Klee's term "expressive ("pathetisch") Romanticism," while in Kandinsky's work of the mid-twenties and the following year, the synthesis of static and dynamic forces corresponds to Klee's ideal of "cool Romanticism,"[54] or, as Kandinsky puts it: "The coming romanticism . . . is a lump of ice, with a flame burning inside."[55]

Theory: The Question of Art and Nature Reconsidered

Both Kandinsky and Klee expanded and consolidated their theoretical concepts of the Blaue Reiter years into a coherent body of theory in their form theoretical teaching at the Bauhaus. Klee's *Pedagogical Sketchbook*, 1925, and Kandinsky's *Point and Line to Plane*, 1926, both published as Bauhaus books, present the essence of their teaching. However, the publication of their original teaching notes revealed that the scope of their teaching was much wider than their Bauhaus writings suggest.[1] The course notes also reveal that the artists varied their teaching over the years according to changes in their own interests. Klee, for example, used a great many examples and comparisons from nature in his teaching of the early twenties (apparently at this time he was much interested in Goethe's scientific writings and experiments), but in the late twenties his interest shifted to geometry and his lessons largely consist of complicated geometrical constructions. There are at present no scholarly editions of their teaching manuscripts, nor do any comprehensive analytical studies of their theories and sources exist.[2]

A detailed comparison of their course notes would show that Klee and Kandinsky frequently discuss the same problems without arriving at quite the same conclusions, and, conversely, they occasionally arrive at similar results by pursuing different lines of argument.[3] Since they dealt with many of the same basic form questions they were certainly interested in each other's ideas—they sometimes make reference to each other in their classes—and each integrated some aspects of the other's ideas in his own theories.

Within the scope of this study, a comparison of the artists' theories *in toto* cannot be undertaken; only one aspect shall be singled out for discussion. In documenting the gradual changes in Kandinsky's theoretical position on the question of the relatedness of art and nature, we can trace the same conceptual *rapprochement* between the artists on the theoretical level that has already been traced in their formal development.

Parts I and II of this study have shown how Klee sought to define his principles of artistic creation in analogy to laws of architectural and natural formation. In his Bauhaus teaching he elaborates this basic concept into a complex morphological theory, along very Goethean lines.

Like Kandinsky, Klee makes the basic form elements the point of departure for his form theories, beginning with the point as the *Urelement*. Point, set in motion, becomes line (here Klee's all-important element of time is introduced), and line then generates plane and eventually cube. Whereas Kandinsky discusses these basic elements very extensively, *per se,* Klee focuses on their changing roles as parts of a larger entity and on their mutual interaction as well as their interaction with other form elements. He investigates the possibilities of repetition, rhythms, and simple and complex form combinations and subdivisions, which he always conceives of in analogy to the structural processes of growth and formation in nature. In his discussion of the form elements and their interaction, Klee devises a hieratic system of so-called 'ideal' means with which the artist can create a simile (*Gleichnis*) of nature on an essentially abstract level.[4] Klee considers all these form elements within the framework of the antithesis of static and dynamic forces, which is at the very core of his art philosophy. 'Static' elements, such as the horizontal or the plummet as symbols of gravitational forces, represent the earthly dimension, while 'dynamic' elements such as the diagonal and symbolic forms such as the arrow and the pendulum set into motion are able to overcome the boundaries of gravity and reach into the cosmic or 'Romantic' realm. On the ideal level of the work of art man can transcend his earthly boundaries.

For Klee the art work comprises a synthesis of various levels of nature. It can present the outer appearance of an object (including its past-present-future stages) as well as its inner construction; it reflects earthly reality as much as cosmic dimensions. Klee created a visual formula for his view of the work of art as a multidimensional microcosmic image in the diagram he designed for his 1923 essay "Ways of Nature Study."[5]

Whereas in his teaching on the basic form elements Klee puts great emphasis on questions of syntax, Kandinsky places most of the weight on the discussion of the elements themselves. Although he gives some consideration to the changed character of each form element as it is placed in different positions on the ground or in combinations with other forms, Kandinsky's primary concern is to definitively establish the inherent perceptual qualities of the basic form elements themselves. Toward this end, Kandinsky defines the elements' 'sound' in far greater detail than Klee.

While Klee discusses what he considers to be the general principles of formation, which would necessarily extend to forms of construction other than works of art (he speaks of the equilibrium of pictorial weights in terms that might equally apply to bricklaying), Kandinsky discusses the form elements primarily in relation to the flat ground of the picture.[6] In his investigation of the innate 'sounds' of form elements Kandinsky postulates correspondences between geometric forms, colors, and temperatures. By way of compli-

cated reasoning that purports to be logical but is in fact highly arbitrary, Kandinsky arrives at the conclusion that blue corresponds to the circle, red to the square, and yellow to the triangle (cf. his diagram, p. 74 in *Point and Line*). While Kandinsky puts great store by this *Ur*triad of forms,[7] he at the same time suggests that no element has to be used only in accordance with these innate sound qualities but that it may indeed be more interesting if it were used 'against the grain.' How the form elements are actually used is determined by 'inner necessity,' which is to say, by the artist's intuition. He analyzes the effects of variously positioning the form elements on the picture surface, but he gives little consideration to either general compositional questions or to the interaction of these elements. Although the theory that Kandinsky puts forth in *Point and Line* is in many respects highly idiosyncratic, it is an important study of visual perception from an artistic point of view and it documents his great sensibility to form.

In *Point and Line,* though intended as a sequel to *Concerning the Spiritual* (Kandinsky had begun work on it in 1914), some changes in Kandinsky's thinking since the Blaue Reiter days are reflected. For one, Kandinsky now—like Klee—associates linear movement with temporal progression and compares the time element in art to that of music.[8] More importantly, the book reflects changes in Kandinsky's thinking on the question of art and nature.

In the Blaue Reiter period Kandinsky had considered art and nature as two distinctly separate realms with their own respective laws of formation, related only in their ultimate cosmic origins (see chapter 1). In the 1920s, however, parallels between artistic and natural construction have become of greater interest to Kandinsky.

In his 1920 program for the Moscow Institute of Artistic Culture, Kandinsky outlined his concept of an 'artistic dictionary' or *Generalbass* for the arts. Kandinsky proposes an investigation of artistic form elements from all angles, including comparisons with architectural and natural construction, sound in music and language, and human gestures. He wants to employ both positive and occult sciences in order to define the gestalt psychological effects of form elements, sounds, and movements. The ultimate goal of his ambitious program is to establish a universally valid code of visual perception. Kandinsky's emphasis on a scientific, rationalistic approach may well be a tribute to the Constructivist spirit predominant in the Moscow art world. He speaks very little of the *geistige* values so central to his thinking; only toward the end he declares that the ultimate purpose of these investigations is:

> . . . to find the connecting threads which run through the different artistic periods and thus attain that which is eternal through the temporary [9]

A pseudoscientific spirit and schematizing line of thought marks much of Kandinsky's writings of the Bauhaus years as well, but in the more congenial atmosphere of the Bauhaus, less utilitarian in orientation than the radical factions of Inkhuk, his mystical and spiritual bent comes to the fore again. In *Concerning the Spiritual* Kandinsky had still considered it necessary that the artist's store of forms be ultimately derived from natural forms; now, having adopted geometric forms, he may have felt less dependent on nature and therefore more ready to study the 'inner' parallels between art and nature. He may well have been encouraged by Klee, who in the early twenties was collecting natural specimens and illustrations of various natural structures and who was working on his 'morphological' art theory. In *Point and Line* Kandinsky devotes much space to pointing out parallels between art and nature. In *Concerning the Spiritual* Kandinsky had made comparisons with natural or musical phenomena primarily in order to circumscribe and define the abstract 'sound' of a color by way of analogy. In *Point and Line* his analogies are more specific, and he implies a more immediate interrelatedness between phenomena in art and in nature as well as in the other arts. By the mid-twenties his stance on this question is still quite ambivalent, but by the late twenties his class notes indicate that he has moved considerably closer to Klee's position.

In the summer of 1925 Kandinsky stated in his lessons:

> . . . painting and nature, which in the final analysis grow from the same root, but whose blossoms are entirely different. At the basis, however, these two realms are *theoretically* connected (the laws of creation), but in their absolute character they differ totally.[10]

In *Point and Line,* however, which was written during the latter part of 1925, Kandinsky devotes much space to noting similarities in 'sound' and construction between artistic form elements and specimens from nature. After discussing the point as the *Urelement* of art *per se* Kandinsky devotes a section to the point in nature and in the other arts. All forms in nature can be traced back to the point or a conglomeration of points—just as they can in art—and Kandinsky points to the poppyseed as a natural example for these micro-macrocosmic relationships:

> The smallest shapes, introverted and purely centrifugal, look to the naked eye as if they were points which are loosely connected with each other. This is how some seeds look and if we open the beautiful, smoothly polished, ivory-like globe of the poppy pod (after all, it is a larger spherical point), we will discover in this warm globe heaps of cold blue-gray points in an ordered compositional arrangement which contain within themselves the latent power of procreation, just as the pictorial point.[11] [revised]

Klee discusses the seed in similar terms, as an example of a primary form element. In his lesson of November 5, 1923 he states:

> Despite its primitive smallness, a seed is an energy center charged to the highest degree. It comprises ineluctable impulses that will give rise to entirely different and highly characteristic forms. . . . A certain impetus from without, the relation to earth and atmosphere, begets the capacity to grow . . . In abstract terms, what we have here is the irritated point as latent energy.[12]

For Klee seed and point are nearly identical as the point 'grows' into line. In his equation of natural and artistic processes Klee goes further than Kandinsky.

To demonstrate parallels Kandinsky adduces examples and illustrations of 'point' phenomena in nature, language, architecture, dance, and music (like Klee he is interested in transpositions of specific musical motifs into abstract visual equivalents), which encompass all the main categories of *Gestaltung*. In his teaching Klee as well cites parallels between art and all these areas of formation, but he usually limits himself to one or two examples for any given point of discussion, while Kandinsky in his book offers an encyclopedic array of analogies.

In speaking about the various manifestations of the point and its changing appearance Kandinsky makes a fundamental statement about the 'roots' of the point, as he calls it:

> If the appearances of the individual phenomena = plants are distinguished from each other so that their inner relationship remains obscured, if these phenomena appear chaotic to the superficial eye, nonetheless they can be traced back to one root on the basis of *inner necessity*.[13] [revised]

As Hofmann has noted, Kandinsky's belief in the ultimately common origins of the point in its various manifestations recalls Goethe's morphological studies and his search for the *Urpflanze*.[14] Similarly Klee, in his 1924 Jena lecture postulates the existence of a common *Urgesetz:*

> The chosen artists are those who dig down close to the secret source where the primal law feeds the forces of development.[15]

Like Klee, Kandinsky defines line as the point set in motion and as embodiment of the dynamic aspect:

> Line . . . is the track made by the moving point, thus it is the product of the point. Line results from motion—from the destruction of the utmost repose of the self-contained point. Here the leap out of the static into the dynamic realm occurs.[16] [revised]

Kandinsky defines the character of the basic types of line in anthropocentric terms. The horizontal implies rest as horizon and base line, while the vertical relates to man standing erect and to the actions of walking and rising. Kandinsky equates the 'cold' horizontal with black and the 'warm' vertical with white and sets up a system of analogies: horizontal: lying, supporting, death, passive, feminine; vertical: motion, growth, birth, active, masculine.[17] As the horizontal and vertical axes become increasingly prominent in Kandinsky's work of the later twenties, such associations provide keys to the interpretation of his work. Klee, too, proposes similar associations, as for example with the horizontal:

> The horizontal in itself, purely as form, is perhaps already movement. However, it gives the impression not of movement, but of rest.
> . . . In discussions of statics, "lying" means to be inactive. Lying and working are not easily compatible.[18]

Kandinsky adds to his categories:

> Thus in white and black there are, furthermore, to be noted the elements of height and depth
> --which coincide with vertical and horizontal.[19] [revised]

Klee, who deals extensively with dark-light relationships and all the intermediary steps, also defines the black and white polarity as parallel to that of top and bottom. In his teaching notes he proposes a justification for this:

> Why white above? Why black below? The phenomenon of top and bottom, considered at the center of the earth.[20] [revised]

While Klee deduces these relationships from the natural order, Kandinsky bases his system primarily on parallels in the perceptual response to forms and colors (primarily, so it seems, his own empirical perceptions). On this basis he postulates equations between the form character of, for instance, the diagonal line and the 'sound' of red as well as between the basic angles and colors: the obtuse angles correspond to blue, the 90° angle to red and the 45° angle to yellow. From here he proceeds to his triad of primary forms and colors, the blue circle, the red square, and the yellow triangle. Although Klee does not establish such correspondences, he occasionally refers to Kandinsky's planes and colors in his teaching. He also adopts Kandinsky's concept of the cold and warm temperatures of colors, but avoids the mathematical precision with which Kandinsky argues his points.

In *Concerning the Spiritual* Kandinsky had associated the color circle between the poles of white and black with the cycle of life between birth and death. In *Point and Line*, lines are defined in the same terms. On the basis of

what he describes as the inherent tensions in lines he equates the straight line with birth, the angular line with youth, and the curved line with maturity. He establishes the three

> primary-antithetical pairs of elements . . .
> Straight line, triangle, yellow,
> curved line, circle, blue,
> 1. pair. 2. pair. 3. pair.[21] [revised]

which represent a *Urgesetz,* as it were, of art, parallel to that in nature:

> This abstract lawfulness inherent in one art . . . which has to be considered in parallel with the lawfulness of nature, and which in both cases—art and nature—grants a very special satisfaction to the inner man; this very lawfulness is certainly, at the heart of the matter, also to be found in the other arts.[22]

This is the first instance where Kandinsky explicitly postulates inner parallels between art and nature, and he notes the satisfaction accorded man when he can experience this *Urgesetz* in art or in nature.[23]

In discussing line in nature, Kandinsky describes the development of the plant as a continual growth from its initial point on into lines which then further subdivide into multiple linear complexes. His metaphor has much in common with Klee's description of the plant's growth from a seed:

> The spirit of this form-creation is linear. In order to spread and gain power over large areas of space, the linear unit branches. . . . The point of origin between soil and atmosphere stretches out, and the generalized plant image becomes tree, root, trunk, crown. . . . The linear forces gather within it (the trunk) to form a powerful stream, and they radiate outward . . . Let us learn: *The whole form results from a single base, the base of inner necessity.*[24] [Emphasis mine]

Citing the tissue of flesh, skeletal construction, linear formations of lighting, leaf structures, and so on as different manifestations of the same basic organic principle, Kandinsky concludes that in nature linear construction is always 'concentric,' which means that lines have to grow out of and be connected to a center. In art, on the other hand, line can be 'eccentric:' it can exist by itself independent of a center or any other base. This thesis touches on an important conceptual difference between Klee and Kandinsky. In his remark cited above Klee implies that art should follow the laws of natural formation because it is based on the same inner necessity as nature. He uses Kandinsky's term of inner necessity in a sense which essentially differs from Kandinsky. The latter acknowledges the parallels between art and nature, but he does not postulate that the laws of nature are binding for artistic creation as

well.[25] That Kandinsky's attitude about this question at this time is ambivalent is reflected in his programmatic statement in *Point and Line:*

> For the artist it would be of special importance to see how nature in her independent realm makes use of the basic elements: which elements are considered, what characteristics they possess and in which manner they combine to form structures. The laws of composition in nature open up for the artist . . . the possibility of contrasting these laws with those of art. In this point, too, which is of decisive importance for abstract art, we already discover the law of setting side-by-side or setting opposite, which postulates two principles—the principle of the parallel and the principle of contrast—which was shown in the discussion of line groupings. The thus separate and independently existing laws of the two great realms—of art and of nature—will eventually lead to an understanding of the all-encompassing law of world composition, and they will demonstrate the autonomous participation of both laws in a higher synthetic order: external and internal.[26] [revised]

In Klee's opinion the artist does not have the option of whether to follow the *Naturgesetz* or not. In a lesson of July 1922, in which he quotes extensively from his diary he states:

> . . . at first glance you do not perceive how the natural law works. You must first look for it, investigate . . . Our work is given form in order that it may function, in order that it may be a functioning organism. To achieve the same as nature, though only in parallel. Not to compete with nature, but to produce something that says: it is as in nature.[27]

In Kandinsky's view art and nature operate with different basic means. In nature, the *Urelement* or cell, is in continual motion whereas in art, the point is basically an element of rest.

> As for the means, art and nature in relation to man move on different tracks, tracks which are far apart from each other, even if they strive toward *one* point.[28] [revised]

However, throughout the book it is apparent that Kandinsky is fascinated with parallels between art and nature. Although for him the artist has the option of using form elements *counter* to their innate qualities, these innate qualities themselves do correspond to organic phenomena. In speaking about the picture plane and its inherent visual tensions, Kandinsky conjures up the vision of a living organism that is in many way similar to Klee's image of the art work as a tree-like organism.

> Each living being continually relates to "above" and "below" and this must be so; this relationship also applies to the ground plane which as such is a living being.
> . . . The artist "fertilizes" this being and he knows how obediently and "happily" the ground plane accepts the right elements in the right order. This living, if primitive, organism can be transformed by the right treatment into a new, living organism which is no longer primitive but instead has all the attributes of a developed organism.[29] [revised]

In a lesson of July 1922 Klee describes the process of giving form to the work of art:

> A work . . . is first and foremost genesis, work in progress. No work is predetermined; every work begins somewhere with a motif and outgrows its organ to become an organism.[30]

While the two artists are in many regards in accord on the parallels between art and nature, they consider them in fundamentally different contexts. For Klee the work of art is an extension of nature and its structural order, as it were. It is a concentrated, microcosmic image of nature in all its manifestations. Operating with 'ideal' means the artist can present in the work of art a synthesis of earthly and cosmic forces, of statics and dynamics. Thus, the *Naturgesetz* is reflected in the work of art on a higher and more encompassing level than can be perceived by man in actual reality. For Kandinsky, on the other hand, it is not the foremost task of art to make the *Naturgesetz* transparent. Rather, he adduces the parallels in formation between art and nature as supporting proof for the validity of his artistic laws. In his 1926 essay, "The Value of Theoretical Instruction For Painting" ("Der Wert des Theoretischen Unterrichts in der Malerei"), Kandinsky states:

> The lawfulness in nature is of a living kind as it combines the static and the dynamic, and in this regard it is equal to the lawfulness in art. Therefore the recognition of the laws of nature is indispensable for the artist, beyond its philosophical-educational import for every man.[31]

At this point Kandinsky deems it of paramount importance that the artist understand the parallels between art and nature, but the artist does not necessarily have to base his art on these parallels.

As the published notes from Kandinsky's teaching, dating mostly from the later twenties, are rather fragmentary in character it is difficult to assess how he actually proceeded in his courses.[32] Even so, it is obvious that he frequently discussed the relationship between art and nature, examining it from various angles. By the early thirties his position on this question has changed to some extent. In his courses Kandinsky discusses the role of measure, weight, and rhythm as important compositional considerations at greater length than in *Point and Line,* and he often adduces natural phenomena as precedents.[33] The course notes also demonstrate that Kandinsky took considerable interest in scientific and parascientific writings as well as in occult sources. In a 1926 lesson he discusses the basic form elements and their symbolic connotations by citing Freemasonic symbols:

Point: archetype of all signs, the central core . . .
Line: vertical: man, from the sky and toward the sky, divine unity, the divine.
 horizontal: the animal, the uniform world, leveling, the terrestrial.

. . . .

the cross: the most ancient of all signs.
 The interpenetration of the divine and the terrestrial.

the circle: God, eternity.
the triangle: Egyptian symbol of God.

. . .

the square: the world and nature.[34]

Certainly Kandinsky did not aim at introducing such specific symbols into his art or into his theory, but his mention of them indicates that he was not opposed to symbolic interpretations of abstract forms in general. He adduces these symbols as additional supportive evidence for the universal validity and relevance of his form elements. His search for parallels and analogies in all cultural and natural areas is reminiscent of medieval cosmological theories where the divine trinity is manifested in all phenomena. Kandinsky's systematizing bent is reflected in a table of correspondences between colors and physical, emotional, and musical phenomena:

Lines
Angles
Planes
Colors

(temperature)	yellow	red	blue
clearness	white	gray	black
vowels	i	a	o (or u)
cadence	presto	moderato	adagio
pulse	135	75	50
temperature	warm	lukewarm	cold
thought	fast	deliberate	cerebral
	too fast		(necessary)
sentiment	affectionate	controlled	profound
action	spontaneous	reflected	careful

Senses:

1. touch	sharp	hard	soft
2. smell	piquant	strong	fragrant
3. taste	piquant		sweet
4. hearing	loud	medium	low
music	sharp	calm	deep.[35]

This elaborate table, apparently dating from the winter of 1927/28, demonstrates that on the theoretical level, at least, Kandinsky was interested in ever expanding his system of correspondences. It is likely that he also explored

these associations in his art, as from about 1926 on he works a great deal with the basic form elements and with simple compositions.

In a class of May 1928 Kandinsky defines what he considers the esthetic goals of his time, expressed not only in art but also in architecture and technology:

> Tendency toward dematerialization, abolition of weightiness, the desire to move away from earth . . . the discovery of the universe, astrology, transition from the reign of Pisces toward the age of Aquarius.[36]

His characterization of the general formal tendencies of his time is also a description of his own art. Like Klee, Kandinsky sees in art the possibility to transcend earthly gravity and to attain a cosmic dimension.

In a lesson that apparently dates from March 1930, Kandinsky further develops his concept of the art work as a synthesis of earthly and cosmic forces along lines that relate to Klee's diagram in "Ways of Nature Study":

The Direction of the Spiritual Revolution in the Twentieth Century

1. "over the wall"
the walls tumble down, as a result

2. "toward the roots"
several roots apparent
eventually: only one root, as a result

3. toward the above = toward the
cosmic = synthesis of the multivalence as a result

4. The kernel instead of the shell.
The contained instead of the
container = inner sound. therefore

simultaneously toward:

below-above = *grand synthesis*
exterior—interior
eccentric—concentric.[37]

Like Klee, Kandinsky here defines art as a synthesis of earthly "roots" and transcendental dimensions, but in contrast to Klee he does not include the phenomena which the eye actually perceives in reality. The visible reality of outward nature, which in Klee's art is one of many dimensions and often the point of reference for his motifs, continues to be excluded in Kandinsky's system of thought, but he now does postulate the inner laws of nature as the basis for art. At another point during the course he states:

> Art is not situated outside of LIFE, it is born from a natural impulse. Its fundamental law is rhythm—as in NATURE. The oscillations in the cosmos are not chaotic, they constitute a complex process which, however, is simple in the final analysis. Never forget that everything consists of the shell *and* the kernel. Especially in art.[38]

Furthermore, in his analysis of the directions art has taken since Impressionism Kandinsky defines "abstract art":

Without "subject"	Pure composition
Absolute objectivity	based internally on
Beginning of a new theory	*Nature*[39]

Eventually, in a lesson dated 1932, Kandinsky postulates an immediate relationship between the laws of art and those of nature, illuminating it with an image which Klee had already used in a diary entry of 1908 in order to define the relationship between art and nature in terms of their *inner* laws.[40]

> As each body has a skeleton: a scaffolding to which the muscles, the intestines, the veins and the nerves are attached; the works of art also have always had 'skeletons,' scaffoldings which constitute the bases of composition . . .

After the 'arbitrary' composition of Impressionism there:

> Soon [followed] organic composition (Cubism, Expressionism, and in the most lucid and most consequent way in abstract art), based, at first unconsciously, then deliberately on "NATURE." The cut thread has been retied.
> . . . Through a slow transition toward a new comprehension of NATURE, inner necessity was born again. As by and by everything seems to vibrate anew, a capacity revealed itself for sensing also the living pulsations in 'silence' and even in the 'void.' From here results a tendency toward displacement (*décalage*), allusion, multipolarity, the fluid "invisible," etc.[41]

In the same year Kandinsky discusses the laws of composition:

> What is the absolute law of composition? A rhythmic construction, logical and efficient = laws of nature extending into the cosmos. What is the rhythm? The relationship between tensions.
> The law of rhythm? Tension, relaxation = contrast. All is relative, therefore the possibilities are inexhaustible.[42]

We have seen that between 1925 and 1932 Kandinsky's thinking has changed considerably. In 1925 he still saw art and nature as two different realms, whereas by the thirties art was to be based on the formative laws of nature. In the late twenties Kandinsky's thinking is informed by a striving for synthesis, a reconciliation of opposites, which he circumscribes with the term "und," meaning "as well as." He envisions a synthesis not only of the arts but of all

aspects of life—for this reason he continually expands his list of correspondences—a synthesis which will enable man to reach into the cosmos. In the March 1930 lesson he says about the "UND":

> Beyond the rapprochement of the different arts—the synthesis, also the separation [or distancing] of present times from "life," from narrow economic interests, from mundane politics, with the aim:
> 1. to elevate oneself above terrestrial contingencies.
> 2. to attain cosmic relationships through those means.
> 3. to attain beyond "nature" the essential "NATURE"[43]

At this time Kandinsky and Klee are closer to each other in their artistic *Weltanschauung* than they had ever been before, even while differing in regard to the actual application of cosmic and natural laws in their art. However, the increasing conceptual emphasis on "organic" order in art—manifest in rhythm, equilibrium, and the use of form elements as symbolic expressions of natural forces—that we traced in Kandinsky's artistic philosophy of the later twenties does indeed find its reflection and expression in his art. The shift of emphasis in his art puts it stylistically closer to the art of Klee than it had been before, and it is to this stylistic neighborhood that we must now turn.

8

Stylistic Relationships in Klee's and Kandinsky's Works, 1927-1932

And today I say: hello! and move slightly toward him, coming from the west. He takes a step forward to meet me and my hand rests in his. In Germany in the year 1926.[1]

With these words Klee concludes his homage to Kandinsky on the latter's sixtieth birthday. His metaphor describes not only their personal friendship, but also their artistic relationship. In Chapter 6 it was noted that Klee took a step 'eastward' in his art in adopting Constructivist space and precise geometrical forms. Kandinsky, on his part, had moved closer to Klee in his art, in respect to compositional principles, painterly qualities, the color range and figurative allusiveness in his art. During the period now under discussion he draws closer to Klee on the theoretical level, as was demonstrated in the chapter on the art-nature question.

In the late twenties and early thirties a close artistic interaction takes place between the two artists, both on a conceptual and a formal level, which manifests itself in the stylistic relatedness of much of their work. Considered within the context of the avant-garde of the 1920s and of the Bauhaus under Meyer's and Mies's directorship in particular, Kandinsky and Klee represent a conservative element. In their general artistic outlook they are still Expressionists, even though they are open to and come to terms with the formal innovations of Constructivism, De Stijl, and—later—Surrealism. In the painting, *The Limits of Intellect,* 1927 (App. III-16), Klee, for example, creates a quite Constructivist linear structure, but he uses it to lampoon the technological positivism of Constructivists like Moholy-Nagy.[2] The painting is as much a stylistic reference to Constructivism as it is a tongue-in-cheek critique of the Constructivist doctrine; it is a latter-day version of the Tower of Babylon story rather than an affirmation of rationalism and technology as society's salvation. In many of Klee's works, Constructivist means are used for fundamentally different ends. For example, the neutral, undefined space of Constructivism is often transformed by Klee into a mystical, atmospheric space, suggestive of cosmic infinity.

Klee's drawing, *Moon Sickle, above Things Rational,* 1925. 235 (App. III-16), succinctly sums up Klee's attitude (and we may extend it to characterize Kandinsky's thinking as well): the linear constructions, symbolic of human ratio, cannot eclipse the crescent moon which, frail, but dominant, reigns over the entire scene as the representative of metaphysical forces.[3] Both Klee and Kandinsky seek to preserve and express this transcendental dimension in their art; they want to uphold the spiritual values of the Blaue Reiter period. They adopt from Constructivism those formal means, such as the indefinite space, transparency and weightlessness of form, immaterial linear constructions, and abstract (geometric) shapes, which, albeit in a stylistically different form, they had already used during the Blaue Reiter period. Broadly speaking, much of their work of the 1920s is a reformulation in updated stylistic terms of artistic concerns developed before the war. This conceptual continuity in the work of both Klee and Kandinsky is often obscured by the considerable stylistic changes that their art has undergone since the Blaue Reiter days.

From 1927 onward the two artists frequently use similar formal means in coming to terms with the challenges of the avant-garde. It cannot be decided from today's vantage point if these formal similarities are the result of more or less unconscious mutual inspiration and stimulation, or if they reflect a joint search and experimentation comparable to the interaction between Picasso and Braque during the heyday of Cubism.[4]

Kandinsky, with his love for tables and schemata, defines his and Klee's position within the context of the contemporary avant-garde quite succinctly in a list of artistic movements that he presents in his Bauhaus course in 1932. In his characterizations of art from Impressionism to Mondrian ("Symbolism: abstract") and the Surrealists ("nature and dream") he states under the heading:

> *Mathematics:* the Constructivists, *the abstract painters of spiritual essence (Klee and myself).*[5] [second emphasis mine]

In discussing their work of 1927 to 1932, the selection of examples emphasizes works which not only demonstrate stylistic relationships between Klee and Kandinsky but also relate to other contemporary art. Much important work by both artists, especially by Klee, has not been taken into consideration, being outside the scope of this study. Because a chronological discussion would quickly get entangled in as of now unsolvable problems of dating and precedence, the works are grouped around predominant formal concerns. Since the artists were preoccupied with certain formal issues in certain years, the sequence does, however, indicate a very rough chronological order.

Linear Configurations, 1927-1929

During the Blaue Reiter years, both artists had already put great emphasis on linear elements in their paintings, often using line in an explicitly 'graphic' sense. In their linear work of the twenties, both artists adopt the precisionist quality of Constructivist line (Kandinsky already in the early twenties, Klee from the mid-twenties onward). Even though in a number of works they come quite close to the Constructivist style, on the whole they both seek to counteract its impersonal, purely geometric character.

In the introduction, the comparison of Klee's *Boats in the Dark*, 1927 (Fig. 1), and Kandinsky's *Points in an Arc*, 1927 (Fig. 2) with Moholy-Nagy's *D IV*, 1922 (Fig. 3), outlined the manner in which Klee and Kandinsky respond to and transform Constructivist impulses. Two other, stylistically related works by Klee and Kandinsky are typical of one predominant mode in which they deal with linear configurations in their paintings. In both Klee's *The Limits of Intellect*, 1927. 298 (App. III-16), painted in oil and watercolor, and in Kandinsky's *Fishform*, 1928 (Fig. 44), a watercolor, the central form is constructed with thin, precisely drawn pen lines. Klee creates a complicated transparent spatial structure, however, without clearly defining the space. Jordan has proposed Gabo's *Project for a Radio Station*, 1920 (App. III-21), as a possible source for Klee's construction.[6] In Gabo's tower there is a strong diagonal thrust, the tower seems to sway on its legs like the Eiffel tower in Delaunay's paintings of 1910/11, as Jordan has noted. Klee's structure is visually more stable, as the individual diagonal directions are counterbalanced so that the whole construction is in near-equilibrium and as a result seems more static than Gabo's soaring tower. Kandinsky's *Fishform* is even less dynamic in composition than Klee's painting. Kandinsky's linear configuration has a definite horizontal axis which is anchored, as it were, to two vertical axes at either end. The oblong format and the band of gradated colors along the upper edge further reinforce the horizontality of the composition. In Kandinsky's watercolor, the linear patterns are organized into planar sections which do not interlock so that there is very little spatial tension within the entire linear structure. The individual sections remain visually discrete and exist *per se*, whereas in Klee's construction the various sections are the 'dividual' parts of an 'individual' whole, in Klee's terminology.[7] That the pictorial elements have greater autonomy as separate units is characteristic of Kandinsky's work in comparison to Klee's. Klee connects all the individual elements in order to create a formal organism, whereas with Kandinsky some of the lines are 'eccentric,' that is, exist outside of a structural context.

In respect to its spatiality Klee's linear structure can be related to Gabo's *Radio Tower*, whereas Kandinsky's way of using overlapping linear forms can be compared to Rodchenko's *Line Construction*, 1920 (App. III-21). (See also

Jordan's comparison of Rodchenko with Klee and Kandinsky quoted on p. 142).

The more static character of Klee's and Kandinsky's compositions aside, they differ from the Constructivist works in their general appearance. In both works the transparent linear configuration is placed over a richly modulated yellow ground with red color accents, which provides an atmospheric setting quite different from the even white ground in Constructivist works. The warm tones invite associations with color effects in nature, in Klee's case with a glowing evening sky. The hazy grounds are pointedly juxtaposed with the precision and (pseudo-) rationality of the linear constructions. Both artists, Kandinsky especially in the late twenties, often use such atmospheric grounds as setting for very precisely constructed drawings. Kandinsky often uses very warm, even 'sweetish' colors for his misty grounds which invest the works with a rather Romantic air. In *The Limits* the atmospheric ground evokes cosmic infinity, just as the red circular form hovering above clearly represents a cosmic body.[8] This and the physiognomic structure beneath it introduce a 'content' entirely at odds with Constructivist ideas. Similarly Kandinsky in *Fishform* goes beyond a purely formal combination of lines and makes the mandala-type shape resemble a fish. He makes this reference to organic forms explicit in the title that he chose for the work. Like Klee, Kandinsky often allows figural allusions to enter into his geometrical constructions, even though he does not elaborate them to the same extent as Klee does. References to nature are not only contained in the forms and the colored grounds, but also in the emphasis on horizontal and vertical compositional axes which puts the 'above' and 'below' of the composition in relation to the natural forces of gravity. In all these respects Kandinsky and Klee run counter to the esthetic principles of Constructivism.

In many works of 1926 and 1927, Klee works with very fine lines which seem to be incised into the ground. These lines can be either somewhat scraggly, as in the well-known *Adventurers' Ship*, 1927,[9] or geometrically exact, as in *Flag-Bedecked Pavilion*, 1927 (in the collection of the Staatsgalerie Stuttgart). As in the *Boats* series, the dark ground is transformed into a nocturnal space. The linear configurations in *Flag-Bedecked Pavilion*, which prefigure Klee's complicated geometrical exercises in his Bauhaus teaching of the later twenties, are superficially reminiscent of some of Rodchenko's form motifs, as in *Line Construction*, 1920 (App. III-21). But Klee alludes with his linear patterns to the structure of trees and plants, and the cubic construction in the center is transformed into an elegant little pavilion. While trees and houses are transparent and immaterial, opaque geometrical color shapes provide planar accents in the otherwise indefinite space. Klee integrates these shapes into the figurative content by declaring them to be flags, ironically reversing the inherent qualities of flags—thin cloth in perpetual billowing

motion—by making them the most solid, immovable form elements in his picture.

Kandinsky also uses similar line constructions for architectural associations or natural structures. An example is the gouache, *Delicate Joy,* 1927 (App. III-47), which is painted on an evenly black ground. Using white and colored lines Kandinsky creates transparent linear constructions which invite associations with a tower (the tall triangle at left), a boat with oars at right, and with the sun or moon (the circle in the upper right). Although considerably more abstract, Kandinsky's painting nonetheless evokes landscape associations similar to those in Klee's painting. This motif combination can be traced backward in Kandinsky's *oeuvre* in a chain which includes for example, *Backward Glance,* 1924; *Small Pleasures,* 1913; and *Lake (Boat Ride),* 1910.[10]

The tower-like structure in *Delicate Joy* reminds one of technical constructions, such as electricity poles.[11] Similar constructions appear in the painting *Pointed Structure,* 1927/399 (Fig. 45), where Kandinsky acknowledges the architectural quality in the title. The linear forms are outlined in white on the unevenly painted warm brown ground. Red, blue and yellow rectangles and circles are placed semitranslucently over some of the linear forms. All the individual forms and patterned shapes remain transparent and visually discrete, but their intersecting and overlapping provides a vague sense of spatial relationships within the conglomerate of separate shapes. Kandinsky's 'architecture' is composed of essentially planar elements which are not joined into a spatial arrangement, whereas in Klee's *Pavilion* the architectural structure is three-dimensional and depicted in perspective foreshortening. The effect of spatiality in *Pavilion,* however, is counteracted by the transparency and changes in viewpoint (the ladder). The architectural effect in Kandinsky's painting results from the symmetry and verticality of the linear forms which are firmly based on a horizontal axis. Compared to the dynamic composition of Gabo's *Radio Station Project* (App. III-21), with its slanted planes, Kandinsky's architectural forms are very static and quite classical in their emphasis on symmetry and compositional equilibrium. In contrast to Klee's whimsical architectural phantasies,[12] Kandinsky draws inspiration for his linear configurations from technical constructions as well as from Constructivist sculptures and stage settings or contemporary skyscraper plans.[13] In regard to the more abstract character of the painting as well as the more geometrical and technical appearance of his forms, Kandinsky is closer to Constructivism than Klee, but the warm brown ground and the yellow sun or moon-like circle in the upper center introduce natural associations and counteract the precisionist qualities.[14]

In another painting of 1927, *Red in the Net,* 1927. 403 (App. III-62), Kandinsky introduces into the linear construction a wealth of associations with natural forms. Within the irregular grid formed by vertical and horizon-

tal bar-like lines there are different linear patterns that look like waves, trees, spider webs and nets. The sand-colored ground with the soft-edged red and green color spots and the three crescent shapes add to the biomorphic dimension of the painting, but it nevertheless is not as interpretable as the geometric line patterns in Klee's nocturnal park scene.

Both artists frequently combine linear configurations with geometrical color forms, such as the flags in Klee's *Pavilion* or the squares in *Red in the Net*. Klee usually creates a more extreme contrast between the fine filigree-like lines and the solid shapes than Kandinsky, whose lines are usually more sturdy and robust.[15] Kandinsky often operates with bar-like lines somewhat similar to the narrow black strips in Mondrian's grid paintings. Reminiscences of Mondrian's grid order appear in Kandinsky's *Mild Hardness,* 1927/ 404 (Fig. 46), an oil painting executed in the later part of the year, after *Red in the Net* and shortly before *Points in an Arc* (Fig. 2). In *Mild Hardness* the basic compositional order is established by two vertical red lines and four horizontal lines (red, orange and light pink), bent upward and downward at a right angle, so that they form a swastika-like shape. These short lines, which protrude from the central double cross shape, introduce an element of visual motion, proceeding from the lower right upward, around and down on the left side, into what is otherwise a completely static composition where vertical and horizontal axes are at equilibrium. Numerous smaller and shorter lines, often in pairs or triads extend parallel to the main axes, like so many variations on a theme. They complicate the composition but do not obfuscate the predominant order. This complex grid forms an almost closed rectangular shape which echoes the picture format. Scattered within this grid of verticals and horizontals are a few diagonal lines providing a dynamic accent in the composition and a few shapes of solid color. Most prominent are the three semibiomorphic shapes, a red one in the center of the composition, an orange one above it, and a smaller yellow one at the top left. Visually they seem to be placed behind the grid, but wherever lines cross through these mushroom-like forms they take on an entirely different color so that they seem to be part of the shape rather than overlapping it. In this way the forms are integrated into the grid and appear to be more or less on the same visual plane rather than behind it. Forms and lines are discrete elements, yet interact so that they seem neither completely solid nor quite transparent. At the same time, Kandinsky introduces very subtle spatial effects. While the red vertical line at the right is coloristically interwoven with the lines crossing it, the left red axis runs its full length without such interruptions and thus seems to be placed in front of all the other lines. Being narrower it is longer than its counterpart on the right so that they are unequal in appearance but equal in visual weight. Formal nuances such as these are typical of Klee's way of composing. Many other details as well, such as the distribution of colors, the variations of motifs, and

the recurrent linear rhythms, relate to Klee's way of exploring a basic pictorial idea in all its variations. The prevalent symmetry and centralized composition as well as the complementary contrast of the deep blue ground and the warm red-orange-yellow 'sound' of the line-shape configuration imbue the painting with a classical sense of equilibrium and balance. In its overall conception it comes close to Klee's color square paintings or his *Boats* series. Yet Klee, in these works stays much more within the limits of the given form motif—be it squares or overlapping triangles—than Kandinsky, who introduces a wealth of different form motifs such as the mandala and the semicircle, as well as many small additional color accents. While the mandala shapes and the 'mushroom' shapes are evocative, the painting ultimately defies interpretation along figurative lines, and this, too, sets it off from Klee.

Klee, on his part, uses the same kind of bar-like lines and semibiomorphic shapes in a painting which in its compositional character, if not in its figurative elements, could be ascribed to Kandinsky. In *Plant on Window Still Life,* 1927.K9 (Fig. 47), linear forms and color shapes, surrounded by dark haloes, are placed on the dark green ground in a curious compositional order. Most of the forms are crowded together in the upper diagonal half of the picture, with the head isolated in the empty lower half. Klee here seems to be experimenting with a composition based on Kandinsky's ideas on the weight of forms in the different sections of a picture. According to Kandinsky's theories the lower right quarter of the ground is the 'densest' area, where form elements have the greatest visual weight. The upper left quarter is the lightest, while the lower left and the upper right sections are intermediate. As these two areas are similar in character, Kandinsky describes the diagonal axis extending from the lower left to the upper right as a "lyrical" tension and as a harmonious diagonal, whereas the other diagonal direction is marked by "dramatic" tension and is disharmonious.[16] If we apply Kandinsky's terms to Klee's composition, the dominant compositional axis is the "lyrical" diagonal from lower left to upper right which is occupied by the biomorphic and geometric shapes of plants, window, and moon. The "dramatic" diagonal direction is secondary, but Klee increases the tension between the 'densest' and the 'lightest' part of the ground plane by juxtaposing the round form at bottom to the linear forms at top, which represent another strong form contrast in Kandinsky's sense. The lower right quarter being the one where forms weigh most heavily, the round head can hold its own against the numerous other form elements placed in the 'lighter' sections of the ground. As Klee generally was much concerned with the questions of the visual weight of form elements and their balancing, it is plausible that he may have tried out Kandinsky's theories of pictorial weight on the ground plane. In Chapter 6 it was already noted that in the late twenties Klee is quite interested in the type of outsize pictorial elements placed in unexpected positions on the surface which

are characteristic of Kandinsky's style.

Since the three primaries predominate in the colored shapes of this picture, it is possible that Klee is also experimenting with Kandinsky's color-shape correlations and their 'sounds,' although he does not adhere strictly to Kandinsky's basic scheme.

Even though most forms in Klee's *Window Still Life* are figurative, the picture as a whole, with the dark head, the tablet inscribed with mysterious signs, the moon-like shapes, and the linear structure at the upper left, remains rather enigmatic and the ambivalent title (is the plant part of the window still life or is it in front of it?) does little to clarify the meaning. The dark haloes around the forms bestow on them a mysterious significance. In its combination of abstract and figurative elements, of geometric and biomorphic forms the painting is similar to some of Kandinsky's, such as *Calm,* 1926 (App. III-47), and, notwithstanding its more clearly figurative aspects, it is ultimately as enigmatic in its expressive meaning as is Kandinsky's.

Kandinsky and Klee deal with linear configurations in a number of other ways that are formally similar. In *Radiating Lines* 1927/401 (App. III-10), Kandinsky works with colored brushlines on a dark ground, as did Klee in his 1926 paintings, *Little Dune Picture,*[17] and *Gate in the Garden,* 1926. 81 (App. III-18). In Kandinsky's painting the intersecting and overlapping bundles of line, similar to the form motifs in Rodchenko's *Line Construction,* 1920 (App. III-21), are more linear and more precisely drawn than the wide, irregular brushlines in Klee's *Gate.* The line bundles converge behind a black circle that has a smaller red circle inside it and a green halo around it. The halo gives a cosmic quality to this form, while the placement of the red circle off-center to the left evokes associations with an eye.[18] Hovering above the small arrow-like form at the lower left, the circle shape with the brightly colored 'rays' emanating from it evokes a mysterious cosmic apparition in a nocturnal sky. Compared to Klee's *Gate in the Garden* (where Klee also places the largest and visually 'heaviest' form, the red doorway, in the upper left corner, in accordance with Kandinsky's theories of the picture ground), Kandinsky's *Radiating Lines* is more abstract and the forms are less organic in character, but in comparison to Constructivist works, such as Rodchenko's *Line Construction,* 1920 (App. III-21), it is very evocative of natural forms and phenomena even if they cannot be interpreted as specific objects.[19]

Another type of linear method is represented by Klee's painting *Plummets to the Wave* (App. III-15). The white ground is strongly textured; distributed over it are misty red and blue color spots. Drawn over this very atmospheric ground are very thin, precise lines surrounded by subtle yellow haloes which integrate the lines into the textural ground and soften their sharpness. The linear configurations become immaterial apparitions in what has been aptly described as a Turnerian atmosphere.[20] Despite its romantic

mood, the painting is a highly theoretical demonstration piece for what Klee considers the cosmic *Urkontrast* of static and dynamic forces. The plummet for Klee symbolizes the force of gravity. The waves introduce a dynamic element. Riding on the waves, the plummet-boats are temporarily deflected from their gravitational orientation, but they cannot completely overcome the laws of gravity to enter into the dynamic realm which, in Klee's thinking, is the cosmic *Urzustand* that all static elements long to attain.

Kandinsky operates with similar formal means in the painting, *Light Blue*, 1929/ 443 (App. III-37).[21] The lightblue-yellowish ground is more even than the ground in Klee's painting, but it, too, has a somewhat atmospheric quality. The thin black lines are surrounded by colored haloes which here, also, serve to soften their precision and integrate them into the ground. In a way similar to the basic contrast of static and dynamic forces in Klee's *Plummets*, Kandinsky works with a number of formal antitheses in *Light Blue*. The main bundle of lines extends diagonally from the lower right to the upper left, establishing a "dramatic" tension as the main compositional element in the painting. The two main forms, the red and green circles, are placed, respectively, into the 'densest' section of the picture ground and in the 'lightest' corner. Thus the smaller red circle can counterbalance the larger green form, and an equilibrium is established between the two sides of the picture. Green and red represent the second basic color contrast in Kandinsky's theory. The juxtaposition of the two picture halves is further underscored by the predominance of straight lines on the left side and of curved lines on the right, these being another *Urkontrast* in Kandinsky's theory.[22] In respect to the formal means and the underlying conception (the formal expression of antithetical concepts), the two paintings are quite comparable, yet Klee sets up a figurative context, the seascape, whereas Kandinsky in this painting keeps his forms quite free of associative qualities.

So far discussion has centered on the ways in which the artists adopt Constructivist and De Stijl linear modes and adapt them to their own purposes. In other works they use the linear element quite differently from De Stijl and Constructivism, since both artists delight in exploring formal means and techniques from many different angles.

Klee's intense interest in textile and scriptural patterns as well as natural structures of all types has already been noted. Kandinsky explores net and web patterns in a number of 1927 works, as in *Red in the Net* (App. III-62) or *In the Net*, 1927 (App. III-45), a watercolor, in which he combines linear structures with gradated bands of color.[23] In 1927 both artists also introduce thick black *cloisonné*-like lines into some works, as, for example, in Klee's *Departing Steamer*, 1927 (App. III-12), and Kandinsky's *Woven*, 1927/ 390 (App. III-3).[24] In works of the type of *In the Net*, Kandinsky depicts some of the color bands visually foreshortened so that there is a spatial back and forth

movement within the net structure, but the directions change so much that it cannot be read in any logical way. As a result, the space is visually inaccessible and unfathomable. Klee creates similarly ambivalent and immaterial spatial effects in his linear patterns. In 1927, Klee works a great deal with overlapping run-on lines forming small geometric units which are filled in with different colors. As Kandinsky does frequently, Klee changes to a completely different color where two forms overlap; as a result the two more or less transparent planes do not seem to overlap as distinct spatial layers. Yet at the same time the overlapping and intersecting implies spatial relationships, as, for example, in *City on Two Hills*, 1927, Y 4 (App. III-22), where Klee uses the predominantly square and rectangular forms to conjure up the vision of an intricate architectural structure. The cluttering of forms atop the brownish 'hills' evokes the silhouettes of old towns, yet Klee emphasizes the abstract character of the watercolor with the color scheme: the foreground is purplish-pink, with a yellow edge along the bottom, while the upper picture half is grey with a black edge at the top, altogether a rather jarring color combination of the kind more frequently found in Kandinsky's work.[25]

In a large watercolor, *Delicate Yellow*, 1927/ 233 (App. III-41) Kandinsky creates a similar Fata Morgana-like architectural image as Klee does in *City on Two Hills* and other works of the same type. The ground is a lemon yellow color which lightens toward the center. In the absence of a horizon line the central motif appears like a flat cut-out or stage prop. Kandinsky does not use one consistent linear pattern, but subdivides the shape into individual sections, each containing different formal motifs. The net pattern and the rounded color band sections introduce some ambivalent spatial effects into the entire shape. In regard to composition, color, and the architectural motif Klee's and Kandinsky's watercolors are quite closely related.[26] What sets them off from each other is the way in which they use the linear patterns that make up the central shape. Klee uses the run-on lines as well as the rhythmic distribution of the colors to establish a continuous visual motion, which guides the eye through the maze of forms. Kandinsky, on the other hand, juxtaposes patterns and forms and introduces abrupt changes of direction, so that the visual motion is discontinuous and restless. Kandinsky's preference for a variety of motifs rather than for variations on one basic form motif—a method with which Klee operates in this work and in many others—shows that even in this very calm, undramatic composition he works along the lines of his postulate in *Concerning the Spiritual:* "Antitheses and contradictions— that is our harmony."[27] The use of run-on contour lines with transparent overlapping is a major formal method which Klee uses in the late twenties and early thirties in order to create continuous visual movement in his works, as he puts more and more emphasis on dynamic qualities. Kandinsky, on his part, in much of his work of the late twenties makes the composi-

tions very static and balanced, often dividing them into more or less symmetrical halves. He does not employ run-on line patterns or the kind of interlocking transparent forms that Klee uses to guide the eye in a steady movement through the picture. This difference in Klee's and Kandinsky's pictorial conceptions has been elucidated by E. Gombrich, who has suggested that Kandinsky—more or less unconsciously—responded to one of Klee's motion-filled works, namely, *Activity of the Harbor Cities,* a 1927 drawing, in his painting *Repose,* 1928, by converting the bustle and restlessness of Klee's drawing into forms and a composition which to him expressed repose and calm. Gombrich says about Kandinsky's painting:

> . . . how much Kandinsky's work, painted a year later, gains in intelligibility when placed side by side with Klee's. Suddenly the massive rectangular forms acquire indeed the dimensions of heaviness and calm; they are the 'pong' to Klee's 'ping'.[28]

Gombrich's ping-pong metaphor appositely characterizes the artistic interaction between Klee and Kandinsky. Each artist often responds to the other's work in this manner, receiving impulses from the other, yet transforming them in the process of creation.

Geometrical Shapes

The boat motif prevails in much of Klee's 1927 work, not only in works with linear configurations, but also in those with a predominance of geometrical shapes. The three paintings, *Boats in the Dark* (Fig. 1) and *Departure of the Boats* (App. III-18, III-55), all of 1927, have been discussed in the introduction. It was noted that in comparison to the gently swaying motion of the ships in Klee's paintings, the triangles in Kandinsky's *Points in an Arc,* 1927 (Fig. 2), were rather frozen in their positions, even though the arc form itself suggested some visual movement.

Kandinsky's marked preference for horizontal and vertical axes is demonstrated by the watercolor, *Pointed in Soft,* 1927 (Fig. 48), where the form motif of *Points in an Arc* is used for a horizontal composition. The broad vertical bar shape in the center divides the composition symmetrically and acts like the central pole in a pair of scales. The four triangles on either side are so distributed that there is near-perfect equilibrium between the two sides of the composition. The pointed triangles with their horizontal baselines evoke associations with boats, but a comparison with the swaying forms in Klee's *Sailboats,* 1927 (App. III-18) shows how much more static and rigid Kandinsky's forms are. The boat motif plays an important role in Klee's work from 1926 to 1928. As it is associated with motion, it lends itself well to the expression of Klee's concepts of statics and dynamics. For Kandinsky, too,

the boat had been a major motif in his prewar work; it appears in a variety of configurations in his work of the twenties.

In 1926 Kandinsky had often worked with one or two large geometric shapes, as in *Conclusion* (Fig. 43), or with variations of the same basic form, as in the circle paintings. In 1927 and 1928 the paintings of this type are even further simplified so that the individual forms become more prominent.

A reflection of Kandinsky's large looming circle forms may be found in Klee's *Physiognomical Lightning,* 1927 (App. III-29). The pink-orange spherical form dominates the entire picture surface. Klee wittily subdivides this expanse with the dark angular line which crosses the circle without breaking it up. The angular line, while reminiscent of lightning, is at the same time the outline of a profile so that the physiognomy appears simultaneously in profile and in full face, much in the manner of Picasso.[29]

A Circle A, 1928/ 420 (App. III-3), is representative of Kandinsky's works with such basic geometric shapes. A white, volumetric circle in the upper right looms large over a small cluster of biomorphic forms in green, red, and yellow, situated in the lower left. On the black ground, the white circle evokes associations with cosmic bodies, such as the moon. Kandinsky discusses the cosmic connotations of 'heavy' forms in the upper picture sections in his Bauhaus course on November 4, 1927:

> Is a heavy form more "natural" at top than at bottom? Why? In nature, before a thunderstorm, the sky is heavy, the forms are light, like the sun setting over the sea.
> Relationship to the spiritual climate of today: the importance of the "above" (Aquarius, the "cosmic," putting things upside down!)[30]

Although Kandinsky's reasoning is somewhat obscure, his remark corroborates my contention that the large geometric forms hovering in the upper sections of Kandinsky's works imply a cosmic dimension.[31]

Kandinsky's works with a few large geometrical shapes, as *A Circle A,* are among his most abstract works of the late twenties, although in most of them an evocative element is introduced which transcends the pure geometry of the forms, as for example, atmospheric grounds, and some biomorphic forms or moon-like crescent shapes. But in another group—works with composite geometric shapes—Kandinsky lets figurative associations come to the fore quite explicitly. In *Glow,* 1927/ 388 (App. III-23), the conglomeration of intersecting triangular and circular shapes appears like a phantastic figure confronting the brilliantly red circle with a blue halo which suggests a fiery sunball.[32] In some 1928 works the figurative dimension becomes even more explicit, as, for example, in *To and Fro,* 1928/ 427 (App. III-3), where the composite geometrical shapes look like two figures moving their arms mechanically back and forth.[33] Possibly Klee's 1929 painting, *Dispute* (App. III-18), is his 'pong' to Kandinsky's 'ping.' While Kandinsky's figures are com-

posed of discrete, planar units and are frontally placed, Klee creates his image with semitransparent overlapping squares and the figures are seen from the side, so that there is more indication of space and volume than in Kandinsky's painting. Once one begins to read the complex structure of overlapping planes in *Dispute* as two figures, there emerge two distinctly different characters engaged in an intense debate. While Kandinsky's figures appear like inventions for a mechanical ballet, *Dispute* demonstrates once more Klee's unusual ability to transform essentially abstract forms by means of small figurative allusions into creatures full of vitality who reenact the human comedy on the pictorial stage.

Small-scale composite geometric forms appear in a number of Kandinsky's works of 1928 and the following years. In *Two Sides Red,* 1928/ 437 (App. III-47), the forms are less figurative than in *To and Fro.* The painting is one of Kandinsky's most balanced and, one might say, 'classical' compositions. Divided by a red bar shape into two almost symmetrical halves, the ground consists of two glowing brownish red areas and a black middle part. The geometric shapes are painted in lighter and darker shades of the same red, with some yellow and brown interspersed. These forms are discrete, but they are integrated into the same plane as the ground. There is no spatial distinction between figure and ground. The geometric shapes appear solid and immaterial at the same time. A red crescent shape in the upper left leads the viewer's eye in an upward direction, while the pointed brownish shape in the lower right pulls it downward, so that an element of visual tension is introduced which enlivens the symmetry and equilibrium of forms.

Klee in the early twenties had often created images with composite geometric shapes, as, for example, in *Senecio,* 1922 (App. III-55). In the late twenties and early thirties, he uses such composite forms in ways similar to Kandinsky's, as, for example, in *Winter Picture,* 1930 (App. III-55) where the colorful composite shapes are also simultaneously solid and immaterial, as in Kandinsky's *Two Sides Red.* They are also equally abstract, but Klee introduces associations with winter through the colors and texture of the ground as well as the barren trees. In works like *Production,* 1930. E 1 (App. III-13) Klee picks up on Kandinsky's combination of geometric shapes and fine graphic lines, as in *Mild Happening,* 1928/ 419 (App. III-3). These linear additions invest the geometric forms with dynamic, active qualities and they tend to increase the figurative allusiveness of what are basically abstract forms. Kandinsky invents a great variety of such form motifs, which uncannily anticipate satellites and science-fiction creatures of our day.[34]

The Spray Paintings

Klee's and Kandinsky's use of geometric shapes in conjunction with the spray technique here is considered separately, as the technique results in a quite

distinctive form character. Both employed the spray technique from the mid-twenties to early thirties and in these works the intense artistic interaction between them is particularly apparent. Klee uses the technique primarily in the mid-twenties, and then takes it up again in the early thirties, while Kandinsky works with it a great deal in the late twenties. Although both artists frequently make use of sprayed grounds for atmospheric effects in drawings and watercolors, the discussion here centers on genuine spray paintings which are produced with cut-out shapes used repeatedly throughout the composition. The color is sprayed around the cut-out shapes which mask the ground and are then removed. The technique creates an immaterial effect as the forms (i.e., the areas not sprayed) appear to be receding rather than superimposed on the ground. Klee's spray paintings of the mid-twenties are either complex composite images, as the well-known *Monsieur Pearly-Pig,* 1925. 233,[35] or they are composed of a few simple forms, as in *Letter Picture,* 1926 (Fig. 31), or *Naval Observatory,* 1926. B 9 (App. III-12). In the group around *Monsieur Pearly-Pig* the colors are light and of equal intensity, whereas in the later works Klee operates with strong chiaroscuro effects. Although the later works are usually more abstract Klee generally establishes some figurative context.

With a few exceptions the forms in Kandinsky's spray paintings are nonfigurative.[36] In the late twenties Kandinsky explores primarily the possibilities of chiaroscuro effects. An example is *Into the Dark,* 1928 (Fig. 49), where Kandinsky creates a rhythmic movement upward into darkness. The brown and green colors, the cross, and the two crescents introduce associational qualities but defy a specific interpretation. The rhythmical progression from light to dark recalls Klee's color band watercolors, such as *Separation in the Evening,* 1922 (App. III-48), but the spray technique results in a misty atmospheric effect that is quite different from the clear order of the color bands.

In the spray paintings, more than in most other works, Kandinsky explores the rhythmical progression of repeated or slightly varied forms. In *Into the Dark* he creates gradual visual movement in a manner similar to Klee. It is reinforced by the gradual transition from light to dark. Like Klee, Kandinsky associated chiaroscuro with the dimension of time, as he explains in his remarks on Rembrandt in "Reminiscences."[37] Thus in *Into the Dark* Kandinsky comes close to Klee's ideas of rhythm and temporal sequence in art.

In another spray painting of 1928 Kandinsky creates movement into depth. In *Into,* 1928/ 299 (App. III-23), a very simple, balanced composition, the progression of rectangular forms draws the viewer's eye into the dark depth in the center. The star of dark lines at the upper right provides a flat accent against which the overlapping, transparent forms seem completely immaterial. Both Klee and Kandinsky in a number of spray paintings pur-

posely juxtapose precise lines to the misty depth of the sprayed ground. Klee does so in the very abstract *Static-Dynamic Tension,* 1927. 240 (App. III-15), where the linear configuration introduces a strong element of visual tension into the composition. The diagonal lines counterbalance the predominantly horizontal and vertical forms of the sprayed ground; they also fasten the floating, dynamic crescent shapes to the vertical and horizontal bar-like lines.[38] In *Junction,* 1928/ 275 (Fig. 50), Kandinsky establishes a more direct relationship between the sprayed forms and the linear configuration than Klee does in *Static-Dynamic.* Kandinsky places a circle in every corner of the roughly star-like central shape. He then draws connecting lines between each circle and all the other circles so that a complex structure of triangular and polygonal shapes results, but he obfuscates the structural order by randomly placing additional circle forms into it. The systematic connection of all circles with lines is no longer apparent and the linear configuration appears instead like a freely invented pattern laid over the sprayed shape. In contrast to Klee, who likes to give the appearance of proceeding systematically even though he deviates often from his systemic order, Kandinsky seeks to counteract and conceal the systemic approach by introducing additional form elements.

Besides these very balanced spray paintings with simple, repeated shapes, Kandinsky in the late twenties also executes a number of ambitious, large-scale spray paintings with complicated forms and strong dark-light and color contrasts.[39] In the early thirties he foregoes the chiaroscuro effects in favor of lighter colors of even intensity, as, for example, in *Wandering Veil,* 1930/ 396 (Fig. 51), which is done in subtle shades of brownish grey and black. In this spray painting Kandinsky creates the effect of horizontal up and down movement on three spatial planes. In the background there are three large white rectangular forms, overlapping and arranged in a semicircle. Laid over them are four grey-black triangles which echo this down and upward motion without repeating it. The solid black bar shapes at the bottom, in turn, echo the motion of the triangles. With these three different 'voices' which interact, yet remain distinct, Kandinsky composes his picture much in the spirit of Klee, who at the same time was trying to realize his concepts of pictorial polyphony in his watercolors with overlapping transparent planes as well as in his pointillist works of the early thirties. Klee's spray painting, *Planar and Linear Polyphony,* 1930 (App. III-48), also in white-grey-black tonalities, is much more complex than Kandinsky's *Wandering Veil.* There is not one basic visual direction in Klee's painting; instead there is movement and counter-movement, both in the intersecting sprayed rectangular shapes, as well as in the linear structure laid over it. As Kandinsky had done in *Junction,* Klee connects the various corners of the rectangles with lines, thus establishing complicated spatial relationships and creating visual tensions between the intersecting sprayed shapes and the linear configurations.

In their spray paintings of the early thirties Klee and Kandinsky both use very light colors and a restricted color range, often just white and grey tonalities. Klee's spray paintings become as abstract as Kandinsky's. But Klee has turned from the figurative whims and romantic nocturnal scenes of his earlier spray paintings to very complicated and highly theoretical explorations of spatial relationships and of polyphony, whereas Kandinsky's spray paintings of the thirties are very clear and simple in their conception. Klee's formal preoccupations are reflected in the titles he chooses for his sprays, such as *Plan of a Castle*, 1930, or *Vista (Durchblick)*, 1930, titles which are comparatively matter of fact and descriptive. Kandinsky, on his part, selects very poetic titles, such as *Dreamy*, 1932, *Wandering Veil*, 1930, which alludes to wandering dunes, or *Square in Haze*, 1932. Such evocative titles one would rather expect from Klee's fanciful inventiveness than from Kandinsky.

Finally, mention should be made of another 'pong' to Klee's 'ping.' Kandinsky's spray painting, *Two to One*, 1933/ 516 (App. III-38), reminds one of Klee's 1926 *Naval Observatory* (App. III-12). The ground in *Naval Observatory* is predominantly black with some red in the corners; the two black circles with white haloes turn into eyes staring at the viewer. The red flag atop the watch tower is both flag and mouth. In Kandinsky's spray painting the ground is predominantly blue, the two circles are black, and the rectangle is a lighter blue. There is a slightly physiognomic quality about these three forms, but Kandinsky counteracts it by placing them off-center in a horizontal format. Klee's vertical format, on the other hand, reinforces the physiognomic aspect of his forms. With the exception of the flag, Kandinsky uses the same basic form elements as Klee, but he bypasses the multileveled, and a bit obtrusive, figurative associations of Klee's work, emphasizing instead the abstract qualities of the simple geometric forms *per se.*

The Grid as Compositional Order

Grid compositions played an important role in Klee's work throughout the twenties. In the late twenties and in 1930, in particular, Klee devised new variations of the grid composition, often in conjunction with the color band motif.

Earlier it was noted that in the mid-twenties Kandinsky used the grid primarily as a form motif. With his increasing preoccupation with vertical and horizontal compositional axes he takes a greater interest in the grid order *per se.* In a number of works of 1927 Kandinsky uses a linear grid as the central configuration which dominates the picture, as, for example, in *Red in the Net,* 1927 (App. III-62) or *Mild Hardness,* 1927 (Fig. 46).[40] But in these works the grid is still a pictorial motif, if the central one, rather than a way of structuring the pictorial ground. In the late twenties and early thirties Kandinsky more

often makes use of the grid as a compositional system. In these works he operates with the type of checkerboard grid that Klee uses rather than with the linear De Stijl grid which had predominated in his works where the grid is used as pictorial motif.[41]

In the painting, *Square,* 1927/377 (App. III-10) Kandinsky fills the entire picture ground with a regularized grey and black checkerboard pattern. However, the squares are tipped, so that they look like rhomboids, which makes the pattern more complicated and lively. Placed in the center of this ground is another large rhomboid shape, slightly tipped to the left. It is composed of rows of color squares in bright colors which recur throughout the pattern in an irregular rhythm. This portion of the picture reminds one strongly of Klee's checkerboard paintings, as, for example, *City Picture (with the Red Dome)* 1923. 90 (App. III-15).

Placed over or into this colorful checkerboard is another black and white checkerboard pattern; this one is foreshortened, generating an effect of depth. Anticipating optical art, Kandinsky operates with optical delusions which create complicated visual tensions between the two planar patterns and the foreshortened grid. The visual tensions are increased by the directional changes and the color contrasts. In *Square* Kandinsky uses the checkerboard grid for different ends than Klee. Kandinsky makes his color units very regular so that they are completely integrated into the whole pattern with no individual character, whereas Klee avoids such mechanical repetition. Instead, Klee explores the visual weight of colors and their rhythmical movement in his color square paintings. Each of Klee's irregular color squares is an individual form, with a character of its own. Compared to Klee's painting the grid divisions in Kandinsky's painting are mechanical and the checkerboard is a repetitive pattern, even in the color square section which is the least monotonous. As Kandinsky, in contrast to Klee, does not compose the grid of individual units, he counteracts the monotony of each pattern by superimposing others and by the visual tensions resulting from their off-center placement in the picture. The interest generated by the picture is based on the cumulative effect of the patterns rather than on the way the pattern is formed.

Kandinsky's mechanistic way of dealing with the checkerboard grid as compositional structure is also evident in the gouache, *Gradation,* 1931/428 (App. III-23), where he places a variety of finely drawn linear motifs and small geometric shapes over the color grid to enliven the composition. Klee, in *Table of Color (in Gray Major),* 1930. 83 (App. III-18), works with a similar type of grid order, but his squares are slightly irregular and the paint texture varies from square to square, so that, even without the different colors each square would be an individual entity. In comparison, the squares in Kandinsky's composition are rather devoid of life. In general, compositional schemata,

such as the grid or the color band order, or structural patterns derived from the crafts or other sources challenged Klee to bring them to life as artistic means by transcending their inherent regularity, without, however, giving up the semblance of regularity. In works of this type, as, for example, in the color square paintings, Klee over the years pushes ever closer to the borderline that separates them from schematic decorativeness. As regards the grid composition alone, in *Table of Color*—compared to the vivid composition of *City Picture* (App. III-15)—Klee comes very close to this borderline. But even here he is less schematic than Kandinsky in *Gradation*. The ultimate powerfulness of Klee's painting, however, results primarily from his use of colors. Here, too, Klee makes matters very difficult for himself by selecting rather drab browns and greys as main colors. In the lower left corners he even sets the colors up as a repetitive pattern of browns and greys in diagonal direction. Yet on closer scrutiny there is a wealth of coloristic action in his painting: contrasting colors as well as gradated tones placed side by side, movement and countermovement, etc. No color square is quite like any other in tone or size. Klee establishes numerous relationships between the individual color squares in all directions, which he then echoes and varies in another area of the picture. Because the color constellations change with each shifted focus, there is constant visual motion in the painting.

Klee himself was certain that this painting was in no danger of schematism or decorativeness, for with confident irony he entitled it *Table of Color*, fully knowing that it is a far cry from being just a color sample.

Throughout this study it has been pointed out that Kandinsky was quite interested in Klee's use of compositional systems and would experiment with them in his own work, as, for example, with the gradated color bands. But Kandinsky, on the whole, is less comfortable with such methods. He tends to introduce additional form elements to generate interest or else he deviates much more from the basic systemic concept than Klee (e.g., his irregular color intervals in the gradated band works). Kandinsky does not share Klee's interest in exploring a single form motif, such as the color square, in all its possible variations; he is more interested in contrasting and varied means.

Kandinsky is more successful in works where the grid order is only implicitly present or where it is modified in a number of ways. In the watercolor, *Untitled,* 1930 (App. III-47), Kandinsky uses a more irregular grid subdivision, with slightly diagonal axes. The eye is led in a back and forth movement across the picture, as the composition can be read in terms of a grid as well as in terms of horizontal layers. Klee had used such a combination of color bands and an underlying or implied grid order in a number of 1929 works, as, for example, in *Monument in the Fertile Land,* 1929.41 (App. III-18), which, however, is more complicated in its compositional structure than Kandinsky's watercolor. Kandinsky enlivens his composition with small black

forms and lines scattered over it, as well as with strong color contrasts and textural surface effects.

In *Red Bridge,* 1928.58 (in the collection of the Staatsgalerie Stuttgart), Klee assembles the geometric forms in such a way that they establish a loose grid order on the even blue ground. In the lower picture half, the ground fills the voids between the forms and, thus, becomes part of the grid. Such an open grid order, which does not subdivide the entire ground, is also used by Kandinsky, for example in *White on Black* 1930/531 (App. III-23). Here, too, Kandinsky uses the ground for a double purpose, both as ground and as figure where it is enclosed by the white forms and becomes part of the rather irregular grid-like configuration. Such freer forms of the grid appear in a number of works by Kandinsky.

The closest Kandinsky comes to Klee's checkerboard paintings is in the 1932 gouache, *Massive Structure* (App. III-10). However, here he does not use the checkerboard as a compositional system. Like Klee, who in many of his checkerboard paintings introduces references to architecture, Kandinsky uses the checkerboard pattern in the central shape to suggest an architectural construction. In this painting he makes the units of the grid into individual color squares of slightly varying shape. He also works with an irregular color rhythm similar to that which Klee uses in his checkerboard paintings. As the title explicitly points to the architectural quality of the checkerboard motif, the painting may well be a somewhat tongue-in-cheek homage to Klee's architectural color square paintings, such as *City Picture (with the Red Dome),* 1923.90 (App. III-15).

Optical Delusions and Spatial Effects

Compositional systems, such as the grid or the color band divisions, are essentially Klee's domain. Kandinsky, in turn, takes the lead in regard to optical delusions and spatial effects which he employs throughout the 1920s. While Klee makes use of Gestalt psychological phenomena in much of his work of the 1920s, they become particularly prominent in his work of the early thirties when he becomes interested in extremely complicated spatial effects.

M. Teuber has examined Klee's and Kandinsky's use of phenomena of visual perception, such as the figure-ground reversal and other optical delusions, and she has suggested that they were familiar with the scientific literature on visual perception.[42] That Kandinsky was interested in this science is corroborated by his remark in his Bauhaus course in the winter of 1928:

> Therefore the transition to space is less complicated than it was earlier, the concepts of "plane" and "space" have been dematerialized (perception of space according to a new psychology).[43]

The relationship of Klee's and Kandinsky's work to the science of visual perception cannot be explored within the scope of this study. The following few examples shall suffice to point out some similar formal solutions in the works of both artists and to demonstrate the ends to which they employ them.

In many works of the twenties Kandinsky introduces the optical delusions for spatial effects; for example, the foreshortened grid motif, without establishing a clearly defined spatial setting. By combining spatial motifs with planar elements, as, for example, the planar and the foreshortened checkerboard patterns in *Square,* 1927 (App. III-10), Kandinsky creates an ambiguous pictorial space. As it cannot be read in any rational way, the space seems unreal and immaterial. Kandinsky's remark cited above corroborates my contention that he operates with such means in order to achieve an effect of dematerialization.

Kandinsky also creates ambivalent spatial effects by means of foreshortened overlapping planes, as in *Asserting,* 1927/355 (App. III-37). The picture is constructed of several overlapping planes which, but for the black one at left, are transparent or semitransparent. All of them have diagonally cut-off edges so that they look as if they were foreshortened, but one cannot read them in a truly perspective fashion. The planes remind one of stage props, but the spatial order and the spatial relationships between them cannot be determined. In addition, the planes are not anchored to the ground; they float freely in the undefined space. The overlapping gives the impression of space, but the space itself remains intangible and irrational, and the forms are dematerialized. Klee and Kandinsky achieve a similar effect in their transparent linear constructions which were discussed earlier.

In a number of works of 1930 Klee makes use of immaterial overlapping forms like those that Kandinsky uses in *Asserting* as well as in *Circle with Brown,* 1929/448 (App. III-23). An example is *Relative-Weighable,* 1930.3 (in the collection of the Museum Boymans-van Beuningen, Rotterdam), apparently an early work of the year.[44] At first sight the painting recalls a Cubist collage, but no spatial tension is established between the different planes.[45] The various planes seem to be inserted into each other rather than superimposed. Other aspects which relate *Relative Weighable* to Kandinsky are the slanting positions of the planes, which results in a picture-within-picture effect, as well as in the completely abstract forms and the rather peculiar color combination.

While in works of this type Klee deliberately counteracts the spatiality that is implied by overlapping forms, in other works he greatly emphasizes it. In *Open Book,* 1930.E6 (App. III-49), he operates like Kandinsky in *Asserting* with overlapping planes which are foreshortened into different directions. By putting shadings around the planes he increases the effect of spatial relationships between the individual planes, but he cancels this effect at the same time by placing the shading all around the forms or by foreshortening a plane both

at the top and at the bottom. Thus, the effect is as ambiguous and immaterial as in Kandinsky's *Asserting.*

In 1929, Klee begins to introduce diagonal or circular subdivisions into his color band paintings which deflect the eye from the original horizontal order. An example is *Monument in Fertile Land,* 1929.41 (App. III-18), where the diagonal breaks in the horizontal pattern create a visual tension between planar and spatial qualities which remains unresolved. Kandinsky had already earlier used such directional changes in works like *In the Net,* 1927 (App. III-45). In contrast to Klee, Kandinsky works with separate sections filled in with color bands rather than with subdivisions of a continuous compositional order. In 1929 and the early thirties, Kandinsky frequently employs color band motifs. But he uses discrete planes, internally subdivided into color bands, placed both flatly on the ground and as foreshortened forms, as for example, in *Definite,* 1929/357 (App. III-36). In *Polyphonous Fluctuations,* 1929 (App. III-60) Klee creates similarly perplexing spatial effects with the movement and countermovement of the color bands, but the forms remain part of the compositional system rather than existing as discrete form segments. In *Fluctuations* some of the color bands are slightly foreshortened, but on the whole Klee makes much less use of foreshortening in his color band works than Kandinsky, who uses it a great deal.

In another group of works Klee uses foreshortened planar form elements which are transparent, which overlap and intersect, resulting in optically confusing spatial effects. In the watercolor *Catastrophe in Winter,* 1930 (App. III-52), the foreshortening of the planes creates a spatial effect, but the exact placement of these planes or the extension of the space cannot be determined, and the viewer is left bewildered in front of this visual labrynth. Although Kandinsky in the early thirties is less intent than Klee on creating such effects of 'hyperspatiality,' he occasionally works along similar lines, as in the watercolor, *Now Up!,* 1931 (App. III-41). At first sight the meandering color band shape is clearly positioned in the pictorial space, but the two overlapping planes at either end, both strongly foreshortened into different directions, cancel the effect of logical spatiality and make the whole set-up visually ambivalent.

Of the two artists Kandinsky was the first to introduce an immaterial, ambiguous space generated by contradictory visual effects, but he rarely makes that the predominant formal theme of his paintings. In most of his works of the 1920s he only places a few 'clues,' as it were, for such ambivalent reading of the picture space. Klee, on the other hand, in the early thirties, extensively explore very complex spatial relationships, often in ways which are formally quite different froms Kandinsky's work (as in the group of works related to *Hovering (About to Take Off),* 1930.220 (App. III-18). Yet, like Kandinsky, he does not create a cohesive illusionistic space, but an intangible immaterial space which defies visual logic.

New Departures

In 1928 Klee wrote a programmatic essay for the Bauhaus journal, "Exact Experiments in the Realm of Art" ("Exakte Versuche im Bereich der Kunst"), in which he defines his own position *vis-à-vis* the positivism and rationalism which was beginning to dominate at the Bauhaus:

> We construct and construct and yet intuition is still a good thing . . . Nonetheless, intuition cannot entirely be replaced. We prove, explain, support, construct, organize: these are good things, but we do not arrive at the totality.[46] [revised]

Another passage from the essay is cited here in the original version of Klee's first draft as it sums up the entire argument and, interestingly, has a rather Kandinskyan ring to it:

> The many analytical souls and the educated will cry out when the great synthesis is achieved and they will utter invectives such as mysticism, cosmic, romanticism . . . but construction does not mean totality. Let us calm down. The *virtue* is that in attending to exactness we lay the foundation for a specific science of art.[47]

In his class notes of October of 1928 Kandinsky describes a conversation he had with the teacher of a school class that had attended Kandinsky's lesson:

> Afterwards a conversation with the teacher: up to this day he had believed that modern painting and especially abstract painting were purely intellectual. Today for the first time he thinks that he has understood their essence.
> I reply that the great principles are unchangeable, we know nothing but variations; in this moment we are living a synthesis of reason and soul.[48]

Thus, both artists looked upon their work as a synthesis of rational and spiritual-intuitive elements, of 'reason and soul,' as Kandinsky put it. Throughout this study it was emphasized that "mysticism, cosmic, romanticism" are at the heart of even their most precisely constructed works. During the late twenties both artists seek to project in their work a balance of 'reason and soul,' occasionally even tipping the balance in favor of 'reason.'[49] In the early thirties, however, they begin to reintroduce 'intuitive,' spontaneous aspects into their art. Although geometric forms and linear constructions continue to dominate in many of their works of the early thirties, new formal qualities begin to appear which mark the transition to their late styles. Biomorphic shapes, textural qualities, sketchy brushwork and rich surface effects appear more frequently in the work of both artists, and figurative references to natural phenomena increase.

Some of the stylistic elements that are outlined below reflect Surrealism, but Klee and Kandinsky make use of them more in the spirit of the Blaue Reiter years than in conformity with Surrealist concepts.

Kandinsky's watercolor, *Scherzo*, 1930 (App. III-47), exemplifies some of the new departures. The color is applied on wet paper so that it runs over the precise outlines and blurs them. The brown shape in the center looks at the same time like a tower with flags and a small figure atop it, and like some wide-bellied figure, some jolly monster from a distant star.[50] Earlier it was noted that the figure-like geometric shapes in Kandinsky's paintings, as in *To and Fro*, 1928 (App. III-3), have a rather mechanistic quality. Kandinsky bio-morphic 'figures' are given more life and individuality than the geometric configurations have, although they are about equally abstract.

The amorphous shapes in Klee's *Plantlike-Peculiar*, 1929 (App. III-18), a watercolor, are explicitly biomorphic. The concentric layers of the tree form and the corresponding haloes around the moon may symbolize the primal process of growth in general, suggestive of amoebas with their cell nucleis as well as of tree rings. The mysterious dark brown-reddish ground and the transparency of all forms also suggest some primeval, natural event rather than a straightforward landscape. Kandinsky uses similarly amorphous shapes in his painting, *Cool Condensation*, 1930/518 (Fig. 52), which he presented to Klee. In Klee's watercolor the forms grow outward from the nucleus, whereas in Kandinsky's painting there is a movement inward, as the colors change from the warm red of the outer ring toward cooler greens, whites, and yellow in the center. Placed on a brilliantly red ground the concentric shapes are introverted rather than extroverted. Even though the title, 'Cool Condensation,' implies a reference to organic processes, the painting as a whole remains more abstract than Klee's *Plantlike-Peculiar*.

Both artists often combine geometrical-abstract forms with some bio-morphic and figurative elements, so that the abstract forms gain in expressive meaning. In Kandinsky's painting, *Surfaces and Lines*, 1930/522 (App. III-3), the individual forms are placed far apart, and each is set off from the blue ground by a halo which increases the significance of each form. Some, like the sun rays, the snake line, and the 'open book,' evoke figurative associations, but all other forms as well have an expression dimension even if their specific meaning cannot be grasped. Klee proceeds similarly in works such as the painting, *The Light and So Much Else*, 1931 (App. III-18).

In *Has Head, Hand, Foot and Heart*, 1930.S4 (App. III-31), Klee combines geometric forms with anatomical parts. The result is a surreal image of a dismembered figure. Kandinsky operates with similar combinations of geo-metric and organic forms in a number of paintings of 1932, as, for example, *Cool Distance*, 1932/580 (App. III-57). On a bright red ground a purple heart,

a white wing-like shape, a coil, and various geometric forms are assembled into an enigmatic still life. Although formally very similar to Klee's painting, Kandinsky's *Cool Distance* does not as readily yield to figurative interpretation as Klee's work. Other works of this type are about equally poised between abstraction and figuration. In Klee's painting *Plants-Analytic,* 1932 (App. III-31), the small forms outlined in black appear to be neither quite geometrical nor biomorphic; they can be looked on as abstract forms or can be interpreted in terms of stages of growth, from seed to blossom.[51] The title provides a key for a reading of the forms as organic forms, but it does not further specify the meaning. In his watercolor, *Growing Spots,* 1932 (App. III-11) Kandinsky makes a similar general allusion to growth processes, thus also inviting an interpretation of the two large green spots with blurred edges as organic forms. He even provides them with 'trunks,' so that they look somewhat like two trees planted in large tubs. At the same time, the organic associations are not outweighing the abstract qualities of the forms. Many works by Klee and Kandinsky of the early thirties can be compared in respect to their abstract-figurative ambivalence. Klee uses figurative allusions with great restraint in many works of this period, often selecting rather abstract or general titles. Conversely, Kandinsky allows more figurative elements in his works and sometimes chooses more evocative titles. More than ever before the two artists share common ground and pursue similar formal goals. During this period they not only work often with the same formal means (as, for example, the spray technique, the grid composition, or planar grounds with small forms scattered over them), but they also use similar form motifs. One could draw up a long list of motifs which occur in the work of both artists, documenting their interaction and mutual inspiration. Beyond the reemergence of biomorphic forms there is another important group of motifs relating to flying, hovering, and ascending. Weightlessness of forms and their floating in space had already been used by the artists during the Blaue Reiter years in order to produce the effect of immateriality. In the early twenties, Kandinsky had operated a great deal with hovering forms, whereas in the later twenties the form elements in his works tend to be more firmly anchored to the ground, in accordance with his increased interest in static compositions.

For Klee, dynamic motion and weightlessly floating forms, which do not appear to be subject to the laws of gravity, or at least succeed in temporarily defying them, represent the 'romantic' component of art, symbolic of the cosmic forces. The static-dynamic or classical-romantic dualism preoccupies his thinking throughout the twenties, and Klee experiments with many different ways of giving expression to it in his art. Certain figurative motifs, such as the arrow, the balloon, the boat, and the fish, recur in Klee's work as symbols of dynamics, which seek to overcome the fetters of gravity and attain a cosmic state.[52]

In works of the late twenties both artists often juxtapose static and dynamic elements, for example in Klee's *The Limits of Intellect*, 1927 (App. III-16), and Kandinsky's *Flat-Deep*, 1929/490 (App. III-3). In the late twenties and early thirties Kandinsky often makes use of Klee's 'dynamic' form motifs, such as the arrow, the balloon, and the flag.[53]

In the early thirties both artists deal with hovering and ascending forms *per se*, forms which belong in Klee's utopian realm of dynamic forces. In Kandinsky's watercolor, *Composition*, 1930 (App. III-57), the small, vividly patterned forms, pulled upward by some undetermined force, float weightlessly on the indefinite blue (spray) ground.

Klee constructs complicated, transparent structures reminiscent of Chinese kites, which rise effortlessly, as for example *Hovering (About to Take Off)*, 1930.220 (App. III-18). Kandinsky achieves a similar effect of weightless ascension in *Floating Pressure*, 1931/563 (App. III-37), where he succeeds in divesting the large dark biomorphic forms of any material heaviness. In the thirties such biomorphic shapes, reminiscent of Surrealist forms, frequently take the place of the large hovering circles that had been so prominent in Kandinsky's works of the twenties.

In these paintings both Klee and Kandinsky deal not only with weightlessly hovering forms in an indeterminate space—in the sense of Constructivism—but furthermore they make it apparent that the forms are *ascending;* that is, rising from the static, earthly realm upward into cosmic infinity.[54] Thus, ultimately the paintings express in abstract terms transcendental ideas similar to those Klee had put forth in his 1912 drawing, *Rise to the Stars* (App. III-32).

In addition to the new form motifs and themes which appear in the early thirties, there are noteworthy stylistic innovations in the *oeuvres* of the two artists. In works of the later twenties both Klee and Kandinsky often had counteracted the precision of geometric forms with hazy, atmospheric grounds and some textural effects. In a number of works dating from the early thirties both artists make use of 'painterly' qualities and a variety of surface effects to an even greater extent. Klee embarks on a series of paintings in dark somber colors with thickly applied brushstrokes, as, for example, in *Necropolis*, 1930 (App. III-22). In a painting of the same year, *Fluttering*, 1930/494 (App. III-3), Kandinsky surrounds the neatly painted pennant-like triangles with loosely brushed white paint. In watercolors such effects of sketchiness and spontaneity are generated by letting the colors 'bleed' on wet paper, as in Klee's *Danger of Lightning*, 1931.159 (App. III-48), and Kandinsky's *Scherzo*, 1929 (App. III-47). In other watercolors—for example in *Ghost of a Warrior*, 1930 (App. III-51)—Klee apparently wiped over the surface with a blackened cloth or some other tool in order to produce a faded, 'antiqued' surface effect. Kandinsky achieves a similar quality in his watercolor, *Light Blue*, 1931 (Fig. 53).

While Klee produces rich surface effects with his pointillist technique, as in *The Light and So Much Else*, 1931 (App. III-18), Kandinsky creates tactile surface qualities in paintings with what appears to be a stippling technique, for example in *Layers*, 1932/569 (App. III-37).

The period from 1929 to 1932 is a transitional stage in the development of both artists. On one hand they further pursue geometric constructions and precisely drawn configurations of lines and shapes; on the other hand they reintroduce biomorphic forms, painterly values, and spontaneous execution. Even in their most 'Constructivist' work they had upheld the spiritual values of the Blaue Reiter years, but in the early thirties they also return to some of the basic *formal* characteristics of the Blaue Reiter years, if in different stylistic terms. In Kandinsky's late style of the Paris years amorphous shapes predominate. Their biomorphism recalls the semiabstract and abstract forms of Kandinsky's prewar works, for example *The Good Contact*, 1938/649 (App. III-37). Klee, in the monumental style of his last years in Bern, returns to soft-contour black lines which—embedded in the color ground or superimposed on it—serve as figural outlines or as more or less abstract signs, as, for example, in *Insula Dulcamara*, 1938.481 (App. III-18).

Epilogue

This study began with a formal comparison of two works by Klee and Kandinsky and it shall be concluded with another comparison. These two paintings, Kandinsky's *Development in Brown*, 1933 (Fig. 54), and Klee's *Gate into Depth*, 1936.25 (Fig. 55), represent a climax of their geometric style of the Bauhaus years and at the same time its finale. The two works are related in formal approach and in their abstract symbolism, yet at the same time they are also representative of the different artistic personalities of the two artists.[55]

Both paintings are composed with entirely abstract geometric shapes, primarily rectangular forms. Kandinsky uses semitransparent rectangular planes, partly foreshortened, which overlap and form a frame for the white plane in the center of the painting, with the foreshortened color bands at the top and the bottom. As the blue color band leads into depth, the white planes seem to recede behind the dark brown and green planes. The near symmetrical arrangement of these two sets of rectangular shapes and the overlapping of shapes—suggestive of a spatial arrangement without establishing any clear spatial order—can be read as some kind of architectural structure, a gateway of sorts, supported by rather wobbly pillars. However, such a reading is valid only in the widest possible sense, as all the formal details produce a visual ambivalence which defies all definitive interpretations. The dark overlapping planes have no firm foundation; they hover weightlessly, neither solid nor quite transparent. The spatial effect is counteracted by planar forms, like the

red horizontal line, cutting across the overlapping planes. Although the composition is basically ordered in terms of horizontal and vertical axes, the individual shapes are slanted so that a rather restless quality of up and down and back and forth movement prevails in the picture.

In Kandinsky's picture the planar elements remain visually discrete and are set off from the ground, whereas in Klee's painting the color planes are joined together in a cohesive structure that covers the entire picture surface. Kandinsky's configuration of overlapping planes may be interpreted as architectural in the widest sense because of the arrangement of the planar elements. Klee, on the other hand, composes his entire picture in a very architectonic way, establishing a firm horizontal base on which the color planes rest like the massive blocks of some archaic wall. Yet the solidity is deceptive. Once one begins to explore the spatial relationships they become as ambivalent and labyrinthic as Kandinsky's. Klee changes viewpoints and creates ambiguities in the reading of each shape and its relation to the adjoining shapes. Ultimately, the space in Klee's painting is as impenetrable and immaterial as in Kandinsky's, but Klee establishes a greater, if deceptive, semblance to architectural or natural space.

In both paintings the immaterial effect is reinforced by the surface texture, which looks faded and semitransparent. The warm colors themselves introduce organic associations, but in a very unspecific sense. The most solid and assertive colors are the white in *Development* and the black in Klee's *Gate*. In both paintings the viewer's gaze is drawn to these colors which stand out from the other colors and, at the same time, recede into infinite depth. In Kandinsky's painting a group of gaily colored triangles, stacked one atop another, leads the way into the luminous distance in a joyous rhythmic motion. In Klee's painting the black depth is rather threatening and forbidding, but the eye is forced to look into it because the yellow rectangle leads the gaze upward into the picture center and from there abruptly into the black area.

We do not know what expressive possibilities Kandinsky had in mind when he painted *Development*. Visually the painting suggests that the white center is an opening into depth, affording the viewer a glimpse of what is beyond the 'wall' erected by the overlapping rectangles. In this general sense, I propose to interpret the painting as a 'gate' picture similar to Klee's. Kandinsky called black the color of absolute silence and of death, whereas he associated white with the silence before life, a hopeful silence, implying birth. Although Klee never articulated any theories on the symbolic value of color, the black area in *Gate into Depth* clearly evokes death and eternal silence, as the title also suggests. If we may interpret Kandinsky's last painting before his move to Paris along symbolic lines similar to those of Klee's painting, it is an expression of optimism and serenity. From his letters and the accounts of

his contemporaries it appears that throughout the hardships of exile and old age Kandinsky remained undaunted in his personal optimism and his hopes for spiritual renewal.

In abstract terms and on a more profound level, the two paintings encompass the same basic difference in Klee's and Kandinsky's thinking that could already be found in comparing Kandinsky's 1911 *All Saints Picture* (App. III-20) and Klee's 1913 drawing, *Grim Message from the Stars* (App. III-8). Klee had never shared Kandinsky's messianic hope for renewal and redemption; he apparently looked upon life with a profound detachment and a rather pessimistic distance. Already in 1914 he had written in his diary:

> I am armed, I am not here,
> I am in the depth, am far away. . .
> I am so far away. . .
> I glow amidst the dead.[56]

Gate into Depth, in its expressive content, is representative of Klee's late work. In his last years, with quiet acceptance of his approaching death, he returns to the metaphysical themes and cosmic beings (now in the guise of angels) that he had first dealt with during the Blaue Reiter years. Many of his late works are meditations, so to speak, on the *Ur*phenomena of life and death, growth and decay.[57]

In 1933 both artists had to leave Germany; Kandinsky went to Paris, where he died in 1944; Klee returned to Bern. Through correspondence they kept in touch and in 1937 the Kandinskys were able to visit Klee in Bern. In 1938 Kandinsky wrote to Klee to invite him to collaborate on a project. Tériade, the editor of the Paris art periodical *Verve,* was asking four artists to represent the four celestial phenomena,. . . "the sun, the moon, the stars and the comets," and Kandinsky continues in his letter:

> He (Tériade) told me that it was his dream that you and I should participate in the "representations" mentioned above. . . . Therefore you are most warmly asked to choose among "moon" and "stars" . . . That it would personally give me great pleasure to "cooperate" with you on the next issue goes without saying. But I mention it anyway. . . . In old friendship, yours Kandinsky.[58]

The project did not materialize, but, in a way, they had already for a long time worked together on 'cosmic' themes, on representing—in the widest sense—"the sun, the moon, the stars and the comets."

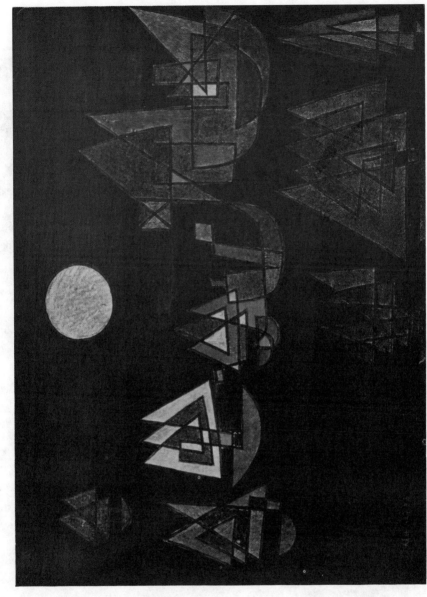

Figure 1. Klee, *Boats in the Dark (Schiffe im Dunkeln)*

Figure 2. Kandinsky, *Points in an Arc*
 (Spitzen im Bogen)

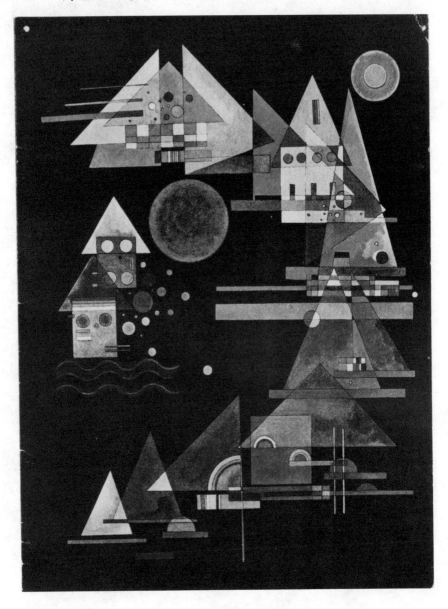

Figure 3. Moholy-Nagy, *D IV*

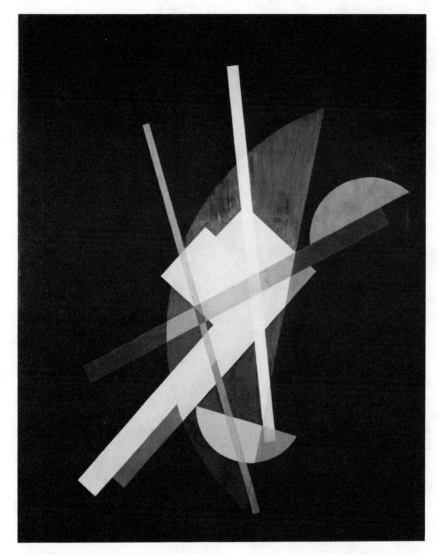

Figure 4. Kandinsky, *Blue Mountain*
 (Blauer Berg)

Figure 5. Klee, *Rider and Outrider (Reiter und Vorreiter)*

Figure 6. Kandinsky, *St. George II (Sankt Georg II)*

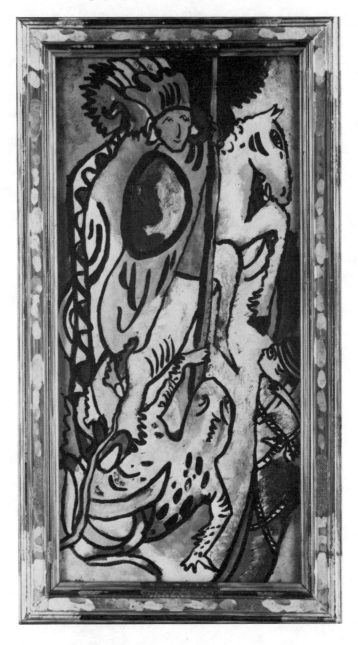

Figure 7. Klee, *Candide et Cacombo
montent en carosse, les six
moutons volaient . . .
Candide, Chapt. 18*

Figure 8. Klee, *Fleeing Rams (Fliehende Widder)*

Figure 9. Klee, *Galloping Horses*
 (Galoppierende Pferde)

Figure 10. Klee, *Three Galloping Horses II (Weakly Animals) Drei galoppierende Pferde II (Schwächliche Tiere)*)

Figure 11. **Klee,** *St. George (Sankt George)*

Figure 12. Klee, *Violent Death*
 (Gewaltsamer Tod)

Figure 13. Kandinsky, *Improvisation 19*

Figure 14. Klee, *The Battlefield (Das Schlachtfeld)*

Figure 15. Klee, *Sun in the Courtyard*
 (Sonne im Hof)

Figure 16. Kandinsky, *Impression III*
(Concert)

Figure 17. Klee, *Cross-Roads*
(Strassenzweigung)

Figure 18. Kandinsky, *Black Lines*
 (Schwarze Linien)

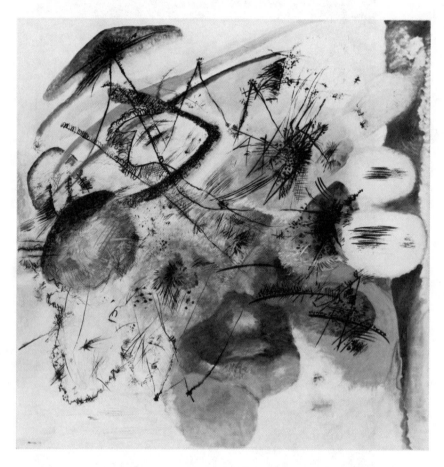

Figure 19. Klee, Composition (Untitled)

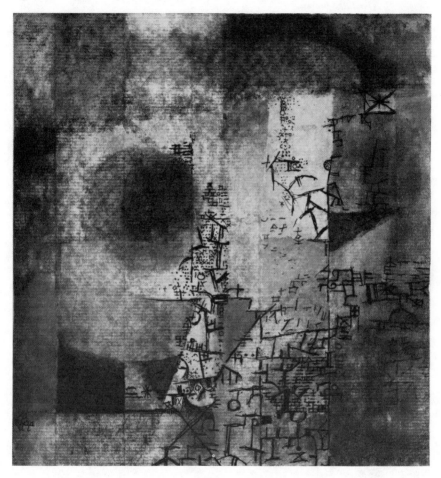

Figure 20. Klee, *Song of Lamentation*
(Lied des Jammers)

Figure 21. Klee, *War, which Destroys the Land (Krieg, welcher das Land verwustet)*

Figure 22. Klee, *Psalm Blown (Psalm geblasen) (23rd Psalm)*

Figure 23. Kandinsky, *Resurrection (Large Version) (Grosse Auferstehung)*

Figure 24. Klee, *Hammamet with the Mosque (Hammamet mit der Moschee)*

Figure 25. Klee, *The Niesen (Der Niesen)*

Figure 26. Hodler, *The Niesen (Der Niesen)*

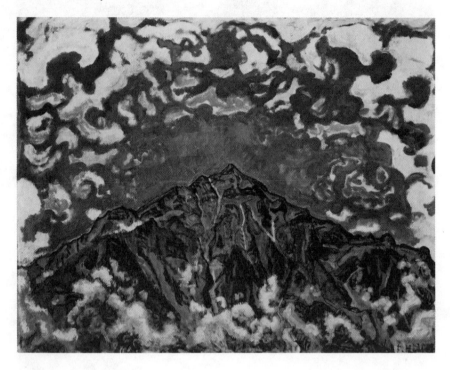

Figure 27. Klee, *Gardencity*
 (Gartensiedlung)

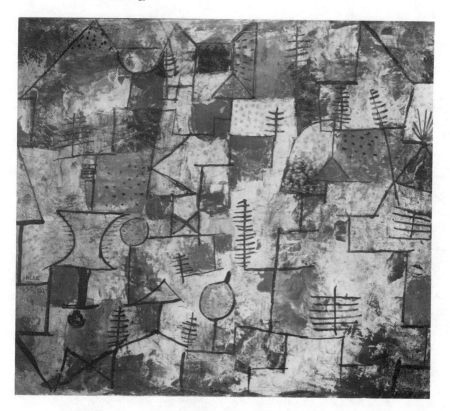

Figure 28. Klee, *Child on the Stairs (Kind
an der Freitreppe)*

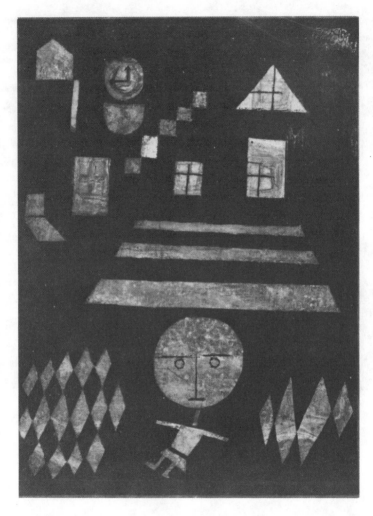

Figure 29. Klee, *Landscape for Lovers*
 (Landschaft für Verliebte)

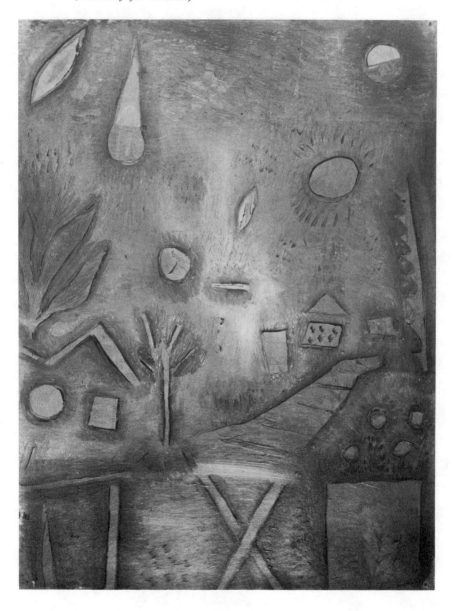

Figure 30. Kandinsky, *Deep Brown (Tiefes Braun)*

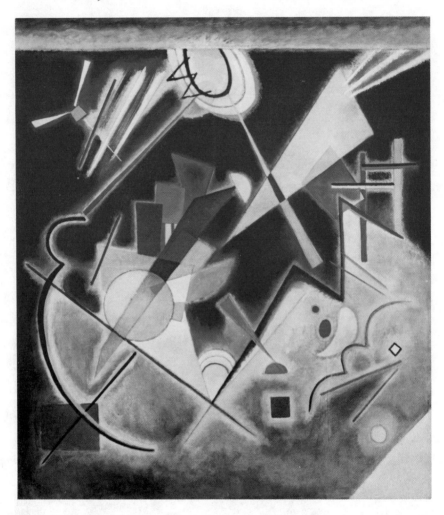

Figure 31.　Klee, *Letter Picture (To Mr. Kandinsky) (Briefbild (An Herrn Kandinsky))*

Figure 32. Kandinsky, *In the Black Square*
(*Im schwarzen Quadrat*)

Figure 33. Rodchenko, *Line Construction*

Figure 34. El Lissitzky, *Proun 5a*

Figure 35. Kandinsky, *Circles in a Circle*
 (Kreise im Kreis)

Figure 36. Moholy-Nagy, *Z III*

Figure 37. Kandinsky, *Landscape*
(*Landschaft*)

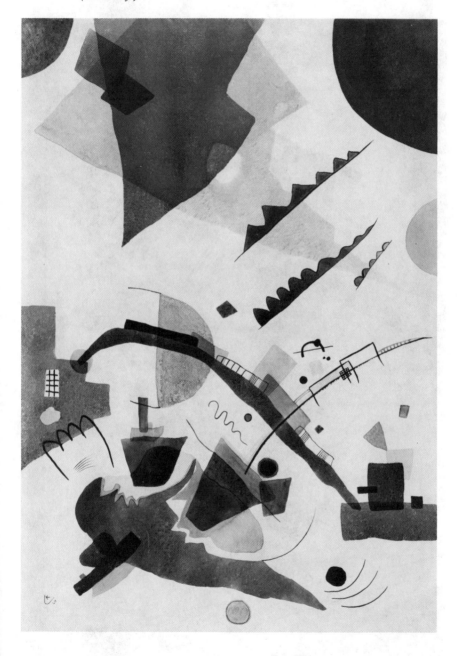

Figure 38. Kandinsky, *Dawn*
(Morgengrauen)

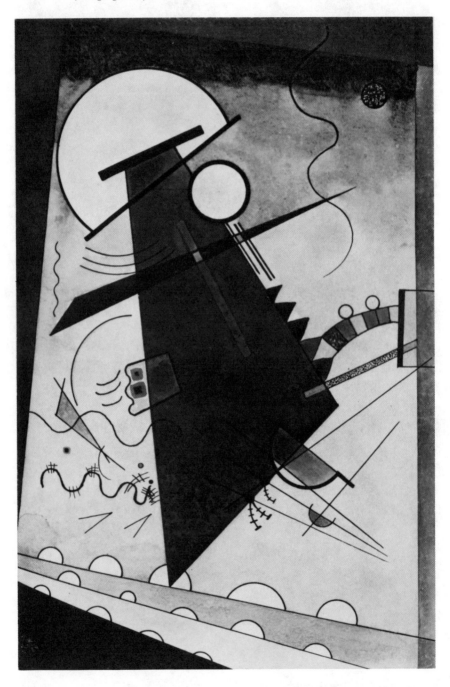

Figure 39. Kandinsky, *Blue Circle (Blauer Kreis)*

Figure 40. Kandinsky, *Descent (Abstieg)*

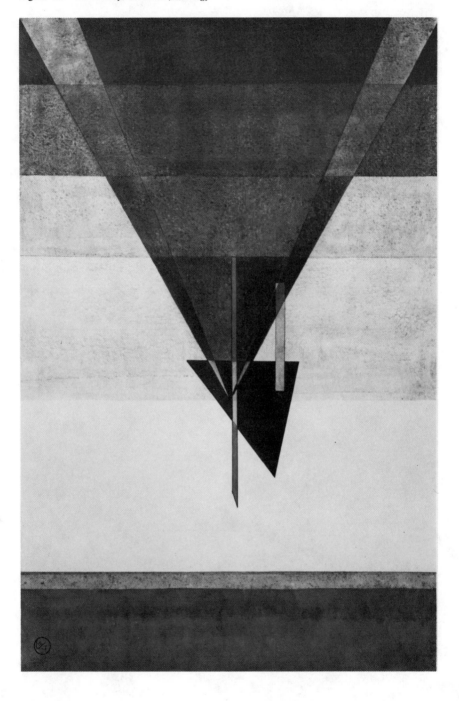

Figure 41. Kandinsky, *Above and Left*
(Oben und Links)

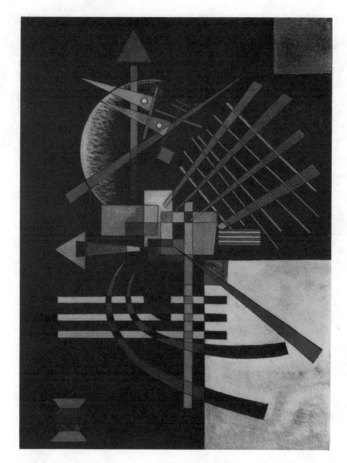

Figure 42. Kandinsky, *Upward (Nach oben)*

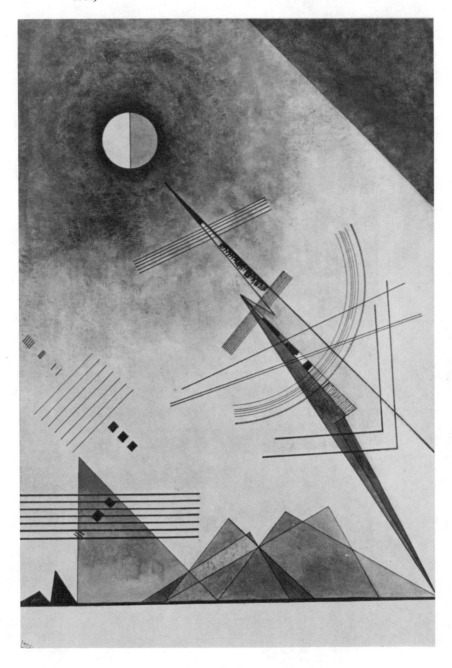

Figure 43. Kandinsky, *Conclusion*
 (Schluss)

Figure 44. Kandinsky, *Fishform*
(*Fischform*)

Figure 45. Kandinsky, *Pointed Structure*
(Spitzenbau)

Figure 46. Kandinsky, *Mild Hardness*
 (Milde Härte)

Figure 47. Klee, *Plant on Window Still Life (Pflanze auf Fensterstilleben)*

Figure 48. Kandinsky, *Pointed in Soft*
 (Spitz im Weich)

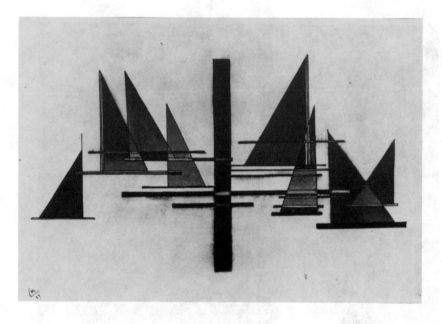

Figure 49. Kandinsky, *Into the Dark (Ins Dunkel)*

Figure 50. Kandinsky, *Junction*

Figure 51. Kandinsky, *Wandering Veil*
(*Wanderschleier*)

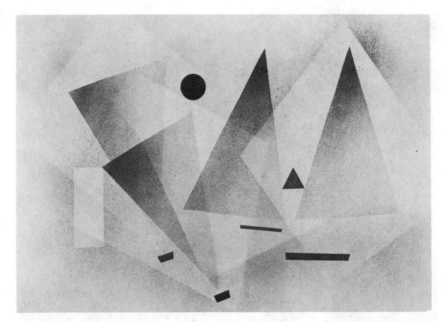

Figure 52. Kandinsky, *Cool Condensation*
 (Kuehle Verdichtung)

Figure 53. Kandinsky, *Light Blue*
 (Hellblau)

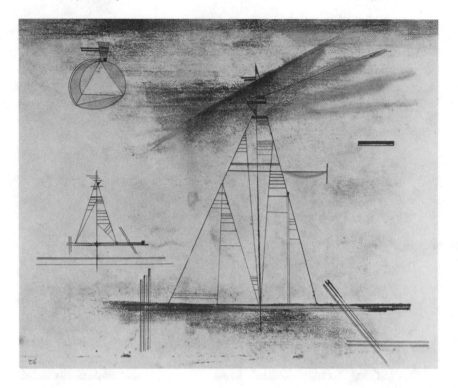

Figure 54. Kandinksy, *Development in Brown (Entwicklung in Braun)*

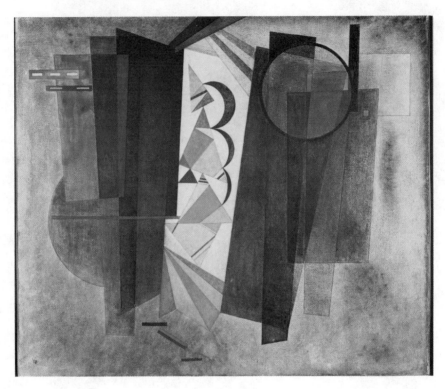

Figure 55. Klee, *Gate into Depth (Tor zur Tiefe)*

Figure 56. Boecklin, *Ulysses and Calypso*
(Odysseus und Kalypso)

Appendix I

Kandinsky and Böcklin

Although Kandinsky's indebtedness to Symbolist and *art nouveau* art and theory has been the subject of much discussion, little attention has been given to Böcklin as a possible artistic and theoretical source and model for Kandinsky.[1] Not only is much of Kandinsky's artistic approach prefigured in Böcklin's work and in Böcklin's ideas but there are also direct stylistic relationships between them. Böcklin's artistic position which represents a counterpoint to French naturalism, is briefly outlined here to supplement the discussion of Kandinsky's artistic development and his sources and to elucidate further what sets off Kandinsky's pre-Blaue Reiter work from his French contemporaries.

In *Concerning the Spiritual* Kandinsky includes Böcklin in the pantheon of seekers who have tried to express the 'inner' values in their art. Referring to him as one of the "seekers of the inner by way of the external" (together with Rosetti and Segantini), Kandinsky says about Böcklin:

> Böcklin bent into the realm of mythology and fairy tales, giving, in contrast to Rosetti, strongly corporeal material form to his abstract beings.[2] [revised]

Although Böcklin's star was beginning to wane among the German artists who looked to the French avant-garde,[3] Böcklin was greatly admired in the George circle with which Kandinsky associated in Munich. For the *Georgianer,* Böcklin represented their ideal of the artist, whom they celebrated in poems as a visionary guide along with Nietzsche.[4]

As a student of Franz Stuck, who owed much to Böcklin, Kandinsky was likely to have been interested in Böcklin at an early point in his training. His 1902 painting, *Mountainous Landscape at a Lake,* ca. 1902, strongly recalls Böcklin's *Villa by the Sea*-type landscapes in motif, color, and painting technique.[5] After Böcklin's death in 1901 a number of publications on the artist appeared, especially recollections by Böcklin's pupils. The most important of these is the book by Gustav Floerke which was published in two editions in 1901 and 1902.[6] Floerke, who worked with Böcklin in the 1880s, strongly emphasizes Böcklin's antinaturalist tendencies. According to his own

recollections in "Reminiscences" Kandinsky in the early 1900s was much troubled by art's relationship to nature and was beginning to look at nature and art as two separate realms. Böcklin's ideas on this point as well as his concepts of color and composition might have been encouraging and stimulating for Kandinsky's searching mind. In Floerke's account of Böcklin's ideas Kandinsky's theories are prefigured in many respects. While Böcklin was, according to Floerke, an untiring observer of nature, he did not want to paint images faithful to nature but sought instead to compress his manifold observations into ideal images, generally valid and possessed of symbolic significance. Böcklin looked on art and nature as two separate realms, feeling that one could never truly render nature in a painted image. Similarly Kandinsky in "Reminiscences" proclaims that the old masters all had had to capitulate before nature (cf. Chapter 1). Floerke states that Böcklin wanted both his realistic and his invented motifs to express inner moods, feelings, and psychological insights. Possessed of an excellent visual memory (as, incidentally, were both Kandinsky and Klee) Böcklin painted mostly from memory; moreover, Böcklin would proudly flaunt his independence from models in the face of his naturalistic painter colleagues and their subservience to the motif. Böcklin conceived of his paintings entirely in terms of their internal coloristic and compositional relationships and expressive values, claiming that he saw a painting complete before his inner eye before starting work on it. (The same has been said of Kandinsky.) At the same time he postulated that a painting should look improvised and spontaneous in its execution. Of particular interest in respect to Kandinsky are Böcklin's ideas on color. His central coloristic principle was that of contrast: contrast of pure, bright colors *per se,* contrast of brilliant and subdued colors, and light-dark contrast. By placing strong local colors against diffuse, 'neutral' colors Böcklin could create spatial effects. For him, the pictorial unity and harmony of a painting was the result of balancing these various types of color contrast. Böcklin used the theory of complementary colors as the point of departure for his selection of colors, without, however, strictly adhering to it. He developed his own ideas on the expressive value of colors and color combinations and even associated colors with sounds (for example, Böcklin thought that red corresponded to the sound of the trumpet).[7] Böcklin's use of color as a means of psychological expression anticipates Kandinsky's concepts of the direct communication of emotions via color.

On the formal level there are relationships between Böcklin and Kandinsky both in terms of style and of motifs. In his paintings, Böcklin put great emphasis on contrasts, of primary colors as well as between primaries and tonal colors; Kandinsky often operates with color along similar lines. Böcklin's method is exemplified in *Vita somnium breve,* 1888 (App. III-6), which depicts the cycle of life. It contains the full range of primaries and their

complementaries. The calm blue of the statue-like, pensive woman is set in sharp contrast to the almost violently red garb of the man riding off to battle. The cheerful green and yellow colors of the meadow with its pink-orange children provide a quieter, secondary contrast, acting as a foil for the drama of life. The composition is quite simple and symmetrical, but there is much visual action and excitement in the painting generated by the numerous color contrasts as well as the dark-light contrasts and the juxtaposition of brilliant colors and tonally subdued colors. This, as well as the landscape, are aspects of *Vita* which can be compared to Kandinsky's *Blue Mountain*, 1908/09 (Fig. 44). Beyond these stylistic parallels there are similarities in the symbolic dimension as well. In both Böcklin's *Vita* and Kandinsky's *Blue Mountain* the viewer is left mystified and begins to speculate about the picture's symbolic significance and meaning beyond what is actually represented. In both paintings the gestures and actions of the figures are enigmatic, hinting at but not revealing their significance. This is particularly evident in comparison with a French artist like Matisse. In Matisse's paintings with allegorical themes, such as *Joy of Life*, 1905/06 (App. III-5) or his 1909 *Dance*, the theme of Arcadia or of rhythmic motion is fully explored within the formal arrangement of the painting itself. On the other hand, both Böcklin and Kandinsky use not only the figures but also color and light to introduce a mystifying, enigmatic element; however, in Kandinsky's *Blue Mountain* the meaning is more difficult to interpret than that of Böcklin's *Vita*, where the inscription included in the picture guides the viewer's thoughts in the intended direction. While Böcklin is always quite explicit in his symbolism, Kandinsky carries the mystical qualities to a point where only the 'initiate' can penetrate into the meaning of his pictures.

Formal contrasts, in Böcklin's sense—of primary colors, of local colors against gradated tonal values, of light and dark, planar and voluminous qualities—predominate throughout Kandinsky's prewar work, much in keeping with his esthetic postulate "Antitheses and contradictions—that is our harmony."[8]

Among the Böcklinesque motifs in Kandinsky's work, the most prominent one is the shrouded figure.[9] Böcklin frequently uses single figures shrouded in antique garb as a focal point and carrier of emotion in his mood landscapes, as in the celebrated *Isle of the Dead* paintings, for example. This type of figure resurfaces in Kandinsky's amorphous beings which inhabit his paintings from 1909 on, as in *Mountain*, 1909 (App. III-20). Two groups of such shrouded figures appear also in Kandinsky's *Improvisation 19*, 1911 (Fig.13), which is possibly a direct reaction to a painting by Böcklin .

Two figure groups are placed in front of a large blue-purple expanse of color which rises diagonally across the surface from the lower left to the upper right. The smaller, more intricately structured group on the left is

placed in front of a cluster of bright colors from which a radiant red spot stands out especially. One of the figures in this group pathetically reaches out toward the other group, but these figures, much taller and more elongated, avert themselves. This group is placed where the 'spiritual' blue color predominates. Warm glowing colors, such as the red and yellow on the left, are contrasted with the quiet blue area; primary colors are set against the 'neutral,' off-colored brown in the upper left corner. The color contrasts, the composition, and the mood generated by the isolation of two figural groups at the extreme sides of the composition (with one group reaching out in vain toward the other) recall Böcklin's *Ulysses and Calypso,* 1883 (Fig. 56).[10] The pointed contrast in Böcklin's painting between the glowing red of Calypso's cloth and the deep blue of the introverted Ulysses, who is both literally and figuratively speaking "all wrapped up" in himself, embodies the contrast between the sensual (or material, in Kandinsky's terms) and the spiritual world. Böcklin expresses this basic dualism in the guise of mythology, giving, as Kandinsky put it, "strongly corporeal, material form" to abstract concepts. On his part, Kandinsky works with semiabstract forms and a less self-evident meaning (there are also more levels of meaning; there is not only the juxtaposition of the two figural groups and their colors, but also the contrast between the figures and the large shape pointing down on them), and he makes his figures transparent so that they appear to be immaterial beings.

The juxtaposition of the two groups in *Improvisation 19* invites associations with Kandinsky's description of the spiritual life of humanity in terms of a slowly ascending triangle, with artists to be found in each segment offering "spiritual" nourishment:

> Every segment hungers, consciously or unconsciously, for adequate spiritual satisfactions. These are offered by the artists, and for such satisfactions the segment below will tomorrow stretch out eager hands.[11]

Set against the 'spiritual' blue background, moving forward and upward unaffected by the clamoring crowd beneath, the group to the right may well symbolize those artists-seekers whose position is further up toward the apex of the "spiritual pyramid"[12] where

> An invisible Moses descends from the mountain and sees the dance around the golden calf. But he brings to man fresh stores of wisdom.
> His voice, inaudible to the crowd, is first heard by the artist. Almost unwittingly artists follow the voice.[13]

Intrepreted in the context of *Concerning the Spiritual* the painting is a 'self-portrait,' in the widest sense, of Kandinsky and his small band of fellow artists who

turn away from the soulless life of the present toward those substances and ideas that give free scope to the nonmaterial strivings of the soul.[14]

Improvisation 19 thus may be a picture about the artist and his exalted role as seer and guide as well as being a picture about art: at the same time a semiabstract, free paraphrase of Böcklin's painting and a critique of Böcklin's way of dealing with "the inner by way of the external."[15]

Appendix II

Matisse Exhibitions in Munich, 1910-1912

In the summary version of his diary Klee simply states for 1911: "Matisse!"[1] Grohmann proposes 1910 as the year for Klee's first acquaintance with Matisse[2] and the literature on other artists of the Blaue Reiter circle also makes reference to a Matisse show taking place in Munich in 1910.[3] As no mention of such a show is made in the literature on Matisse, I have tried to reconstruct the exhibitions in which Matisse participated in Munich in order to establish what Klee, who did not travel much except for his annual trips to Bern, could have known of Matisse's work.

Although Matisse was well-known in Germany as a figurehead of the notorious French avant-garde, his actual work was primarily known to the artists who had actually been to Paris. Following the fiasco of his show at Cassirer's in Berlin in the winter of 1908/09, Matisse rarely exhibited major works in Germany until 1912. He regularly sent a few works, mostly drawings, to the Berlin Sezession exhibitions and to a few other German shows, and he sold a number of works to German collectors, but his work was rarely illustrated or discussed in the major German art journals with the exception of the 1909 publication of "Notes d'un Peintre" *Kunst und Künstler,* which included a few illustrations of early works by Matisse. In Munich, where the artistic climate was even more conservative than in Berlin, no Matisse works were exhibited until January 1910 when the Thannhauser gallery, then the most progressive gallery in Munich, opened a show called *Junge Französische Landschafter.* No catalogue of the show has come to light so far, but the general content can be reconstructed from the newspaper reviews. The exhibition, originally devoted to the Fauves as a group, opened on January 16, 1910. During the course of the show a collection of works by Matisse, including drawings and a small sculpture, was added (January 23), and later (January 28) two more paintings by Matisse arrived. Because the exhibition closed on February 13, it is not likely that it included any of the works in the 1910 Matisse show at Bernheim's in Paris, which opened on February 14. The exhibition caused some stir in the papers; the more enlightened critics cautiously praised some of the painters, notably Marquet and Camoin, but they

were unanimous in their condemnation of Matisse, proclaiming his recent daubs unworthy of his talent which had manifested itself in his Impressionist works. No specific work by Matisse can be identified, but the show appears to hav included very recent works with rather general titles ("For that which he calls paintings, studies and drawings, are ridiculous dabblings..." [*Münchner Zeitung,* Jan.25, 1910]). It appears unlikely that large major works by Matisse were shown, as they surely would have been discussed by the critics in more detail.

The only work by Matisse exhibited in 1911 appears to have been an early landscape. It is listed in the catalogue of the 1911 show *Junge Französische Landschafter,* which took place at the Thannhauser gallery in March and April of 1911.[4] The catalogue lists one painting by Matisse, *Weg unter Bäumen,* which in the extensive review of the show in the *Münchner Neueste Nachrichten* of April 4, 1911, is described as an early work. Possibly it is identical with the 1904 painting, *Chemin sous les arbres, à Bohain en Vermondois,* which was exhibited at Bernheim's in 1910.

The only other works by Matisse to be seen in Munich were those in the private collections of Hugo von Tschudi and his assistant Heinz Braune. Tschudi, the director of the Alte and Neue Pinakothek, ordered a painting from Matisse in 1910 for his own collection, hoping that it could later be acquired for the public collection. By the time of Matisse's visit to Munich in the summer of that year Tschudi had already obtained the painting, *Geraniums.* Although it was not publicly exhibited until after his death in 1912, his intention was known to the public. (G.W. Wolf wrote of him in *Münchner Woche,* July 2, 1910: "Others hate him [Tschudi], because he wants to buy a painting by Matisse.") Braune eventually owned several works by Matisse, of which I have only been able to identify the drawing, *Male Model,* ca. 1900.[5] There is no evidence that Klee knew either Tschudi or Braune personally. On the whole his acquaintance with Matisse's work must have been limited to the works in the 1910 show and to some illustrations; it is only in 1912 that he had a chance to see more of Matisse's work on his trip to Paris, in the Moderner Bund show in Zürich, and in the private collection of Hans Arp, who owned a number of drawings by Matisse.

Until 1912 Klee's awareness of the artistic avant-garde elsewhere was, in general, quite limited. It was largely restricted to what he could see in Munich exhibitions and in publications. Kandinsky, in contrast, who traveled extensively and had numerous artistic contacts, was usually much better informed, and at an earlier point, about the avant-garde.

Appendix III

Reference Guide for Works Not Illustrated in the Text

1. Ammann, J.C. "Die Tunsien-Aquarelle Paul Klees von 1914," *Kunstnachrichten,* vol. II, no. 3, Dec. 1965.

2. Baden-Baden, Staatliche Kunsthalle. *Robert Delaunay,* exh. cat., 1976.

3. ———. *Wassily Kandinsky. Gemälde 1900-1944,* exh. cat., 1970.

4. ———. *Der fruehe Paul Klee,* exh. cat., 1964.

5. Barr, A. *Matisse. His Art and His Public,* New York, 1951.

6. Basel, Kunstmuseum. *Arnold Böcklin,* exh. cat., 1977.

7. Bern, Kornfeld & Klipstein. *Moderne Kunst,* auction cat., June 13-15, 1968.

8. Berlin, Galerie Der Sturm. *Erster Deutscher Herbstsalon,* exh. cat., 1913.

9. Bologna, Edizioni de' Foscherari. *Paul Klee,* Bologna, 1971.

10. Bovi, A. *Wassily Kandinsky,* Lucerne, 1972.

11. Cassou, J. *Wassily Kandinsky. Watercolors, Drawings, Writings,* New York, 1961.

12. Des Moines, Art Center. *Paul Klee. The Bauhaus Years 1921-1931,* exh. cat., 1973.

13. Düsseldorf, Kunstsammlungen Nordrhein-Westfalen. *Paul Klee.* Collection cat., Duesseldorf, 1971.

14. Franciscono, M. Review of the Albert Gleizes Exhibition at the Guggenheim Museum, *College Art Journal,* vol. 24, no. 3, Spring 1965, 310-12.

15. Geelhaar, C. *Paul Klee and the Bauhaus,* Greenwich, Conn., 1972.

16. ———. *Paul Klee. Leben und Werk,* Cologne, 1974.

17. Glaesemer, J. *Paul Klee. Handzeichnungen I. Kindheit bis 1920,* Kunstmuseum Bern, Bern, 1973.

18. ———. *Paul Klee. Die farbigen Werke im Kunstmuseum Bern,* Bern, 1976.

19. Golding, J. *Cubism. A History and Analysis, 1907-1914,* New York, 1968.

20. Gollek, R. *Der Blaue Reiter im Lenbachhaus München,* Munich, 1974.

21. Gray, C. *The Great Experiment: Russian Art 1863-1922,* 2nd. ed., London, 1971.

22. Grohmann, W. *Paul Klee,* New York, 1954.

23. ———. *Wassily Kandinsky. Life and Work,* New York, 1958.

24. Haftmann, W. *Malerei im zwanzigsten Jahrhundert,* 2 vols., Munich, 1954-1955.

25. Hamburg, Kunsthalle. *Caspar David Friedrich,* exh. cat., 1974.

26. Hanfstaengl, E. *Wassily Kandinsky. Zeichnungen und Aquarelle,* Munich, 1974.

27. Hulton, N. *An Approach to Paul Klee,* London, 1956.

28. Klee, P. *On Modern Art,* intro. by H. Read, London, 1948.

29. ———. *The Thinking Eye,* New York, 1961.

30. ———. *The Diaries of Paul Klee, 1898-1918,* Berkeley and Los Angeles, 1964.

31. ———. *Notebooks vol. 2. The Nature of Nature,* New York, 1973.

32. Kornfeld, E. *Verzeichnis des graphischen Werkes von Paul Klee,* Bern, 1963.

33. Lahnstein, P. *Gabriele Münter,* Ettal, 1971.

34. Lankheit, K. *Franz Marc. Katalog der Werke,* Cologne, 1970.

35. London, Marlborough Fine Arts Ltd. *Kandinsky and His Friends,* exh. cat., 1966.

36. London, Sotheby & Co. *Impressionist and Modern Paintings, Drawings, and Sculpture,* Part III, auc. cat., July 5, 1962.

37. ———. *Fifty Paintings by Vasily Kandinsky, the Property of the S.R. Guggenheim Foundation,* auct. cat., June 30, 1964.

38. ———. *Impressionist and Modern Drawings and Watercolors,* auct. cat., June 30, 1976.

39. Münster, Westfälisches Landesmuseum. *August Macke. Aquarelle und Zeichnungen,* exh. cat., 1976.

40. Munich, Haus der Kunst. *Der Blaue Reiter,* exh. cat., 1949.

41. ———. *Wassily Kandinsky 1866-1944,* exh. cat., 1976.

42. Munich, Staedtische Galerie im Lenbachhaus. *Paul Klee. Das Frühwerk 1883-1922*, exh. cat., 1979.

43. ———. *Gabriele Münter 1877-1962*, exh. cat., 1977.

44. New York, Museum of Modern Art. *Cézanne. The Late Work*, exh. cat., 1977.

45. New York, Parke-Bernet Galleries. *Important Twentieth Century Paintings, Watercolors and Drawings from the S.R. Guggenheim Foundation*, auc. cat., Oct. 20, 1971.

46. New York, Saidenberg Gallery. *Paul Klee*, exh. cat., 1969.

47. New York, S.R. Guggenheim Museum. *Kandinsky at the Guggenheim*, coll. cat., 1972.

48. ———. *Paul Klee 1879-1940*, exh. cat., 1967.

49. ———. *Paul Klee at the Guggenheim*, coll. cat., 1977.

50. Overy, P. *Kandinsky, the Language of the Eye*, New York, Washington, 1969.

51. Paris, Galerie Berggruen & Cie. *Klee - Kandinsky, une confrontation*, exh. cat., 1959.

52. ———. *Paul Klee*, exh. cat., 1961.

53. Roethel, H.K. *Kandinsky. Das Graphische Werk*, Cologne, 1970.

54. ———. J.K. Benjamin. *Kandinsky*, New York, 1979.

55. San Lazzaro, G. di. *Klee*, New York and Washington, 1957.

56. Stuttgart, Württenbergischer Kunstverein. *Laszlo Moholy-Nagy*, exh. cat., 1974.

57. Tokyo, International Publishers, ed. *Klee - Kandinsky*, New York, 1972.

58. Toronto, Art Gallery of Ontario. *Kandinsky Watercolors*, exh. cat., 1970.

59. XXe Siècle. *Centenaire de Kandinsky*, special number, n.s. 27, Dec. 1966. reprinted as *Hommage à Wassily Kandinsky*, Paris, 1974.

60. Vitrac, R. "A Propos des oeuvres recentes de Paul Klee," *Cahiers d'Art*, Paris, vol. 5, 1930, 300-6.

61. Weiler, C. *Alexej Jawlensky*, Cologne, 1959.

62. Wingler, H.M. *The Bauhaus*, Cambridge, Ma., 1969.

63. Zervos, C. *Pablo Picasso, Oeuvres de 1906-1912*, vol. II, reprint, Paris, 1967.

Notes

Introduction

1. W. Grohmann, *Kandinsky, Life and Work*, New York, 1958, p. 208, writes *"Points in an Arc* suggests at once a musical fugue and a Chinese village."* Associations with boats might be equally appropriate.

2. W. Grohmann, "Paul Klee und die Anfänge einer Harmonielehre in der Kunst," *Neue Deutsche Hefte*, no. 39, October 1957, p. 632.

Chapter 1

1. P. Weiss, *Wassily Kandinsky: The Formative Munich Years (1896-1914)—From Jugendstil to Abstraction*, unpublished Ph.D. thesis, Syracuse University, New York, 1973 (microfilm).

2. Weiss, *Wassily Kandinsky*, p. 29. Weiss has been the first to investigate the importance of Ažbé, Kandinsky's first teacher, who advocated the use of pure color and broad sweeping brushlines, as well as of Stuck, whose work and teaching is characterized by great freedom in the use of a-naturalist forms and colors, with an emphasis on their expressive value.

3. K. Lindsay, *An Examination of the Fundamental Theories of Wassily Kandinsky*, unpublished Ph.D. thesis, University of Wisconsin, Madison, Wis., 1951. In what is the earliest scholarly study of Kandinsky's theories Lindsay notes the intuitive, unanalytical and pseudoscientific quality of Kandinsky's writings, but he discounts influence from theosophy, noting that by 1911 Kandinsky was already disappointed by Steiner and turned away from the movement. K. Brisch, *Kunstgeschichte Wassily Kandinsky 1900-1921*, unpublished Ph.D. thesis, Bonn, 1955 (microfilm), has countered Lindsay's contention by pointing out that in the early 1900s Kandinsky was quite strongly interested in theosophy and he suggests that Kandinsky's color symbolism might well have been influenced by it.

4. S. Ringbom, "Art in the Epoch of the Great Spiritual: Occult Elements in the Early Theory of Abstract Painting," *Journal of the Warburg and Courtauld Institutes*, 29, 1966, 386-418; and *The Sounding Cosmos. A Study in the Spirituality of Kandinsky and the Genesis of Abstract Painting*, Acta Academiae Aboensis, ser. A, vol. 38, no. 2, Abo, 1970.

5. Ringbom, *Cosmos*, p. 88.

6. R.-C. Washton, *Vasily Kandinsky, 1909-13: Painting and Theory*, unpublished Ph.D. thesis, Yale University, New Haven, 1969 (microfilm). Washton, "Kandinsky and Abstraction: The Role of the Hidden Image," *Artforum*, 10, 1972, 42-49. Washton, "Kandinsky's Abstract Style: The Veiling of Apocalyptic Imagery," *Art Journal*, Spring 1975, 217-28.

7. Cf. V. Marcadé, *Le Renouveau de l'Art Pictural Russe 1863-1914*, Lausanne, 1971. Of greater interest than Marcadé's very general study is J. Hahl-Koch, *Marianne von Werefkin und der russische Symbolismus, Slavistische Beiträge*, 24, Munich, 1967, where the relationship of Werefkin's ideas to those of the Russian Symbolist poets is investigated. Werefkin belonged to the immediate circle around Kandinsky in Munich, and her ideas may very well have stimulated and reinforced Kandinsky's thinking.

8. "Rückblicke" was first published in *Kandinsky-Album*, Der Sturm, Berlin, 1913. One has to read the essay with caution as a source for Kandinsky's early years, as in retrospect Kandinsky sees his earlier development in light of his current move into abstraction. The best English translation is in R. Herbert, ed., *Modern Artists on Art*, Englewood Cliffs, N.J., 1964, p. 19ff., from which the quotations are taken.

9. Although Ažbé was a very liberal teacher and not rigidly academic (cf. Weiss, *Wassily Kandinsky*) he set great store by his principles of form construction, such as the "principle of the sphere" that Kandinsky mentions in "Reminiscences."

10. See Kandinsky, "Reminiscences," p. 37.

11. Ibid.

12. Ibid.

13. Ibid., p. 38.

14. Kandinsky, *Über das Geistige in der Kunst*, Munich, 1911, 9th ed., Bern, 1970. Kandinsky worked on the book over several years. The manuscript was essentially complete by 1909. The English translation used for the quotations is *Concerning the Spiritual in Art, The Documents of Modern Art*, vol. 5, New York, 1947. (Wittenborn, ed.)

15. Klee, *Tagebücher 1898-1918*, ed. by F. Klee, Cologne, 1957. English ed., *The Diaries of Paul Klee, 1898-1918*, Berkeley and Los Angeles, 1964. Klee himself later copied and edited the earlier entries to some extent, so it cannot be considered a completely reliable source for his early years. Henceforth cited as *Diaries*.

16. Quite different from the state of research on Kandinsky, there are no extensive studies of the sources of Klee's art theoretical concepts and of his early years. The unpublished dissertation by Ch. W. Haxthausen, *Paul Klee. The Formative Years*, Columbia University, New York, 1976, which was not accessible to me, has not been taken into consideration in the preparation of this text.

17. Klee, *Diaries*, p. 69, no. 294.

18. Klee, *Diaries*, p. 69, no. 295. On a personal level Klee looked to Goethe in general as his model. In a later diary entry he writes: "As a matter of fact, Goethe is the only bearable German (I myself would like perhaps to be German in his way)" (*Diaries*, p. 91, no. 375).
 Goethe was one of Klee's favorite authors whom he read and reread throughout his life, cf. W. Grohmann, *Paul Klee*, Stuttgart, 1954, p. 41, 57. Apparently Klee preferred the writings of the late Goethe. During the Bauhaus years he was greatly interested in Goethe's morphological writings. Felix Klee suggested to me that Klee might have been familiar with them even earlier.

19. J.W. Goethe, *Italienische Reise*, first published in 1816/17, English ed., *Goethe, Travels in Italy: Together with His Second Residence in Rome and Fragment on Italy*, London, 1883, p. 408. Goethe assembled his travel recollections from diaries and letters many years after the trip.

20. M. Franciscono, "Paul Klee's Italian Journey and the Classical Tradition," *Pantheon*, 32, 1974, 54-62. Based on the study of Klee's etchings and the few surviving works from the Italian journey, Franciscono reevaluates the importance that the trip had for Klee. He has been the first to note the impact of the humanist tradition and of classical art on early Klee, but he does not consider the influence from Goethe.

21. Klee, *Diaries*, p. 87, no. 366.

22. Goethe, *Italienische Reise*, p. 158 f. The formation of Goethe's mature art philosophy and its basic tenets are excellently presented in H. von Einem, *Goethe-Studien*, Munich, 1972. His summary of Goethe's views in many ways prefigures Klee's theories of the Bauhaus period and therefore shall be quoted here: ". . . the mature Goethe considers art to be the continuation of nature's creative work, in which, through the medium man, the primeval law *(Urgesetz)* manifests itself more and more purely. Just as each stage of nature does not contradict the stage which had preceded it, but instead keeps its *Gestalt* alive within itself, so the consummate work of art is at the same time the highest work of nature and is 'produced by man in accordance with true and natural laws.' This conception provides an answer to the open questions of young Goethe. At the same time it gives profound expression to the idea of autonomy. Goethe's conception indeed accomplished what from the beginning had existed as potential in the historical evolution: the liberation of art from extra-artistic forces and at the same time the overcoming of subjective arbitrariness through a new bond" (p. 82).

 Kandinsky, who frequently cites Goethe on the autonomy of art, saw Goethe primarily in terms of the first aspect of von Einem's conclusion, namely that of the liberation of art from extra-artistic demands and ties. For Klee, in contrast to Kandinsky, both aspects were valid, the autonomy of the work of art as well as the "overcoming of subjective arbitrariness through a new bond"; that is, the subjection of the art work to the *Urgesetz*.

23. Klee, *Diaries*, p. 94, no. 380.

24. Goethe, *Italienische Reise*, p. 526. An excellent discussion of Moritz's esthetics is presented by P. Szondi, in *Poetik und Geschichtsphilosophie I (Antike und Moderne in der Aesthetik der Goethezeit)*, Frankfurt/Main, 1974.

25. In general terms the Goethean aspects of Klee's thinking and artistic personality have often been noted. Grohmann, *op. cit.*, 1954, and elsewhere (see Bibliography) has frequently compared Klee to Goethe. See also W. Haftmann, "Über das Humanistische bei Paul Klee," *Prisma*, no. 17, 1948, 31-32; Haftmann, *Paul Klee. Wege bildnerischen Denkens*, Munich, 1950; M. Huggler, *Paul Klee. Die Malerei als Blick in den Kosmos*, Frauenfeld 1969. Possible direct influence from Goethe on Klee's thinking has been suggested by Ringbom, "Art in the Epoch of the Great Spiritual," and by A. Quintavalle, *Klee. Fino al Bauhaus*, exh. cat., Parma 1972-73. Quintavalle especially points to Klee's self-education and self-stylization along Goethean lines of thought. The general relationship of Klee's and Kandinsky's theories to Goethe is discussed by W. Hofmann, in "Ein Beitrag zur morphologischen Kunsttheorie der Gegenwart," *Alte und neue Kunst*, II, 1953, 63-80. For Klee's art-nature theories and their relationship to Goethe see also: A. Mösser, *Das Problem der Bewegung bei Paul Klee*, Heidelberg, 1976. This study was not available to me until after completion of this manuscript.

26. Klee, *Diaries*, p. 119, no. 411-12.

27. Klee, *Diaries*, p. 125, no. 429.

28. Ibid. The term "the constructive element" which is frequently used by Kandinsky, indicates that the phrase in parenthesis was probably added during the Blaue Reiter years.

29. Klee, *Diaries*, p. 146f, no. 536.

30. Jacobsen (1847-85) belonged to the Danish avant-garde of the 1870s. His novel, which first appeared in 1880 (in Germany in 1889) was widely read and influential around the turn of the century. It prefigures much of French Symbolist literature, such as Huysman's *A Rébours*, with its synaesthetic descriptions, recurrent motifs of yearning and unfulfillment, and the protagonist's ultimate resignation and *dégoût* of life, but Jacobsen writes with more warmth and realism, and a subtle sense of humor relieves the *fin-de-siècle* melancholy.

31. Klee, *Diaries*, p. 89, no. 371. Schmoll von Eisenwerth was a German landscape painter with whom Klee was friendly in Rome.

32. Klee, *Diaries*, p. 125f. no. 430.

33. Kandinsky "Reminiscences," p. 26. The most extensive study to date of Kandinsky's formal development is Brisch, *Kunstgeschichte Kandinsky*. He suggests influence from Monet, van Gogh, Neo-Impressionism, and Whistler on early Kandinsky. For the impact of *art nouveau*, which manifests itself particularly in Kandinsky's prints, see Weiss, *Wassily Kandinsky*.

34. Kandinsky, "Reminiscences," p. 26. That Kandinsky was well familiar with Impressionism is evident from the shows arranged by the Phalanx association of which he was president. In 1903 a collection of 16 Monet paintings was shown and a Pissarro exhibition was planned for the same year. In 1904 the Phalanx held a Neo-Impressionist show. For a complete list of the Phalanx exhibitions see Weiss, *Wassily Kandinsky*.

35. Examples are: *The English Garden in Munich*, 1901; *Nikolaiplatz in Schwabing*, 1901/02; *The Isar near Grosshesselohe*, 1903; *Beach Chairs in Holland*, 1904; *In the Park of St. Cloud*, 1906. All illustrated in R. Gollek, *Der Blaue Reiter im Lenbachhaus München, Materialien zur Kunst des 19. Jahrhunderts*, vol. 12, Munich 1974. Henceforth cited as Gollek 74.

36. W. Grohmann, *Wassily Kandinsky*, New York, 1958, p. 47 relates Kandinsky's impasto style to that of the *Scholle*, a group of landscape painters in Munich, whose moody landscape paintings are stylistically a mixture of Barbizon and *art nouveau*. In Kandinsky's later studies the individual brushstrokes become more pronounced, reminiscent of van Gogh.

37. Kandinsky, "Reminiscences," p. 29 f.

38. In his later writings Kandinsky takes a critical stance *vis-á-vis* Impressionism, which in his opinion failed to overcome the materialism implicit in nineteenth century Naturalism. See *Concerning the Spiritual*, p. 24, 36, and "Malerei als reine Kunst," 1913, in *Essays über Kunst and Künstler*, ed. M. Bill, Bern, 1963, 66 f.

39. For example *Promenading Lady*, ca. 1903, and *A Russian Beauty in a Landscape*, ca. 1904, ill. in E. Hanfstaengl, *Wassily Kandinsky, Zeichnungen und Aquarelle, Katalog der Sammlung im Städtischen Lenbachhaus München*, Munich, 1974, p. 28 and pl. IV.

40. Brisch, *Kunstgeschichte Kandinsky*, has related Kandinsky's decorative use of the dot technique to Segantini and Klimt.

41. Kandinsky, "Reminiscences," p. 30.

42. Grohmann, *Kandinsky*, 1958, p. 51.

43. Kl. Lankheit in his edition of *The Blaue Reiter Almanac*, New York, 1974, p. 18, has suggested that the title of the painting originally was only "The Rider," which was later changed by Kandinsky. He also points to the *art nouveau* planarity of the painting and suggests compositional analogies to Hodler.

44. Grohmann, *Wassily Kandinsky*, p. 48 has pointed to the relationship with the artistic circle around the *World of Art* periodical. The *Salon d'Automne* of 1906 included a special exhibition of modern Russian art, assembled by Diaghilev.

45. Bilibin who studies at Ažbé's at the time Kandinsky studied there, belongs to the circle of the *World of Art* magazine. See, for example, his illustrations for *Maria Morezna*, 1901.

46. For example, the genre motifs of the paintings *The Cow*, 1910; *Improvisation IV (Policeman)*, 1911, *Improvisation VI (Sunday)*, 1911, all ill. in Gollek 74.

47. The etchings are illustrated in E. Kornfeld, ed. *Verzeichnis des graphischen Werkes von Paul Klee*, Bern 1863, nos. 3-18.

48. See Franciscono, *Klee's Italian Journey*, for the sources from antiquity. See also A. Comini, "All Roads Lead (Reluctantly) to Bern: Style and Source in Paul Klee's Early 'Sour' Prints," *Arts Magazine*, Sept., 1977, 105-11.

49. Klee mentions the relatedness of his etchings to Hodler's work in a letter to his bride of June 1906. Cf. Paul Klee, *Schriften, Rezensionen und Aufsätze*, ed. C. Geelhaar, Cologne 1976, p. 106, n. 5.

50. Cited from J. Glaesemer, ed., *Paul Klee. Handzeichnungen I, Kunstmuseum Bern*, Bern, 1973, p. 116. The etchings were intended to be Klee's official debut as an artist. He first exhibited them in 1906 at the Munich Sezession.

51. See Glaesemer 73 for an excellent discussion of the stylistic development in Klee's drawings and for his technical experiments.

52. The linear refinement of these drawings might reflect some influence from Beardsley, whose work Klee had studied in the fall of 1904. See *Diaries*, p. 158, no. 578.

53. Cf. Klee, *Diaries*, p. 232, no. 842.

54. H. Hofstaetter, "Symbolismus und Jugendstil im Frühwerk von Paul Klee," *Kunst in Hessen und am Mittelrhein*, 5, 1965, p. 97-118, has studied Klee's early work within the context of European Symbolism and points to the typically Symbolist themes in Klee's graphic work.

55. Klee was in Paris from June 1 to 13. He visited the two official *Salons* and the Whistler retrospective, but he was too late to see the *Salon des Indépendants* (closed on April 30), which included the Fauves and a van Gogh retrospective. In his recollections of the trip Klee notes Manet and Monet in particular, cf. *Diaries*, p. 179 ff, nos. 645-49.

56. Klee, *Diaries*, p. 196, no. 756.

57. Klee, *Diaries*, p. 183, no. 660.

58. The "dogma" Klee mentions may be an allusion to Meier-Graefe's interpretation of French art in his *Entwicklungsgeschichte der modernen Kunst*, 1904. Klee owned a copy, but I do not know when he read it.

59. For a statistical breakdown of the works in each category see Glaesemer 73, p. 138.

60. Klee had been introduced to Ensor and to van Gogh's letters by the artist Ernst Sonderegger. Sonderegger came to Munich from Paris; Klee was impressed by his French orientation.

61. Klee, *Diaries*, p. 216, no. 798.

62. Meier-Graefe discusses van Gogh in *Impressionisten*, published in 1907 by Piper in Munich. Klee was friendly with Piper and may have become acquainted with the book, which was later also in his library, through him.

63. See Klee, *Diaries*, p. 221, no. 809 for a fictitious pupil-teacher dialogue with Meier-Graefe in which Klee basically admonishes himself to work along naturalist lines. Shortly thereafter Klee characterizes himself as "belonging more with the Impressionists," cf. *Diaries*, p. 222, no. 812.

64. In the summary version of the diaries (probably written around 1920), published in F. Klee, *Paul Klee, His Life and Work in Documents*, New York, 1962, p. 12. While Meier-Graefe championed French art above all, Scheffler focused in his criticism on German Impressionism. He also edited the widely read and influential journal, *Kunst und Künstler*.

65. Klee, *Diaries*, p. 223, no. 813a.

66. The motif of *Busy Square* recalls the Paris Boulevard scenes by Monet which Klee had admired in an exhibition of 1907 (cf. *Diaries*, p. 211, no. 785.) I have not been able to ascertain which Monet paintings were included. His Paris scenes of the 1860s and 70s were also illustrated in *Kunst und Künstler*.

67. Klee, *Diaries*, p. 232, no. 842.

68. See Klee, *Diaries*, p. 226f., nos. 822, 824, 827.

69. Klee, *Diaries*, p. 231, no. 840.

70. For Kandinsky's stay in Paris, see J. Fineberg, *Kandinsky in Paris, 1906-07*, unpublished Ph.D. thesis, Harvard University, Cambridge, Mass., 1975.

71. Grohmann, *Kandinsky 58*, p. 48, relates that Kandinsky received a visit from Gertrude Stein, but as neither took very much to the other, the acquaintanceship did not continue. The episode suggests that Kandinsky would have had the chance to get to know the future Cubist artists.

72. For an extensive discussion of the dating problems and iconography of this painting, see A. Rudenstine, *The Guggenheim Museum Collection, Paintings, 1880-1945*, New York, 1976, vol. I, 218-23.

73. A. Barr in *Matisse, His Art and His Public*, New York, 1951, p. 86. The painting was exhibited in the *Salon des Indépendants* in 1906 which officially closed on April 30. According to Grohmann, *Kandinsky 58*, Kandinsky did not arrive in Paris until May 1906, but at the same time Grohmann claims that Kandinsky did see the *Salon*. Possibly Kandinsky had a chance to see the painting chez Steins (Leo Stein bought *Joy*), if he repaid Gertrude Stein's visit to him. Cf. n. 71.

74. From a distance the paint surface of many of Kandinsky's canvases looks very densely painted and pastose, although in reality the paint is quite thinly applied.

75. The combination of ideal nude figures and modern landscape in *Joy* may well have appeared as a concrete model for Kandinsky's goal of painting 'compositions' in which he could synthesize nature studies and figural invention. From 1908 on, he no longer works in separate styles for landscapes and figural inventions.

76. In F. Klee, *Klee*, p. 14. Klee saw the Cézanne paintings in the spring show of the Munich Sezession in 1909. The catalogue includes 13 works, while Klee mentions only eight paintings in his diary.

77. Klee, *Diaries*, p. 239, no. 862.

78. "Notizen eines Malers," *Kunst und Künstler*, vol. 7, 1909, p. 335-47. The article was accompanied by an extensive qualifying footnote by the editor who acknowledges the

essay's instructive value for a deepened appreciation of Impressionism, but expresses his misgivings about Matisse, an "ambitious epigone." Only a few early works by Matisse are illustrated.

79. Klee later erroneously dated his first acquaintance with Matisse as 1911 (cf. F. Klee, *Klee*, p. 14.)

80. Klee, *Diaries*, p. 244, no. 873.

81. Klee, *Diaries*, p. 244, no. 875.

82. *Diaries*, p. 244, no. 876.

83. Klee, *Diaries*, p. 245, no. 879 (June 1910).

84. Another painting of 1910, *Female Nude (down to the Knees)*, 1910.124 (ill. in J. Glaesemer, ed., *Paul Klee. Die farbigen Werke im Kunstmuseum Bern*, Bern 1976, no. 32), typifies the somber tonalities that Klee reverts to periodically throughout his life. Like Kandinsky, Klee is interested in tonal colors and light-dark gradations as well as in primary colors, although he rarely juxtaposes them as pointedly in one painting as Kandinsky does.

85. Klee, *Diaries*, p. 259, no. 899.

86. Klee, *Diaries*, p. 240, no. 865. See also Klee's remark, ibid., p. 236, no. 857: "Nature can afford to be prodigal in everything, the artist must be frugal down to the smallest detail."

87. In 1911 Klee begins to think again about van Gogh who had gone beyond naturalism in his art, but he realizes that van Gogh already belongs to history and therefore cannot be a model for himself.

Chapter 2

1. In the summary version of the diary Klee recalls his impression of Kandinsky during his own short stay in Stuck's studio: "I can dimly recollect Kandinsky and Weisgerber who studied at the school at the same time. Weisgerber was a kind of model pupil, Kandinsky was quiet and mixed the colors on his palette with the greatest diligence and, so it seemed to me, with a kind of studiousness, peering very closely at what he was doing." [revised] F. Klee, *Klee*, p. 5.

2. Klee writes that while Moilliet was staying with the Klees, he was irked by the Mackes, who played a practical joke on him. See Klee, *Diaries*, p. 264, no. 903. Macke spent October with the Marcs in Sindelsdorf, his wife joined him there in the later part of October (see the invitation to her to come, dated October 11, in *Macke-Marc Briefwechsel*, Cologne, 1964, p. 74). By November 9, the Mackes had already been back home for a few days. This places Moilliet's visit with the Klees into the second half of October or very early November.

3. See Klee, *Diaries*, p. 272, no. 913.

4. Klee, *Diaries*, p. 264 f., no. 903. In the original manuscript the last sentence is added as a footnote.

5. While Macke was in Thoun, Marc sent him long letters in which he described the mounting tensions between Kandinsky and himself on one side and the other *NKV* artists on the other, which were to lead to their secession from the group. He asked Macke, however, not to discuss these problems with anybody else.

6. See Klee, *Diaries*, p. 254, no. 888.

7. That Klee regularly attended the shows in the Thannhauser gallery is even more likely, as at the time it was the only Munich gallery that dared to show avant-garde art. In June of 1911

Klee had his first one-man show in Munich at the Thannhauser gallery, arranged with the help of the critic Wilhelm Michel. See, *Diaries*, p. 254, no. 889 and p. 258, no. 896.

8. In the summary version of the diary Klee places his meeting with Jawlensky and Werefkin into 1911. In conversation with me, Felix Klee stated that Klee thought very highly of Marianna von Werefkin. He owned a number of paintings by her.

9. K. Lankheit, *Franz Marc*, Cologne 1976, p. 99 suggests that at the latest, Klee met Marc in January of 1912. In May 1911 Marc had a show at Thannhauser's. Klee possibly was familiar with his work before personally meeting him.

10. Felix Klee, in an interview in the catalogue of the show, *Paul Klee, Aquarelle und Zeichnungen*, Essen Folkwang Museum, 1969, states that Klee helped Kandinsky with the style and grammar of his writings, particularly during the Bauhaus years. Felix Klee thinks it possible that Klee helped with the correction of *Concerning the Spiritual*, which appeared late in 1911. This, however, does not seem to be very likely; it is more plausible that Kandinsky would have turned to Münter and Marc for aid than to so recent an acquaintance as Klee.

11. P. Klee, *Stone Cutters*, 1910.74.111. in *The Blaue Reiter Almanac*, ed. by K. Lankheit, New Documentary Edition, New York, 1974, p. 197. The size of the illustration provides a clue to the artist's place in the hierarchy of Kandinsky's taste; cf. his remark to Marc (*re* reproductions by the *Brücke* artists): "The small reproduction means: This *too* is being done. The large one: *this* is being done." *The Blaue Reiter Almanac*, p. 20.

12. Quoted in J.Th. Soby, *The Prints of Paul Klee*, New York, 1945, p. VIII.

13. Klee, *Diaries*, p. 274, no. 914.

14. Ibid.

15. In the summary version of the diary Klee writes: "Second Retrospective Show at Thannhauser's arranged by Marc," [revised], in F. Klee, *Klee*, p. 15.

16. See K. Lankheit, "Bibel-Illustrationen des Blauen Reiters," *Anzeiger des Germanischen Nationalmuseums*, 1963, p. 199-207.

17. K. Lankheit discusses the project in *The Blaue Reiter Almanac*, p. 34; Peg Weiss, in *Wassily Kandinsky*, describes the history and goals of the *Münchner Künstlertheater*.

18. See Klee, *Diaries*, p. 264, no. 902. In the catalogue of the *1. Ausstellung der Künstlervereinigung Sema*, Thannhauser gallery, Munich 1912, M.K. Rohe, in an introductory essay, opposes the *Wild Ones*, namely those artists who purport to follow Gauguin's teachings, and warns against severing all ties with tradition as well as against a purely formalist approach. He defines the artistic goal of the *Sema* artists to be ". . . an elevation of mind and soul, through the senses, an art which transcends all purely artistic enjoyments and serves its own time as well as the future by fulfilling its inner fate. . ." Thirteen works by Klee were included in the show.

19. Reprinted in *Klee Schriften*, p. 139.

20. Quoted from J. Glaesemer, "Die Druckgraphik von Paul Klee," *Paul Klee. Das graphische und plastische Werk*, exh. cat., Wilhelm-Lehmbruck-Museum, Duisburg, 1974, p. 23.

21. Kandinsky announced Klee's visit to Delaunay, cf. Delaunay's letter to Kandinsky in *Robert Delaunay*, exh. cat. Baden-Baden, 1976, p. 61.

22. For Le Fauconnier and Kandinsky, see Ann Murray, *Henri Le Fauconnier: His Significance in France and Germany in the Early 20th Century*, unpublished M.A. thesis, Brown University, 1970.

23. F. Klee, *Klee*, p. 14.

24. Klee, *Diaries*, p. 267, no. 907.

25. See Klee, *Diaries*, 1915, p. 318, no. 961, and 1916, p. 343 ff., no. 1008.

26. In conversation with me in March 1976, Felix Klee recalled that as a child he was allowed to paint alongside Kandinsky in the latter's studio.

27. E. Harms, "Paul Klee as I remember him," *College Art Journal*, Winter 1972/73, p. 178. Harms at the time worked for the publisher Piper.

28. Harms, "Paul Klee." See also J. Eichner, *Kandinsky und Gabriele Münter*, Munich, 1957, p. 66: "From the beginning he may have harmonized most with Paul Klee."

29. Kandinsky's letters to Klee are reprinted in F. Klee, *Klee*, p. 36.

30. Felix Klee related the story of Klee's help with the storage of Kandinsky's paintings in conversation with me. Klee mentions his visit to Kandinsky in a letter of October 17, 1914 to Marc, reprinted in *Der frühe Klee*, exh. cat., Baden-Baden, 1964.

31. P. Klee, "An Kandinsky," *Kandinsky*, exh. cat., Galerie Arnold, Dresden 1926. Reprinted in *Klee Schriften*, p. 127.

32. In *The Blaue Reiter Almanac*, p. 15. See also P. Vergo, *The Blue Rider*, Oxford, New York 1977.

33. Klee wrote reviews of Munich cultural events, exhibitions as well as concerts, for the periodical which was edited by his friend Hans Bloesch. All reviews are reprinted in *Klee Schriften*, from which the quotations are taken.

34. See his introduction to *Klee Schriften*, p. 15. Geelhaar notes that Klee primarily reviewed shows in galleries, where he had exhibited or was to exhibit.

35. Klee, *Diaries*, p. 265, no. 904.

36. Cited from Klee *Schriften*, note 5, p. 158, where Klee's early interest in Hodler is extensively documented.

37. For an excellent discussion of Klee and primitive sources see J.S. Pierce, *Paul Klee and Primitive Art*, New York, 1976 (Ph.D. thesis, Harvard, 1961).

38. P. Vergo, review of Klee *Schriften*, *Burlington Magazine*, October 1977, p. 720 f.

39. In fact, Kandinsky was apparently inspired to include children's drawings in *The Blaue Reiter* by some artistic *Wunderkinder* who fit exactly Klee's description of corruption as he defines it in the review: "The more helpless these children are, the more instructive is their art for us; for here, too, there is a corruption: when the children begin to absorb more developed art or, worse, to imitate it." *Schriften*, p. 97. In a letter to Marc of June 19, 1911, in which he outlines the plan for the almanac, Kandinsky writes: We shall have an Egyptian next to a little *Zeh*, a Chinese work next to Rousseau . . . [revised] *The Blaue Reiter Almanac*, p. 17f. At least two of the children's drawings in *The Blaue Reiter*, hitherto unidentified, can be attributed to Nikl Zeh, born in 1900, namely the drawings on p. 108 and p. 154, which bear the initials N.Z. The drawing on p. 108 includes also the initials O.Z., presumably those of his younger brother Oskar Zeh, who later became a sculptor and portraitist. The three Zeh brothers, sons of an architect, were artistic child prodigies of sorts. Greatly encouraged in their artistic pursuits by their parents, they were considered so talented that the conservative Brakl gallery, otherwise dominated by Impressionism and *Die Scholle* painters, mounted an exhibition of about 80 of their drawings in April of 1911. In an extensive review of the show

in *Münchner Nachrichten* of April 21, 1911, the reviewer voices equivocal feelings. He praises the talent of the boys, but warns that the drawings, in their primitive forms and brilliant colors related to the works of the current extreme avant-garde artists, should not be misunderstood as art. It is clear from the review that the boys were familiar with 'real' art from which they sometimes borrow, and that they were very sophisticated in their subject matter, which includes such learned themes as the goddess Demeter. Klee's remark may indeed contain his criticism of these precocious children and the acclaim accorded to them.

40. *Klee Schriften*, p. 98.

41. Ibid.

42. *Klee Schriften*, p. 100.

43. *Klee Schriften*, p. 102. In speaking of Amiet's earlier works Klee implies that naturalism is a thing of the past for him, too: ". . . those works in which he grapples with much-praised Nature, the mother of our artistic childhood."

44. For the history of the *Moderner Bund* and Klee's participation, see H.C. von Tavel, "Dokumente zum Phänomen 'Avantgarde.' Paul Klee und der Moderne Bund in der Schweiz, 1910-12" *Jahrbuch des Schweizerischen Instituts für Kunstwissenschaft*, 1968/69, p. 69 ff.

45. See, for example, H. Bahr, *Der neue Standpunkt*, 1916, and H. Walden, *Die neue Malerei*, Berlin, 1919. According to P. Selz, *German Expressionist Painting*, Berkeley, 1974, p. 256, the term itself was first used in conjunction with an exhibition of the French Fauves in Berlin in 1911 and then was quickly popularized by *Der Sturm*.

46. *Klee Schriften*, p. 106.

47. *Klee Schriften*, p. 107. Jim M. Jordan, *Paul Klee and Cubism*, unpublished Ph.D. thesis, New York University, 1974, p. 105-09 concludes from Klee's review: "Klee thus identifies the primacy of the abstract compositional order on the picture plane, and not object distortion as the central issue in modernism. . . . Klee implies that all Cubism would lead to abstraction."

48. *Klee Schriften*, p. 106.

49. *Klee Schriften*, p. 107.

50. *Klee Schriften*, p. 107.

51. In *The Blaue Reiter Almanac*, p. 105 Allard writes: "Instead of the impressionist illusion of space . . . Cubism renders simple, abstract forms in defined relationships and proportions to one another. The first postulate of Cubism is, therefore, the order of objects—not, however, the order of naturalistic objects, but of abstract forms." Jordan, *Paul Klee and Cubism*, p. 106, notes that Klee puts primacy on the construction of things, whereas Allard stresses reduction.

52. *Klee Schriften*, p. 107.

53. Kandinsky, *Concerning the Spiritual*, p. 39.

54. *Klee Schriften*, p. 108.

55. *Klee Schriften*, p. 108.

56. Kandinsky, *Concerning the Spiritual*, p. 68.

57. In fact, while Klee frequently denounces Lessing's *Laocoon,* Kandinsky seems to have thought quite highly of Lessing's esthetics, as he makes reference to Lessing's rule of not presenting the climax of an action in his Bauhaus teaching. Cf. Kandinsky, *Ecrits complèts,* ed. by Ph. Sers, vol. III, Paris, 1975, p. 363.

58. *Klee Schriften,* p. 108.

59. *Klee Schriften,* p. 110. Klee notes that Lüthy "chooses neither the dangerous path of Delaunay nor is his art as measured as Le Fauconnier's."

60. Klee's personal contacts with Delaunay after his visit in Paris were limited. While Delaunay kept up a lively correspondence with Kandinsky and Marc, he exchanged only a few short letters with Klee. Klee did a very free translation of his essay, "La Lumière," which appeared in *Der Sturm,* vol. III, January 1913, no. 144/45, p. 255f.

Chapter 3

1. According to H.K. Roethel, ed., *Kandinsky. Das graphische Werk,* Cologne, 1970, p. 447, *Klänge* was already published in the fall of 1912 rather than in 1913 as usually stated. Although a catalogue exists for a large Kandinsky exhibition in Munich in September of 1912, it apparently did not take place. See Rudenstine, *Guggenheim Collection,* vol. I, p. 222f for the history of this show.

2. In this regard I am in disagreement with Jordan, *Paul Klee and Cubism,* who points to the Expressionist aspects of Klee's art and ideas and analyzes the influence from Kandinsky on Klee's 1913 work, but puts greater emphasis on what he considers the Cubist qualities of Klee's art. In discussing the views on Cubism in the Blaue Reiter circle, Jordan states: "Over the next several years, Klee's intentions will, I suggest, at times resemble those of Cubism more than those of Expressionism." (p. 101f.). As Jordan is concentrating on the formal development of Klee and his adaptation of Cubist form and compositional structure, he does not deal very much with the fundamental conceptual differences between Klee and Cubist esthetics and the resulting stylistic differences. These differences will be examined in greater detail throughout this study.

3. Although entailing some repetitiveness, the discussion of Kandinsky's influence will be divided into themes, rather than follow a strictly chronological order. For one, while the number of works which are stylistically comparable is limited, there are general artistic issues which relate Klee to Kandinsky, and Klee deals with them over a number of years and in different styles. Furthermore, given the problems of chronology within any given year, any attempt to discuss Klee's development along chronological lines has to be highly conjectural because Klee was in the habit of working in different modes at the same time as well as returning periodically to earlier stylistic approaches. From 1911 on, Klee kept a very thorough record of his *oeuvre,* numbering and describing each work, but the numbers do not necessarily reflect the sequence of production within one year. Stylistically related groups are sometimes grouped together, at other times their numbers are far apart. On the whole, it is advisable to use other facts and criteria for dating within the work sequence of a year.

4. Klee, *Diaries,* p. 242, no. 842.

5. Klee, *Diaries,* p. 256, no. 894. Klee himself dates his emancipation from nature in the year 1911, as he writes in a postscriptum to a 1903 diary entry in which he had discussed the question of abstraction and nature: "Nature had already become a useful crutch which I was then forced to use too long, I would say until the year 1911, inclusively." (*Diaries,* p. 147, no. 536). Klee's renewed emphasis on contour in 1911 was largely influenced by van Gogh.

6. Klee, *Diaries,* p. 260, no. 899.

7. That Kandinsky's own *oeuvre* catalogue numbers essentially reflect the chronological sequence of his production is indicated in Grohmann, *Kandinsky,* 58. Kandinsky kept two separate catalogues, one for paintings and one for watercolors. However, not all of Kandinsky's dates for his early works are reliable.

8. Klee mentions having seen works by Matisse and Guys at the Bernheim gallery, but it cannot be established what he could have seen, as there was no Matisse exhibition at the time. The *Moderner Bund* exhibition also included some works by Matisse, and Klee voices his admiration for Matisse in his review, attributing to Matisse a similar interest in childlike primitivism as his own: "With the gains made by Impressionism he turned far back toward the infantile stages of art and achieved extraordinary effects." (*Klee Schriften,* p. 109)

9. The pen and wash drawing, *Grazing Horses,* 1912.109, ill. in W. Grohmann, *Paul Klee Handzeichnungen,* Cologne, 1959, no. 64, recalls with its theme of peacefully grazing horses Marc's paintings of horses in landscape, such as *The Red Horses,* 1911, which was included in Marc's show at Thannhauser.

10. As it is more likely that the drawing was made on the piece of paper with notes than that the notes were made on the verso of the drawing; the drawing must date from the second half of 1912 (after the July show).

11. According to J.S. Pierce, *Klee and Primitive Art,* p. 85 ff, such scribbles in children's drawings represent motion.

12. See, for example, the oil paintings, *St. George,* 1911/128; *Saint George II,* 1911; and *Saint George III,* 1911, as well as related studies. H. Nishida, in "La Genèse du Cavalier Bleu", *XX Siécle,* n.s. no. 27, Dec. 1966, 18-24, suggests that Kandinsky's rider images are often references to St. George.

13. Pierce, *Klee and Primitive Art,* p. 135, suggests that both Klee and Kandinsky use the "flying gallop", as in *The Hunt* and *Lyrical,* a prehistoric form device found, for example, in the Altamira paintings which he thinks may have influenced both artists.

14. *Ibid.,* p. 121 ff. Transparency results from the additive drawing method of children.

15. Klee takes up the motif of St. George again in a painting of 1936. (*St. George,* 1936.21, in the Bern Kunstmuseum).

16. Other works of this type are *Important Hurry,* 1912, 149, ill. in E. Kornfeld, ed. *Verzeichnis,* no. A. 126, and *The Two Hunters,* 1912, 163, ill. in *Stuttgart Auktionskatalog,* 1955, no. 1375, which recalls the figures in Kandinsky's *All Saints Picture I,* 1911 (behind glass), ill. in Gollek 74, p. 23.

17. The drawing was exhibited in October 1912 in Klee's show at the Gereonsklub in Cologne.

18. Ill. in Glaesemer 73, p. 209, nos. 481-82.

19. The show included *The Palace,* 1912.56. See *Klee Schriften,* p. 166, where Geelhaar has identified the works in the show.

20. Perhaps some of Klee's themes were inspired by the Futurist postulate for "painting of states of mind" which was described in the manifestos published in the spring of 1912 in *Der Sturm.* When Klee actually saw Futurist paintings he was not very enthusiastic about them.

21. In 1909 Klee made some brush drawings that he designated as designs for woodcuts, for example *View from the Window of the Parental Apartment, Intended as a Woodcut,*

1909.25, ill. in Glaesemer 73, p. 165, no. 373. In these drawings Klee operates with strong black-white contrasts but also with undulating contours and complex patterns which would be difficult to transform into a woodcut. It was probably the example of Kandinsky and Marc, who were prolific printmakers and especially keen on woodcuts, which induced Klee to try his hand at the graphic medium.

22. The only known impression of this print was in the possession of Franz Marc.

23. See *Klee Schriften*, p. 98. Klee says of Munch: "With him the formative process proceeds again from the interior towards the exterior as it did with van Gogh, our true contemporary. . ." At the time of Klee's review the graphic works to be shown had not yet arrived, but given his interest in Munch we may suppose that Klee later returned to see them.

24. That this type of post-van Goghian undulating lines were by no means considered passé in the Blaue Reiter circle is demonstrated by the inclusion of a Morgner drawing in the *Blaue Reiter Almanac* (p. 144.) Wilhelm Morgner also exhibited in the second Blaue Reiter show.

25. The most important study to date of Klee's formal development during the Blaue Reiter years is Jordan, *Paul Klee and Cubism*. Jordan has traced what Cubist art was available to Klee for study, and he shows that Klee assimilated the influences much more slowly but also more thoroughly than Marc and Macke. Jordan proposes that Klee "understood Cubism as, progressively a new kind of shape, a new relationship between shapes, and finally, as a new way of composition" (p. 252). The drawings of 1912 with geometrical shapes, which Jordan also places late in the year, represent the initial stage of Klee's assimilation of Cubist shapes. The late date is also corroborated by the fact that no drawings of this type were included in the October 1912 Gereonsklub show. Jordan points to Klee's different attitude toward nature, the absence of fragmentation of forms, and the non-Cubist iconography as features that distinguish Klee's art from Cubism and he proposes: ". . . Klee adopted Cubist space because it provided a modernist context—shallow, non-perspectival—for his romantic, metaphysical, and psychological content" (p. 3). Jordan does not further elaborate on the un-Cubist aspects of Klee's stylistic and esthetic position.

26. Pierce, *Klee and Primitive Art*, shows how Klee utilizes the very early forms of children's artistic expression and their techniques. On Klee and children's art, see also O.K. Werckmeister, "The Issue of Childhood in the Art of Paul Klee", *Arts Magazine*, Sept. 1977, p. 138-51.

27. In *The Blaue Reiter Almanac*, p. 161.

28. See Kandinsky, *Concerning the Spiritual*, p. 51.

29. Cited from K. Lankheit, *Franz Marc*, Cologne 1976, p. 101.

30. F. Klee, *Klee*, p. 201 ff. Klee used a great variety of media, techniques and painting grounds which often defy classification in terms of traditional categories. "Colored Sheets" are all those works not painted on canvas or board. For the sake of simplicity they will be referred to as paintings as well.

31. Klee, *Diaries*, p. 244, no. 875.

32. Jordan, *Klee and Cubism*, p. 266 f., points to a relationship with Gleizes and Le Fauconnier's landscapes. He considers the painting primarily within the context of Blaue Reiter paintings, but I think that Klee here is already emulating Delaunay as well.

33. Klee, *Diaries*, p. 231 f., no. 842.

34. See, for example, *The Spirit on the Heights*, 1913.151 (App. III-17), and *Plants at Night in the Rain*, etching, 1913.178, ill. in Kornfeld, *Verzeichnis*, no. 57.

35. Initially, the precision of Cubist lines must have been alien to Klee. In terms of "psychic improvisation" line has an expressive function; it has to be intuitive and spontaneous. In Kandinsky's work the linear element has exactly these qualities.

36. See, for example, the horse and rider motif which by 1913 has been reduced to a whiplash line. Weiss, *Wassily Kandinsky*, suggests that the horse and rider motif metamorphoses into the circle motif of the 1920s.

37. I am grateful to Professor Klaus Lankheit for permission to read his transcripts of the Kandinsky-Grohmann correspondence from which this quote is taken. Portions of the correspondence are published in K. Gutbrod, ed., *Lieber Freund. Künstler schreiben an Will Grohmann*, Cologne, 1968.

38. This work, along with a similar gouache, *In the Suburb* 1912. ll, was included in the second Blaue Reiter show in the spring of 1912.

39. A very early example of Klee's use of transparent contours in drawings is *Outdoor Restaurant*, 1911.76 (ill. in *Klee Schriften*, Fig. 12).

40. The painting was acquired by the poet Karl Wolfskehl.

41. For this type of composition, see also Klee, *Yellow House in the Fields*, 1912.69 (ill. in *Paul Klee*, Kunstsammlungen Nordrhein-Westfalen, Düsseldorf, 1971).

42. The painting was included in Klee's exhibition in March of 1913 at the Neuer Kunstsalon Schmid und Dietzel in Munich as well as in the *Herbstsalon*.

43. The painting is now in Russia, but it was included in the second *NKV* show as well as in the *Sonderbund* show of 1912, so it must have been in Kandinsky's possession at least until then.

44. Ill. in Gollek 74, p. 124, p. 129.

45. M. Franciscono, "Paul Klee's kubistische Druckgraphik", in *Paul Klee, Das graphische Werk*, p. 52 suggests that the weightless, floating figures and forms in Kandinsky's 1910-11 paintings are pried loose from the sky-earth gravitational orientation in order to stress the autonomy of the picture as a world in itself and that Klee adopts this organization from Kandinsky for similar purposes.

46. Although there is probably no direct connection, both paintings recall Turner's *Petsworth* interiors.

47. Kandinsky, *Concerning the Spiritual*, p. 77.

48. Jordan, *Klee and Cubism*, has analyzed Klee's 1913 production very thoroughly, subdividing it into four stylistic groups which, he suggests, are roughly chronological in sequence. In the first group Cubist forms are interpreted from a primitivist angle, as in *Idols*, 1913.89 (ill. in Glaesemer 73, p. 217, no. 511), which may reflect Klee's growing friendship with Marc, who was very interested in primitive cultures. For Jordan, the second group represents a kind of retardataire coming to terms with Kandinsky's work of 1910-1912 (primarily via the woodcuts for *Klänge*), as well as with the *NKV*-style in general and with Blaue Reiter biomorphism. Paintings, drawings, and prints of this group, such as *Flowerbed*, 1913.191 (App. III-49), *In the Quarry*, 1913.135 (App. III-18), and *Garden of Passion*, 1913.155 (App. III-32) are characterized by a planar, overall compositional order, and dense Cézannesque *passage*, as well as by themes and figural motifs that relate to the art of the Blaue Reiter group. Jordan places these works around the Bible project initiated by Marc in the spring of 1913. In his third group, primarily watercolors of the summer and fall of 1913, Klee combines *NKV*-type landscape composition with Cubist forms and begins to experiment

with the spatial inflection of these forms. In the fourth, and final group, in which motifs from the second group are taken further into an abstract direction, Klee begins to operate with Cubistically determined interrelationships of translucent geometrical forms, and in a few works he adopts Cubist scaffolding as the structuring agent for his composition, as in *Flight Toward the Right, (Abstract),* 1913.158 (App. III-17). Many of the works he cites will be discussed in this study too, in order to point to their Expressionist dimension, the existence of which Jordan acknowledges but does not explore in its wider implications. While Jordan's developmental line of argument is in itself convincing, it is not always supported by the factual evidence. *Cross-Roads,* 1913.27 (Fig. 17), for example, a major work of Jordan's third group was already included in Klee's March 1913 exhibition, so that it actually dates from early in the year and must be roughly contemporary with such un-Cubist works as *Sun in the Courtyard* (Fig. 15) and predates the also rather un-Cubist *In the Quarry* (App. III-18). It appears quite likely that Klee experimented with both Cubism and a more Blaue Reiter-oriented approach throughout the year.

49. In their *collages* of 1912-1914 the Cubists also use the linear element in a quite autonomous way, yet there is an important difference between their method and that of Kandinsky and Klee. This is evident from the analysis presented in J. Golding, *Cubism,* New York, 1968, p. 113: "It has already been seen how the strips of colored paper could be used as an abstract compositional structure over which an ordinary Cubist drawing could be overlaid; form was thus preserved independently of the color beneath it, *although a subsidiary relation between color and form is almost always established subsequently.* "[emphasis mine]. With Klee and Kandinsky, however, this subsidiary relation is frequently completely absent.

50. Ill. in D. Chevalier, *Paul Klee,* New York 1971, p. 5; *Paul Klee,* exh. cat., Hannover 1952; Glaesemer 76, p. 89, no. 42; *Der frühe Klee,* nos. 193, 195.

51. Perhaps Klee chose the title for this work as a kind of tongue-in-cheek reference to Kandinsky's remark in *Concerning the Spiritual,* p. 68, ". . . we would create works which look like abstract ornamentation, which . . . would resemble a carpet." [revised] See also chapter 2 of this study.

52. The drawing bears the date 1911, but K. Lindsay, in his review of Grohmann's Kandinsky monograph, *Art Bulletin,* vol. 41, Dec. 1959, 348-50, has convincingly suggested a 1913 date for the *I. Abstract Watercolor,* 1910, and *With the Red Spot,* 1911, which, in my opinion, also makes the 1911 date of *In the Circle* questionable.

53. A related drawing, *Cross-Roads (Construction of the purely Graphic Structure),* 1913.12 (B), is illustrated in Glaesemer 73, p. 210, no. 484. In *Katalog der II. Gesamtausstellung,* Neue Kunst Hans Goltz, August-September 1913, Munich, *Cross-Roads* is listed (as well as *Cemetary Building*), without date or medium, however.

54. In February 1913 there was a large Picasso show at Thannhauser's which included works of 1912. Thus by mid-1913 Klee was quite well acquainted with Analytical Cubism.

55. Klee, *Diaries,* p. 224, no. 824.

56. Illustrated in H.K. Roethel, *Kandinsky. Das Graphische Werk,* Cologne 1970, nos. 148-51.

57. Further examples are *The Palace,* 1913, (exh. March 1913), *The Gilvarry Collection,* exh. cat., Santa Barbara 1967, no. 4, *Mountain behind Fir Trees,* 1913.114; and *Transmission Poles,* 1913.119, illustrated in E. Kornfeld, *Paul Klee, Bern und Umgebung,* Bern 1962. All of the works discussed in this group belong in Jordan's group III of 1913, but chronologically they extend throughout the first half of the year.

58. Illustrated in Grohmann, *Klee 54,* p. 157.

59. A very similar drawing, *Worldswing*, 1914.17, is illustrated in C. Geelhaar, ed. *Klee-Zeichnungen* Cologne, 1975, no. 31. The similarity of the drawing to the drawing in *I. Moses* supports my contention that Klee in this work conceived of the drawing as essentially autonomous and not interdependent with the color ground.

60. A stylistically similar work, also in watercolor and pen, is entitled *Necropolis*, 1914.13. On the whole, it is equally abstract. Only the sky-blue color in the upper section of the ground hints at a landscape theme. [Known to me only from a photograph.]

61. An example of Klee's 'abstract' work method is *Carpet of Memory* 1914 (App. III-18). Glaesemer 76, p. 34, points out that Klee originally conceived of the composition as a vertical format. Turned by 90 degrees it relates to the drawing, *Jerusalem, My Highest Joy*, 1914.161 (App. III-18), and other works, but in each of them the title leads to completely different interpretations.

62. Jordan, *Klee and Cubism*, p. 263 and p. 251 f.

63. See n. 48 for Jordan's groups of 1913. His group II extends from spring to fall fo 1913, with *Garden* placed early in this period. However, *Garden* was not exhibited until November 1913 (*Die Walze* exhibition, which also included the etching, *Pomp in Miniature*, 1913.29), and then again in March 1914 at Thannhauser's. From the exhibition lists in Klee's *oeuvre* catalogue it appears that none of the drawings and prints that are stylistically related to *Garden* were exhibited or sold or given away before the fall of 1913 (with the exception of *Pomp* all the works of this type have *oeuvre* numbers which start in the 140s, while all the works exhibited up to and including the *Herbstsalon* have lower numbers). As in 1913 Klee was exhibiting fairly often as well as privately selling and exchanging works, the *oeuvre* catalogue numbers may indicate a rough chronological order, since he must have titled and numbered the works before sending them off.) While the dating question cannot be settled conclusively, there is some possibility that Klee worked on the works in Jordan's group II primarily in the late summer and fall of 1913 and from there went on to the more directly Cubist works in Jordan's group IV.

64. Kandinsky, *Concerning the Spiritual*, p. 70, 73.

65. Reprinted in M. Bill, ed. *Kandinsky. Essays über Kunst und Künstler*, 2nd ed., Bern 1963, p. 69.

66. Kandinsky, *Concerning the Spiritual*, p. 48, no. 6.

67. For Kandinsky's use of these means see Washton, *Kandinsky: Painting and Theory*.

68. See also Washton, "Kandinsky and Abstraction: The Role of the Hidden Image," *Artforum*, X, June 1972, 42-49.

69. Garden motifs are fairly frequent in the Blaue Reiter circle. See, for example, Kandinsky's *Improvisation 25 (Garden of Love)*, 1912. Weiss, *Kandinsky: the Formative Years* has pointed to the importance of the park and garden motif in the poetry of the George circle. Through Wolfskehl both Klee and Kandinsky were connected with this circle. A small drawing with motifs, from *Garden* bears the equally ambivalent title, *Upward Striving (Auf-Strebende)*, 1913.149. Ill. in *Moderne Kunst*, Auction cat., Kornfeld und Klipstein, June, 1976, p. 87.

70. Illustrated in Grohmann, *Kandinsky 58*, C.C. 58 and 69.

71. Lankheit, "Bibelillustrationen," has associated the drawing with the 137th Psalm, but it is just as possible that the drawing was to accompany any other Psalm that is a song of lament and plea for help.

72. Kandinsky, *Concerning the Spiritual*, p. 51.

73. The drawing may in fact have been cropped; it is known that Klee frequently cropped works or cut them up into several parts.

74. Lankheit, "Bibelillustrationen," p. 204, says about this drawing: "The drawing is all moving sorrow, heavy with tears."

75. Lankheit, *Marc*, p. 130, dates Marc's first abstract works in December of 1913. In his preceding work there is a noticeable trend toward abstraction.

76. This belongs in Jordan's group IV: "Characteristic of the group is an open and broken linear patterning, very much like the high Analytical Cubist scaffolding, which is composed as well in a near-Cubist way." *Klee and Cubism*, p. 240.

77. Glaesemer 73, p. 217, no. 511 publishes the drawing with both titles. Klee's use of such forms for expressive ends is further corroborated by the drawing *At the Abyss*, 1913.157, of which I saw a photograph at the Klee Foundation. A figure of the type of *Spirit* stands above a facet structure of the type of *Flight*, which thus represents the abyss.

78. The letter of October 17, 1914 is reprinted in *Der frühe Klee*.

79. See Klee, *Diaries*, p. 319, no. 962, and p. 322, no. 964 (1915). For Marc's attitude toward the war see his *Briefe aus dem Felde*, Berlin, 1941. Marc on his part seems to have been rather disappointed by Klee's neutrality.

80. Klee, *Diaries*, p. 313, no. 952.

81. Klee, *Diaries*, p. 315, no. 956.

82. Illustrated in Glaesemer 73, p. 227, no. 527.

83. Klee, *Diaries*, p. 307, no. 928.

84. Illustrated in Kornfeld, *Verzeichnis*, no. 62. II. Klee found Däubler's poetic, expressive language very congenial. In 1917 he read Däubler's prose epos *Die silberne Sichel* with great enjoyment and planned to illustrate it.

85. Letter to Marc of November 22, 1914, reproduced in *Der frühe Klee*.

86. Lankheit, "Bibelillustrationen," p. 203.

87. Strictly speaking, the cross as a Christian symbol would be out of place in a representation of the Old Testament-Jerusalem described in the Psalm. But, given the fact that Klee usually settled on the titles of his works after their completion, it is still possible that the cross was included by him as a sacral symbol in the widest sense.

88. Klee, *Diaries*, p. 345, no. 1008.

89. Ill. in Klee, *Diaries*, p. 319.

90. See also M. Franciscono, "Paul Klees kubistische Druckgraphik," *Klee. Das graphische Werk*, p. 50, who also notes Klee's play with the construction and its symbolic value as 'idea.'

91. Both in style and content Klee's lithograph has much in common with Kafka's 1922 novel *The Castle*, for which it would be an ideal 'illustration.'

92. Some aspects of Klee's subject matter have been studied; see, for example, Ch. Kröll, *Die Bildtitel Paul Klees*. Ph.D. thesis, Bonn. 1968; M. Rosenthal, "Der Held mit dem Flügel. Zur Metapher des Flugs im Werk von Paul Klee," in *Klee. Das graphische Werk*, p. 30-38.

93. *The Blaue Reiter Almanac,* p. 85.

94. *The Blaue Reiter Alamanac,* p. 64.

95. *The Blaue Reiter Alamanac,* p. 64.

96. *The Blaue Reiter Alamanac,* p. 59.

97. Kandinsky, *Concerning the Spiritual,* p. 48.

98. Kandinsky, *Concerning the Spiritual,* p. 24 f.

99. Kandinsky, *Concerning the Spiritual,* p. 48.

100. *The Blaue Reiter Almanac,* p. 180.

101. Klee, *Diaries,* p. 345, no. 1008.

102. Usually Klee's titles are so poignant and evocative that it is almost impossible to interpret a work in another direction than that suggested by the title, although the purely visual character alone of many works would allow quite different interpretations.

103. Illustrated in Glaesemer 73, p. 209, nos. 479, 482, and Kornfeld, *Verzeichnis,* nos. 132, 134.

104. Illustrated in *Der frühe Klee,* nos. 156, 160, and Glaesemer 73, p. 206, nos. 469, 471.

105. Illustrated in Glaesemer 73, p. 211, no. 489, p. 209, no. 480, p. 212, no. 493, p. 213, no. 497.

106. Illustrated in Glaesemer 73, p. 212, no. 491.

107. See, for example, *The Lonesome Agitated One,* 1929, and *Collapse,* 1938, illustrated in *Paul Klee,* exh. cat., Stuttgart, 1974, p. 43, 101.

108. Illustrated in Gollek 74, p. 103, pl. 28.

109. Illustrated in Glaesemer 73, p. 211, no. 490.

110. See Grohmann, *Klee 54,* p. 124 ff.

111. See M. Franciscono, "Die kubistische Druckgraphik Paul Klees", p. 52 ff. for interesting observations on Klee's view of the world. I concur in his characterization of the attitude behind Klee's pictorial microcosms: "Klee's universe is based on an all-encompassing inner dependence in which figures and objects are devoid of their independence, not just as the result of their foolishness—though often enough they seem to be foolish—but also because they are shown, without they themselves understanding that, as part of a larger and unfathomable totality."

112. See, for example, his analogies in *Concerning the Spiritual,* p. 59: "In music a light blue is like a flute, a darker blue a cello; a still darker the marvellous double bass; and the darkest blue of all—an organ."

113. In 1914 Kandinsky does entitle a painting "Fugue" (ill. in Grohmann, *Kandinsky 58,* p. 147). The title may either refer to the sound experience of a fugue or allude to its compositional structure, as specific colors and form motifs recur throughout the painting in a way that might be compared to fugal composition. As such it would be an exception in Kandinsky's *oeuvre.*

114. R. Verdi, "Musical Influence on the Art of Paul Klee," *Museum Studies,* no. 3, 1978, 81-107; A. Kagan, "Paul Klee's "Ad Parnassum": the Theory and Practice of Eighteenth Century Polyphony as Models for Klee's Art," *Arts Magazine,* Sept. 1977, 90-104. Kagan suggests that Delaunay influenced Klee's ideas on music and that eventually Klee hit on the planar

color cube as a basic unit comparable to the musical note which enabled him to operate with 'polyphonic' composition.

115. I have seen a photograph of this drawing at the Klee Foundation in Bern, but have not been able to locate an illustration.

116. The work was exhibited in February 1978 at the Saidenberg Gallery in New York.

117. Marc apparently felt deep affinities between art and music. This is evident from Klee's description of the last evening they spent together: "We played Bach, and Jawlensky's variations lay before him on the floor. This was just his way of looking at paintings and listening to music. In the past he had often painted in his sketch book while listening to music." [revised] *Diaries*, p. 333, no. 964 (1915).

118. A 1914 tempera painting by Marc is entitled *Scherzo*, cf. K. Lankheit, *Franz Marc. Katalog der Werke*, Cologne, 1970, no. 459.

119. Illustrated in *Der frühe Klee*, no. 194.

120. This is the title of the drawing in Klee's *oeuvre* catalogue. See also Lankheit, *Bibel-Illustrationen,"p. 202*.

121. Klee, *Diaries*, p. 239, no. 862: "I am equally well-acquainted with the pathetic region of music and easily conceive pictorial analogies for it."

122. See also: *Hommage à Schönberg. Der Blaue Reiter und das Musikalische in der Malerei seiner Zeit*, exh. cat., Berlin, 1974.

123. M. Franciscono, "Paul Klees kubistische Druckgraphik," p. 48. He characterizes Klee's use of Cubist forms very pertinently: "Klee used Cubism as a motif, as it were . . . he metaphorically integrates Cubist constructions as symbols or signs into his work and thus in his playful or ironic manner he elevates them to vehicles for ideas." The Gleizes works are also ill. in App. III-14.

124. We recall Klee's criticism of Cubist form segmentation: "Desctruction, for the sake of construction?" in his 1912 review of the *Moderner Bund* show, cf. *Schriften*, p. 108.

125. See Kornfeld, *Verzeichnis*, no. 68 for the different versions. The brushed-in signs vary in color and shape in different prints.

126. 1914.153 is illustrated in Grohmann, *Klee 54*, p. 142; *Sleep* is illustrated in P. Klee, *On Modern Art*, with intro. by H. Read, London, 1948, p. 20.

127. Reflections from Marc's art are particularly evident in Klee's work of around 1917/18.

128. Klee, *Diaries*, p. 374, no. 1081.

Chapter 4

1. *Macke-Marc Briefwechsel*, p. 175.

2. Cf. U. Laxner, *Stilanalytische Untersuchungen zu den Aquarellen der Tunisreise 1914: Macke, Klee, Moilliet*, Ph.D. thesis, Bonn 1967. Jordan, *Klee and Cubism*, discusses the Tunis watercolors extensively. He aptly characterizes Macke's development prior to the trip: "Principally in watercolors, over the winter of 1913-1914, Macke manages his final adaptation of the Cubist-Orphist grid, inflected spatially primarily by constructive "abso-lute" color. Macke had achieved a potent balance between the pictorial grid structure and observed nature." (p. 160) Jordan suggests indirect influence from Delaunay on Klee via Macke's grid structure. In the Tunis watercolors Klee succeeds in fully integrating the Cubist

shallow space and the grid order into his work; they represent the beginning of what Jordan terms Klee's "color Cubism" in which the linear element gradually recedes.

3. See Macke's letter to Marc of May 19, 1913, in *Macke-Marc Briefwechsel,* p. 161.

4. Laxner, *Stilanalytische Untersuchungen,* p. 57 ff. no. 6. Laxner divides Macke's watercolors into groups with various formal approaches and proposes a developmental sequence rather than a chronological one.

5. Laxner, *Stilanalytische Untersuchungen,* p. 60 f compares it to the predominantly rhomboid forms in Delaunay's 1910 *Cité* paintings.

6. Laxner, p. 144 f., proposes *View Toward the Harbor of Hammamet,* 1914.35 as the turning point from whence Klee no longer abstracts from nature, but creates work parallel to nature with basically abstract forms. The work is not known to me.

7. Klee, *Diaries,* p. 287, no. 926 e.

8. *Ibid.,* p. 287, no. 926 f.

9. *Ibid.*

10. Klee could also study a Delaunay *Windows* painting at Kandinsky's, which the latter had received as a present from the artist. The data usually given is 1914 (cf. Gollek 74, p. 28), but stylistically it is close to the 1912 *Windows.* I have been unable to ascertain when Delaunay gave the picture to Kandinsky; a more likely date for such a gift would be 1912/13, when the two artists were in close contact and helped each other with various projects.

11. *Kairouan,* however, was the town they visited after Hammamet; if Klee painted *Hammamet with the Mosque* during his stay there, Macke's *Kairouan I* can only be cited as a parallel, not as the specific model for this method.

12. Cf. Kandinsky, *Concerning the Spiritual,* p. 39. See also chapter 2.

13. Klee, *Diaries,* p. 297, no. 926n. Cf. also Klee's "I myself am the moonrise of the South," *Ibid.,* no. 926 k.

14. *Ibid.,* no. 926o.

15. In the collection of Felix Klee there is a small, very elaborate drawing by Klee, dating from 1896, which represents the Aare river with the pyramidal shape of the Niesen in the background.

16. In 1905 Klee writes about his summer stay in Oberhofen on Lake Thoun: "A good moment in Oberhofen. No intellect, no ethics. An observer above the world or a child in the world's totality. The first unsplit instance in my life." *Diaries,* p. 190, no. 713/14. In 1915 Klee spent the only few enjoyable days of his summer stay in Switzerland in the Lake Thoun area. He stayed for some days with Louis Moilliet in Gunten, from where he could see the mountain across the lake. Cf. *Diaries,* p. 320 f., no. 963.

17. It is likely that Klee knew Hodler's painting quite well. It was included in the 1911 Hodler retrospective in Frankfurt and Berlin which traveled on to Munich, where Klee reviewed it. (No catalogue of the Munich show has come to light.) At least by 1913 Thannhauser in Munich owned the painted (it is listed in the catalogue of the Armory show as in his possession), so that Klee might have seen it more often at the gallery. Cf. Glaesemer 76, p. 35f. Glaesemer notes the relationship of *Der Niesen* to Friedrich's landscapes. For a comparison with Hodler, see also R. Rosenblum, *Modern Painting and the Northern Romantic Tradition,* London, 1975, p. 150 f.

18. *Klee, Schriften,* p. 95.

19. *Ibid.*

20. Jordan, *Klee and Cubism,* p. 390.

21. In 1913 a Cézanne exhibition was held at the Thannhauser gallery in Munich, but no catalogue has thus far come to light.

22. This painting was briefly exhibited in 1912 and went on permanent show at some time during 1913.

23. Pierce, *Paul Klee and Primitive Art,* p. 151 f, suggests that these "celestial folk symbols" are inspired by Franz Marc.

24. For a discussion of the symbolic implications of Friedrich's painting, see *C.D. Friedrich,* exh. cat., Kunsthalle Hamburg, 1974.

25. Klee could see the painting at Kandinsky's house as well as in the Kandinsky show at Thannhauser's in January of 1914.

26. See also A.Z. Rudenstine, *The Guggenheim Museum Collection,* vol. I, p. 264 ff. for a discussion of the theme.

27. Klee, *Diaries,* p. 313, no. 951.

28. Glaesemer, 76, p. 37.

29. See Petitpierre, *Aus der Malklasse,* p. 20.

30. Kandinsky, *Concerning the Spiritual,* p. 58.

31. *Macke-Marc Briefwechsel.,* p. 28.

32. *Marc-Macke Briefwechsel,* p. 28.

33. W. Worringer, *Abstraktion und Einfühlung,* Munich, 1908, new ed., Munich 1959. English ed., *Abstraction and Empathy,* transl. by M. Bullock, New York, 1953. For Klee and Worringer, see also the following chapter.

34. Worringer, *Abstraction and Empathy,* p. 91.

35. Kandinsky, *Concerning the Spiritual,* p. 40

36. In "On Graphic Art," reprinted in *Paul Klee. Das graphische Werk,* Klee gives an example for the 'content' of the work of art: "II: An apple tree in bloom, its essence, its roots, the rising juices, its trunk, the cross-section with the annual rings, the blossom, its structure, the sexual functions, the fruit, the core with the seeds. A structure of stages of growth." (p. 16). See also Klee's 1923 essay, "Wege des Naturstudiums," in *Bauhaus, 1919-23,* exh. cat., Weimar 1923.

37. F. Klee, *Klee,* p. 9.

38. See Klee's remark in a letter of January 1903, in which he discusses Hebbel's diaries: "Hebbel is altogether my writer, whom I do not only respect as I do a Goethe or a Shakespeare, but genuinely love, the man above all," cited from F. Klee, *Klee,* p. 29.

39. From 1903 to 1905 Klee read most of Hebbel's dramas as well as the theoretical writings and the two volumes of Hebbel's diaries. According to Felix Klee (in his interview in the exh. cat., *Paul Klee-Aquarelle und Zeichnungen,* Essen, 1969), Hebbel was one of Klee's favorite writers and he frequently took up the diaries again. Grohmann, *Klee 54,* p. 41, states that Klee filled his copy of Hebbel's diaries with marginal comments and self-reflections.

40. For Klee's Nietzschean bent see Ch. Kröll, *Die Bildtitel Paul Klees*, and M. Rosenthal, "Der Held mit dem Flügel."

41. F. Hebbel, *Theoretische Schriften*, in *Werke*, vol. III, Munich, 1965, Hanser edition, p. 546. Many of Klee's formal concepts of the twenties are prefigured in the last paragraph in respect to the interelatedness of elements, their proportions, development, mirroring etc. See, for example, Klee's discussion of 'dividual' and 'individual,' in Paul Klee, *The Thinking Eye, Notebooks* vol. I, ed. by J. Spiller, London, 1961, p. 217 ff.

42. Hebbel, *Theoretische Schriften*, p. 547. Hebbel compares the dramatist to the painter who does not create the image of a human face with skin and blood, but with the "ideal" means of color. Similarly Klee refers in his 1924 Jena lecture to the "ideal" means of the painter.

43. Klee, *Diaries*, p. 345, no. 1008.

44. Hebbel, *Theoretische Schriften*, p. 545.

45. *Ibid.*, p. 545.

46. Klee, *Diaries*, p. 310, no. 943.

47. Klee, *Diaries*, p. 312, no. 944.

48. Hebbel, *Theoretische Schriften*, p. 545.

49. Klee, *Diaries*, p. 345, no. 1008.

50. Hebbel, *Theoretische Schriften*, p. 620.

51. Hebbel, *Theoretische Schriften*, p. 666.

52. Klee, *Diaries*, p. 387, no. 1104.

53. In his diaries Hebbel comes to grips with the whole spectrum of the German philosophical and literary tradition, ranging from Goethe and Schiller to Tieck and Schlegel. His complex, often contradictory world view reflects the influence of German Idealism as well as of the Romantic philosophers Schelling, Solger, Hegel, and Schopenhauer. Beyond that, Hebbels' diaries are a veritable treasury of observations, epigrammatic thoughts, and quotes as well as anecdotes. How attentively Klee read them is evident from the use he makes of Hebbel's remark: "The relationship of most people to each other: ⦻ ." (*Hebbels Tagebücher in zwei Bänden*, ed. F. Brandes, Leipzig, n.d., vol. I, p. 406). In 1915 Klee writes to Marc a letter which he summarizes in his diary: ". . . I went on, my trust in others rested on the common domain of two egos. To illustrate this point, I used two intersecting circles: ⦻ 'Your circle and mine, it seemed to me, had a relatively large communal area'." Klee, *Diaries*, p. 318, no. 961.

54. After completion of this manuscript, the publication of Klee's letters documented in greater detail Klee's enormous interest in Hebbel's writing. The hypothetized influence from Hebbel on Klee's concept of the organism is corroborated by a letter from Klee to his bride Lily of September 24, 1903: ". . . I read in Hebbel's *Theoretische Schriften*. I am convinced that I can set against the earnestness of his concept of art something that is equal to it; therefore his theory is for me a source of faith and trust in the work I have begun. His critical writings are well-formed examples of what has for some time been my conviction, namely the significance of the organic in art. His understanding of the organism in general finds its proof in the specifics of his treatment of language, for example. The structure of his sentences is exemplary and well thought-through. Likewise the larger form in periods, sections, and finally the whole of a piece of his prose. A paradigm of the art of language is, for example, his 'Dismissal of an Esthetic Tub-Thumper,' You see, Hebbel has become my best friend. The courage which I derive from this character consists in the conviction that

I will be equal to him in terms of honest desire, understanding and endurance, even if I do not trouble myself with asking, if I will be able to create something of only approximately the same value." Cited from Paul Klee, *Briefe an die Familie,* ed. by F. Klee, Cologne, 1979, vol. I, p. 349.

Chapter 5

1. Klee was among the first to be asked by Marc to read the manuscript of his Aphorisms. Klee read them with great interest but without agreeing completely with Marc. Indeed, he was quite critical of the turn Marc's thinking was taking during the war.

2. That Klee from early on had in mind the potential publication of his diary may be indicated by his 1905 remark: "The autobiography your masterpiece????" *Diaries,* p. 187, no. 692.

3. For a general study of Klee's theories see G. Henniger, *Paul Klees Theorie von der Malerei in ihrem Verhältnis zur Struktur seines Gesamtwerks,* unpublished Ph.D. dissertation, Berlin, 1955.

4. See K. Lankheit, "Die Frühromantik und die Grundlagen der gegenstandlosen Malerei," *Neue Heidelberger Jahrbücher* 1951, 55-90, for a study of those aspects of Romanticism which anticipate the theoretical basis of abstract art. Lankheit, however, focuses on "geistesgeschichtliche" parallels, not on specific sources.

5. For Marc and Romanticism see K. Lankheit, *Franz Marc.*

6. Klee, *Diaries,* p. 374, no. 1081.

7. Kandinsky, in *The Blaue Reiter Alamanac,* p. 165.

8. Klee, *Diaries,* . 278, no. 920.

9. Klee, *Diaries,* p. 278, no. 922.

10. Kandinsky, *Concerning the Spiritual,* p. 54.

11. Klee, *Diaries,* p., 278, no. 922.

12. I am grateful to Dr. Glaesemer for allowing me to look up the title in Klee's *oeuvre* catalogue. In an 1914 exhibition list Klee simply refers to the drawing as "abstract drawing."

13. Terms like *Vergeistigung* are rather outmoded in contemporary German and no longer carry the authority and conviction that they had in Expressionist days.

14. Glaesemer 76, p. 28 ff.

15. Klee, *Diaries,* p. 313, no. 950.

16. *Ibid.,* p. 313, no. 951.

17. C. Geelhaar, in *Paul Klee und das Bauhaus,* Cologne, 1972, has first discussed the relationship of Klee's thinking to Worringer's book. He suggests that Klee might have been aware of it as early as 1908. Possibly Klee knew Worringer personally, since on a postcard of March 30, 1912 Kandinsky asks him to visit Worringer: "Dear Mr. Klee, please do visit Dr. W. Worringer . . . in Bern, the author of "Abstraction and Empathy," of "The Gothic," etc. He is an interesting and kind person. If you see him, please give him my kindest regards." Cited from the transcripts of Kandinsky's letters in Prof. Lankheit's possession. This letter, in fact, disproves Kandinsky's later contention that he did not know Worringer.

18. Macke and Marc discuss the book in their correspondence. Kubin seems to refer to him in his letter to Klee of December 16, 1910: "Didn't we both start out from abstractions, to find outselves today with deeper empathy for the actual world?" Klee, *Diaries,* p. 252, no. 883.

19. Worringer, *Abstraktion und Einfühlung,* new ed., Munich, 1959. English ed., *Abstraction and Empathy,* transl. by M. Bullock, New York, 1953, p. 4.

20. "... in which the need for empathy abandons the sphere of the organic, that naturally falls to its lot, and takes possession of abstract forms, which are, thereby, of course robbed of their abstract value." Worringer, *Abstraction and Empathy,* p. 48.

21. Worringer, *Abstraction and Empathy, p. 109.*

22. Worringer, *Abstraction and Empathy,* pp. 47.

23. Worringer, *Abstraction and Empathy,* p. 23.

24. Klee, *Diaries,* p. 315, no. 952.

25. Klee, *Diaries,* p. 371, no. 1076.

26. *Ibid.,* p. 387, no. 1104D.

27. *Ibid.,* p. 384, no. 1008.

28. *Ibid.,* p. 375, no. 1082.

29. See, for example, Klee, *Diaries,* p. 310, no. 940.

30. *Ibid.,* p. 307, no. 928.

31. *The Blaue Reiter Almanac,* p. 149.

32. Klee, *Diaries,* p. 308, no. 932D.

33. Kandinsky, *Concerning the Spiritual in Art,* p. 27 f.

34. Published in J. Eichner, *Gabriele Münter und Kandinsky,* Cologne, 1957, p. 110.

35. Kandinsky, *Concerning the Spiritual,* p. 74.

36. Klee, *Diaries,* p. 310, no 943.

37. *Ibid.,* p. 312, no. 944.

38. *The Blaue Reiter Almanac, p. 147.*

39. S. Ringbom, "Art in the Epoch of the Great Spiritual."

40. *The Blaue Reiter Almanac,* p. 147.

41. Kandinsky, "Reminiscences", p. 35.

42. Klee, *Diaries,* p. 345, no. 1008.

43. F. Marc, *Briefe aus dem Felde, repr.* Berlin, *1946, p. 56.*

44. Published in G. Vriesen, *August Macke,* Stuttgart 1953. Second ed. 1957.

45. *Ibid.*

46. Kandinsky, *Concerning the Spiritual,* p. 105.

47. Klee, *Diaries,* p. 278. no. 921. For the central role of the chaos-logos antithesis in Klee's later thinking, see H.-M. Schweizer, "Die Immanenz des Transzendenten in der Kunsttheorie von Paul Klee," *Festschrift Georg Scheja zum 70. Geburtstag,* Sigmaringen, 1975, 237-61.

48. Klee, *Diaries,* p. 307, no. 929.

49. Kandinsky, *Concerning the Spiritual*, p. 66.

50. Klee, *Diaries*, p. 372, no. 1079.

51. Klee, *Diaries*, p. 316, no 958.

52. *Ibid.*

53. *Ibid.*

54. Klee, *Diaries*, p. 317, no. 959. In entry no. 957 Klee describes his inner distance from his Bern friend Lotmar, a doctor, who, although very interested in music, looked at things from a scientific-rational point of view that was entirely alien to Klee.

55. Tolstoy's book was first published in Russia in 1896 and in Germany in 1911.

56. Lankheit briefly discusses this debate in *Franz Marc*, p. 141. Maria Marc's letters to her husband on this question are not known to me. The Marc Archive in Nuremberg, where they might be located if they are extant at all, was not accessible to research.

57. Cited from the English edition, ed. by V. Tomas, New York, 1960.p. 51.

58. Tolstoy, *What is Art*, p. 51.

59. Marc, *Briefe*, p. 60.

60. *Ibid.*, p. 68.

61. *Ibid.*, p. 64.

62. See Klee, *Diaries*, p. 318, no. 961.

63. Quoted from the photocopies of the original correspondence. Prof. Lankheit kindly made these accessible to me. Some of the letters have been published in F. Klee, *Paul Klee*. I am also grateful to Prof. Lankheit for providing me with the full names of some of the personages identified only by their initials in the published versions of Marc's letters.

64. Reprinted in F. Klee, *Klee*, p. 38 ff.

65. Quoted from the photocopies.

66. Quoted from the photocopies.

67. Klee, *Diaries*, p. 318. no. 961.

68. Klee's thinking relates to Schelling's concept of the *Weltseele* and of art as the revealer of the transcendental, ideal world. Similar ideas are expressed by Hebbel in his *Theoretische Schriften*.

69. Eichner, *Kandinsky*, p. 110.

70. Kandinsky, *Concerning the Spiritual*, p. 52. That Kandinsky is indeed referring to the divine is clear from a preceding remark where he speaks of the means by which "pure art is in the service of the divine." p. 52.

71. Ibid., p. 75 (translation revised) and p. 29.

72. In his aphorisms, written during the war, Marc tried to map out new paths for art, stressing the role that art had to play in the anticipated cultural renewal after the war.

73. Klee, *Diaries*, p. 344. no. 1008.

74. "Über Graphik" has been published (with a reproduction of original manuscript) in Klee, *Das graphische Werk*, p. 15-17. The final version as well as the draft are reprinted in

Klee Schriften. In the footnotes the editor quotes from the letters in which Klee discusses his essay. Most of these letters are also included in the diary, but there not all of them are identified as letters.

75. Klee, *Diaries,* p. 402, no. 1127.

76. *Ibid.*

77. *Ibid.,* p. 406, no. 1131.

78. See Klee, *Diaries,* p. 382, no. 1094 (1917), and p. 387, no 1105 (1918).

79. "Über Graphik", p. 15.

80. See Kandinsky, *Concerning the Spiritual,* p. 51.

81. Klee, "Über Graphik", p. 15.

82. Kandinsky, "Malerei als reine Kunst", 1913, repr. in W. Kandinsky, *Essays über Kunst and Künstler,* ed. by M. Bill, 2nd ed., 1963, p. 64.

83. Kandinsky, *Essays,* p. 64.

84. Klee, "Über Graphik", p. 15.

85. Kandinsky, *Concerning the Spiritual,* p. 73.

86. Cf. P. Petitpierre, *Aus der Malklasse von Paul Klee,* Bern, 1957, p. 58.

87. Klee, "Über Graphik", p. 15.

88. Kandinsky, "Reminiscences", p. 24.

89. The *Kunstwende* book also contains an article by Rudolf Bauer, the epigone of Kandinsky, about the expressive properties of lines and line clusters. Bauer's article is very mystical in tone, but some of the line patterns are quite similar to those described by Klee. Apparently the expressive properties of abstract forms were widely discussed in Expressionist circles, possibly in relation to contemporary or older theories of visual perception. See also S. Ringbom, "Paul Klee and the Inner Truth to Nature" in *Arts Magazine,* Sept. 1977, p. 112-117, for some *geistesgeschichtliche* precedents.

90. Klee, "Über Graphik", p. 15.

91. Cf. Klee, *Diaries* p. 374, no. 1081 (1917).

92. Kandinsky, *Concerning the Spiritual* p. 40.

93. Klee, "Über Graphik", p. 16.

94. Cf. Kl. Lankheit, "Die Frühromantik. . . .".

95. Kandinsky, *Essays,* p. 63.

96. Klee, "Über Graphik", p. 16. This paragraph as well as all the subsequent quotations is written in ink, whereas the earlier parts of the essay were written in pencil. Perhaps the pen sections of the essay were added at later dates than Sept. 19.

97. Klee, *Ibid.*

98. Kandinsky, *Essays,* p. 66.

99. Klee, "Über Graphik", p. 16.

100. Klee, "Über Graphik", p. 16.

101. Cf. Klee, *Diaries,* p. 393, no. 1121.

102. Klee, "Über Graphik", p. 17.

103. *Ibid.*

104. *Ibid.*

105. *Ibid.*

106. Kandinsky, *Concerning the Spiritual*, p. 27.

107. Klee, "Schöpferische Konfession", repr. in *Klee Schriften*, p. 122.

108. *Ibid.*

Introduction to Part III

1. Cf. Grohmann, *Kandinsky 58*, p. 172; see also E. Scheyer, "Molzahn, Muche, and the Weimar Bauhaus", *Art Journal*, vol. 28; no. 3, 1969, 269-77, for details on Klee's and Kandinsky's appointments.

2. For the history of the Bauhaus, see H.M. Wingler, *Das Bauhaus*, 3rd. ed., Bramsche, 1975. The most important sources which chronicle the Bauhaus life are J.L. Ness, ed. *Lyonel Feininger*, New York, 1974 (excerpts from his letters), and O. Schlemmer, *Briefe und Tagebücher*, 2nd. ed., Stuttgart, 1977. Engl. ed. *The Letters and Diaries of Oskar Schlemmer*, Middletown, 1972.

3. See Wingler, *Das Bauhaus 1919-1933*, p 130f. for Klee's correspondence with Gropius on this matter. F. Kröll, *Das Bauhaus 1919-1933. Künstler zwischen Isolation und kollektiver Praxis*, Düsseldorf, 1974, investigates the school's history from a sociological point of view. He suggests that with the changing orientation of the school, artists like Kandinsky, Klee, and Feininger becane 'dysfunctional' and retreated into their own work.

4. Cf. Kröll, *Das Bauhaus 1919-1933* p. 96, and Wingler, *Das Bauhaus, 1919-1933* p. 175.

5. Grohmann, *Klee 54*, p. 70, states that Klee was deeply impressed by the 1928 performance of Mussorgsky's *Bilder einer Ausstellung* for which Kandinsky designed the stage settings. Felix Klee recalls that the annual highlight of their social life was an excursion in a carriage to the park in Wörlitz.

6. Quoted from Prof. Lankheit's transcripts of Kandinsky's letters which he has kindly made available to me.

7. The correspondence is preserved at the Norton Simon Museum of Art at Pasadena, Galka Scheyer Bequest. I am grateful for having had the opportunity to study the correspondence between Galka Scheyer and Kandinsky, as well as the Klees.

8. W. Grohmann, "Fünf Maler und ihr Interpret", *Jahrbuch preussischer Kulturbesitz 1967*, Berlin, 1968, 97-108. Grohmann gives a vivid account of the friendship between the two artists. For Kandinsky's and Klee's activities as printmakers during the twenties see C. Geelhaar, "Paul Klees druckgraphische, Kleinwelt: 1912-1932", in *Klee. Das graphische Werk*, p. 58-66.

9. F. Klee in the Essen interview, suggests that Klee helped Kandinsky with correcting and editing his writings.

10. O. Schlemmer, *The Letters and Diaries*, p. 304, writes about a Berlin exhibition: "Klee: more caught up in abstruse games than ever; Kandinsky: so close to Klee now that at first I thought Kandinsky was missing and only later realized that I had taken his paintings for Klee's." Already in 1926 E. Harms mistook paintings by Kandinsky for paintings by Klee as he recalls in "My Association with Kandinsky", *American Artist*, vol. 27, June 1963, 36-41.

11. Quoted from Grohmann, *Klee 54*, p. 68.

Chapter 6

1. The main studies are W. Haftmann, *Paul Klee. Wege bildnerischen Denkens*, Munich, 1950; C. Giedion-Welcker, *Paul Klee*, London, 1952; W. Grohmann, *Klee 54*.; M. Huggler, *Klee die Malerei*; C. Geelhaar, *Klee und das Bauhaus* 72; Jordan, *Klee and Cubism*; J. Glaesemer, *Paul Klee. Die farbigen Werke im Kunstmuseum Bern*, Bern, 1976.

2. Glaesemer, *Klee 76*, discusses Klee's formal development in the twenties in terms of these two formal approaches, while Geelhaar's groupings are based on formal, technical or iconographic characteristics.

3. Ill. in Grohmann, *Klee 54*, p 396.

4. Ill. in Grohmann, *Klee 54*, p. 237.

5. Klee felt that art had an advantage over music because in art the temporal sequence, past-present-future, could be compressed into a simultaneous image. Cf. *Diaries*, p. 374, no. 1081. for Kandinsky's views see *Concerning the Spiritual*, p. 55.

6. For the role of music in Klee's thinking see Verdi, "Musical Influences on the Art of Paul Klee," and Kagan, "Klee's 'Ad Parmassum'." In the late twenties and early thirties Klee tried to create 'polyphonous' paintings by operating with distinct but overlapping transparent color planes, as for example in *White, Framed Polyphonously*, 1930.140 (ill. in Glaesemer 76, p. 274).

7. Jordan, *Klee and Cubism*, p. 427f suggests that Klee's exceptional interest in such systems *per se* may have been inspired by the crafts techniques of the Bauhaus. Much of Klee's work of the twenties is indeed marked by his appropriation of extrapainterly techniques, such as calligraphy, writing, various forms of ornaments, textile patterns, glass and collage effects, etc.

8. Jordan, *Klee and Cubism*, p. 431. In Part II of this study, I pointed out that such a trend toward dematerialization had already manifested itself in Klee's adaptation of Cubism. See also J. M. Jordan, "The Structure of Paul Klee's Art in the Twenties: fom Cubism to Constructivism", *Arts Magazine*, Sept. 1977, p. 152-157.

9. Jordan, *Klee and Cubism*, p. 464 f.

10. The book was published in 1922 in Berlin. It also appeared in the *De Stijl* periodical, which, Felix Klee told me, was well known and read in the early Bauhaus years.

11. Illustrated in Röthel, *Kandinsky 70*, nos. 164-75.

12. S. Henry, "Form-Creating Energies: Paul Klee and Physics" *Arts Magazine*, Sept. 1977, p. 118-21, suggests that the type of hatching Klee uses in this and related drawings is inspired by illustrations of energy fields and electromagnetic phenomena.

13. Klee's use of figure-ground reversals, delusive foreshortening (as with the grid motifs in *Child on the Stairs*) etc. may well reflect his awareness of theories of visual perception. This has been studied by M. Teuber, in *Paul Klee. The Bauhaus Years*, exh. cat., Des Moines Art Center, Des Moines, 1973, 6-17 and idem, "Paul Klee: Abstract Art and Visual Perception", abstract, 61st Annual Meeting of the College Art Association, New York, 1973. See also idem, "Blue Night by Paul Klee", in *Vision and Artefact*, ed. M. Henle, New York, 1976, p. 131-51.

14. Kandinsky had used such 'haloes' quite frequently during the Blauer Reiter period, as, for example, in *Romantic Landscape*, 1911 (App. III-20). Similar haloes can also be found in some Klee works, as in *Under the Spell of the Star*, 1921 (ill. in Grohmann *Klee 54*, p. 393) In both these works the 'haloes' introduce a cosmic dimension. Kandinsky's and Klee's use of this device for similar effects in the late twenties will be discussed further below.

15. W. Kandinsky, *Point and Line to Plane*, Engl. ed., transl. by H. Dearstyne and H. Rebay, New York, 1947, p. 107.

16. Other examples of such 'top-heavy' compositions with large forms are *Fixed Lightning*, 1927, exh. at the Sabarsky Gallery, New York, Febr. 1978, and *Full Moon*, 1927, ill. in G. San Lazzaro, *Klee*, New York, 1957, p. 85.

17. The spray technique is said to have been introduced to the Bauhaus by Moholy-Nagy (cf. Geelhaar 72, p. 167, n. 94), but at the Bauhaus Archive in Berlin there are works by Hirschfeld-Mack of 1922 in which this technique is already used. Although spray effects can be found in some earlier works by Klee, he uses the technique primarily around 1925/26 and again in the early thirties. Kandinsky works with it a great deal in the later twenties.

18. Aside from Grohmann's basic, but very general study on Kandinsky, the main book on his work of the twenties is P. Overy, *Kandinsky. The Thinking Eye*, London, 1969, an attempt to place Kandinsky's work within the context of theories of visual perception.

19. Ill. in T. Anderson, ed., *Malevich*, Exh. Cat. Stedelijk Museum, Amsterdam, 1970, no. 66.

20. L. Hirschfeld-Mack recalls that he first experimented with colored papers before working with light and that he showed his experiments in a color seminar in 1921/22 which was attended by Klee and Kandinsky. Cf. B. Gilbert, "The Reflected Light Compositions of Ludwig Hirschfeld-Mack", *Form*, Cambridge, Sept. 1966, 10-14. There is no record of such a color seminar at the Bauhaus; possibly Hirschfeld-Mack is referring to *Vorkurs* exercise sessions where Kandinsky and Klee might have dropped in informally.

21. Within the context of Kandinsky's 'cool' period *Circles* is closer to Constructivism than most other works, for here the circle exists primarily as a geometrical form and seems devoid of the cosmic overtones that it has in most other works, such as *Composition VIII* (App III-47) or *In The Black Circle*, 1923, ill. in Grohmann, *Kandinsky 58*, p. 361.

22. Quoted from the transcripts of the original letters which Prof. Lankheit has made available to me. Portions of the Kandinsky-Grohmann correspondence are published in K. Gutbrod, ed., *Lieber Freund*.

23. Quoted from the transcripts.

24. Kandinsky apparently took a very active part in the preparation of Grohmann's publications. The extensive correspondence served only for supplementary communication, as there were frequent visits between the Grohmanns and the Kandinskys. Kandinsky occasionally criticizes Grohmann for not presenting his ideas forcefully enough.

25. Cf. Grohmann's recollections in "Fünf Maler und ihr Interpret", *Jahrbuch Preussischer Kulturbesitz 1967*, Berlin, 1969, p. 104.

26. Schlemmer notes in his diary in early June 1922: "Kandinsky has become Gropius's chancellor," *Letters and Diaries*, p. 140.

27. On February 13, 1924 Schlemmer writes to Meyer-Amden about Gropius and his new preference for Moholy-Nagy: "Kandinsky, who like everyone else was very close in the beginning, has become disgruntled and has already been displaced by Moholy, the newest member," *Letters and Diaries*, p. 151.

28. Quoted from the transcripts.

29. Quoted from the transcripts.

30. Quoted from the transcripts.

31. Cf. Klee, *Diaries,* p. 319, no. 951. See also Part II, chapt. 4.

32. Grohmann, *Kandinsky 58,* in discussing Kandinsky's work of the twenties, often points to the associational qualities of Kandinsky's form elements, motivated, so it would seem, by the desire to make the paintings more accessible to a public suspicious of abstraction. He reports that Kandinsky did not encourage such interpretations, but, at least in private, did not oppose them either. This study emphasises such associational dimensions, less in order to offer interpretations than to better define the stylistic position of Kandinsky's work of the twenties and its relationship to the contemporary avant-garde.

33. The boat, which was a central motif in Kandinsky's pre-war work, recurs throughout the twenties in different guises; for example in *Kleine Welten.* Perhaps the central shape in *Red in Blue* 1923. (App. III-45) also is a boat.

34. Another work of this type is the watercolor, *On Violet,* 1924, in the Hilla Rebay Collection (S. R. Guggenheim Museum).

35. Quoted from the transcripts of Kandinsky's letters. For the sake of completeness it should be noted that complicated compositions with an emphasis on diagonals and with numerous, often overlapping form elements continue to exist in Kandinsky's *oeuvre,* as, for example, *In the Blue,* 1925/288. But even works of this type are marked by a tendency toward simplicity and calm.

36. I know the painting only from a black and white reproduction. Grohmann, *Kandinsky 58,* p. 195 gives a brief description of the colors.

37. Cf. his remark in a letter to Grohmann of Oct. 1930: "You once talked about the circle, and I agree with your definition. It is a connection with the cosmic. But I use it primarily in a formal sense." Quoted from the transcripts.

38. Cf. Kandinsky, *Point and Line ,* p. 63.

39. Usually the circle is placed in the upper part of the picture, evoking the association with above and the sky; often it is also volumetric, as in *Tempered,* 1925 (Grohmann, *Kandinsky 58,* CC 193) or surrounded by a halo, as in *One Spot (Red on Brown),* 1925 (*Ibid.,* CC. 201).

40. In his Bauhaus teaching Klee discusses the arrow at length. The father of every projectile, whether fired or thrown, hence also of the arrow, was this thought: how shall I increase my range in that direction? Across that river, this lake, this mountain? Klee, *The Thinking Eye,* p. 407. For the arrow motif in Klee's work see also M. Rosenthal, "Der Held mit dem Flügel".

41. Cf., for example, Klee's *Ship* II in Harbor, 1925, ill. in San Lazzaro, *Klee,* p. 72.

42. According to Grohmann, *Kandinsky 58,* p. 194, Kandinsky did not paint during the last six months of 1925, after his move to Dessau. That would place all the works discussed in the first half of the year.

43. Such cut-off corners appear frequently in Kandinsky's paintings; possibly they inspired Klee to introduce the curtain motif in paintings of the late twenties, where they also serve as a planar prop behind which the ground seems to recede indefinitely.

44. The same is true of *Accent in Pink,* 1926/326 (ill. in Grohhmann, *Kandinsky 58,* CC 207), where the surface is worn and 'faded' in the manner of *Ancient Sound.*

45. Ill. in Grohmann, *Kandinsky 58*, CC. 219.

46. Ill. *Ibid.*, CC 244.

47. Chronologically Kandinsky's painting stands in the middle of his 1926 production. It cannot be established when Klee painted *Around the Fish;* therefore this comparison does not postulate any chronological precedence for Klee's picture.

48. In 1926 Kandinsky chooses quite a few titles with biomorphic associations, such as *Cool Energy, Thorny., Rift,* etc.

49. The first two of the three paintings are known to me only in black and white illustrations.

50. Ill. in Grohmann, *Kandinsky 58*, CC. 233.

51. Ill. *Ibid.*, CC. 234.

52. Kandinsky, *Point and Line,* p. 82.

53. However, if one adduces Kandinsky's theories, the three paintings can be interpreted on the basis of the predominant character of the linear elements: in *Point and Line* (p. 79) Kandinsky associates straight lines with birth (cf. the horizontals and verticals in *Beginning,*) angular lines with youth (such lines prevail in *Development*), and the curved line (which forms the circle) with maturity. In *Conclusion* the circle predominates, but it also contains the straight line and the angular line (the zigzags of the triangle,) so that it encompasses the totality of life. Seen in this context, the three paintings 'represent' a cycle of life.

54. Cited in Glaesemer 76, p. 37.

55. Quoted from the transcripts of Kandinsky's letters to Grohmann.

Chapter 7

1. J. Spiller, ed., *Paul Klee. Das bildnerische Denken,* 3rd ed., Basel, Stuttgart, 1971 (first published 1956), Eng. ed. *The Thinking Eye,;* and Paul Klee, *Unendliche Naturgeschichte,* Basel, 1970. Eng. ed. *The Nature of Nature; Notebooks, vol. 2,* London, New York, 1973. The two volumes are the first two of a planned series of four. The death of Spiller has brought the publication to a halt. Spiller's edition of Klee's notes has been strongly criticized, as his edition obscures the chronological order. For a basic assessment of the extant course material (in the Paul Klee Stiftung) see M. Huggler, "Die Kunsttheorie von Paul Klee" in *Festschrift Hans R. Hahnloser,* Basel, Stuttgart, 1961, 425-41. In an exhibition in the Bern Kunstmuseum in the summer of 1977 part of the manuscript material was presented more clearly. Kandinsky's class notes have been published in French in *Écrits Complets,* vol. III, ed. by Ph. Sers, Paris, 1975. The notes are only a very fragmentary record of Kandinsky's teaching.

2. For an exposition of Klee's basic theories, as expressed in his writings of the Bauhaus period, see Glaesemer 76; Geelhaar 72, and idem, *Paul Klee. Progressionen,* Kunstmuseum Bern, exh. cat., Bern, 1975 (a selection of the geometrical drawings from the late Bauhaus years). On Klee's color theories see M. Huggler, "Die Farbe bei Paul Klee", *Palette,* no. 25, 1967, 12-22, and C. V. Poling, *Color Theories in the Twentieth Century,* unpublished Ph.D. thesis, Columbia University, New York, 1973. For Kandinsky see K. Lindsay, *An Examination.*

3. S. V. Smigocki, *An Inquiry into the Art Pedagogy of Klee and Kandinsky,* Ph. D. Thesis, Florida State University, 1974 (microfilm) presents a very general comparison of their

theories based only on the then published writings. W. Hofmann, "Ein Beitrag zur "mor-phologischen Kunsttheorie der Gegenwart", *Alte und Neue Kunst, II, no. 2, 1953, 63-80,* and idem, "Klee und Kandinsky", *Merkur,* XI, no. 11, 1957, 1096-1102, has first pointed to the common aspects in their ideas about art and nature. He also suggests that Klee may have influenced Kandinsky's thinking on this question and he notes the relationship to Geothe.

4. Klee in "On Modern Art", the celebrated Jena lecture of 1924, reprinted in *The Thinking Eye,* p. 81-95.

5. Published in the 1923 Bauhaus catalog, reprinted in *The Thinking Eye,* p. 63-67.

6. In contrast to Klee, Kandinsky gives consideration to the changed character of the form elements in the various techniques and graphic media.

7. Kandinsky sought to verify his findings in a questionnaire passed around at the Bauhaus in 1923. Most answers agreed with his. Kandinsky would probably be delighted to know that his three forms and corresponding colors are used in a new stop light designed by Gestalt psychologists. Cf. *ADAC-Motorwelt,* August 1977, 14 f.

8. Cf. Kandinsky, *Point and Line,* p. 98 f.

9. Kandinsky, *Écrits,* III, p. 142.

10. Kandinsky, *Écrits III,* p. 169.

11. Kandinsky, *Point and Line,* p. 38 f.

12. Klee, *The Nature of Nature,* p. 25 and p. 29.

13. Kandinsky, *Point and Line,* p. 46.

14. Hofmann, "Ein Beitrag. . . "

15. Klee, *The Thinking Eye,* p. 93.

16. Kandinsky, *Point and Line,* 57.

17. *Ibid.,* p. 63.

18. Klee, *The Thinking Eye,* p. 163.

19. Kandinsky, *Point and Line,* p. 63.

20. Klee, *The Nature of Nature,* p. 329.

21. Kandinsky, *Point and Line,* p. 82.

22. *Ibid.,* p. 83.

23. In his discussion of line Kandinsky briefly touches on compositional orders of line, such as repetition, rhythmic order, mirroring, and line as accompaniment and variation. He notes analogies for these groupings in music, but he does not deal with these questions as extensively as Klee. Kandinsky's interest in Constructivism is reflected in his selection of linear formations in technics and the other arts. He illustrates Moholy-Nagy's photo of a radio tower as well as pictures of telephone poles and of the 1921 Constructivist exhibition in Moscow.

24. Klee, *The Nature of Nature,* p. 29-35. The lesson dates from November 1923.

25. In Chapter 6, it was suggested that in some of his linear compositions Klee experimented with 'eccentric' compositions in Kandinsky's sense.

26. Kandinsky, *Point and Line,* p. 103.

27. Klee, *The Thinking Eye*, p. 453.

28. Kandinsky, *Point and Line*, p. 109.

29. *Ibid.*, p. 116. Kandinsky associates the inherent tensions of the sections and directions of the picture plane with sky (above), earth (below), movement into the distance (leftward) and movement homeward (rightward). While Klee does not discuss the picture ground as specifically as Kandinsky, he draws similar parellels, although he reverses the left-right/cold-warm direction.

30. Klee, *The Thinking Eye*, p. 449.

31. Kandinsky, *Essays*, p. 94.

32. The edition of the course notes is very confusing; the dated notes are not printed in chronological order and undated lessons are interspersed with them.

33. Cf. Kandinsky, *Ecrits III*, p. 190 ff. In his discussions of color Kandinsky frequently refers to Goethe with whom he appears to be quite in agreement.

34. Kandinsky, *Ecrits III*, p. 258 f.

35. Kandinsky, *Ecrits III*, p. 381. Klee draws up a similar table of correspondences between key terms such as static, dynamic, melodic, pathetic, active, passive etc., and sciences, literature, music, cf. *The Thinking Eye*, p. 458 f. What he presents appears to be a skeletal philosophical system rather than analogies in sensory perception.

36. Kandinsky, *Ecrits III*, p. 330.

37. The lesson is wedged in between lessons dated 1926 and 1929. At the end of this lesson Kandinsky puts in parenthesis "(also in Dresden, March 1930)." It cannot be ruled out that this lesson was written prior to or after the given date. *Ecrits III*, p. 177.

38. *Ecrits III*, p. 191.

39. *Ibid.*, p. 194.

40. Klee, *Diaries*, p. 231, no. 840. Klee reuses this entry in his teaching. See also Chapter 1.

41. Kandinsky, *Ecrits III*, p. 311.

42. *Ibid.*, p. 319.

43. *Ibid.*, p. 178.

Chapter 8

1. *Klee Schriften*, p. 128.

2. Jordan, *Klee and Cubism.*, p. 465f. has analyzed the Constructivist aspects of the painting, comparing it to Gabo's design for a radio tower.

3. Geelhaar, *Paul Klee*, Cologne, 1974, p. 67 has noted that a human physiognomy is 'hidden' in the linear construction, as it also appears in *Limits*.

4. Grohmann, *Kandinsky 58*, p. 192, hints at such an exchange in writing about Klee's drawing *Steerable Grandfather*, 1930:. . . "possible Klee in this and similar cases was inspired by Kandinsky—we know that the two artists, for all their differences, freely shared their experiences."

5. Kandinsky, *Ecrits III*, p. 318.

6. Jordan, *Klee and Cubism*, p. 465. Stylistic influence from Gabo seems more evident in the drawing, *Oriented Man*, 1927, (Ill. in *Paul Klee. Die Ordnung der Dinge*, exh. cat., Stuttgart, 1975, no. 152.).

7. See Klee, *The Thinking Eye*, p. 257 ff, 307.

8. Cf. Geelhaar, *Klee 74* p. 67, for an interpretation of the circles as cosmic form. See also Klee, *The Thinking Eye*, p. 32.

9. An early example of this type of work is *Demon as Pirate*, 1926, watercolor (Philadelphia Museum of Art). Kandinsky uses this type of scraggly line on dark ground, combined with solid color areas in *Some Red*, 1929 (oil on board), ill. in *Kandinsky at the Guggenheim Museum*, New York, 1972. This work, which has very much the character of a landscape, is rather exceptional in his *oeuvre* of the late twenties.

10. Ill. in Grohmann, *Kandinsky 58*, CC 157, p. 137, and CC 41.

11. Kandinsky had illustrated such constructions in *Point and Line*. (cf. Figs. 68-70).

12. See, for example, the medieval town in *Flag-Bedecked Town*, 1927, (App. III-55).

13. See, for example, the stage setting by A. Vesnin for *The Man who was Thursday*, 1923 (ill. in Gray, *The Russian Experiment in Art: 1863-1922*, New York, 1971 p. 267), Possibly Kandinsky knew this from illustrations.

14. In a work related in motif, *Gradated Drawing*, 1928/302, the brown ground is replaced by a blueish spray ground with red and yellow spots. (Ill. in *Klee/Kandinsky*, Tokyo, 1968, no. 66).

15. Kandinsky's *Light in Heavy* 1929 (ill. in *50 Paintings by Vasily Kandinsky*, auct. cat. Sotheby & Co., London, 1964, no. 33) operates with a similar contrast of very fine white and colored lines and solid geometric forms. While the forms are purely geometrical here, the volumetric rendering of the red circle evokes associations with a cosmic body.

16. See Kandinsky, *Point and Line*, p. 126f for his ideas on the weight of forms on the picture ground.

17. Ill. in Grohmann, *Klee 54*, p. 255.

18. The circle form is reminiscent of the green and red eyes in the expressionistic self portraits by some of Kandinsky's associates during the Munich years; for example, M.V. Werefkin's *Self-Portrait* of ca. 1907-1909 (ill. in M.V. Werefkin, *Briefe an einen Unbekannten*, 1901-5, ed. by C. Weiler, Cologne, 1960, p. 51) or Arnold Schönberg's *Self-Portrait*, ill. in *The Blaue Reiter Almanac*. The latter, in particular, provoked August Macke. In a letter to Marc of Jan. 23, 1912, he wrote: "And on top of that, Schönberg! He really made me mad, with these green-eyed water-buns and their astral gaze". (*Macke-Marc Briefwechsel*, p. 99). One wonders how Macke would have reacted to Kandinsky's 'cosmic' circle paintings had he lived to see them.

19. Kandinsky uses similar colored lines in the painting, *Colored Sticks*, 1928. 434 (ill. in *Kandinsky at the Guggenheim*).

20. Cf. Geelhaar 72, p. 116.

21. Kandinsky works with spotted grounds similar to Klee's in some works of 1928, such as *Veiled Glow*, 1928. 422 (Grohmann, *Kandinsky 58*, CC 282) and the watercolor *Impulses*, 1928, (known to me only from a photograph), but there the linear forms are placed over the ground and kept discrete.

22. Cf. Kandinsky, *Point and Line*, p. 80 ff.

23. P. Overy, Kandinsky, *The Language of the Eye*, p. 174, suggests that the type of linear structure of *Im Netz* and related works was possibly inspired by Moholy-Nagy's photograph of a radio tower which Kandinsky had reproduced in *Point and Line*. Fig. 68.

24. In 1928 Klee actually calls a painting of this type *Cloisonné*. (Ill. in San Lazzaro, *Klee*, p. 122).

25. Cf., for example, Kandinsky's 1925 painting, *Pointed-Round*, color ill. in *Wassily Kandinsky*, exh. cat., Galerie Bargera, Cologne, 1973.

26. Jordan, *Klee and Cubism*, p. 470, compares the transparency of forms in *City on Two Hills* to Moholy-Nagy.

27. Kandinsky, *Concerning the Spiritual*, p. 66.

28. E. Gombrich, *Meditations on a Hobby Horse*, London, 1963, 68 f. Both works are illustrated there.

29. The angular line in the painting is clearly inspired by Kandinsky, who frequently use such lightning shapes. (A watercolor by Kandinsky of 1925 is actually entitled *Lightning*) Klee uses such lines in a number of works of 1927, as for example *Many-Colored Lightning* 1927. i l. ill. in *The Thinking Eye*, p. 368, or the watercolor *Fixed Lightning*, 1927, (exh. at the Sabarsky Gallery, New York, winter 1977/78). The association with lightning further enhances the inherently dynamic character of the zigzag lines.

30. Kandinsky, *Ecrits Complets* vol. III, p. 375.

31. Klee rarely works with such oversize geometric form elements. Quite exceptional in this regard is the somewhat surrealist painting, *Error on Green*, 1930 (ill. in J. Spiller, *Paul Klee*, Berlin and Munich, 1962, p. 55), where the orange circle dominates the entire picture.

32. The figure reminds one of the abstract figurines in El Lissitsky's *Sieg über die Sonne* lithographs, published in Hannover in 1923.

33. Another painting of 1928 is called *Red Figure*, 1928/430 (Grohmann, *Kandinsky 58*, CC 289). The figurative forms as well as the stage-like compositional set-up of a number of works of this time may reflect Kandinsky's work on the stage designs and figurines (which are somewhat reminiscent of Schlemmer's *Triadic Ballet* figures) for Mussorgsky's *Pictures of an Exhibition*, which was performed in Dessau in 1928.

34. See, for example, the 'satellite' form in *Echoes*, 1928/296, watercolor, (ill. in *Important 20th Century Paintings, Watercolors and Drawings*. auct. cat., Parke-Bernet, Oct. 20, 1971, no. 34), and *Serious-Joke* 1930/514 (Grohmann, CC 363).

35. Ill. in Geelhaar, *Klee 72*, p. 80.

36. An exception is the boat form in Kandinsky's *Upright* 1930, (ill. in *50 Jahre Bauhaus*, exh. cat., Stuttgart, 1968, no. 126).

37. See Kandinsky, "Reminiscences", p. 28.

38. Geelhaar, *Klee 72*, p. 152f interprets the painting as an abstract expression of the conflict of static physical limitations and dynamic psychic desires in man which is a central theme in Klee's art.

39. See, for example, Kandinsky's *From Cool Depths*, 1928/272 (Pasadena Museum of Art).

40. For a very De Stijl-like grid as central motif, see *Sign with Accompaniment* 1927/382 (Grohmann CC 250).

41. The checkerboard as a form motif appears already early in the twenties in Kandinsky's work.

42. M. Teuber, cf. chapt. 6, no. 13.

43. Kandinsky, *Ecrits III*, p. 378.

44. That the *Oeuvre* number indicates an early date within the year is made likely by the title of a related work, *A New Game Begins*, 1930.1 (ill. in *Paul Klee, the Bauhaus Years*, no. 48), which seems to refer to the beginning of the year.

45. The work is described as gouache and collage, but in examining the original I noticed the complete flatness of the surface, to which nothing seemed to be affixed.

46. Cited fom Klee, *The Thinking Eye*, p. 69.

47. Cited from the microfilms of the original manuscripts preserved in the Klee Foundation in Bern.

48. Kandinsky, *Ecrits III* p. 376.

49. Klee, in particular, often works in a quite rationalist way in the late twenties and early thirties, as, for example, in his geometrical drawings and the works based on them, cf. Geelhaar, *Klee 72*, p. 147 ff.

50. Kandinsky already uses such forms earlier, as in *One-Two*, 1929/468 (Grohmann, CC 320).

51. M. Teuber, "Blue Night", has pointed out that the forms are based on Max Wertheimer's diagrams.

52. Cf. Klee's remark in his Bauhaus teaching in 1924: "Example for such a utopia: b) the palace of the fish, a structure floating lightly up and down between surface and ground, without a top or bottom, instead it lightly circulates. At the most it has a center of sorts in its inner construction, but otherwise is constructed according to a purely dynamic law./ a) nature/ the entire great house of terrestrial creatures, the earth in its totality where, too, there is no bottom and top, where for example men stand opposite each other as antipodes./ c) some aristophanian air castle (for aviators or for balloons)." Cited from *Glaesemer 76*, p. 156.

53. See, for example, the arrow in *From the Little Arrow*, 1930/543 and the flags in *Dense*, 1929/455 (ill. in Grohmann, *Kandinsky 58*, CC 387 and 310).

54. On this work group and parallels between Klee and Kandinsky, see also Geelhaar 72, p. 154 ff.

55. According to Grohmann, *Kandinsky 58*, p. 227 this was the last painting which Kandinsky did in Germany. Klee's painting belongs in a group of works which begin in 1933. I have chosen this painting, rather than an earlier one, for example *Opened*, 1933, because of the 'gate' motif. Most likely Klee did not know Kandinsky's painting.

56. Klee, *Diaries*, p. 308, no. 931.

57. In 1936 Klee fell seriously ill with the measles, the after effects of which caused protracted suffering and ultimately led to his death in 1940.

58. Quoted from the transcripts of Kandinsky's letters in the possession of Professor K. Lankheit.

Appendix I

1. For a brief discussion of Kandinsky and Böcklin see J. Wissmann, *Arnold Böcklin und das Nachleben seiner Malerei*, Ph. D. Dissertation, Münster, 1968, p. 89-90. Brisch, *Kunstge-*

schichte Kandinsky discusses influence from Böcklin on Kandinsky, primarily in terms of pictorial motifs.

2. Kandinsky, *Concerning the Spiritual*, p. 36.

3. The signal for a critical evaluation of Böcklin was given by Meier-Graefe in his book *Der Fall Böcklin*, 1905.

4. The Böcklin poems by George and Wolfskehl are reprinted in *Arnold Böcklin*, exh. cat., Kunstmuseum Basel, 1977, 142 f. The view of Böcklin that was held in the George circle and shared by Kandinsky has been succinctly formulated by Wölfflin: "That Böcklin was a seer, all eye and yet a dreamer, that is it. He gave art back its soul. Where all the others believed that only perception counted," in "Arnold Böcklin Festrede 1897," *Kleine Schriften*, ed. J. Gantner, Berlin, 1946, 109 ff.

5. Ill. in *Wassily Kandinsky*, exh. cat., Munich, 1976, no. 6.

6. G. Floerke, *Zehn Jahre mit Böcklin*, Berlin, 1901, 2nd. ed., 1902. Other sources are R. Schick, *Tagebuchaufzeichnungen 1866-69*, Berlin, 1901, O. Lasius, *Tagebücher 1884-89*, Berlin, 1903.

7. For a summary of Böcklin's color symbolism see A. Reinle, J. Gantner, *Kunstgeschichte der Schweiz*, vol. IV, Frauenfeld, 1962, p. 217-19.

8. Kandinsky, *Concerning the Spiritual*, p. 66.

9. Böcklin's invented animals also reappear in some of Kandinsky's work, as, for example, the fabulous sea animal in Kandinsky's 1907 print *Moon Night* (App. III-53) or the dragon in *St. George*, no. 3, 1911 (App. III-20), which has the ludicrous appearance of Böcklin's saucy monsters.

10. The painting has been in the Kunstmuseum Basel since 1895. Kandinsky might have seen it on his trips to Switzerland in 1905 and 1907. It is also illustrated in the early literature on Böcklin.

11. Kandinsky, *Concerning the Spiritual*, p. 27.

12. *Ibid.*, p. 40.

13. *Ibid.*, p. 29.

14. *Ibid.*, p. 33.

15. In Kandinsky's case such paraphrasing of images can be quite unintentional. He had an eidetic memory, and there are many cases when stored images resurface in his works quite transformed, at a much later date.

Appendix II

1. F. Klee, *Klee*, p. 14.

2. Grohmann mentions the show at Thannhauser's, cf. *Klee 54*, p. 50.

3. Macke and Marc also saw the exhibition, according to K. Lankheit, *Franz Marc*, Cologne, 1976, p. 52.

4. A copy of the catalogue, along with some other early Thannhauser catalogues, exists at the Munich *Stadtarchiv*.

5. The drawing is now at the Guggenheim Museum. I am grateful to Vivian Endicott Barnett, who is preparing the catalogue of the Thannhauser collection, for informing me about the provenance of the drawing.

Bibliography

Anderson, Troels. "Some unpublished Letters by Kandinsky," *Artes*, 2, 1966, 90-110.
_____, ed. *Malevich*, cat., Stedelijk Museum, Amsterdam, 1970.
Armitage, Merle, ed. *Five Essays on Klee*, New York, 1950.
Baden-Baden, Staatliche Kunsthalle. *Der frühe Paul Klee*, exh. cat., 1964.
_____. *Wassily Kandinsky. Gemälde 1900-1944*, exh. cat., 1970.
_____. *Robert Delaunay*, exh. cat., 1976.
Barr, Alfred. *Matisse, His Art and His Public*, New York, 1951.
Basel, Kunsthalle. *Paul Klee 1879-1940*, exh. cat., 1967.
Basel, Kunstmuseum. *Arnold Böcklin*, exh. cat., 1977.
Bayer, Herbert, and Gropius, Walter and Tse. *Bauhaus 1919-1928*, Museum of Modern Art, exh. cat., New York, 1938.
Berlin, Nationalgalerie. *Hommage à Schönberg. Der Blaue Reiter und das Musikalische in der Malerei der Zeit*, exh. cat., 1974.
Berlin, Nationalgalerie et. al. *Tendenzen der zwanziger Jahre*, exh. cat., 1977.
Bielefeld, Kunsthalle. *Wassily Kandinsky*, exh. cat., 1973.
Bill, Max, ed. *Wassily Kandinsky*, Boston, Paris, 1951.
Bovi, Arturo. *Wassily Kandinsky*, Lucerne, 1972.
Bremen, Kunsthalle. *Paul Klee. Aquarelle und Handzeichnungen*, exh. cat., 1967.
Brisch, Klaus. *Kunstgeschichte Wassily Kandinsky 1900-1921*, unpublished Ph.D. thesis, Bonn, 1955.
Buchheim, Lothar-Günther. *Der Blaue Reiter*, Feldafing, 1959.
Burnett, David. "Paul Klee: The Romantic Landscape," *Art Journal*, 36, 1977, 322—26.
_____. "Klee as Senecio: Self—Portraits 1908-1922," *Art International*, 21 Dec. 1977, 12-18.
Cambridge, Mass., Busch—Reisinger Museum, Harvard University. *Concepts of the Bauhaus*, exh. cat., 1971.
Cassou, Jean, ed. *Wassily Kandinsky. Gegenklänge*, Cologne, 1960.
Chevalier, Denis. *Paul Klee*, New York, 1971.
Cologne, Galerie Bargera. *Wassily Kandinsky, 1866-1944*, exh. cat., 1973.
Comini, Alexandra. "All Roads Lead (Reluctantly) to Bern: Style and Source in Paul Klee's Early "Sour" Prints," *Arts Magazine, September, 1977, 105-11*.
Des Moines, Art Center. *Paul Klee. The Bauhaus Years, 1921-1931*, exh. cat., 1973. Introduction by Marianne Teuber.
DU. Special issue on *Paul Klee*, Zurich, 8, October 1948.
Düsseldorf, Kunstsammlungen Nordrhein-Westfalen. *Paul Klee*, cat., 1964. Third edition, 1971.
Duisburg, Wilhelm-Lehmbruck-Museum. *Paul Klee. Das graphische und plastische Werk*, exh. cat., 1974. Essays by M. Franciscono, Ch. Geelhaar, J. Glaesemer, M. Rosenthal.
Edinburgh, Royal Scottish Academy. *Teh Blue Rider Group*, exh. cat., The Arts Council of Great Britain, 1960.

Eichner, Johannes. *Wassily Kandinsky und Gabriele Münter,* Munich, 1957.

Einem, Herbert von. *Goethe-Studien,* Munich, 1972.

Eitner, Lorenz. "Kandinsky in Munich," *Burlington Magazine,* 99, June, 1957, 192-97.

Erdmann-Macke, Elisabeth. *Erinnerungen an August Macke,* Stutgart, 1962.

Essen, Folkwang Museum. *Paul Klee. Aquarelle and Zeichnungen,* exh. cat., 1969. Interview with Felix Klee.

Ettlinger, L. D. *Kandinsky's 'At Rest,'* Charlton Lecture on Art, Oxford, 1961.

————. "Kandinsky," *Oeil,* June, 1964, 10-17, 50.

Ferrier, J. L., Crevel, R. *Paul Klee: Les Années Vingt,* Paris, 1971.

Feininger, Julia and Lyonel. "Wassily Kandinsky," *Magazine of Art,* 38, May, 1945, 174—75.

Feininger, Lyonel. *Lyonel Feininger,* ed. by June L. Ness, London, 1975.

Fineberg, Jonathan. *Kandinsky in Paris 1906-1907,* unpublished Ph.D. thesis, Harvard University, Cambridge, Mass., 1975.

Floerke, Gustav. *Zehn Jahre mit Böcklin,* Berlin, 1901. 2nd ed. 1902.

Franciscono, Marcel. *Walter Gropius and the Creation of the Bauhaus in Weimar,* Urbana, 1971.

————. "Paul Klee's Italian Journey and the Classical Tradition," *Pantheon,* 32, 1974, 54-62.

————. "Paul Klee in the Bauhaus: The Artist as Lawgiver," *Arts Magazine,* September, 1977, 122-27.

Gallwitz, Klaus. "Kandinsky à Baden-Baden," *XXe Siècle,* 36, June, 1971, 21-30.

Geelhaar, Christian. *Paul Klee und das Bauhaus,* Cologne, 1972.

————. "Paul Klee: 'Früchte auf Rot'," *Pantheon,* 30, May, 1972, 222-228.

————. *Paul Klee. Leben und Werk,* Cologne, 1974.

————. *Paul Klee. Progressionen. Schriftenreihe der Paul-Klee Stiftung,* no. 1, Kunstmuseum Bern, Bern, 1974.

————. *Klee-Zeichnungen,* Cologne, 1975.

Giedion-Welcker, Carola. "Bildinhalte und Ausdrucksmittel bei Paul Klee," *Werk,* 35, no. 3, March, 1948, 81-89.

————. "Kandinsky's Malerei als Ausdruck eines geistigen Universalismus," *Werk* 37, April, 1950, 117-23.

————. *Paul Klee,* New York, 1952.

————. *Klee in Selbstzeugnissen und Bilddokumenten,* Hamburg, 1961.

Gilbert, B. "The Reflected Light Compositions of Ludwig Hirschfeld-Mack," *Form,* no.2, Cambridge, September 1966, 10-14.

Glaesemer, Jürgen. *Paul Klee. Handzeichnungen I. Kindheit bis 1920,* Kunstmuseum Bern, Bern, 1973.

————. "Paul Klees persönliche und künstlerische Begegnung mit Alfred Kubin," *Pantheon,* 32, 1974, 152-62.

————. *Paul Klee. Die farbigen Werke im Kunstmuseum Bern,* Bern, 1976.

Goethe, Johann Wolfgang. *Die Italienische Reise,* 3 vols., Munich, 1962 (dtv-Gesamtausgabe).

————. *Goethe. Travels in Italy: Together with His Second Residence in Rome and Fragment on Italy,* London, 1883.

Golding, John. *Cubism. A History and Analysis 1907-1914,* New York, 1968.

Gollek, Rosel. *Der Blaue Reiter im Lenbachhaus München, Materialien zur Kunst des 19. Jahrhunderts,* 12, Munich, 1974.

Gombrich, Ernest. "Expression and Communication," in: *Meditations on a Hobby Horse,* London, 1963, 56-69.

Gordon, Donald E. *Modern Art Exhibitions 1900-1916, Materialien zur Kunst des 19. Jahrhunderts,* 14, 2 vols., Munich, 1974.

Gray, Camilla. *The Great Experiment: Russian Art, 1863-1922,* London, 1962. 2nd ed., 1971.

Greenberg, Clement. "Kandinsky," in: *Art and Culture,* New York, 1961, 111-14.

Grohmann, Will. "Paul Klee, 1923-1924," *Der Cicerone*, 16, August, 1924, 786-98.

————. *Wassily Kandinsky*, Leipzig, 1924.

————. "Paul Klee", *Cahiers d'Art*, 3, 1928, 295-302.

————. *Kandinsky, Cahiers d'Art*, special number with contributions by Clapp, Flouquet, Th. Däubler, K. Dreier, F. Halle, M. Raynal, E. Tériade, C. Zervos, Paris, 1930.

————. *Paul Klee. Handzeichnungen 1921-1930*, Berlin, 1934. Reprint, Bergen, 1948.

————. *Paul Klee*, Stuttgart, 1954. 4th ed., 1965.

————. "L'humour Goethéen de Paul Klee," *XXe Siècle*, n. s., no. 8, January, 1957, 33-38.

"Paul Klee und die Anfänge einer Harmonielehre in der Kunst," *Neue Deutsche Hefte*, October, 1957, 632-38.

————. *Wassily Kandinsky. Life and Work*, New York, 1958.

————. *Paul Klee. Handzeichnungen*, Cologne, 1959.

————. "Kandinsky et Klee retrouvent l'Orient," *XXe Siècle*, n.s., no. 17, 1961, 51-56.

————. *Wassily Kandinsky. Eine Begegnung aus dem Jahre 1924*, Berlin, 1966.

"Fünf Maler und ihr Interpret," *Jahrbuch Preussischer Kulturbesitz 1967*, Berlin, 1969, 95-108.

Grote, Ludwig, "Der Blaue Reiter," *Die Kunst*, 48, 1950, 4-11.

————. ed. *Erinnerungen an Paul Klee*, Munich, 1959.

Gutbrod, Karl, ed. *Lieber Freund. Künstler schreiben an Will Grohmann*, Cologne, 1968.

Haftmann, Werner. "Über das Humanistische bei Paul Klee," *Prisma*, 1948, no. 17, 31-32.

————. *Paul Klee. Wege bildnerischen Denkens,*Munich, 1950.

————. *Malerie im zwanzigsten Jahrhundert*, 2vols., Munich, 1954-55.

Hahl-Koch, Jelena. *Marianne von Werefkin und der russische Symbolismus, Slavistische Beiträge,*24, Munich, 1967.

Hanfstaengl, Erika. *Wassily Kandinsky. Zeichnungen und Aquarelle, Katalog der Sammlung in der Städischen Galerie im Lenbachhaus München*, Munich, 1974.

Harlan, Veit. "Die Kraft des Schöpferischen. Zum theoreotischen Werk des Malers Paul Klee," *Die Drei*, 42, 1972, 29-31.

Halle, Fannina. "Dessau: Burgkühnauer Allee, 6-7 (Kandinsky und Klee)," *Das Kunstblatt*, July, 1929, 203-10.

Harms, Ernest. "My Association with Kandinsky," *American Artist*, June, 1963, 36-41.

————. "Paul Klee as I remember him," *Art Journal*, 32, Winter 1972/73, p. 178.

Hausenstein, Wilhelm *Kairuan, oder eine Geschichte von Maler Klee und von der Kunst dieses Zeitalters*, Munich, 1921.

Hebbel, Friedrich. *Hebbels Tagebücher in zwei Bänden*, ed. by F. Brandes, Leipzig, n. d.

————. *Theoretische Schriften, Werke*, 3, Munich, 1965.

Henniger, Gerd. *Paul Klees Theorie von der Malerei in ihrem Verhältnis zur Struktur seines Gesamtwerkes*, unpublished Ph. D. thesis, Freie Universität, Berlin, 1955.

————. "Die Auflösung des Gegenstandes und der Funktionswandel der malerischen Elemente im Werke Kandinskys 1908-1914," in *Edwin Redslob zum 70. Geburtstag; eine Festgabe*, Berlin, 1955, 347-56.

————. "Paul Klee und Robert Delaunay," *Quadrum*, 3, 1957, 137-41.

Henry, Sara L. "Form-Creating Energies: Paul Klee and Physics," *Arts Magazine*, September, 1977, 118-21.

Hess, Walter. "Die grosse Abstraktion und die grosse Realistik," *Jahrbuch für Aesthetik*, V, 1960, 7-32.

Hirschfeld-Mack, Ludwig. *The Bauhaus*, Victoria, 1963.

Hofmann, Werner. "Ein Beitrag zur 'Morphologischen Kunsttheorie' der Gegenwart," *Alte und Neue Kunst*, 2, 1953, 63-80.

————. "Studien zur Kunsttheorie des 20. Jahrhunderts,"*Zeitschrift für Kunstgeschichte*, 18, January, 1955, 136-50.

————. "Klee und Kandinsky," *Merkur*, 11, November, 1957, 1096-1102.

Hofstätter, Hans H. "Symbolismus und Jugendstil im Frühwerk von Paul Klee," *Kunst in Hessen und am Mittelrhein,* 5, 1965, 97-118.

Huggler, Max. "Die Kunsttheorie von Paul Klee," *Festschrift Hans R. Hahnloser,* Basel and Stuttgart, 1961, 425-41.

_____ . "Die Farbe bei Paul Klee," *Palette,* no. 25, 1967, 13-22.

_____ . *Paul Klee. Die Malerei als Blick in den Kosmos,* Frauenfeld, 1969.

Itten, Johannes. *Mein Vorkurs am Bauhaus,* Ravensburg, 1963.

Jaffé, H. L. *Paul Klee,* Lucerne, 1970.

Jordan, Jim M. *Paul Klee and Cubism, 1912-1926,* unpublished Ph. D. thesis, New York University, New York, 1974.

_____ . "The Structure of Paul Klee's Art in the Twenties: From Cubism to Constructivism," *Arts Magazine,* September, 1977, 152-57.

Kadow, Gerd. "Paul Klee and Dessau in 1929," *Art Journal,* 9, 1949, 34-36.

Kagan, Andrew. *Klee-Studies,* unpublished. Ph. D. thesis, Harvard University, Cambridge, Mass., 1977.

_____ . "Paul Klee's "Ad Parnassum:" The Theory and Practice of Eighteenth Century Polyphony as Models for Klee's Art," *Arts Magazine,* September, 1977, 90-104.

Kandinsky, Nina. *Kandinsky und ich,* Munich, 1976.

Kandinsky, Wassily. *Über das Geistige in der Kunst,* Munich, 1912. New edition, ed. by Max Bill, Bern 1952, 9th printing Bern, 1970; English edition, *Concerning the Spiritual in Art,* trans. by F. Golffing, N. Harrison, F. Ostertag, New York, 1947 (Wittenborn edition).

Kandinsky, Wassily and Marc, Franz. *Der Blaue Reiter,* Munich, 1912; Dokumentarische Neuausgabe ed. by Klaus Lankheit, Munich, 1965; English edition, *The Blaue Reiter Almanac,* London, 1974.

Kandinsky, Wassily. *Klänge, Munich, 1913.*

_____ . *Kandinsky Album,* Der Sturm, Berlin, 1913.

_____ . *Punkt und Linie zu Fläche,* Munich, 1926. 2nd ed., 1928, New ed., ed. by Max Bill, Bern, 1955. Sixth printing, 1969; English edition, *Point and Line to Plane,* transl. by H. Dearstine and H. Rebay, New York, 1947.

_____ . *Essays über Kunst und Künstler,* ed. by Max Bill, Stuttgart, 1955. 2nd ed., Bern, 1963.

_____ . *Rückblicke (1913),* ed. by Ludwig Grote, Baden-Baden, 1955; English translation in Robert Herbert, ed. *Modern Artists on Art,* Englewood Cliffs N.J., 1964, 19-44.

_____ . "Brief an Hermann Rupf," *Du,* 16, March, 1956, 27-29.

_____ . *Regards sur le passé et autres textes 1912-1922,* ed. by Jean Paul Bouillon, Paris, 1974.

_____ . *Ecrits complets, III (La synthèse des arts),* ed. by Philippe Sers, Paris, 1975.

Klee, Felix, ed. *Paul Klee. Leben und Werk in Dokumenten,* Zurich, 1960; English edition, Paul Klee. *His Life and Works in Documents,* New York, 1962.

Klee, Paul. *Pädagogisches Skizzenbuch,* Munich, 1925; English edition, *Pedagogical Sketchbook,* transl. by Sybil Moholy-Nagy, New York, 1953.

_____ . *Das Bildnerische Denken,* ed. by Jürgen Spiller, Basel and Stuttgart, 1956. English edition, *The Thinking Eye,* transl. by Ralph Manheim, New York, 1961. 4th ed., 1973.

_____ . *Tagebücher 1898-1918,* ed. by Felix Klee, Cologne, 1957; English edition, *The Diaries of Paul Klee, 1898-1918,* Berkeley and Los Angeles, 1964.

Klee, Paul. *Unendliche Naturgeschichte,* ed. by Jürgen Spiller, Basel and Stuttgart, 1970.; english edition; *Notebooks Volume 2. The Nature of Nature,* transl. by Heinz Norden, New York, 1973.

_____ . *Schriften, Rezensionen und Aufsätze,* ed. by Christian Geelhaar, Cologne, 1976.

Kornfeld, Eberhard. *Paul Klee. Bern und Umgebung, Aquarelle und Zeichnungen, 1887-1915,* Bern, 1962.

_____ . *Verziechnis des graphischen Werkes von Paul Klee,* Bern, 1963.

Kröll, Christina. *Die Bildtitel Paul Klees. Eine Studie zur Beziehung von Bild und Sprache in der Kunst des zwanzigsten Jahrhunderts,* Ph. D. thesis, Bonn, 1968.

Kröll, Friedhelm, *Bauhaus 1919-1933. Künstler zwischen Isolation und Kollektiver Praxis,* Düsseldorf, 1974.

Lankheit, Klaus. "Zur Geschichte des Blauen Reiter," *Der Cicerone,* no. 3, 1949, 110-14.

_____. "Die Frühromantik und die Grundlagen der gegenstandslosen Malerei," *Neue Heidelberger Jahrbücher,* n. s., 1951, 55-90.

_____. "Bibel-Illustrationen des Blauen Reiters," *Anzeiger des Germanischen Nationalmuseums,* Nürnberg, 1963, 199-207.

_____. *Franz Marc. Katalog der Werke,* Cologne, 1970.

_____. *Franz Marc,* Cologne, 1976.

Lassaigne, Jacques. *Kandinsky,* Geneva, 1964.

Laxner, Uta. *Stilanalytische Untersuchungen zu den Aquarellen der Tunisreise 1964. Macke, Klee, Moilliet,* Ph. D. thesis, Bonn, 1967.

Lindsay, Kenneth. *An Examination of the Fundamental Theories of Wassily Kandinsky,* unpublished. Ph. D. thesis, University of Wisconsin, Madison, Wis., 1951.

_____. "Genesis and Meaning of the Cover Design for the first Blaue Reiter exhibition catalogue," *Art Bulletin,* 35, March, 1953, 47-52.

_____. "Review of W. Grohmann, *Kandinsky,* 1958," *Art Bulletin,* 41, December, 1959. 348-350.

London, Lefevre Gallery. *Wassily Kandinsky. Oil Paintings and Watercolors,* exh. cat., 1973.

London, Marlborough Fine Art Ltd. *Kandinsky: The Road to Abstraction,* exh. cat., 1961. Introduction by H. K. Roethel.

_____. *Painters of the Bauhaus,* exh. cat., 1962.

_____. *Kandinsky and His Friends,* exh. cat., 1966. Introduction by W. Grohmann.

London, Sotheby & Co. *Fifty Paintings by Vasily Kandinsky, the Property of the S. R. Guggenheim Foundation,* auct. cat., June 30, 1964.

Lützeler, Heinrich. "Bedeutung and Grenze abstrakter Malerei,",*Jahrbuch für Aesthetik und Kunstwissenschaft,* 3, 1-35.

Lynton, Norbert. *Paul Klee,* London, 1964.

Macke, August. *Die Tunisreise,* Cologne, 1958.

Macke, Wolfgang, ed. *Macke/Marc Briefwechsel,* Cologne 1964.

Marc, Franz. *Briefe, Aufzeichnungen und Aphorismen,* 2 vols., Berlin, 1920.

_____. *Briefe aus dem Feld,* Berlin, 1941. Reprint, Berlin, 1946.

Marcadé, V. *Le Renouveau de l'art pictural russe 1863-1914,* Lausanne, 1971.

A. Mösser, *Das Problem der Bewegung bei Paul Klee. Heidelberger Kunstgeschichtliche Abhandlungen,* N.F. 12 Heidelberg, 1976.

Muche, Georg. *Blickpunkt Sturm Dada Bauhaus Gegenwart,*Munich, 1961.

Munich, Haus der Kunst. *Der Blaue Reiter,* exh. cat., 1949. Introduction by L. Grote.

_____. *Die Maler am Bauhaus,* exh. cat., 1950. Introduction by L. Grote.

_____. *Paul Klee,* exh. cat., 1970. Introduction by J. Spiller.

_____. *Wassily Kandinsky, 1866-1944,* exh. cat, 1976. Introduction by. Th. Messer.

Münster, Westfälisches Landesmuseum. *August Macke, Aquarelle und Zeichnungen,* exh. cat., 1976.

Myers, Bernard. *The German Expressionists,* New York, 1957.

Neumann, Eckart, ed. *Bauhaus and Bauhaus People,* New York, 1970.

New York, Marlborough Gerson Galleries, Inc. *Kandinsky: The Bauhaus Years,* exh. cat., 1966.

New York, Museum of Modern Art *Paul Klee,* exh. cat., 1941.

New York, Parke-Bernet Galleries. *Important Twentieth Century Paintings, Watercolors, and Drawings from the S. R. Guggenheim Foundation,* auct. cat., October 20, 1971.

New York, Solomon R. Guggenheim Foundation. *Kandinsky,* ed. by Hilla Rebay, 1945.

_____. *Wassily Kandinsky Memorial,* ed. by Hilla Rebay, 1945.

New York, Solomon R. Guggenheim Museum. *Kandinsky 1866-1944,* exh. cat., 1962. (Circulating show USA)

———. *Vasily Kandinsky 1866-1944*, exh. cat., 1962. (also at Basel, Den Haag, Paris)

———. *Vasily Kandinsky: Paintings on Glass (Hinterglasmalerei)*, exh. cat., New York, 1966.

———. *Paul Klee, 1879-1940*, exh. cat., 1967.

———. *Kandinsky at the Guggenheim Museum*, cat., 1972.

———. *Klee at the Guggenheim Museum*, cat., 1977.

Orlandini Volpi, Marisa. *Wassily Kandinsky*, 1968.

Osterwold, Tilmann, ed. *Paul Klee. Die Ordnung der Dinge*, Stuttgart, 1975.

Overy, Paul. *Kandinsky, The Language of the Eye*, New York and Washington, 1969.

Paris, Galérie Berggruen. *Klee-Kandinsky, une confrontation*, exh. cat., 1959. Introduction by K. Lindsay.

———. *Kandinsky-aquarelles et dessins*, exh. cat., 1972.

Paris, Galérie Flincker. *Wassily Kandinsky*, exh. cat., 1972.

———. *Kandinsky. 82 oeuvres sur papier de 1902 à 1944*, exh. cat., 1977.

Paris, Galérie Maeght. *Derrière le Mirroir. Kandinsky*, exh. cat., 1953. Introduction by W. Grohmann.

———. *Derrière le Mirroir. Kandinsky: oeuvres de 1921-1927*. exh. cat., Paris, 1960. Introduction by A. Chastel and W. Grohmann.

———. *Derrière le Mirroir. Kandinsky: Bauhaus de Dessau 1927-1930*, exh. cat., 1965. Introduction by W. Haftmann.

Paris, Musée National d'Art Moderne. *Paul Klee*, exh. cat., 1969.

Parma, Università di Parma, Instituto di Storia dell'arte. *Klee. Fino al Bauhaus*, exh. cat., 1972. Introduction by A.C. Quintavalle.

Petitpierre, Petra. *Aus der Malklasse von Paul Klee*, Bern, 1957.

Pfeiffer-Belli, Erich. *Paul Klee. Eine Bildbiographie*, Munich, 1964.

Pierce, James Smith. *Paul Klee and Primitive Art*, New York, 1976. (Ph.D. thesis, Harvard University, Cambridge, Mass., 1961)

———. "Pual Klee and Baron Welz," *Arts Magazine*, September, 1977, 128-131.

Poling, Clark V. *Color Theories in the Twentieth Century*, unpublished Ph.D. thesis, Columbia University, New York, 1973.

Polson, Margaret. *Paul Klee: A Study in Visual Language*, unpublished Ph.D. thesis, University of North Carolina at Chapel Hill, 1974.

Read, Herbert. *Klee (1879-1940)*, London, 1948.

———. *Kandinsky (1866-1944)*, London, 1959.

Ringbom, Sixten. "Art in the "Epoch of the Great Spiritual:" Occult Elements in the Early Theory of Abstract Painting," *Journal of the Warburg and Courtauld Institutes*, 29, 1965, 386-418.

———. *The Sounding Cosmos. A Study in the Spiritualism of Kandinsky and the Genesis of Abstract Painting, Acta Academiae Aboensis*, ser. A 38, no. 2, Abo, 1970.

———. "Paul Klee and the Inner Truth to Nature," *Arts Magazine*, September, 1977, 112-17.

Roditi, Eduardo, "Interview with Gabriele Münter," *Arts*, 34, January, 1960, 36-41.

Roethel, Hans Konrad. "Kandinsky: Improvisation Klamm. Vorstufen einer Deutung," *Festschrift Eberhard Hanfstaengl*, Munich, 1961.

———. *Kandinsky. Das Graphische Werk*, Cologne, 1970.

———. *Paul Klee in München*, Bern, 1971.

Rosenblum, Robert. *Modern Painting and the Northern Romantic Tradition*, London, 1975.

Rosenthal, Deborah. "Paul Klee: The Lesson of the Master," *Arts Magazine*, September, 1977, 158-60.

Roskill, Mark. "Three Critical Issues in the Art of Paul Klee," *Arts Magazine*, September, 1977, 132-33.

Roters, Eberhard. "Wassily Kandinsky und die Gestalt des Blauen Reiters," *Jahrbuch der Berliner Museen*, V, Berlin, 1963, 201-26.

———. *The Painters at the Bauhaus*, New York, 1969.

Roy, Claude. *Paul Klee. Aux Sources de la Peinture,* Paris, 1963.

Rudenstine, Angelica Z. *The Guggenheim Museum Collection. Paintings 1880-1945,* 2 vols., New York, 1976.

San Diego, Fine Arts Gallery. *Color and Form, 1909-1914,* ed. by H.G. Gardiner, exh. cat., 1971.

San Lazzaro, Gualtieri di. *Klee,* New York and Washington, 1957.

Scheyer, Ernst, "Molzahn, Muche, and the Weimar Bauhaus," *Art Journal,* 28, 1969, 269-77.

Schiff, Gerd. "Paul Klee at the Guggenheim," *Artforum,* 5, no. 9, 1967, 49-52.

Schlemmer, Oskar. *Briefe und Tagebücher,* ed. by Tut Schlemmer, Munich, 1958. 2nd ed., Stuttgart, 1977. English edition, *The Letters and Diaries of Oskar Schlemmer,* Middletown, 1972.

Schreyer, Lothar. *Erinnerungen an Sturm und Bauhaus,* Munich, 1956.

Schweizer, Hans-Martin. "Die Immanenz des Transzendenten in der Kunsttheorie von Paul Klee," *Festschrift Georg Scheja zum 70. Geburtstag,* Sigmaringen, 1975, 237-61.

Selz, Peter. *German Expressionist Painting,* Berkeley and Los Angeles, 1957.

_____. "The Influence of Cubism and Orphism on the 'Blue Rider'," *Festschrift Ulrich Middeldorf,* 2 vols., Berlin, 1968, 582-90.

Smigocki, Stephen V. *An Inquiry into the Art Pedagogy of Klee and Kandinsky,* unpublished Ph.D. thesis, Florida State University, 1974.

Soby, James Thrall. *The Prints of Paul Klee,* New York, 1945.

Soupault, Ré. "Quand j'étais l'élève de Kandinsky," *Jardin des Arts,* no. 103, 1963, 48-55.

Storrs, William Benton Museum of Art, University of Connecticut. *Vasily Kandinsky, an Introduction to his Work,* exh. cat., 1974

Strauss, Ernst. "Paul Klee: 'Das Licht und Etliches'," *Pantheon,* 28, January, 1970, 50-56.

_____. "Zur Helldunkellehre Klees," *Koloritgeschichtliche Untersuchungen zur Malerei seit Giotto,* Munich, 1972, 121-33.

Stuttgart, Württembergischer Kunstverein, *50 Jahre Bauhaus,* exh. cat., 1968.

_____. *Laszlo Moholy-Nagy,* exh. cat., 1974.

Szondi, Peter. *Poetik und Geschichtsphilosophie I. Antike und Moderne in der Aesthetik der Goethezeit,* Frankfurt, 1974.

Tavel, Hans-Christian von. "Vor 50 Jahren: Reise nach Kairuan," *Mitteilungen des Berner Kunstmuseum,* no. 69, March, 1964, 2-5.

_____. "Dokumente zum Phänomen 'Avantgarde.' Paul Klee und der Moderne Bund in der Schweiz, 1910-1912," *Jahrbuch des Schweizerischen Institutes für Kunstwissenschaft,* 1968/69, Zurich, 1970, 69-116.

Teuber, Marianne. "Blue Night by Paul Klee," *Vision and Artefact,* ed. by M. Henle, New York, 1976.

Thwaites, John Anthony. "Paul Klee and the Object," *Parnassus,* 9, November 1937, 9-11; December 1937, 7-9, 33-34.

_____. "The Blaue Reiter, a Milestone in Europe," *Art Quarterly,* 13, Winter, 1950, 12-20.

_____. "Bauhaus Painters and the New Style-Epoch," *Art Quarterly,* 14, Winter 1951, 19-32.

Tolstoy, Leo. *What is Art?,* English edition by V. Tomas, New York, 1960.

Tomas, Vincent. "Kandinsky's Theory of Painting," *British Journal of Aesthetics,* 9, January 1969, 19-38.

Toronto, Art Gallery of Ontario. *Kandinsky Watercolors,* exh. cat. 1970. Introduction by Paul Overy.

Tokyo International Publishers, ed. *Klee-Kandinsky,* New York, 1972.

Ueberwasser, Walter. "Zu Klee's Bild 'Genien'. Goethes Weltseele, Versuch einer Interpretation," *Frankfurter Allgemeine Zeitung,* no. 200, 30. August 1963.

Uhde-Bernays, Hermann, ed. *Künstlerbriefe über Kunst,* Munich, 1956.

Verdi, Richard. "Musical Influences on the Art of Paul Klee," *Museum Studies,* no. 3, 1968, 81-107.

Vergo, Peter. *The Blue Rider,* Oxford and New York, 1977.

_____ . "Review of *Paul Klee. Schriften,*" *Burlington Magazine,* October, 1977, 20-21.

Vogt-Göknil, Ulya. "Ein Deutungsversuch von Kandinsky's Kunstheorie," *Gotthard Jedlicka. Eine Gedenkschrift,* Zurich, 1974, 127-234.

Volboudt, Pierre. *Die Zeichnungen Wassily Kandinskys,* Cologne, 1974.

Vriesen, Gustav. *August Macke,* Stuttgart, 1953. 2nd ed., 1957.

_____ . and Imdahl, Max. *Robert Delaunay: Light and Color,* New York, 1969.

Washton, Rose-Carol. *Vasily Kandinsky 1909-1913: Painting and Theory,* unpublished Ph.D. thesis, Yale University, New Haven, 1969.

_____ . "Kandinsky and Abstraction: The Role of the Hidden Image," *Artforum,* 10, June 1972, 42-49.

_____ . "Kandinsky's Abstract Style: The Veiling of Apocalyptic Imagery," *Art Journal,* Spring 1975, 217-28.

Weiler, Clemens. *Alexej Jawlensky,* Cologne, 1959.

Weimar, Staatliches Bauhaus. *Staatliches Bauhaus in Weimar, 1919-1923,* exh. cat., 1923.

Weiss, Peg. *Wassily Kandinsky: The Formative Munich Years (1896-1914)—From Jugendstil to Abstraction,* unpublished Ph.D. thesis, Syracuse University, Syracuse, 1973.

_____ . "Kandinsky and the 'Jugendstil' Arts and Crafts Movement," *Burlington Magazine,* May 1975, 270-79.

_____ . "Kandinsky: Symbolist Poetics and Theater in Munich," *Pantheon,* 35, July 1977, 209-18.

Werckmeister, O.K. "The Issue of Childhood in the Art of Paul Klee," *Arts Magazine,* September 1977, 138-215.

Wingler, Hans Maria. *Das Bauhaus 1919-1933,* Bramsche, 1962. 3rd ed., Cologne, 1975.

Worringer, Wilhelm. *Abstraktion und Einfühlung,* Munich, 1908. New edition, Munich, 1959; English edition, *Abstraction and Empathy,* transl. by Michael Bullock, London, 1963.

XXe Siècle. *Centennaire de Kandinsky,* special number, n.s. 27, December, 1966, 1-120; Essays by B. Dorival, M. Deutsch, C. Giedion-Welcker, W. Grohmann, K. Lankheit, K. Lindsay, H. Nishida, R. Soupault-Niemeyer, P. Volboudt, et al., 2nd ed., *Hommage à Wassily Kandinsky,* Paris, 1974; German edition, Wiesbaden, 1976.

Zahn, Leopold. *Paul Klee: Leben, Werk, Geist,* Potsdam, 1920.

Zehder, Hugo. *Wassily Kandinsky,* Dresden, 1920.

Index